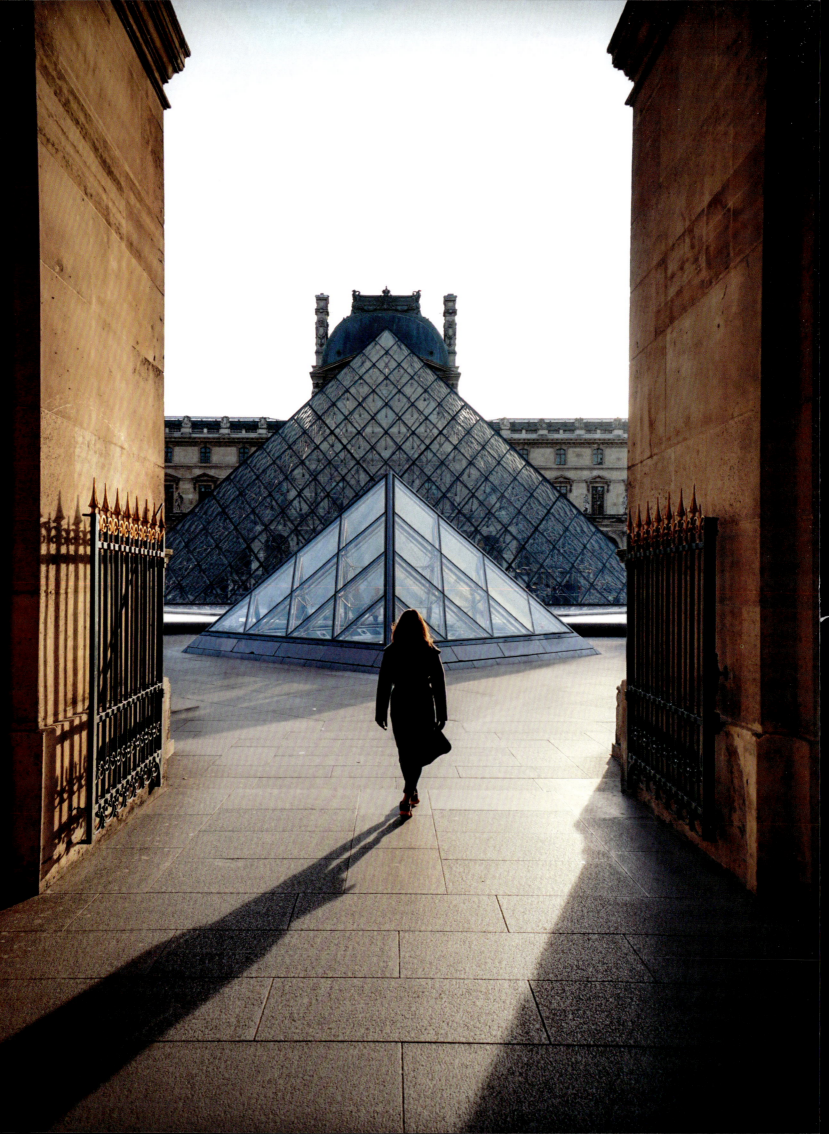

Pierre Toromanoff

PARIS

IN FASHION

ACC ART BOOKS

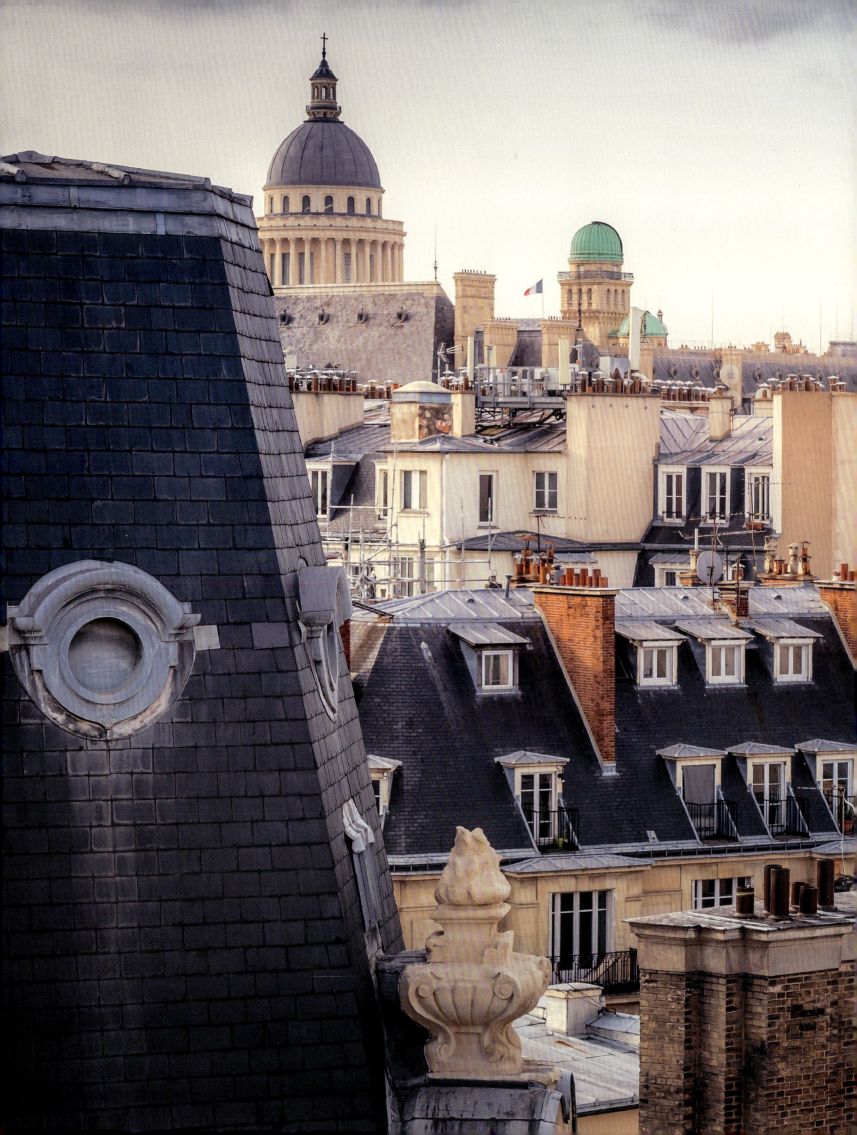

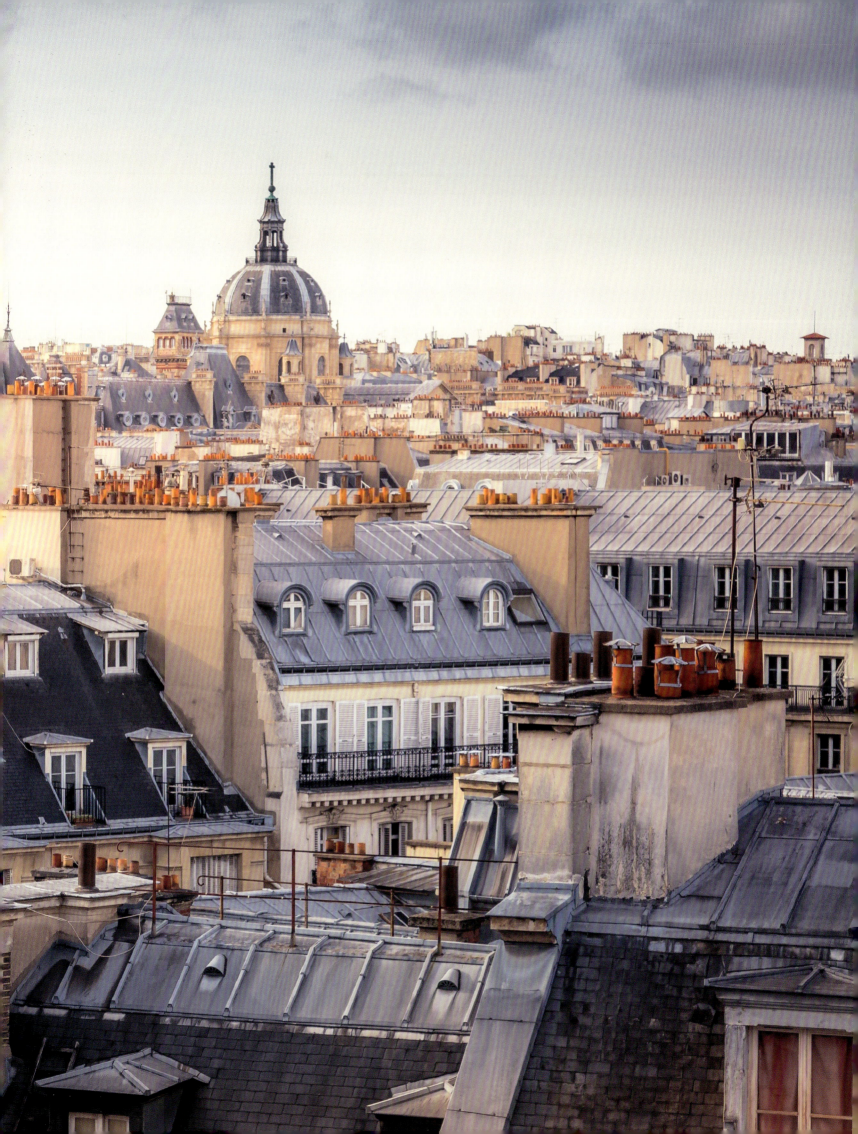

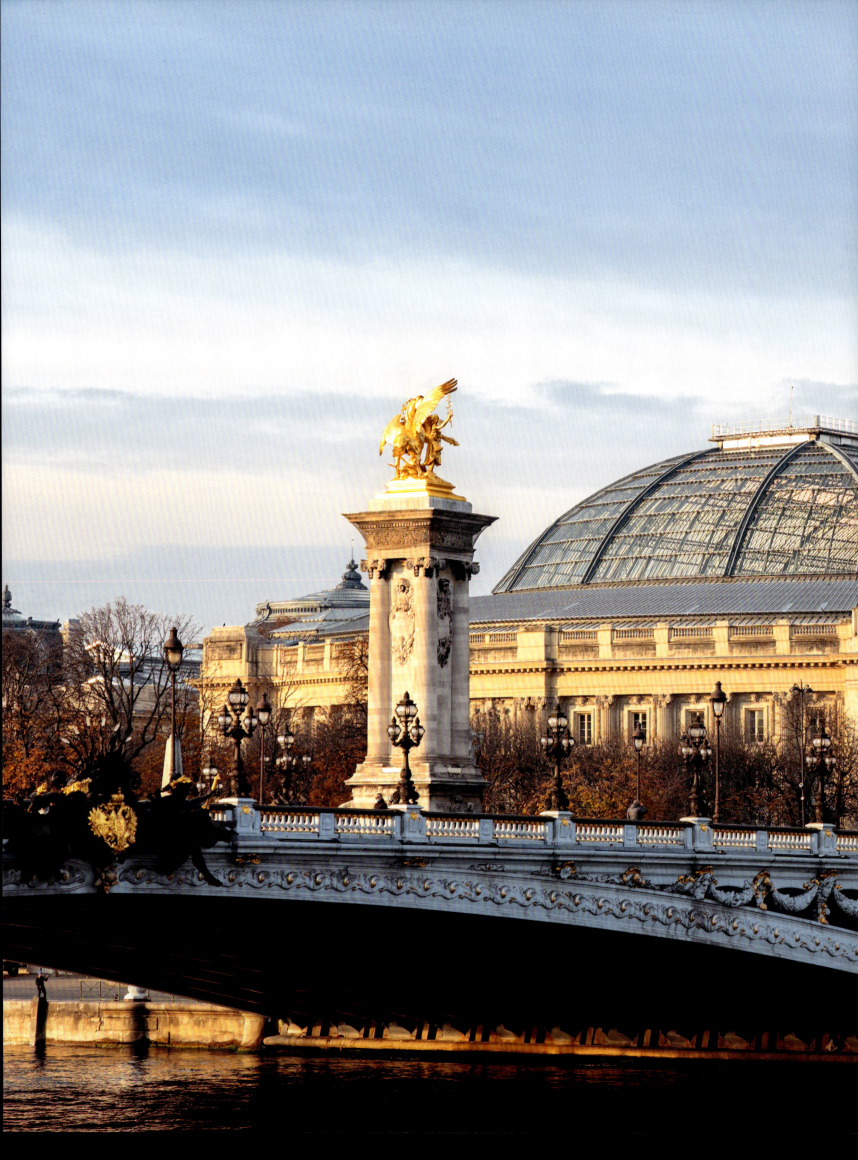

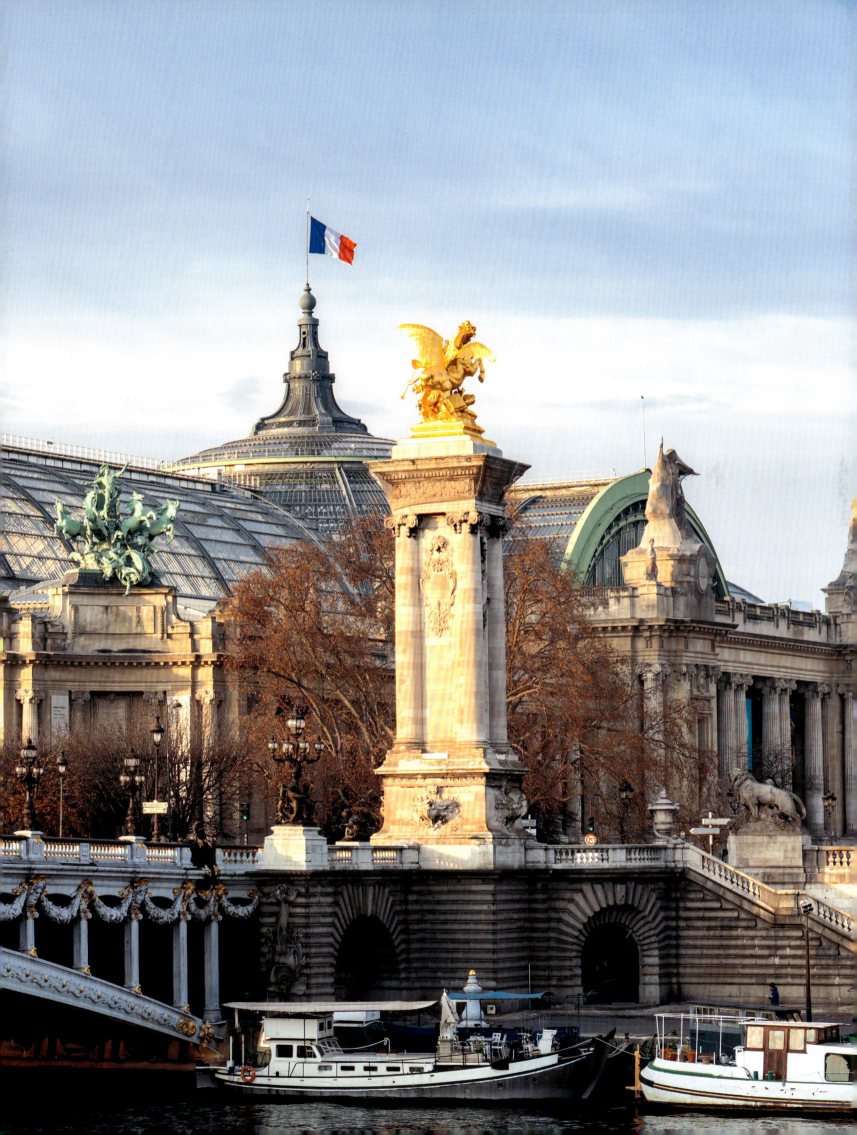

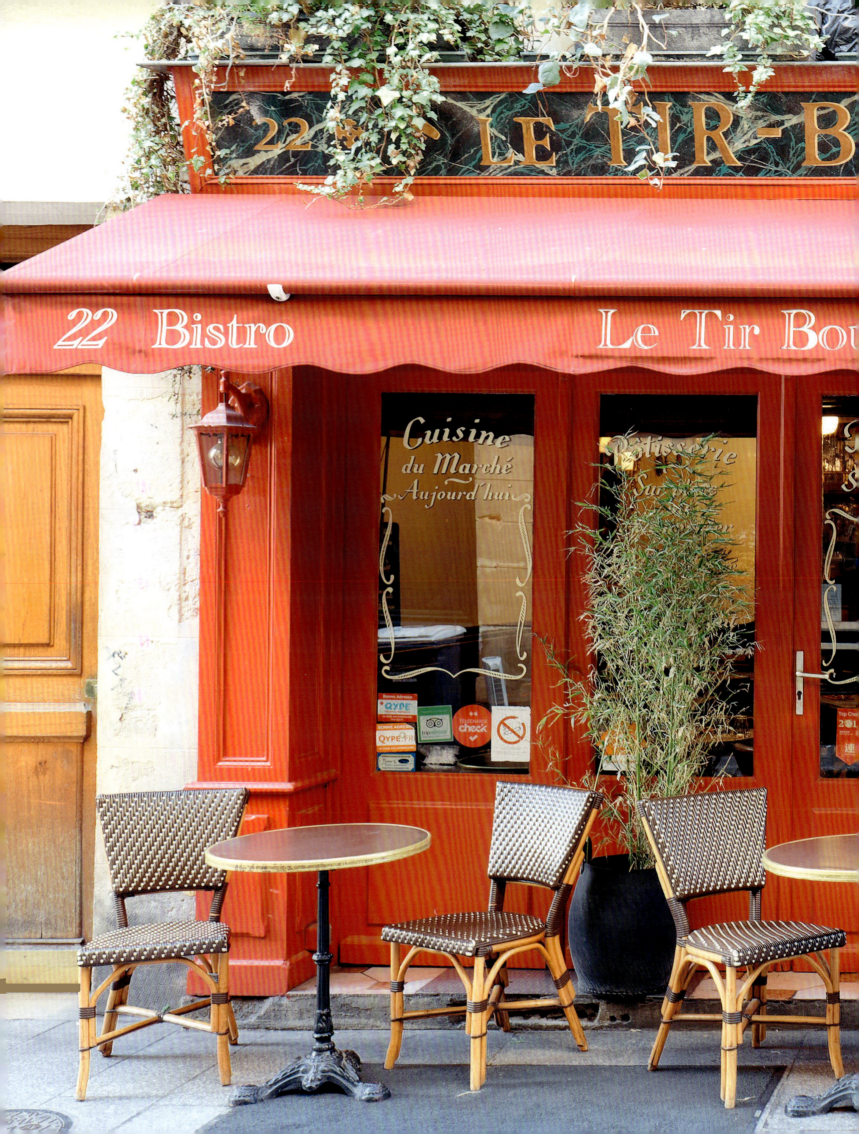

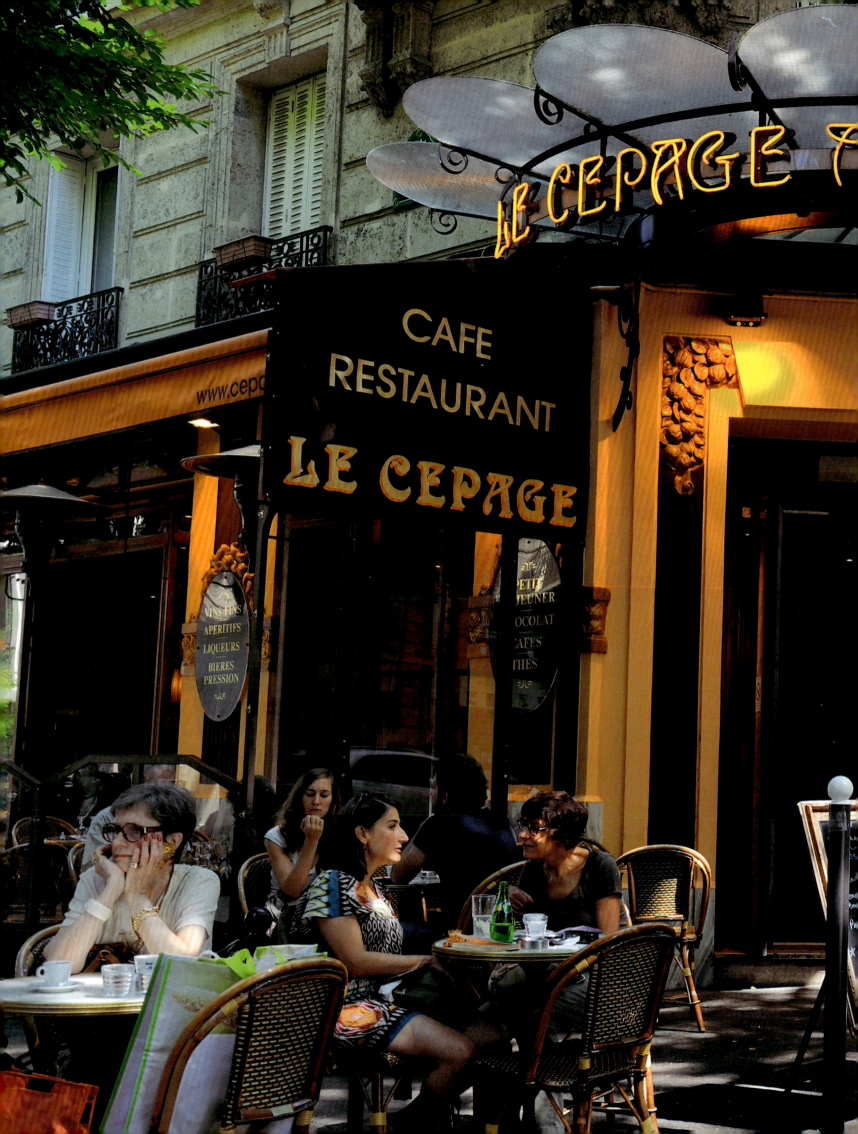

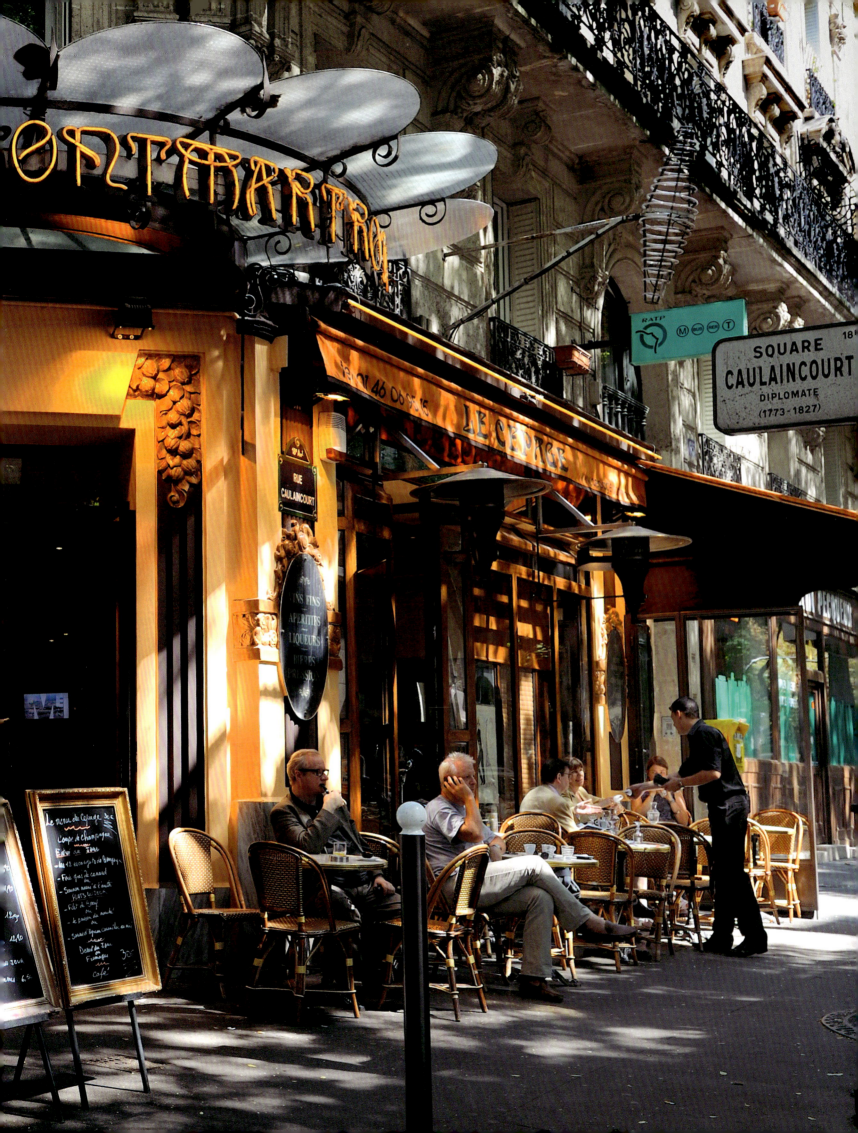

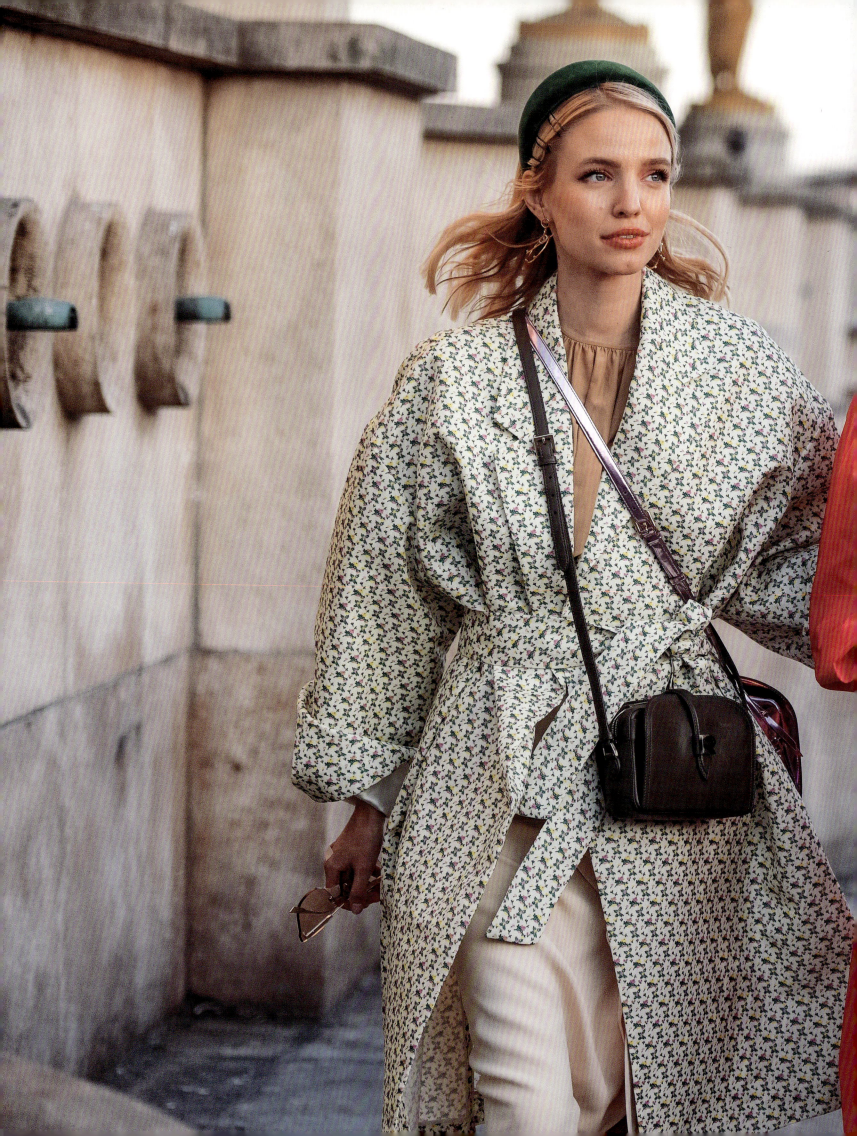

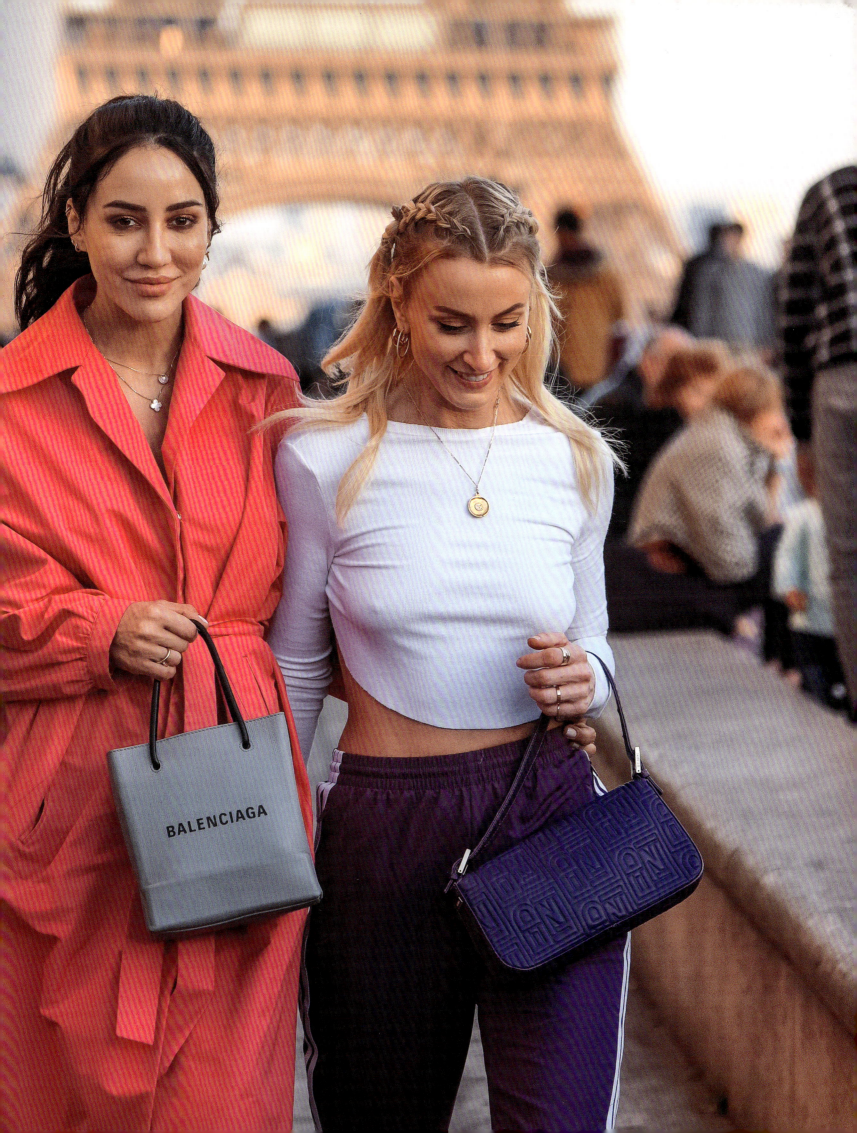

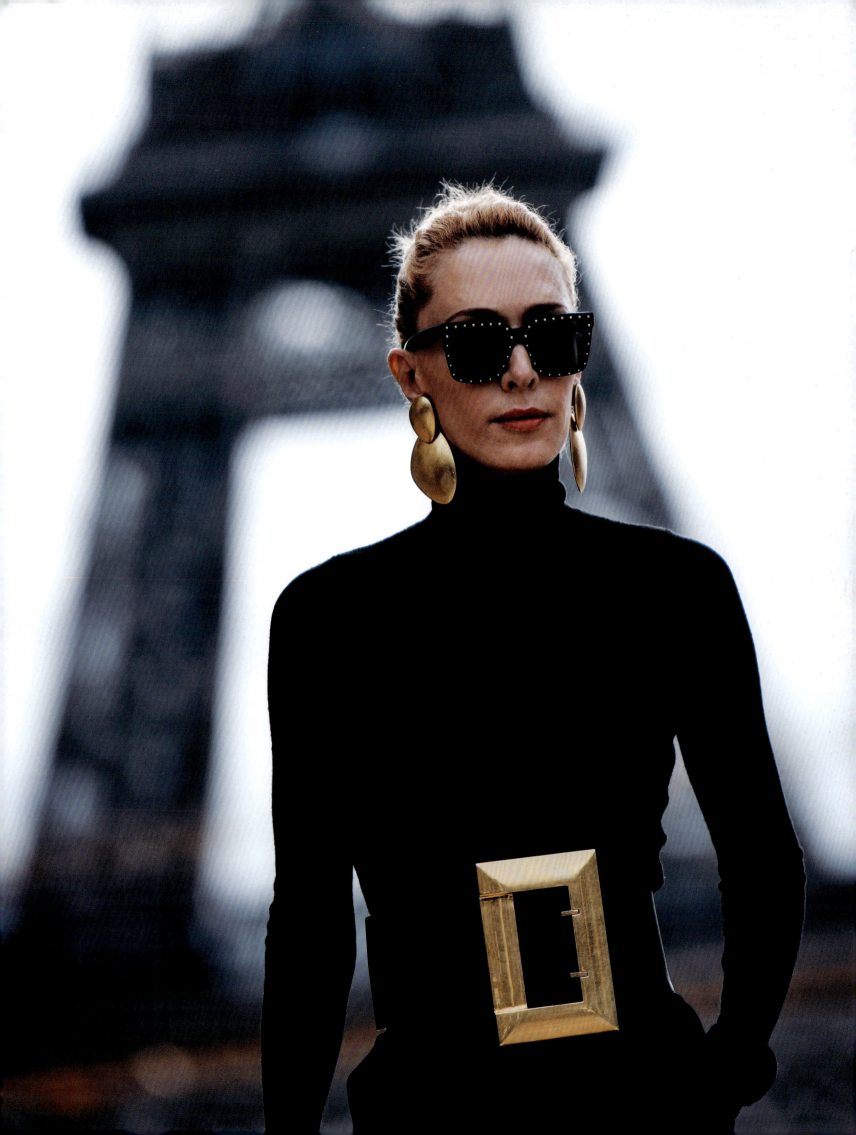

Introduction
18

Fashion in Paris:
Past and Present
20

Celebrating Couture
54

Parisian Street Style
114

Shopping
172

Only in Paris
244

Photo Credits
294

Acknowledgements
295

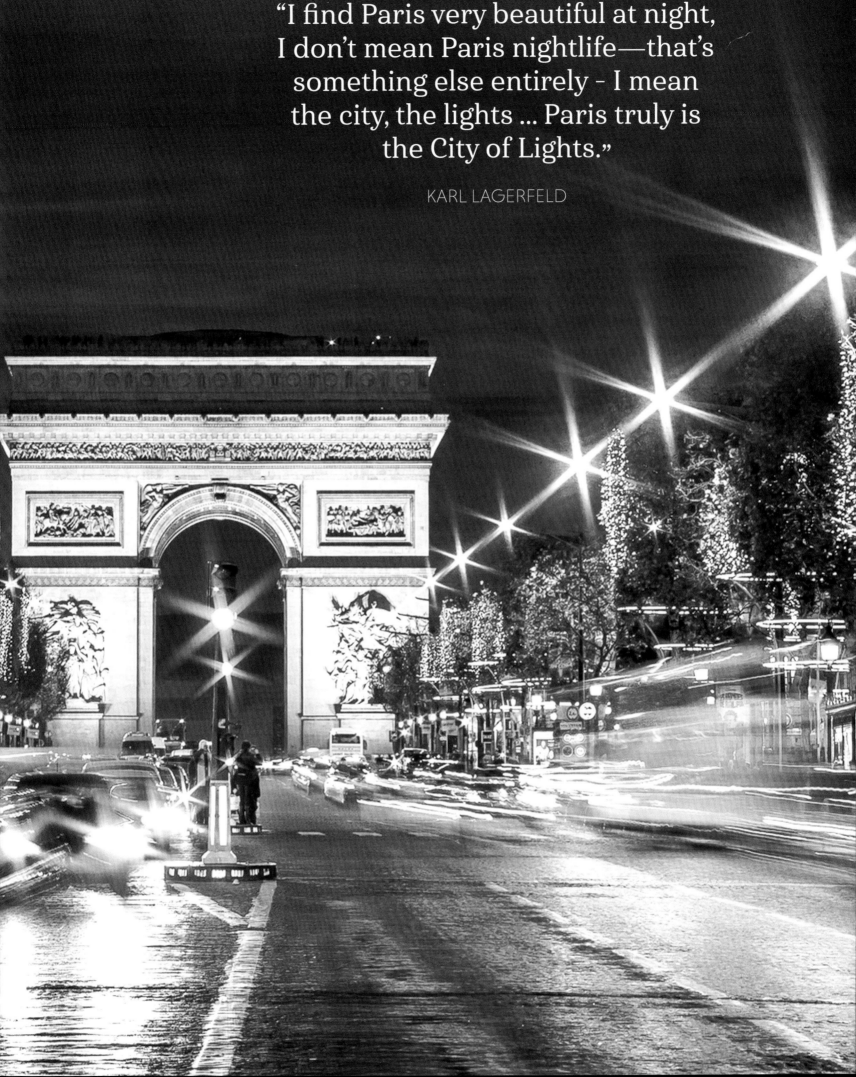

"I find Paris very beautiful at night, I don't mean Paris nightlife—that's something else entirely - I mean the city, the lights ... Paris truly is the City of Lights."

KARL LAGERFELD

"Paris makes more than the law,
it makes the fashion."

VICTOR HUGO

INTRODUCTION

A millennia-old city at the crossroads where fashion, luxury, creativity and multiple diverse cultural influences meet, Paris naturally appeals to lovers of all things beautiful. The words of French poet Charles Baudelaire come readily to mind: "There, all is peace and beauty, luxury and sensuality." The birthplace of haute couture is also home to many of the world's finest jewellers, perfumers, and leather goods manufacturers, who have all contributed to creating a distinctive, enchanting atmosphere. Fashion in Paris is not confined to fashion shows – even if these are part of the festive ambience and a splendid showcase for French excellence – but is also present in the streets and cafés, which are ideal observation points for admiring the effortless sophistication and sartorial choices of the locals.

Flâner, the French verb for wandering aimlessly through the streets, is the ideal way to immerse yourself in the Parisian spirit. In the first lines of his book about the city, Paris-born American writer Julien Green confesses: "I have often dreamed of writing a book about Paris that would be like one of those long, aimless strolls on which you find none of the things you are looking for but many that you were not looking for." With that in mind, get ready to make some surprising discoveries. *Paris: In Fashion* will give you valuable clues for exploring the essence of Parisian fashion and stumbling on hidden gems that will define your vision of Paris and help you fall in love with this unique city.

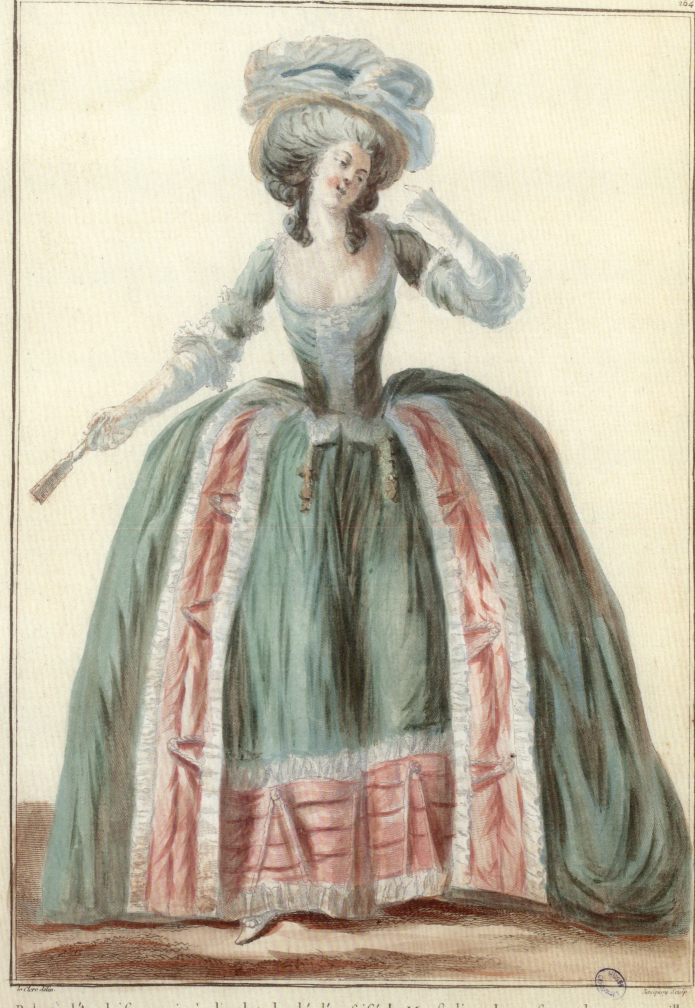

Robe à l'Anglaise garnie à plis plats bordé d'un frisé de Mousseline, des tresses et boutons pareilles à la Robe; Chapeau garnie d'une toque de gaze négligemment ajusté avec un ruban

A Paris chez Esnauts et Rapilly, Rue St Jacques à la Ville de Coutances.

FASHION IN PARIS: PAST AND PRESENT

If the fashion world were a constellation in the skies, and Paris one of its stars, it would certainly be Sirius, the brightest star visible to the naked eye. Or perhaps the North Star, the one that guides adventurers, sailors, and travellers and that is sometimes called the "hub of the heavens". Even though it now shares the name of 'fashion capital' with London, Milan, and New York (the famous 'Big Four'), for many centuries Paris was the ultimate authority on elegance and sartorial taste. As such, it has enjoyed undisputed leadership in the realm of style. It would be quite difficult to imagine the history of fashion without the city's contribution of haute couture and the three key elements that underpin the city's glory: the excellence of its craftspeople specialising in luxury goods, the genius of couturiers and designers who have always been keen to push forward the boundaries of refinement and extravagance, and, last but not least, the insatiable appetite of Parisians for everything new, original, and trendy.

Paradoxically, while Paris has become the epitome of elegance and refinement, fashion hasn't always reigned supreme in the hearts of Parisians. Around 1003 AD, Constance of Arles, the third wife of Robert II, King of the Franks, was criticised by the Parisian clergy for the eccentric clothing worn by her retinue, who had accompanied the young queen from her native Provence. Five centuries later, despite the influence of Italian refinement that began to permeate the capital of France at the end of the Renaissance, King Henry III was still regularly mocked for the extreme care he took with his clothing and his taste for luxury.

The first golden age of couture and fashion in Paris had to wait until the reign of Louis XIV (1638–1715). Arguably the most famous monarch in French history, Louis was determined to make France a leading European power, not only in the military and diplomatic spheres, but also in luxury craftsmanship and trade – a good way of bolstering the state coffers while laying the foundations for French cultural hegemony on the continent. Jean-Baptiste Colbert, the King's Minister of Finance, was quick to state that "fashion is to France what the mines of Peru are to Spain", in other words, an inexhaustible source of gold – and a lasting one, as the French fashion industry is typically estimated to be worth tens of billions of euros.

The court at the newly built Palace of Versailles fervently adopted the new rules of elegance and style set by the Sun King, followed by the aristocracy and the rapidly expanding wealthy bourgeoisie. Royal and imperial courts across Europe were quick to mimic the splendour and sartorial magnificence of Versailles – an early example of France's "soft" power. For over a century, Paris was the epicentre of elegance and refinement in clothing until the Revolution put an end to the reign of Louis XVI and the fashion extravaganzas of his wife Marie Antoinette.

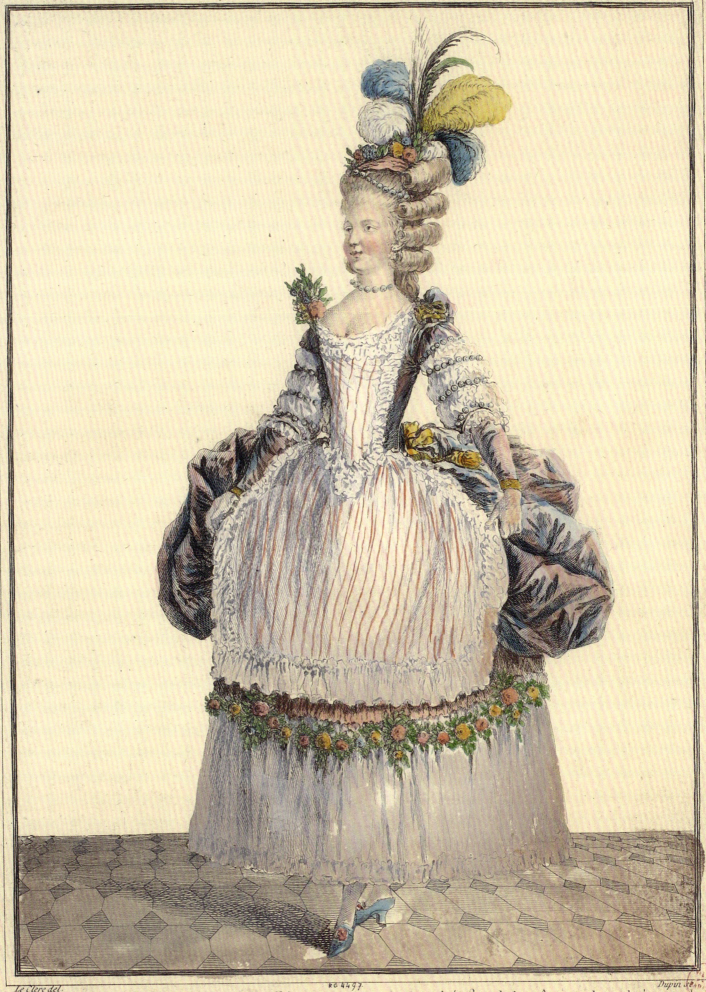

Habit de bal, le corsage et le juppon retroussés avec des glands, les côtés sont de la même couleur; la juppe de dessous est d'une autre couleur: les manches sont recouvertes en pouf et garnies de perles; la garniture de la juppe de dessous ornée d'une guirlande de fleurs; toutes les garnitures sont de gaze légère; une très g.^de coëssure en plumes.

A Paris chez Esnauts et Rapilly rue S.^t Jacques, à la Ville de Coutances. A.P.D.R.

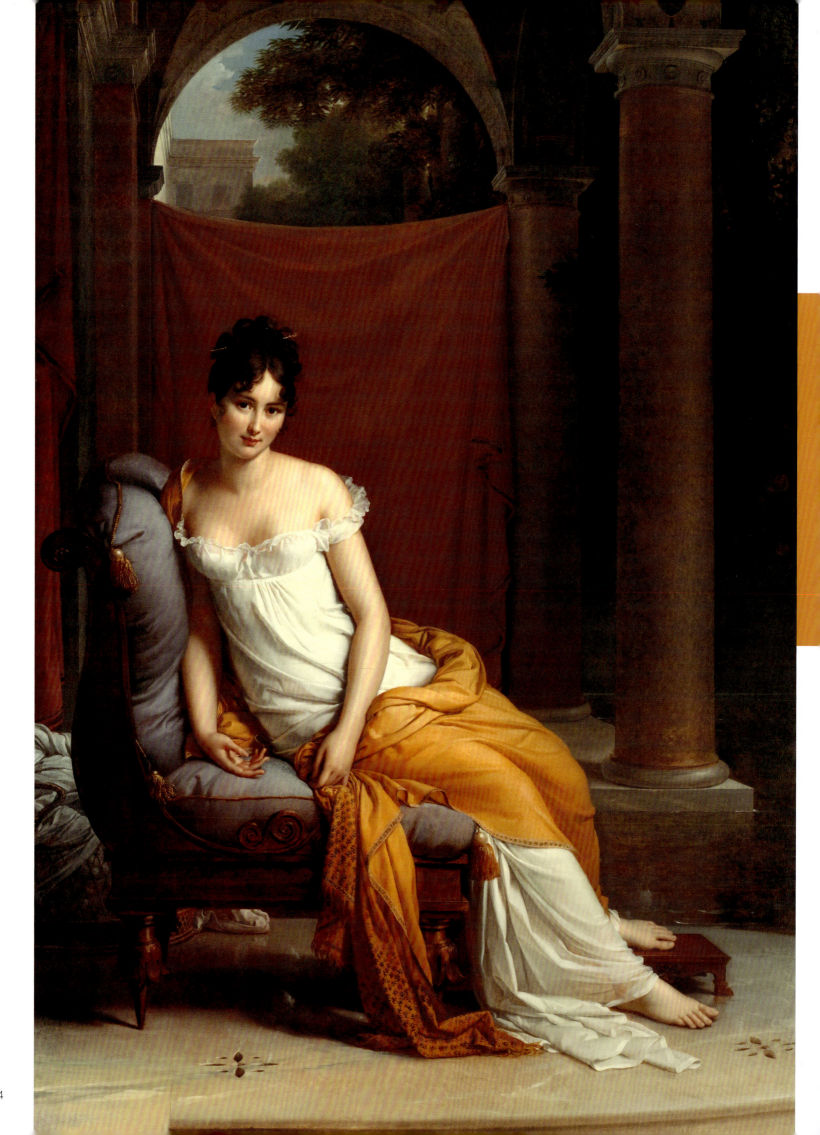

> "You fall in love at her feet
> and are chained to her by respect."
>
> FRANÇOIS-RENÉ DE CHATEAUBRIAND ABOUT JULIETTE RÉCAMIER

The fashion hiatus caused by the Revolution in 1789 proved short-lived, however, and ending with the overthrow of the Terror in 1794. The last years of the 18th century saw new trends emerge in the wake of neoclassicism. Young (mostly high-born) ladies called *Les Merveilleuses* (Marvellous Women), enjoyed countering the revolutionary austerity by taking up the Greek chiton, a long tubular tunic that exposed the shoulders, chest, and forearms. Made of diaphanous fabric, it bluntly revealed the naked body underneath. The fabric was belted just below the bust to elongate the waist and emphasise the delicacy of the silhouette. Their male equivalents were known as *Les Incroyables* (Incredible Men). Some especially determined *Merveilleuses* went as far as to dress in scant muslin outfits during the winter months, reportedly resulting in a handful of deadly chills.

In the last decade of the 18th century, the first illustrated fashion magazines, such as *Journal des dames et des modes* (1797–1839), started spreading the Parisian trends beyond the borders of France, reaching readers as far as Boston, Saint Petersburg, and Vienna. Fashion magazines enjoyed a pivotal influence throughout the 19th century, because they put dressmakers in touch with their customers thanks to advertisements and fashion plates. Today, their archives offer an unrivalled source of information on trends and changes in Parisian fashion.

The fashion system as we know it today, with shows and seasonal collections, emerged in the 1850s, largely thanks to Charles Frederick Worth (1825–95), a genius couturier born in the East Midlands (UK) who settled in Paris in 1845, aged 20, and opened the first modern-day couture house at the prestigious Rue de la Paix in 1858. This high-end street was home to most of the luxury jewellers in Paris, and their clientele easily found their way to Worth's fashion boutique. Instead of carrying out his clients' commissions, as was customary for the couturiers of his time, Worth offered them his own creations, thus transforming his role from artisan to creator. For the first time, new collections were launched at fashion shows held at the boutique, and models, including Worth's own wife Marie, walked in dresses that had been specially designed for the occasion, as opposed to the traditional practice, which consisted of sending the wealthy clientele dolls adorned with the dresses on offer. Under the opportune patronage of Empress Eugénie, Napoléon III's wife, Maison Worth enjoyed a lasting success among Parisian celebrities and Europe's most famous women. Actress Sarah Bernhardt, Countess Greffulhe, Empress Elisabeth (Sisi) of Austria-Hungary, and Queen Victoria were seen wearing dresses designed by the couturier.

Charles Worth would soon be emulated by other couturiers, such as Jacques Doucet (1853–1929), Jeanne Paquin (1869–1936), Jeanne Lanvin (1867–1946), and John Redfern (1820–95). His vision inspired a new generation of avant-garde couturiers, some of whom trained at Worth's workshop, such as Paul Poiret (1879–1944), who, together with Madeleine Vionnet (1876–1975), revolutionised female fashion at the turn of the 20th century by advocating the suppression of the corset, thus paving the way for the physical emancipation of women.

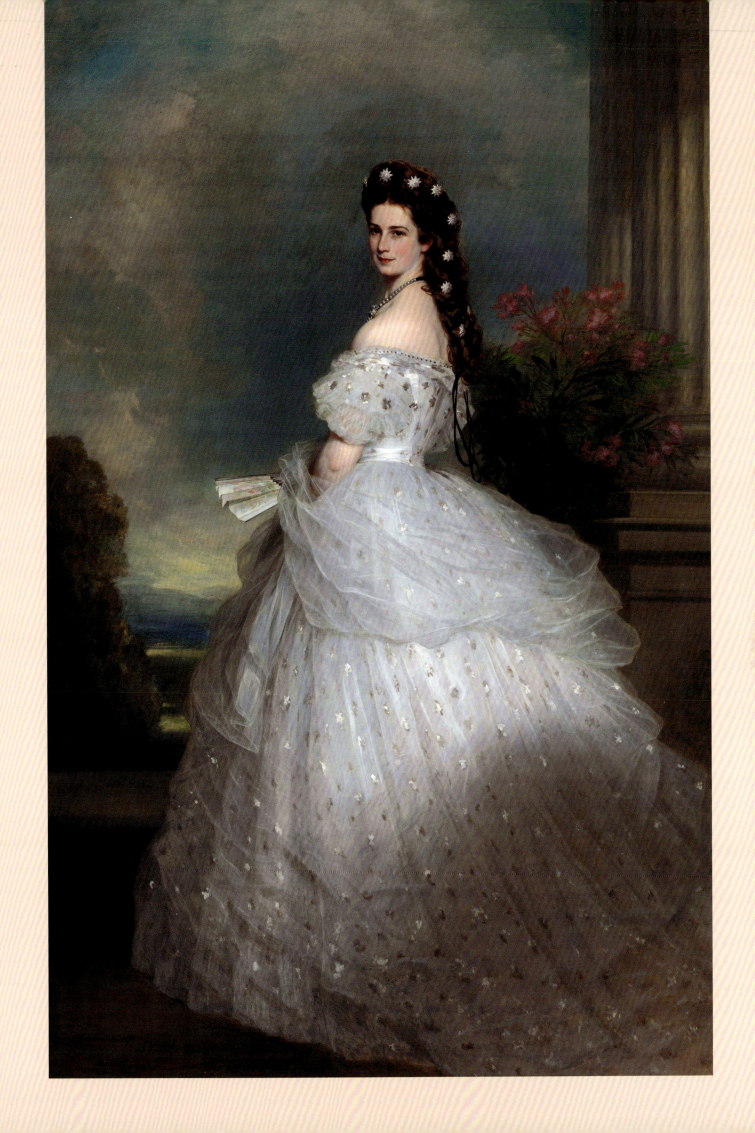

In the last years of the Belle Époque, just before the outbreak of the First World War, Paris experienced a peerless burst of creativity in fashion and in all the arts in general. Fashion kept pace with the avant-garde, with innovative creations by Jean Patou (1887–1936) and the debut of Gabrielle 'Coco' Chanel (1883–1971), who reinvented women's fashion by borrowing elements from menswear. In line with various elements of Art Nouveau and Art Deco aesthetics and the concept of *Gesamtkunstwerk* (total work of art), Parisian couturiers expanded fashion to include lifestyle, creating perfumes and exploring interior decoration – Paul Poiret was the first to launch his fragrance in 1911, soon followed by Jeanne Lanvin and Coco Chanel. A number of big-

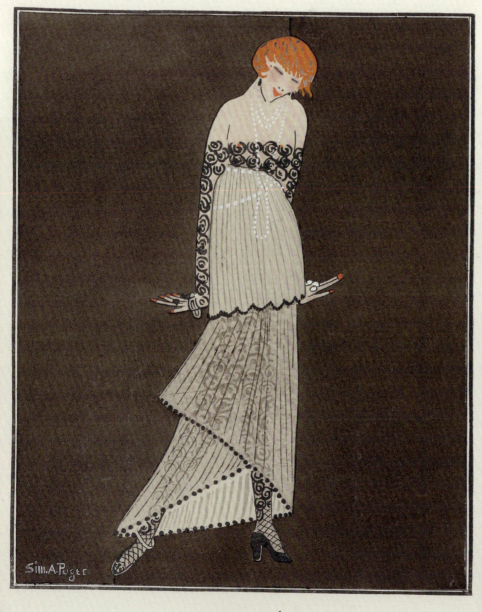

"SALOMÉ"
Robe du soir de Paul Poiret

ticket designers also commissioned the best illustrators of the day to create fashion plates for a new, luxurious fashion magazine, *La Gazette du bon ton*, launched in 1912 by Lucien Vogel. Raoul Dufy and Léon Bakst were regular contributors, among many others. A further example of the dynamism in Parisian fashion during the Belle Époque was the founding, in 1911, of the Chambre Syndicale de la Couture Parisienne, which later became the Chambre Syndicale de la Haute Couture.

Despite restrictions on fabric supplies and the dispatch of some prominent personalities, such as Jean Patou, to the front, the First World War did not significantly affect the predominance of Paris in the world of fashion. On the contrary, a delegation of French couturiers was invited to present French fashion in the United States in November 1915 to celebrate the friendship between France and the United States, thus boosting the sales of French Haute Couture items in the USA. The enthusiasm shown by the clientele in the Americas – both Brazil and Argentina, in addition to the United States, were steady markets highly coveted by the Parisian fashion houses – came just in time to compensate for the loss of the wealthy Russian and Austro-Hungarian aristocrats and bourgeoisie whose fortunes were swept away by the collapse of their empires. Also, for the first time, a woman, Jeanne Paquin, presided over the Chambre Syndicale de la Couture from 1917 to 1920.

The general atmosphere of mourning and hardship caused by the war gave way to a decade of exuberant joy, lightheartedness, and extravagance. Paris enthusiastically embraced the spirit of the Roaring Twenties and their unbridled *joie de vivre*, although, for the first time, certain trends were now coming from across the Atlantic: the Charleston, jazz, and cinema set the pace for Parisian evenings and helped shape 1920s fashion. The City of Light resumed its role as the capital of audacity, with a revolutionary turn in women's hairstyles – the *garçonne*, with hair cut short, was all the rage. Tubular knee-length dresses were also en vogue, whereas before the war, they would have been considered an affront to public decency. Some women even dared to wear men's trousers and suits, which caused an absolute scandal. Incidentally, a bylaw requiring women in Paris to seek permission to wear men's trousers in public was not abolished until 2013, even though it had fallen into disuse. In 1972, a young conservative politician Michèle Alliot-Marie threatened the parliamentary ushers that she would show up in her knickers in the Chamber if she were not allowed to enter in her perfectly decent business suit.

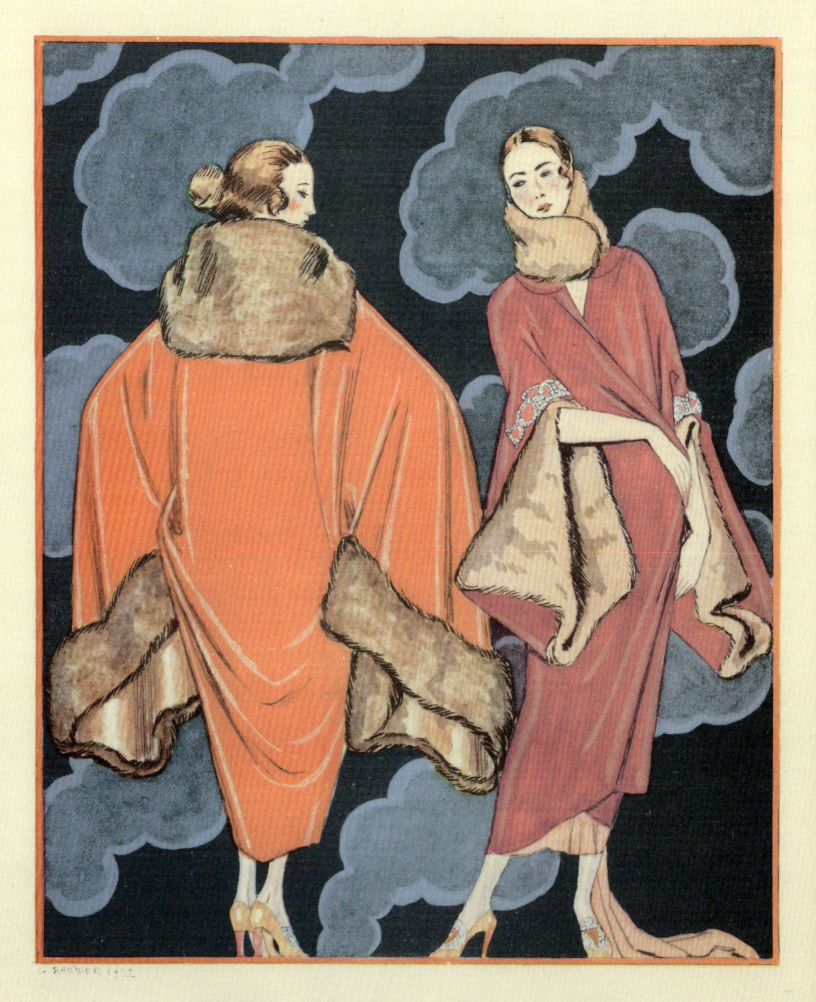

DEUX HEURES DU MATIN

MANTEAUX, DE WORTH

While Jeanne Lanvin was already at the height of her fame by the early '20s, a number of young designers were just beginning to take off. Coco Chanel rose all the way to the top, Marcel Rochas (1902–55) opened his first haute couture boutique in 1925 and Jean Patou dressed the celebrities of the day: Louise Brooks, Joséphine Baker, Mistinguett, and one of the most famous tennis champions of the 1920s, Suzanne Lenglen, who became his muse and paved the way for chic sportswear. For the International Exhibition of Decorative Arts, held in Paris in 1925, Paul Poiret, an incorrigible fan of excess, rented three barges on the Seine and had them lavishly decorated and furnished to showcase his collections. Sadly enough, this exorbitant craze led him to bankruptcy.

The party atmosphere of the Roaring Twenties ended as abruptly as it began, with the stock market crash of 1929. American shoppers vanished overnight, and the effects of the turmoil were quickly felt in Europe. Sobriety and practicality were the leitmotifs of the 1930s, with an emphasis on simple elegance and classic shapes. And yet, despite the political crises and financial uncertainties that characterised the decade, the 1930s were a time of innovation. Lucien Lelong (1889–1958), one of Marlene Dietrich's favourite designers, launched the first deluxe ready-to-wear collection in 1934. Although somewhat forgotten today, Lelong played a considerable role in the 1930s and 1940s, both as a pioneer of contemporary fashion – Christian Dior, Hubert de Givenchy, and Pierre Balmain trained with him – and through his connections to the most famous movie stars of the time (Greta Garbo and Michèle Morgan, among others). These relationships enabled him to promote his signature design, the 'kinetic' silhouette, with garments that would highlight the body's movements and elegance in motion and to offer practical clothing for the modern woman. Young foreign designers also tried their luck in Paris, demonstrating the city's power of attraction: Italian Elsa Schiaparelli (1890–1973) with her models inspired by Surrealism, Spanish designer Cristóbal Balenciaga (1895–1972) who settled in Paris in 1937, fleeing the civil war in his country; and British couturier Edward Molyneux (1891–1974), a follower of the modernist aesthetic.

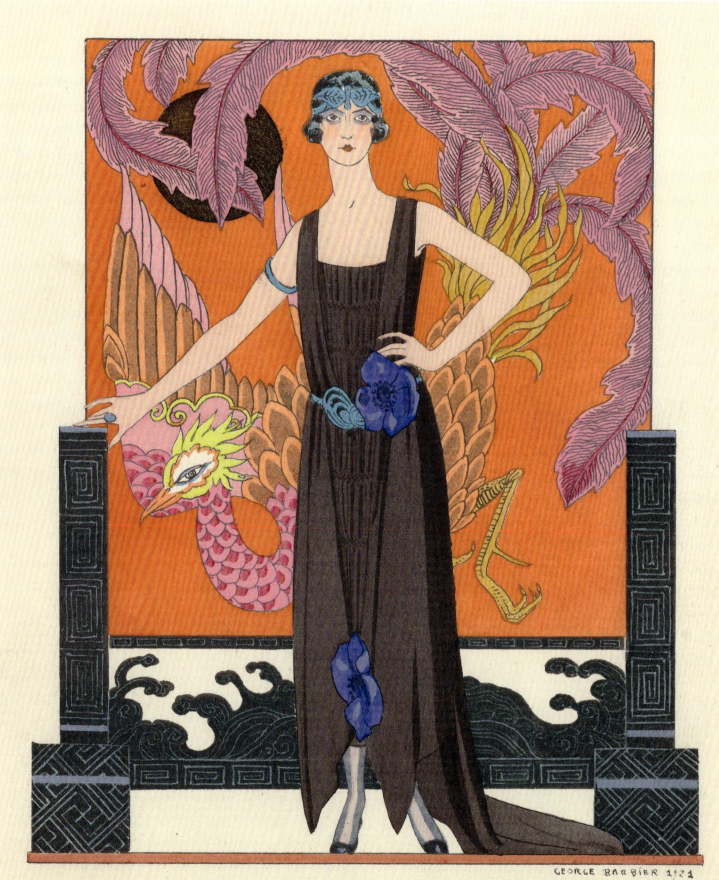

LA BELLE DAME SANS MERCI
ROBE DU SOIR, DE WORTH

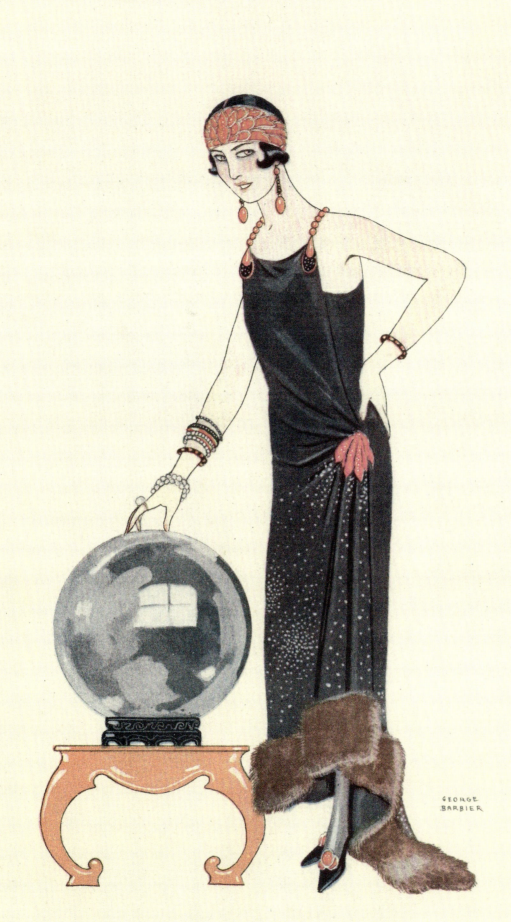

L'EMPIRE DU MONDE

ROBE DU SOIR, DE WORTH

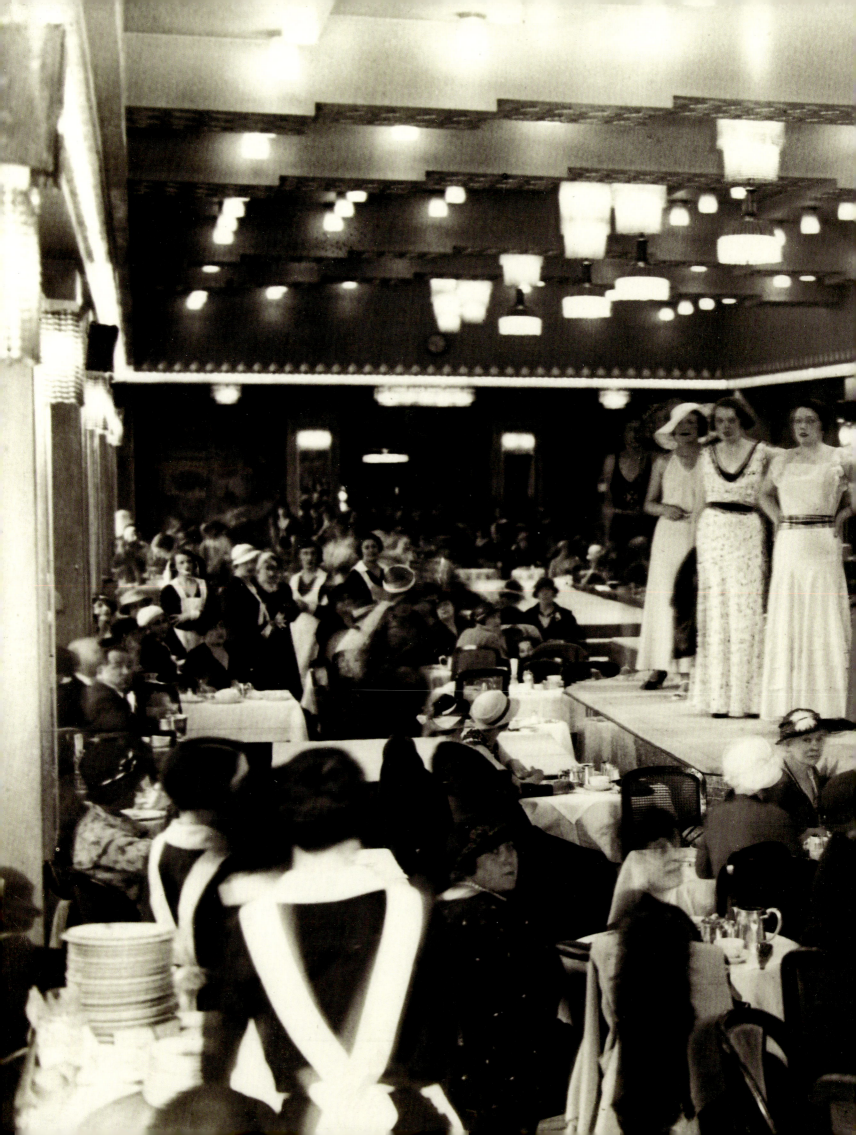

The French defeat in 1940 and the German occupation that followed could have sounded the death knell for Parisian fashion. No sooner had they settled in Paris than the German authorities demanded that French couturiers transfer their boutiques, workshops, and employees to Berlin or Vienna, which were intended to become the new fashion capitals. Lucien Lelong, who had been chairman of the Chambre Syndicale de la Couture since 1937, bluntly refused this absurd diktat and was invited to Berlin to explain his views. This highly intelligent and educated man used all his brainpower to convince his counterparts and eventually win his case, to the great relief of the industry. However, wartime restrictions made working conditions very difficult: textile supplies were extremely limited (designers reused fabrics from previous collections for new ones); foreign buyers stopped coming to Paris, a city controlled by the German army (semi-clandestine fashion shows took place in Lyon, while it remained under French authorities), and, worst of all, the anti-Jewish laws promulgated by the German-obedient Vichy regime prohibited fashion houses from keeping Jewish employees (though it is thought that some houses refused to comply). Taking advantage of a very favourable exchange rate for the German Reichsmark, the wives of officers stationed in France and female employees of the German army were frequent customers of the Parisian fashion boutiques. A handful of couturiers, such as Elsa Schiaparelli and Edward Molyneux, decided to close their workshops and leave France, while others, like Jeanne Lanvin, felt responsible for the fate of their employees and kept their activities afloat while silently resisting the oppression. Just a few adopted a collaborative, pro-German attitude.

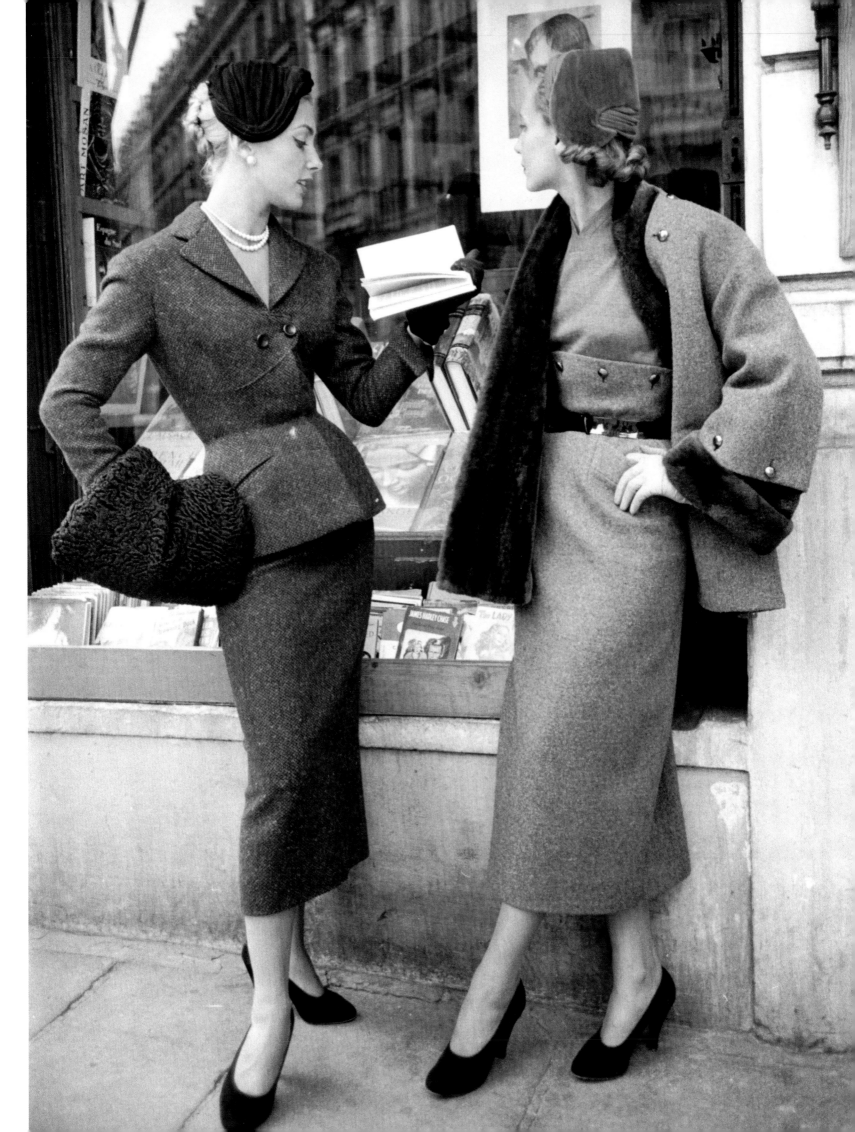

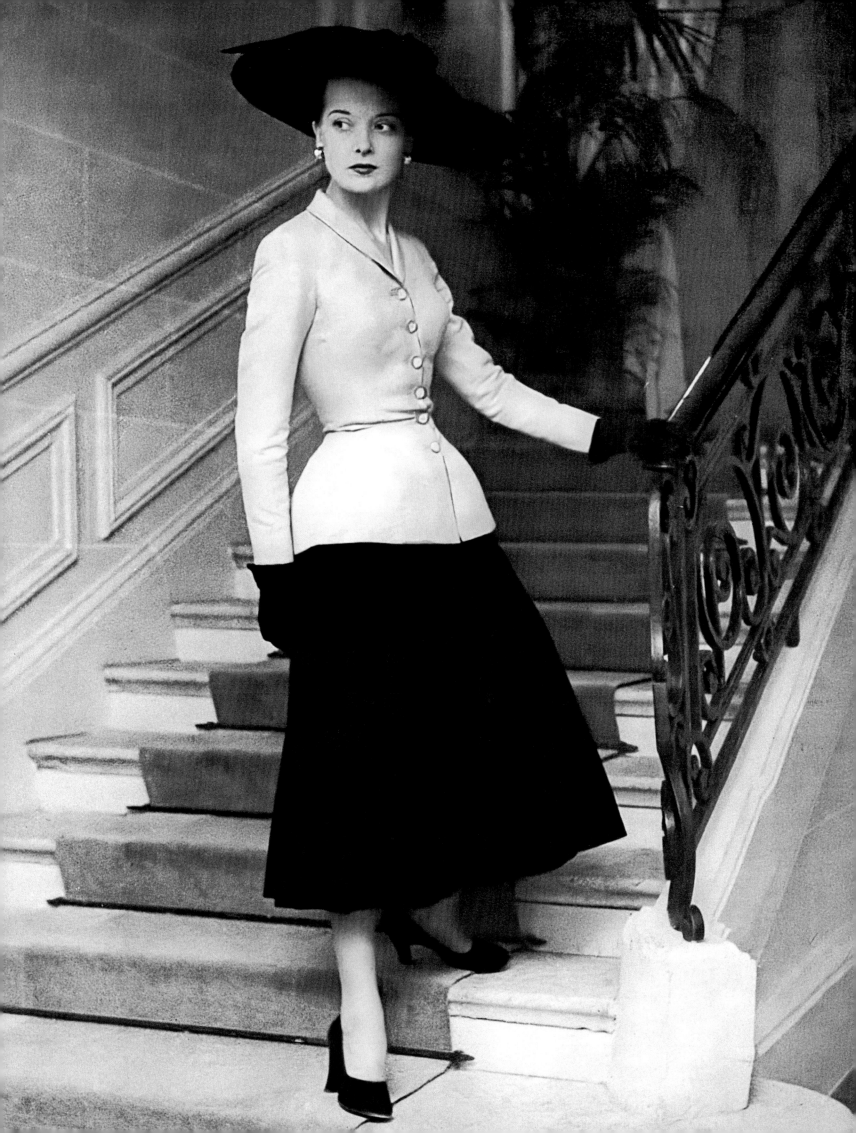

In the aftermath of the Second World War, France enjoyed an extraordinary cultural and intellectual renaissance, which was to have a lasting influence well into the 1980s. Haute couture was not left out of this exceptional creative movement. From beneath the inferno of war and destruction sprang the flame of talents that were eager to blossom. Three leading figures embodied this revival of French haute couture. The first was Christian Dior (1905–57), who revolutionised fashion in a single day. A former gallery owner and friend of the Surrealists, Dior launched his first collection on 12 February 1947, in his brand-new boutique on Avenue Montaigne. After years of war austerity, when fashion had taken on a uniform-like feel and skirts were tightened and shortened to save on textiles, Dior's romantic, feminine designs were seen as a turning point characterised by opulent fabrics, lavish embroidery, and a celebration of the curvy feminine silhouette.

Christian Dior's creations were often compared to an hourglass, with a rounded bust (rounded shoulders and chest), a tight waistline above the hips, and skirts that resembled flower calyxes. Delighted by the beauty and originality of the collection and buoyed by the incessant applause that accompanied the runway show, Carmel Snow, editor-in-chief at *Harper's Bazaar*, found the right words to congratulate the new master of elegance: "It's quite a revolution, dear Christian. Your dresses have such a New Look!" Some scoffing pundits argued that the abundance of fabrics in Dior's dresses contributed to the fortune of Marcel Boussac, the French textile magnate who had financed the brand. However, these caustic remarks failed to overshadow the magnificence and elegance of Dior's creations, and his lasting influence on fashion.

Just like Dior, with whom he had been friends since their early years at Lelong's, Pierre Balmain (1914–82) captured the essence of femininity and seduction in his designs, which earned him countless show-business stars as his clients, from French singer Juliette Gréco to Katharine Hepburn, Brigitte Bardot, and Sophia Loren. Balmain's memories of his first collection perfectly summarise his aesthetic vision: "I had only about 45 or 50 models to show, but they were enthusiastically received, mainly, I think, because they struck a new note of freshness and luxury in those austere days just after the war. I had based the whole collection on the theme of luxury combined with simplicity, and a slight touch of the East."

The third 'musketeer' of new French fashion in the 1950s, Hubert de Givenchy (1927–2018), had also worked for Lelong before following the example of his two elders, whom he appreciated and admired, and opening his own fashion house in 1952, aged 24. Inspired by Balenciaga, who became his mentor, and by the years he spent working with Elsa Schiaparelli as her right-hand man, Givenchy focused on the casual, timeless chic embodied by Audrey Hepburn's little black dress in *Breakfast at Tiffany's* (an iconic New York garment, created by a Parisian couturier), Princess Grace of Monaco, Jackie Kennedy, and Ingrid Bergman.

In 1954, another landmark piece of French fashion – the famous Chanel jacket – was launched just after Coco Chanel had returned to Paris from her long exile in Switzerland, as a riposte to Dior's aesthetics, which ruled the roost at the time. The French press was not kind: Mademoiselle Chanel's comeback was described as a flop, but the American public was thrilled by this supremely chic jacket, and saved Coco's late career – she was 71 at the time.

"His are the only clothes in which I am myself. He is far more than a couturier, he is a creator of personality."

AUDREY HEPBURN ON HUBERT DE GIVENCHY

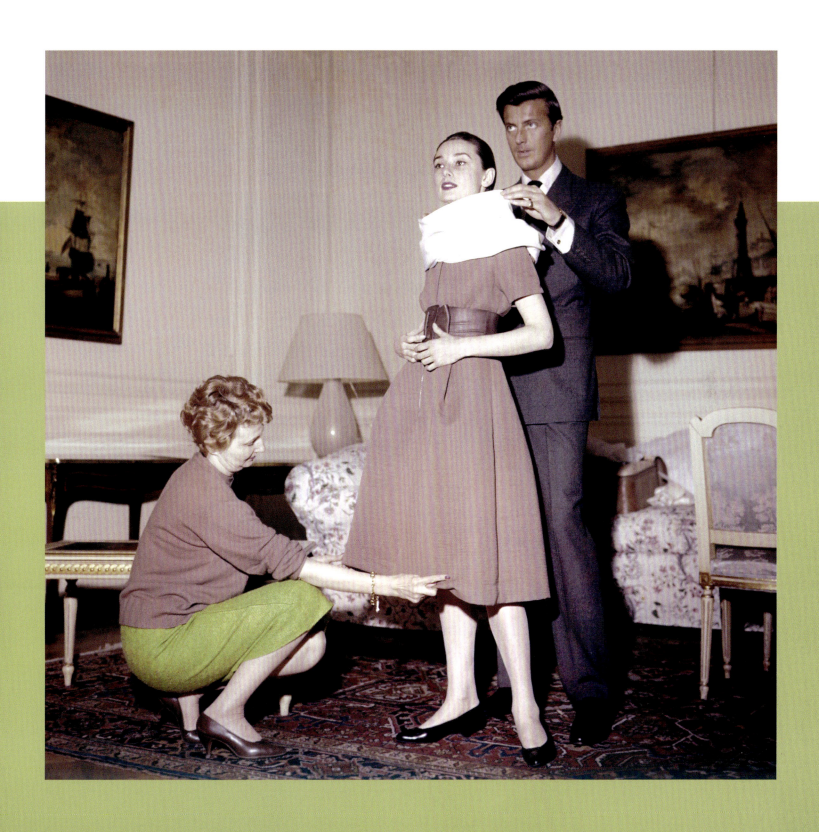

By completely changing fashion codes and breathing new life into Parisian style, the three heroes of French fashion in the 1950s also opened the door to a young, effervescent, and talented generation that would take over in the 1960s and firmly establish Paris as a modern fashion capital. Although already active in the previous decade, Pierre Cardin (1922–2020) took off in the Sixties when the modernist spirit of the decade began to resonate with his personal aspirations: "The clothes I like best are the ones I invent for a life that doesn't yet exist, the world of tomorrow." An ardent advocate of ready-to-wear clothing, he repeatedly broke the rules set by the Chambre Syndicale de la Haute Couture to create luxury garments that were accessible to as many people as possible. Deeply influenced by modernist architecture and Le Corbusier's works, André Courrèges (1923–2016), who opened his house in 1961, took a radical turn towards Futurism with his 'Space Age' fashion, characterised by materials resembling astronaut spacesuits and a deliberate desire to free women from traditional dress codes (he was one of the ardent promoters of the miniskirt in France). Along with Paco Rabanne (1934–2023) and Emanuel Ungaro (1933–2019), Cardin and Courrèges laid the foundations for unisex clothing.

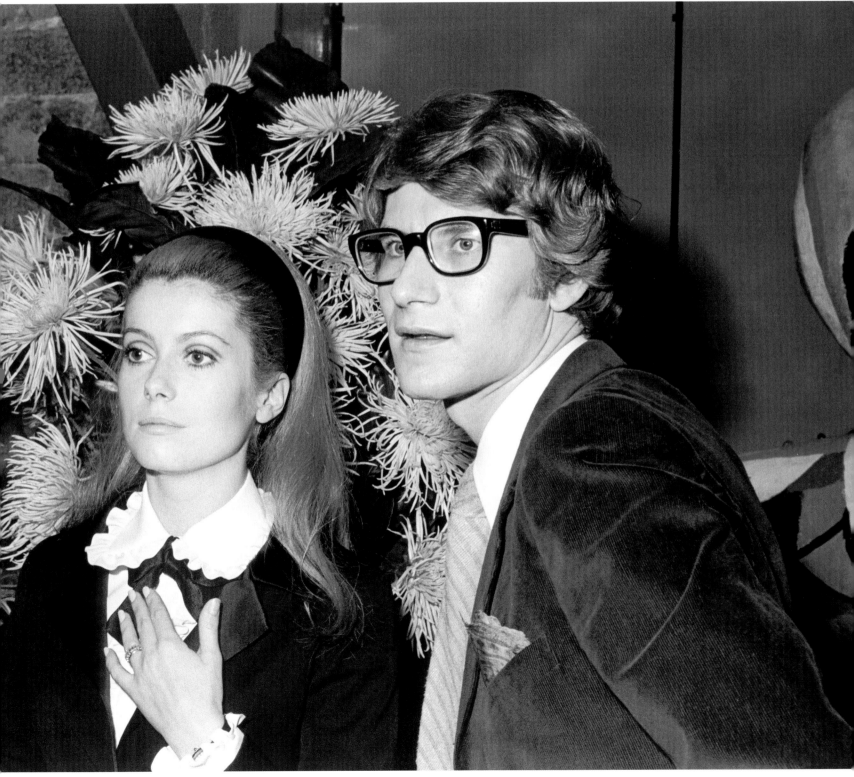
43

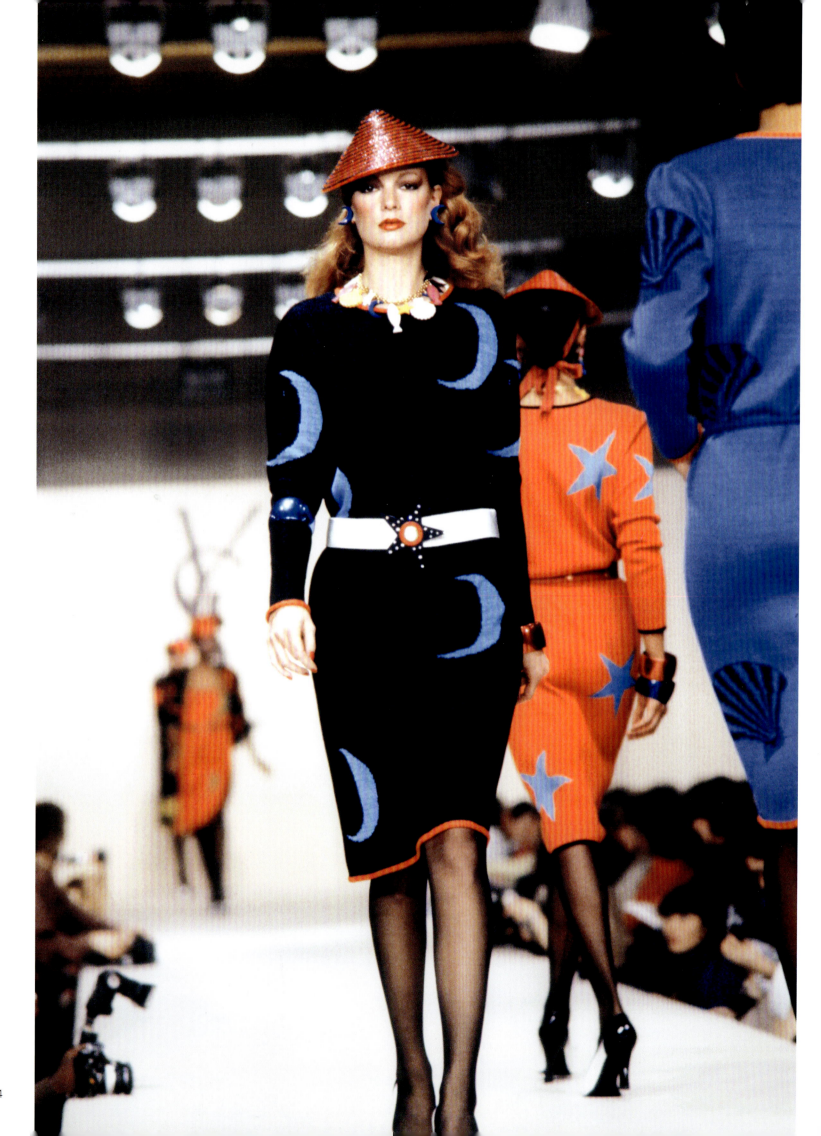

Meanwhile, more traditional haute couture at the turn of the 1950s and 1960s was largely led by a young prodigy, Yves Saint Laurent (1936–2008), who had taken over the artistic direction of Dior after the sudden death of the brand's founder in 1957. Barely 21, Yves Saint Laurent established himself as the *enfant terrible* of couture with his hugely successful Trapèze collection. Despite mental health issues that regularly plunged him into depression, Saint Laurent made his label, founded in 1960, a benchmark of contemporary fashion, notably with his Mondrian dress (1965) and the first safari jacket (Saharienne) for women in 1968. Yves Saint Laurent's future arch-rival – and for the moment still friend – Karl Lagerfeld (1933–2019) had already learned his craft from Pierre Balmain in the late 1950s, before joining the house Patou as artistic director. However, as he was too independent and talented to limit himself to a single brand, Lagerfeld decided to pursue a career as a fashion 'mercenary', working in parallel for Chloé and Fendi, among others. His appointment as artistic director of Chanel in the 1980s ultimately made him a living fashion legend.

The effervescence of the Parisian fashion scene in the early 1960s gave way to a relative decline at the end of the decade. This continued into the 1970s, when French couturiers seemed outdated in the face of the audacity of young London and New York designers, who had unreservedly embraced the countercultural styles of the era, such as hippie, rock, and punk. Despite a handful of emerging talents, such as Guy Laroche (1921–89), Daniel Hechter (b. 1938), and Kenzō Takada (1939–2020), and the first Paris Fashion Week in 1973, it wasn't until the 1980s that the vibrant atmosphere reappeared.

With vivid colours that expressed an insatiable lust for life, and a dazzling explosion of shapes and styles, the Parisian fashion scene of the 1980s was like the nightclubs of the time: wild and crazy. This was something of a clambake in a time of crisis, as AIDS began to strike its first victims while a whole world of exciting new fashion was cooked up by a string of maverick designers, such as Jean Paul Gaultier (b. 1952), Jean-Charles de Castelbajac (b. 1949), Claude Montana (1947–2024), Azzedine Alaïa (1935–2017), Christian Lacroix (b. 1951), and Thierry Mugler (1948–2022), with spectacular shows and provocative ideas. This new revolution in Parisian fashion prompted more traditional brands to innovate and give free rein to creative minds in order to survive. For example, in 1983, 12 years after the death of Coco Chanel, Karl Lagerfeld was called in to rescue what had become a moribund label. He brought the full measure of his talent and visionary spirit to regenerate the house while keeping alive the unique combination of the rebellious and elitist style set by the founder.

As a counterpoint to this flamboyant fashion, some designers embarked on a reinterpretation of minimalism, seen as anti-fashion, a trend that would persist throughout the following decade, with Rei Kawakubo (b. 1942) and her label Comme des Garçons, and the conceptual catwalks by Martin Margiela (b. 1957). Although the two main fashion trends of the time evolved in totally opposite directions, they both reflected the extraordinary vivacity of French couture, which also drew in a younger generation of designers from around the globe. Gibraltar-born John Galliano (b. 1960) joined Givenchy and the LVMH group in 1995, before becoming artistic director of Dior in October 1996. He was succeeded at Givenchy by another British designer, Alexander McQueen (1969–2010). This continued in the early 2000s with the arrival of the American designer Marc Jacobs (b. 1963) at Louis Vuitton and Israeli designer Alber Elbaz (1961–2021) at Lanvin, where Elbaz restored the glory of the oldest haute couture house still in operation.

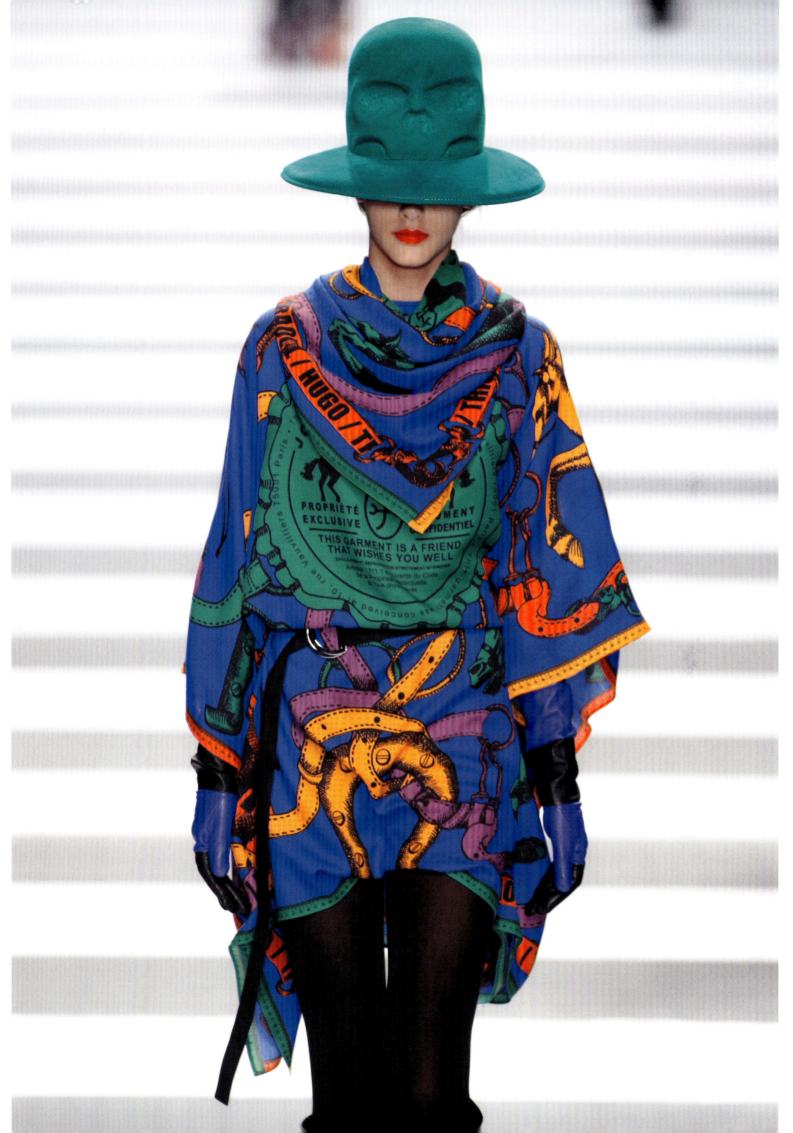

The couturiers who have embodied Parisian fashion since the 2010s tend to have at least one point in common – their very young age. Charles de Vilmorin (b. 1996), who designed the outfits for one of the shows in the opening ceremony of the Paris Olympics, was appointed to Rochas at the age of 25; Olivier Rousteing (b. 1985), the artistic director of Balmain, was appointed to this position at the same age, in 2011. Simon Porte Jacquemus (b. 1990) founded his internationally acclaimed brand, aged 19, in 2009. And Paris has kept its power of attraction for foreign designers, who see the opening of a boutique in the French capital, an appointment to one of the most prestigious Parisian brands, or simply participation in Paris Fashion Week as the ultimate consecration. As fashion insider Serge Carreira put it in an interview with CNN: "London is a scene of revelations [...], whereas Paris is a destination once the brand is established, to reach a more global audience."

This historical overview of fashion in Paris would not be complete without a tribute to the Parisienne, and to all those who have embodied this model of wit, beauty, and style through the centuries, from Juliette Récamier (1777–1849), immortalised by the painter Jacques-Louis David in an Empire dress, and her friend Thérésa Tallien (1773–1835) to the contemporary, self-declared 'icon and symbol of Parisian style', Inès de la Fressange, who was Karl Lagerfeld's muse at Chanel for more than a decade. Her best-selling book *Parisian Chic*, first published in 2011 and since translated into 17 languages, has been the indispensable companion to millions of fashionistas. She has also inspired countless young women who share the latest Parisian trends and tips on social networks, where some fashion influencers have been followed by hundreds of thousands of fans – proof, if any were needed, of Parisian women's commitment to fashion and elegance.

Fluctuat nec Mergitur (She's tossed by the waves but doesn't sink) is the motto engraved on the coat of arms of Paris, which directly refers to the Seine, the city's historic heart and principal axis. This sentence could also apply to Parisian fashion, which is always questioning itself and facing new challenges, but never losing its way. And if the Seine is the heart of Paris, fashion is certainly its soul.

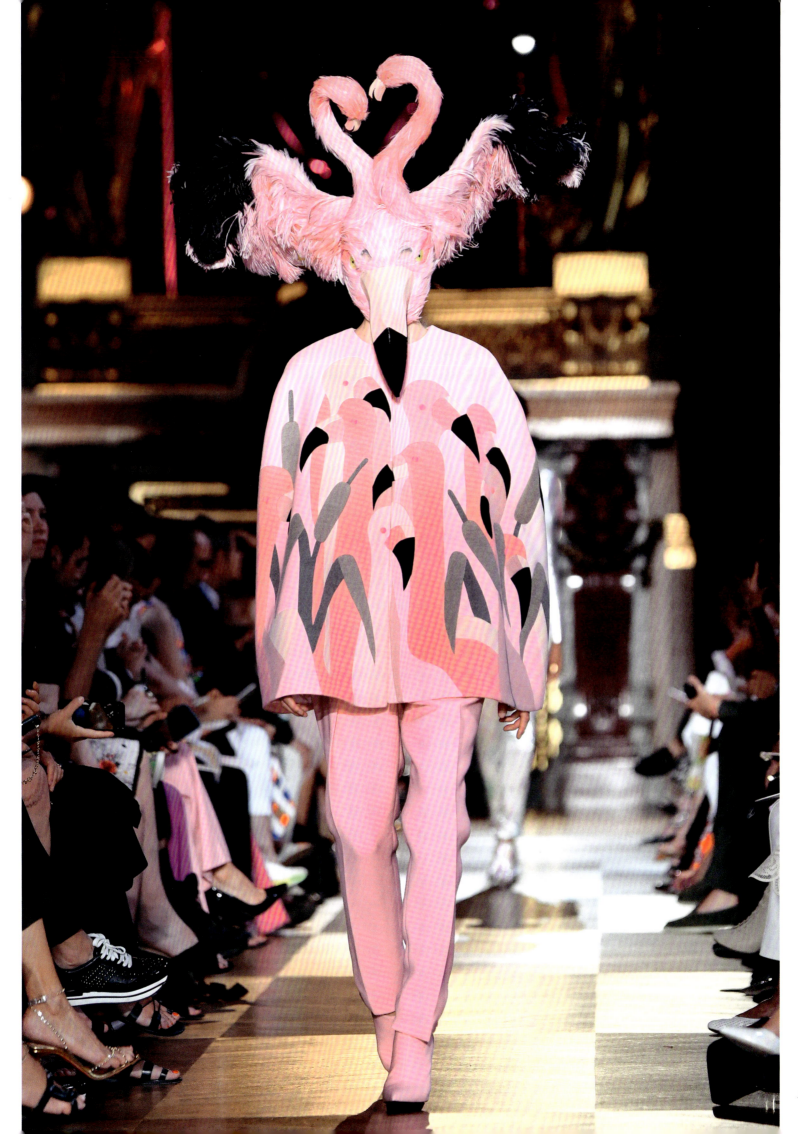

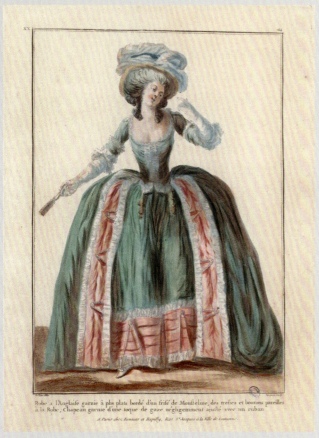
An 18th-century dress *à l'Anglaise* (English style) and hat.

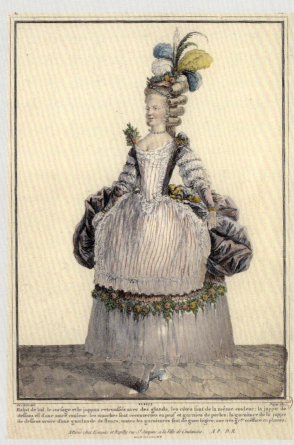
Illustration of a ball gown, c.1785.

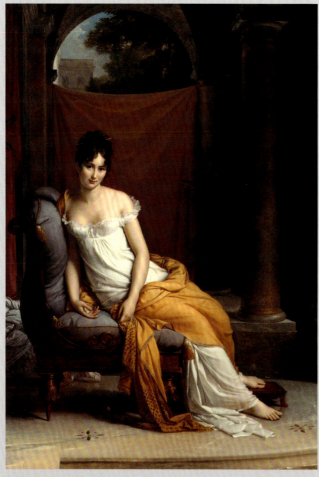
Portrait of Juliette Récamier by François Gérard, c.1802.

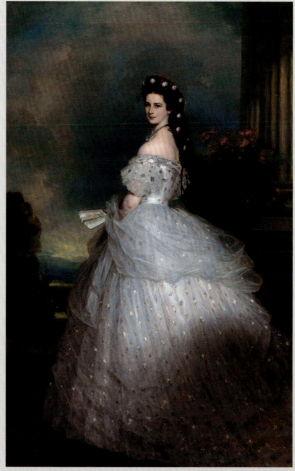
Empress Elisabeth of Austria, wearing a Charles Frederick Worth ball gown. Franz Xaver Winterhalter, 1865.

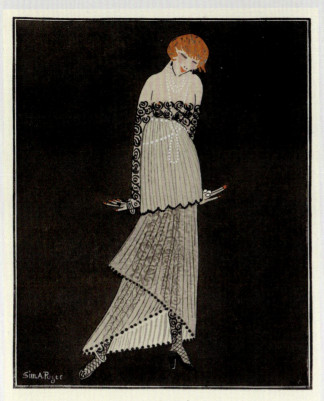

'Salomé' evening gown designed by Paul Poiret, depicted in *La Gazette du bon ton*, March 1914.

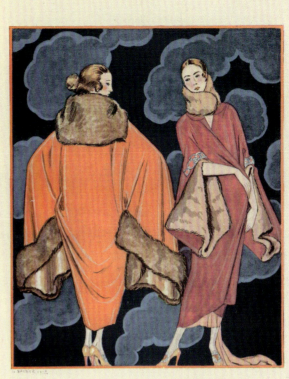

House of Worth winter coats. Fashion plate by George Barbier for *La Gazette du bon ton*, 1923.

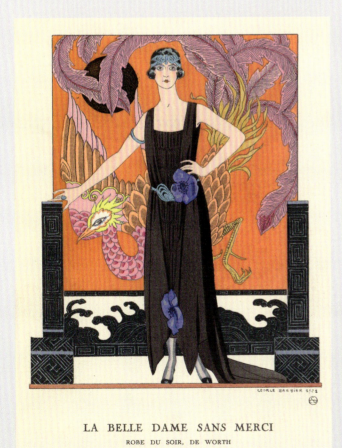

A House of Worth evening gown, illustrated by Barbier for *La Gazette du bon ton*, 1921.

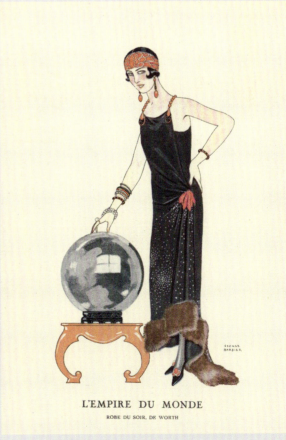

Another Barbier illustration for *La Gazette* depicting a House of Worth evening gown, 1924.

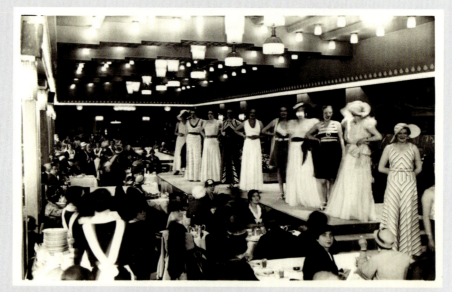
A fashion show at Le Bon Marché, 1925.

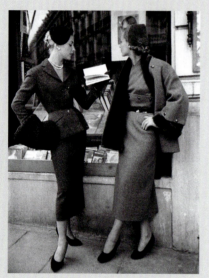
Two models standing in front of a Parisian bookstore, wearing tweed suits designed by Pierre Balmain, 1953.

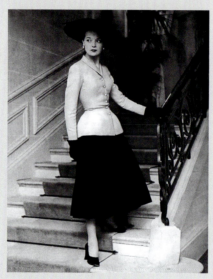
Model wearing a suit designed by Christian Dior, 1947.

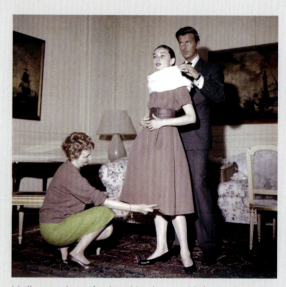
Hollywood star Audrey Hepburn with long-time friend, fashion designer Hubert de Givenchy, 1958.

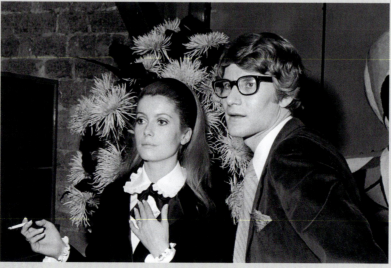
French actress Catherine Deneuve with Yves Saint Laurent, 1966.

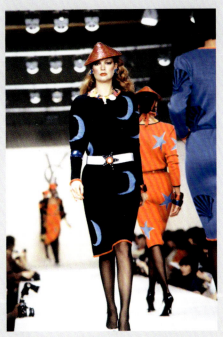

Models at the Yves Saint Laurent Spring/Summer 1979 fashion show, October 1978.

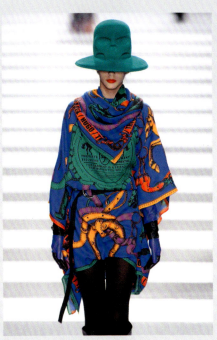

A model walking the runway at Jean-Charles de Castelbajac Autumn/Winter 2011–2012 show, March 2011.

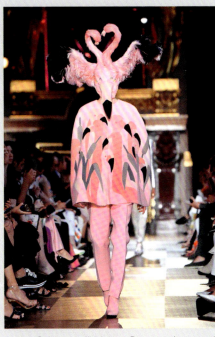

At the Schiaparelli Haute Couture Autumn/Winter 2018–2019 show, July 2018.

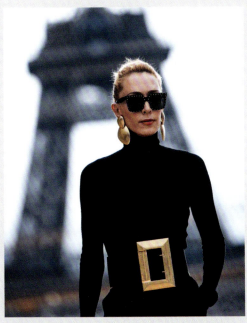

Stylist Elina Halimi in a street-style outfit, Paris Fashion Week, March 2019.

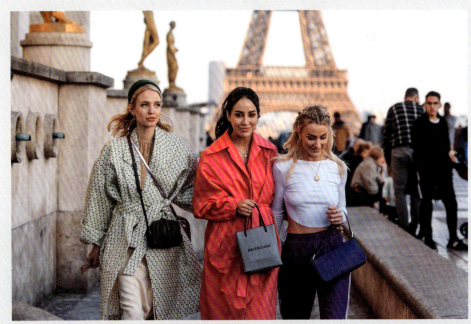

Three stylish women in the heart of Paris.

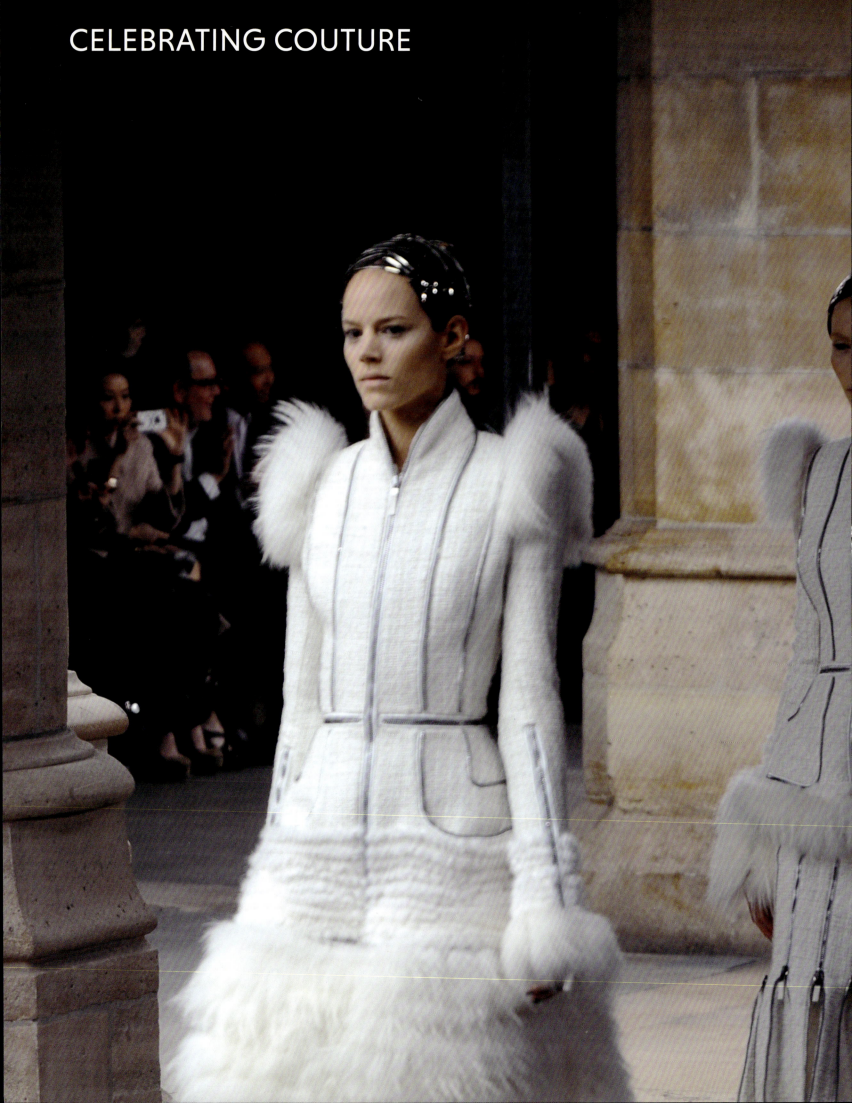
CELEBRATING COUTURE

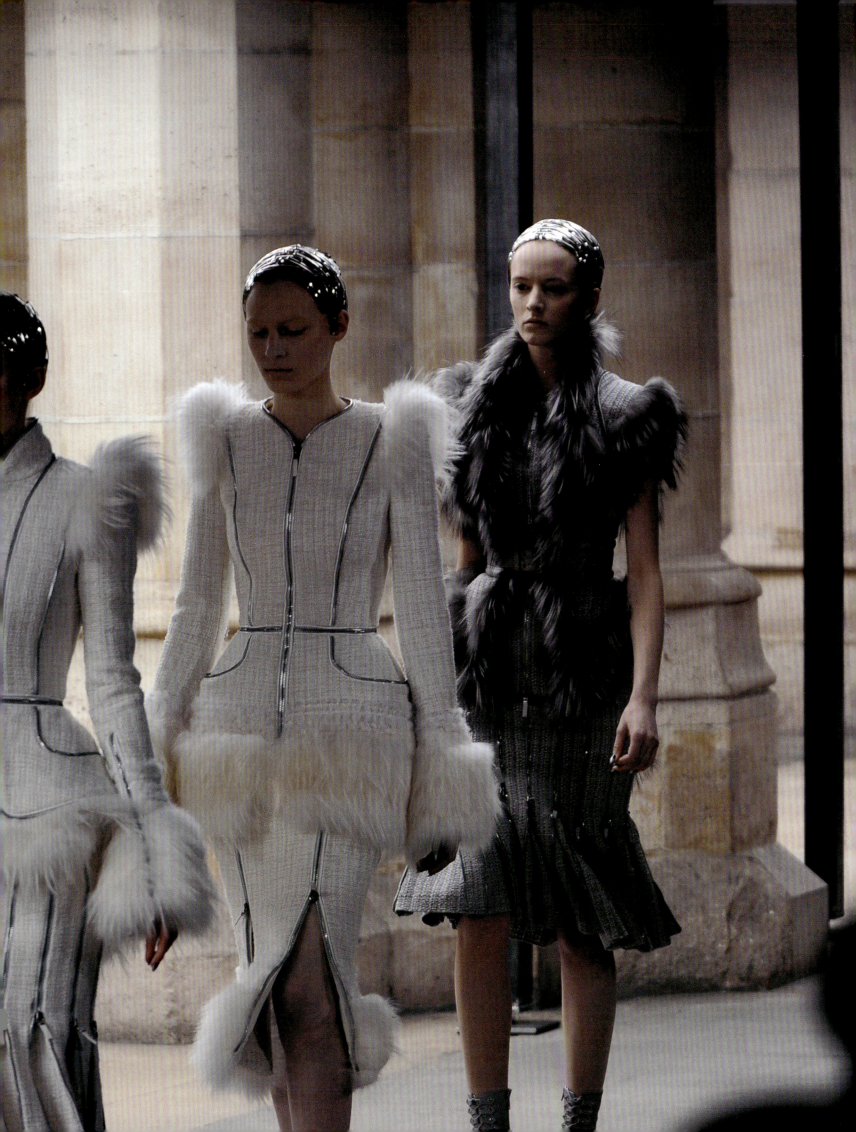

Long before the breathtaking runway shows that fashion weeks have become synonymous with, the royal balls held at the Palais du Louvre at the end of the Renaissance, and later at the Château de Versailles were the ideal stages for elegance and refinement in dress. In the same vein, festive parties given by the Parisian aristocracy and the wealthy bourgeoisie throughout the 17th and 18th centuries were often occasions for excessive displays of luxury clothing, or of sheer extravagance when it came to costume balls.

In 1864, during a ball at the Tuileries Palace, Empress Eugénie, Napoléon III's wife, noticed a particularly elegant gown on her friend, Princess Pauline von Metternich, the wife of the Austrian ambassador. As she was curious about the dressmaker, the Empress asked the Princess if the couturier could pay her a visit the next morning at 10 o'clock. In this way, Charles Frederick Worth was introduced to the Empress and became her favourite dressmaker. Many other crowned heads across Europe followed Eugénie's example, and it is said that on court ball days, a line of carriages would form in front of Worth's workshop where his clients would swarm for their final adjustments.

Couturiers could easily rely on people's desire for novelty and on the occasional rivalries between ladies in the highest circles to maintain a market for dresses that were out of the ordinary and astronomically expensive. To spare himself endless visits to his customers, as was the custom for couturiers, Worth had the idea of inviting them to a drawing room adjoining his workshops, where he would show his designs to the shoppers. These first fashion shows, in which Worth's wife Marie and a number of the company's employees took part as *mannequins vivants* (live models), became regular events for loyal customers and celebrities.

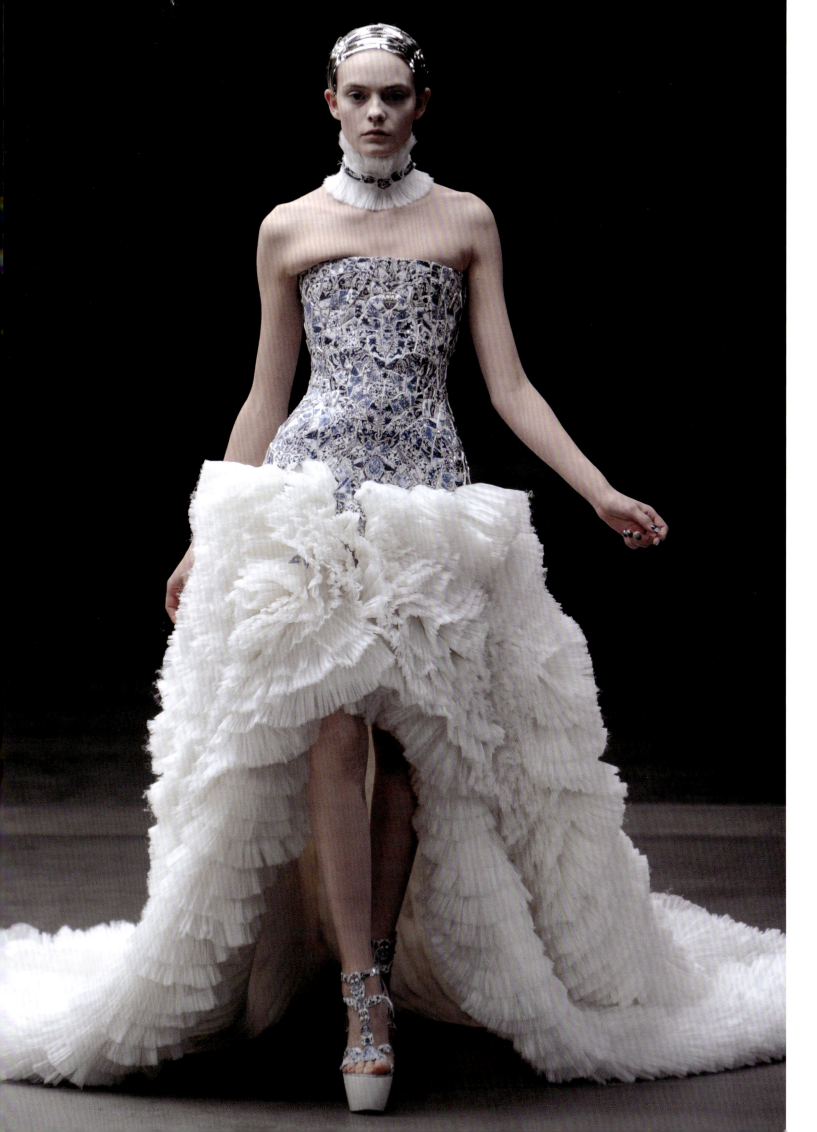

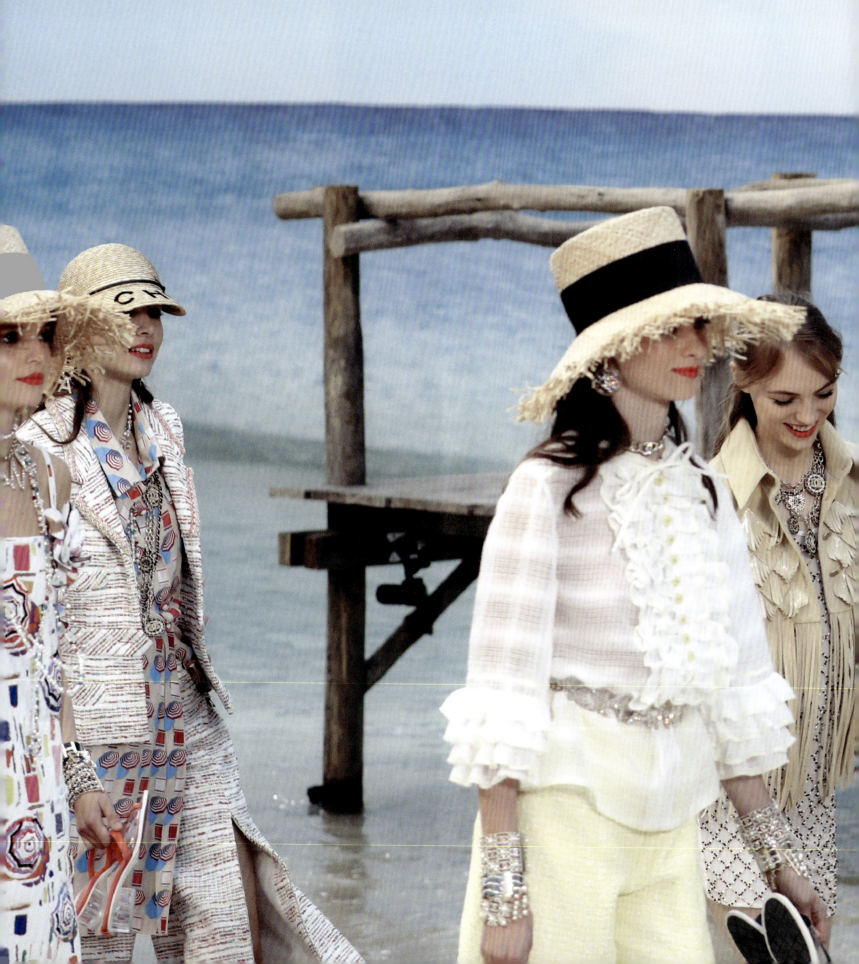

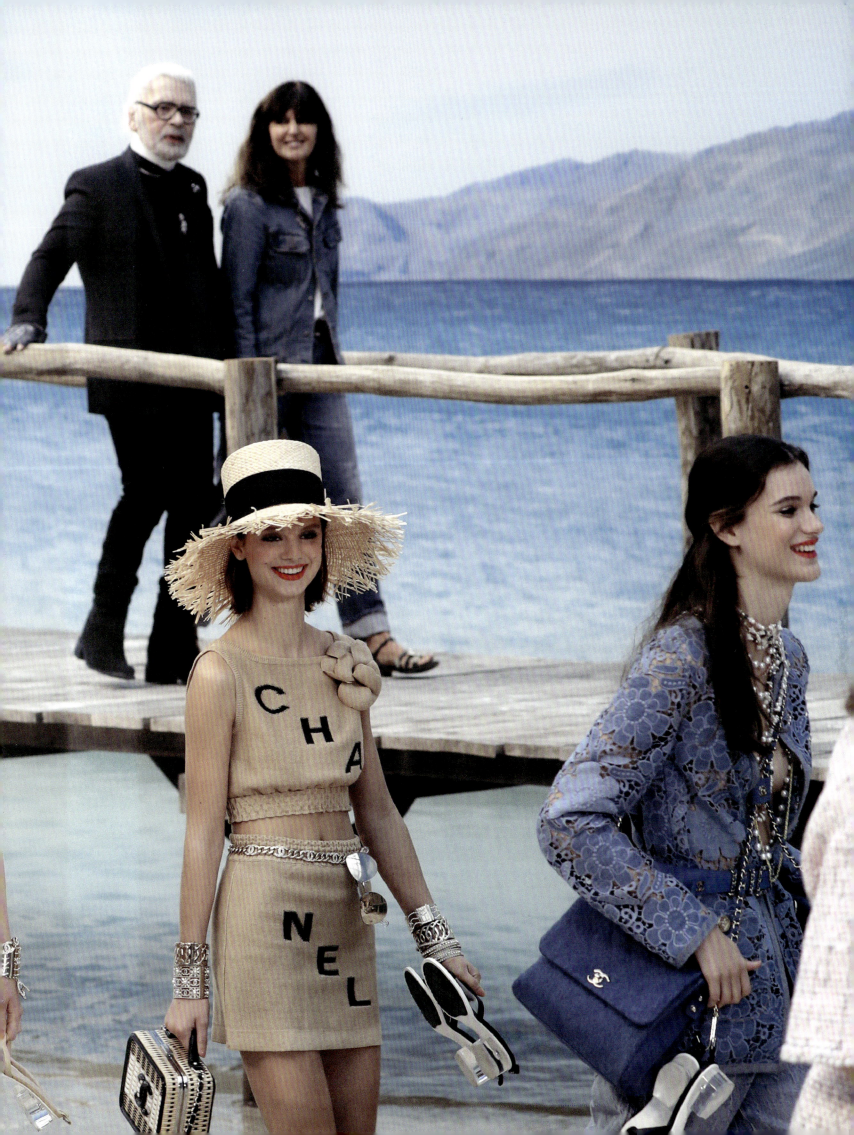

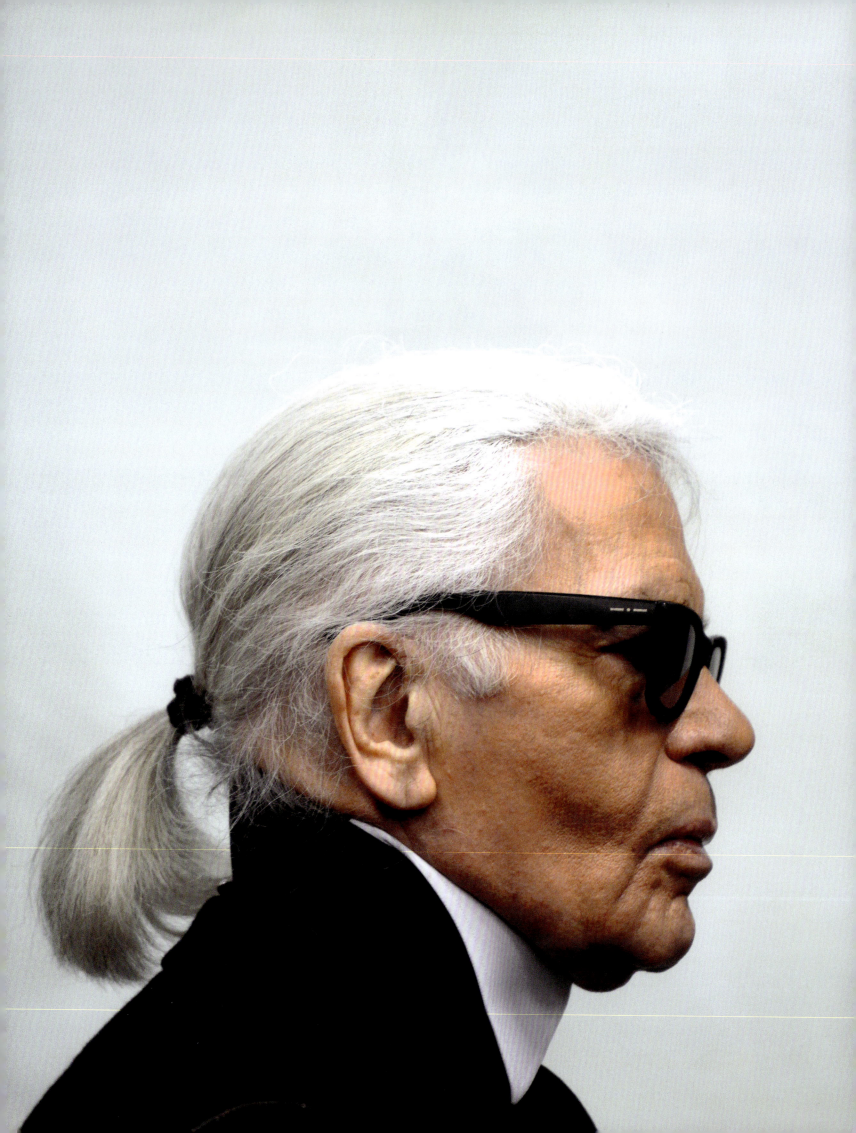

"Don't dress to kill,
dress to survive."

KARL LAGERFELD

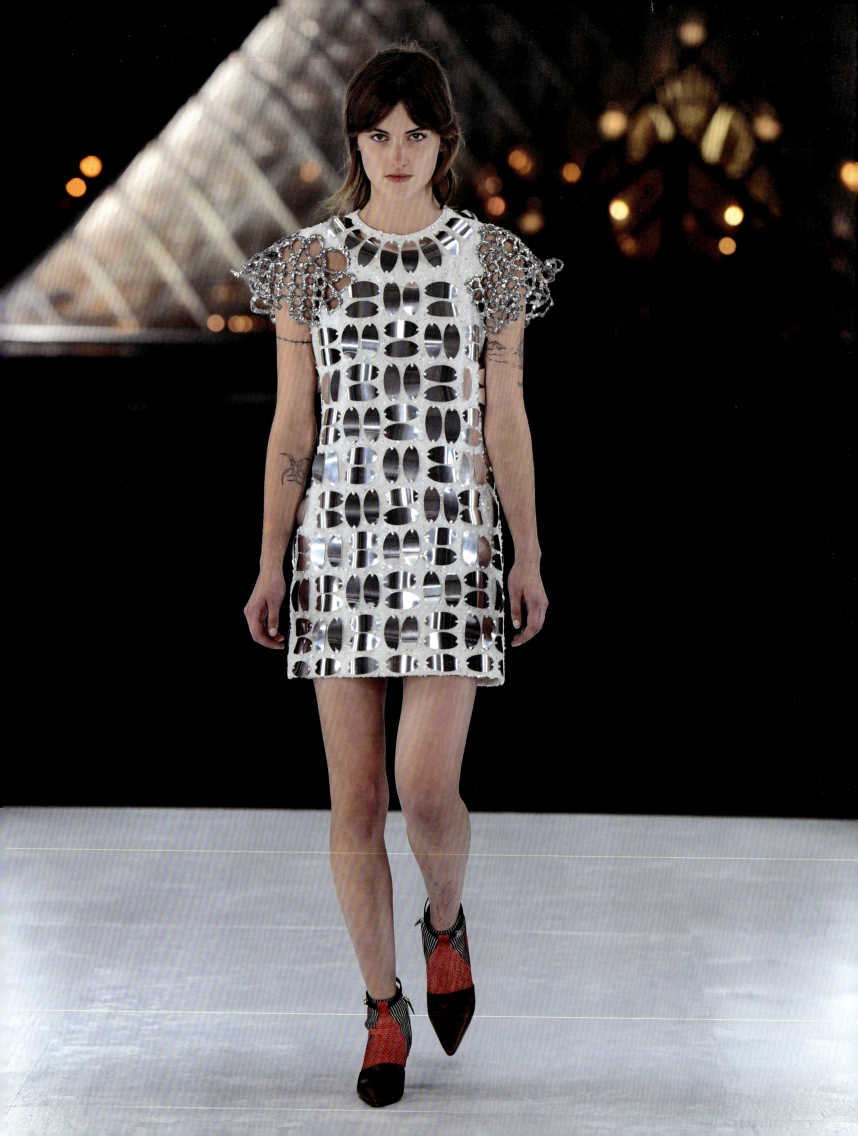

During the Belle Époque, the very prodigal Paul Poiret was fond of organising sumptuous parties in his private mansion on the Rue du Faubourg Saint-Honoré, where it was of course fashionable to appear in a dress made by the master. One such costume ball, entitled *La mille et deuxième nuit* (The Thousand and Second Night), was attended by 300 invitees from the Parisian elite on a beautiful night in June 1911, and transported the guests with a Persian-themed atmosphere that left a lasting impression on even the most critical minds. Always ahead of his time, Poiret was possibly the first modern-day couturier to devise a narrative setting for his collections.

Over the course of the 20th century, fashion shows became social events that gradually opened their doors to journalists and photographers, and then to radio and television, but the way they were staged hardly changed at all: the models walked in a line between the guests, with no real choreography, even for game-changing catwalks like Christian Dior's first collection in 1947.

The first Paris Fashion Week, held in the prestigious setting of the Château de Versailles in November 1973, is commonly referred to as 'The Battle of Versailles', because it was staged as a (peaceful) duel between five French fashion houses and five of their New York counterparts. Under the patronage of Baroness Marie-Hélène de Rothschild, who organised the event for a fundraising cause (proceeds went to the restoration of the royal castle), five Parisian challengers – Yves Saint Laurent, Hubert de Givenchy, Pierre Cardin, Emanuel Ungaro, and Christian Dior (represented by Marc Bohan) – took on Anne Klein, Oscar de la Renta, Halston, Bill Blass, and Stephen Burrows. Despite a quite original staging by the French designers, in the spirit of Charles Perrault's fairy tales, the advantage went to the

New Yorkers, whose showmanship was much better honed. As good losers, the French team felt encouraged to rethink the concept of catwalk shows and turn them into glamorous celebrations of fashion. The 1980s marked a turning point, with the first crazy fashion shows by Jean Paul Gaultier, and rock-concert-like catwalks by Thierry Mugler, which were attended by over 6,000 paying spectators. Karl Lagerfeld, who had just taken over as artistic director of Chanel in 1983, followed in their footsteps. His shows at the Grand Palais, whose magnificence and extravagance were surpassed year after year, quickly became a model to be emulated.

Fashion shows today are comparable to ephemeral works of art, one-off operas that are aimed at thrilling their audiences and causing global buzz.

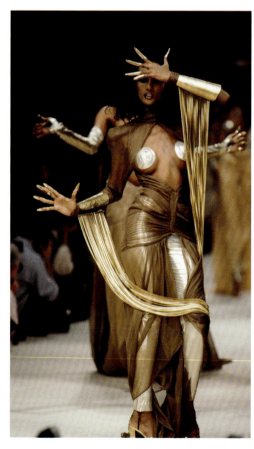 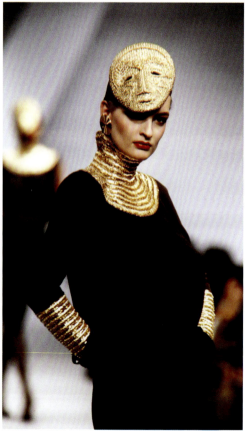

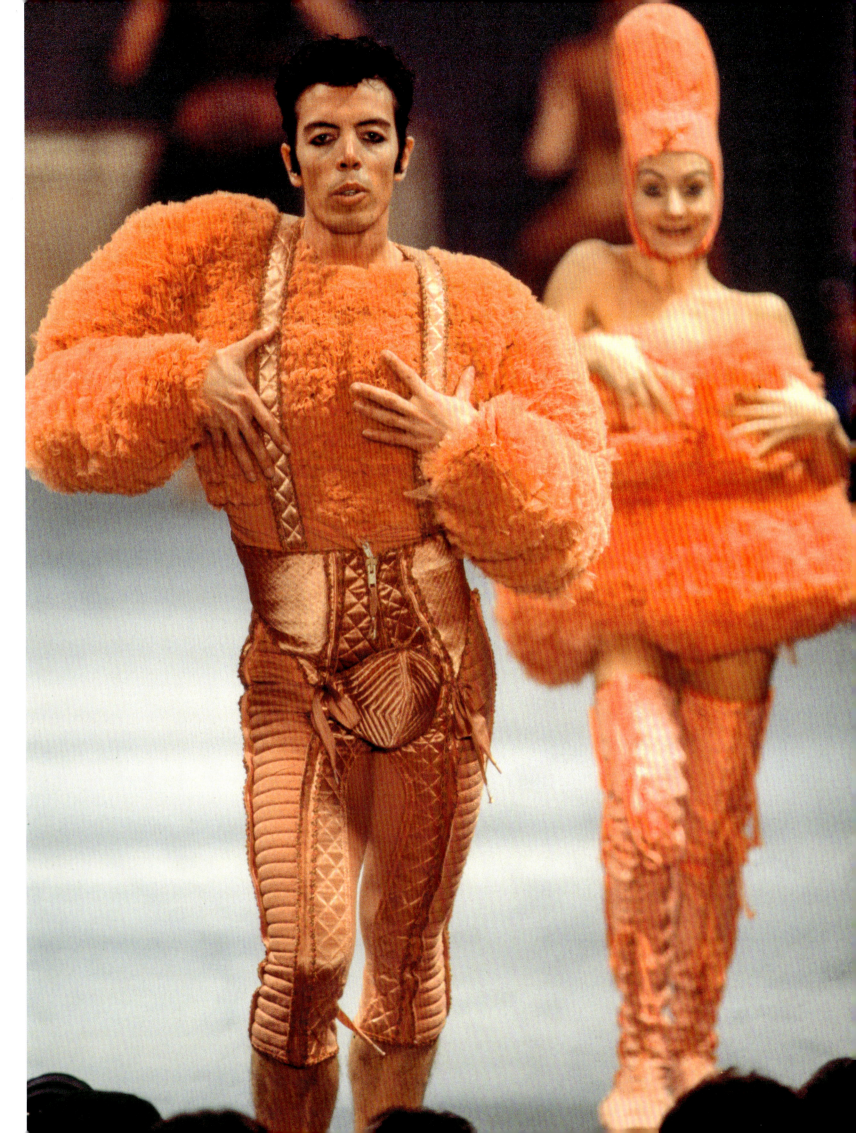

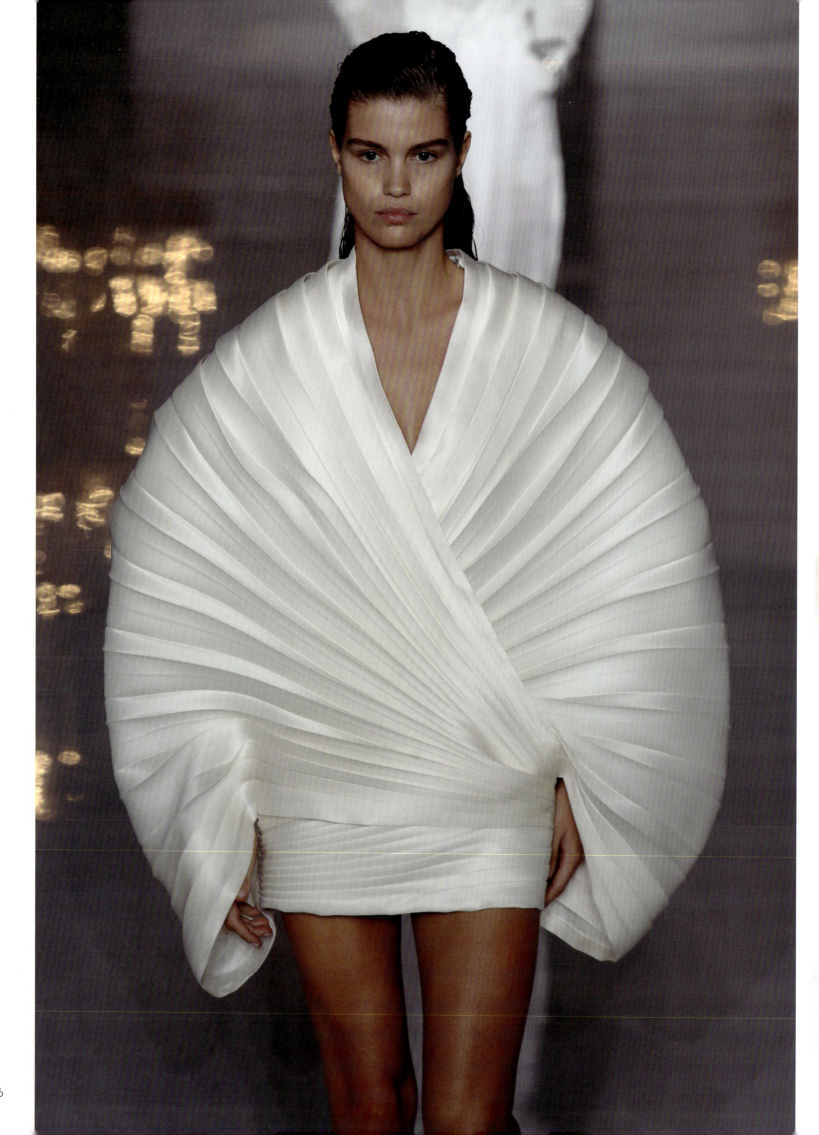

"Individuality is really important to having style."

CARA DELEVINGNE

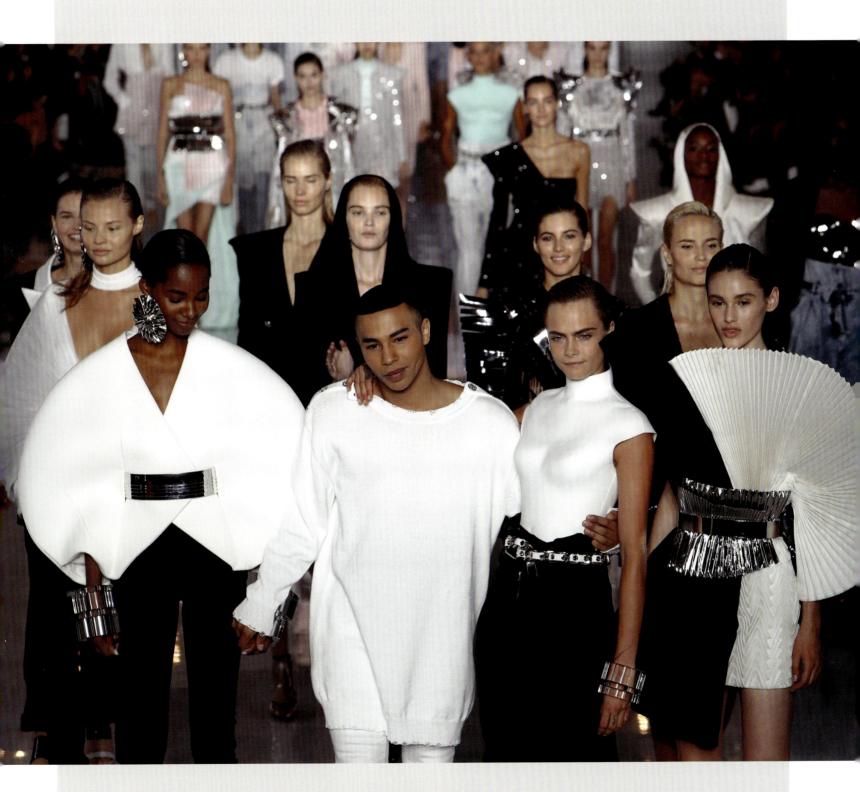

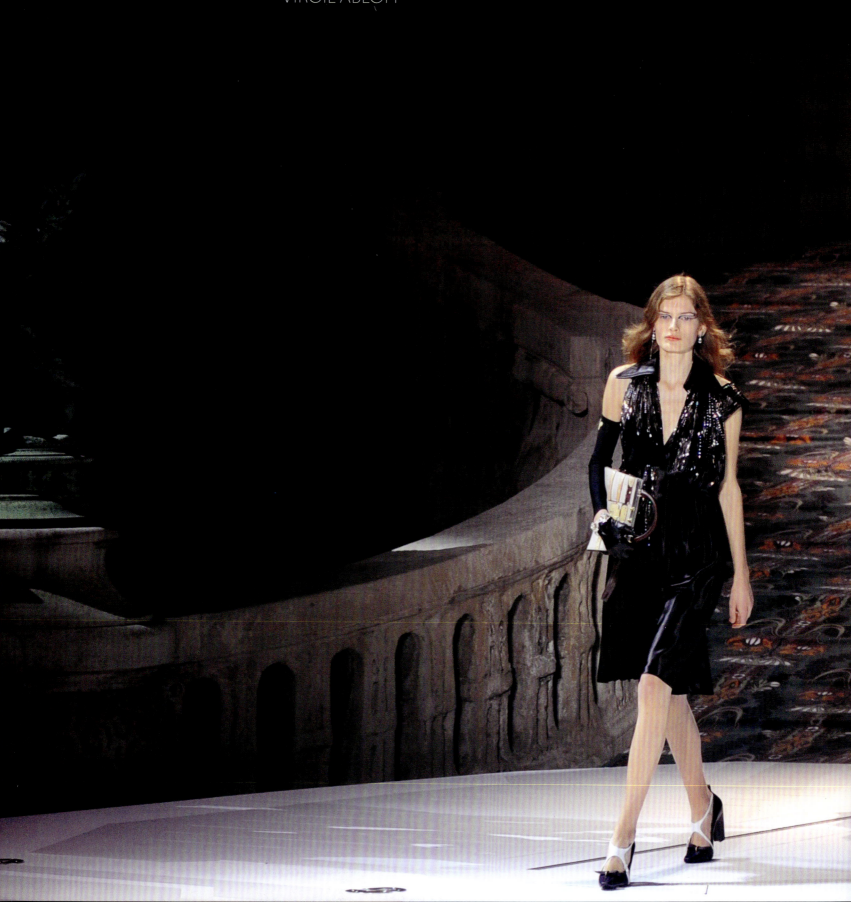

> "Visually and design oriented I am heavily influenced by glorious '80s graffiti culture and its evolution to today's street art."
>
> VIRGIL ABLOH

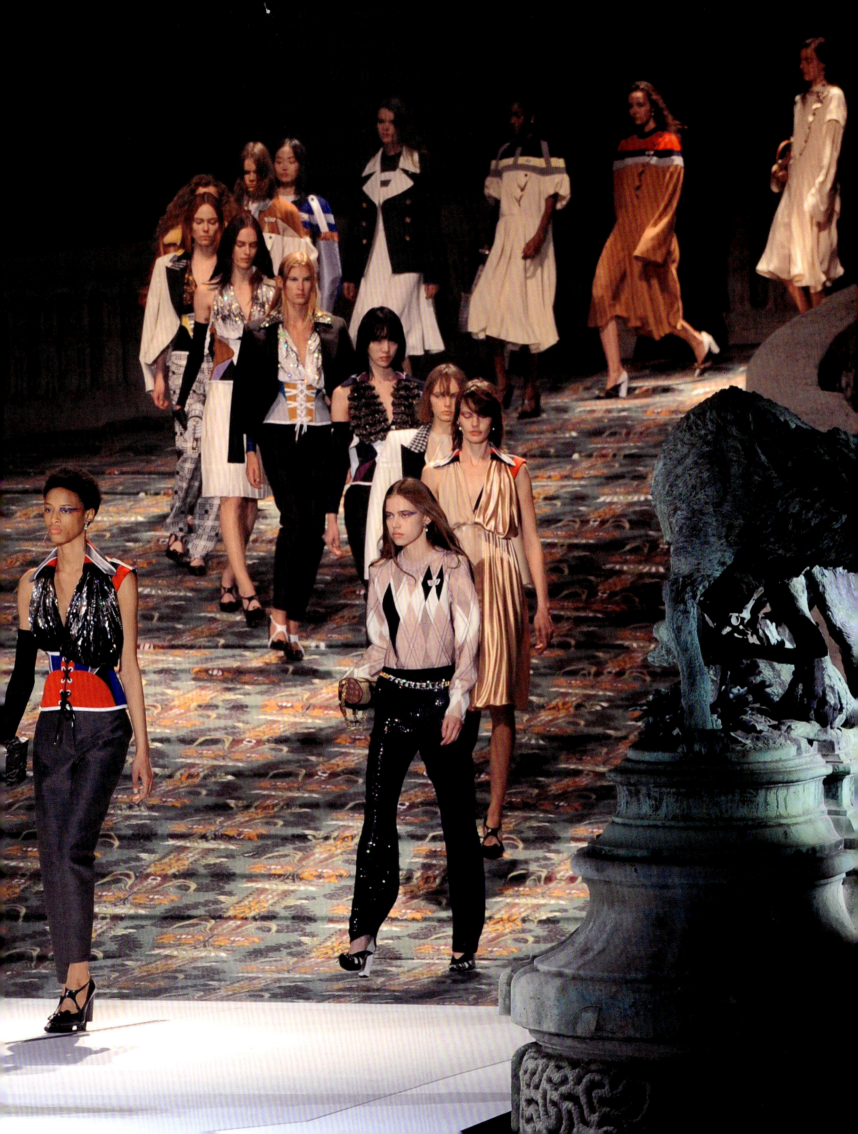

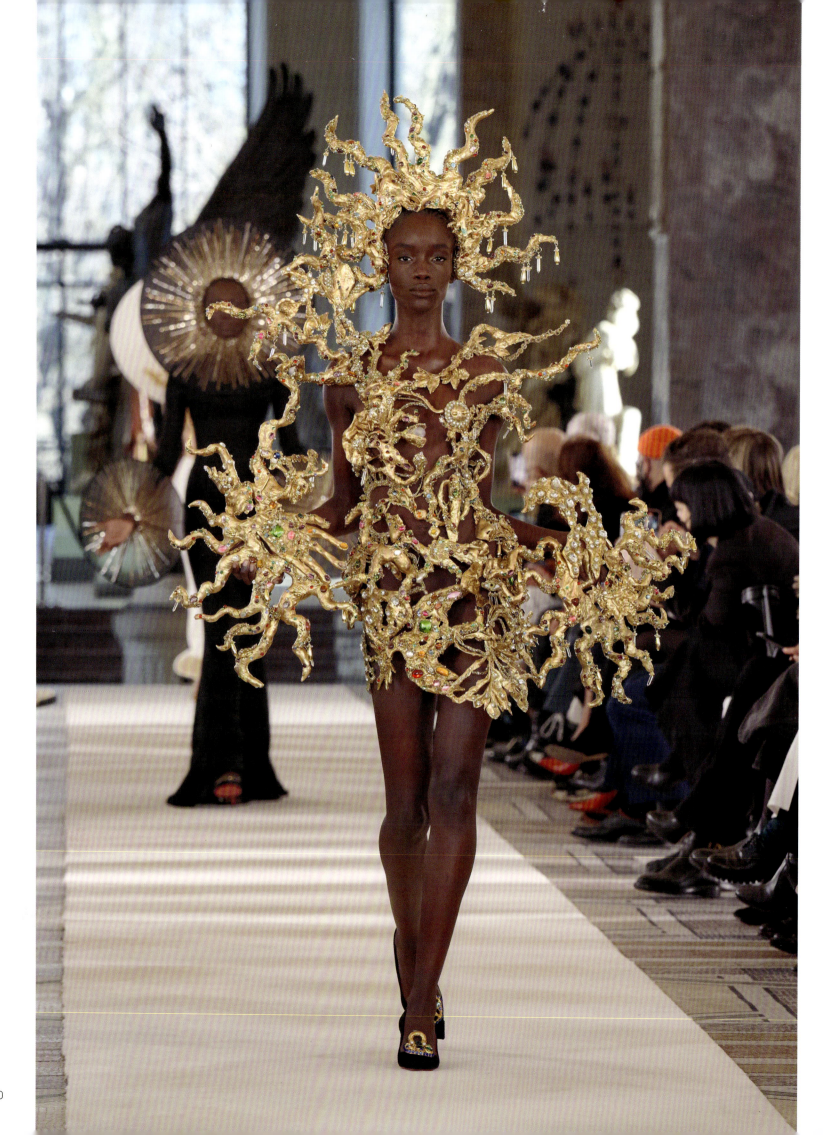

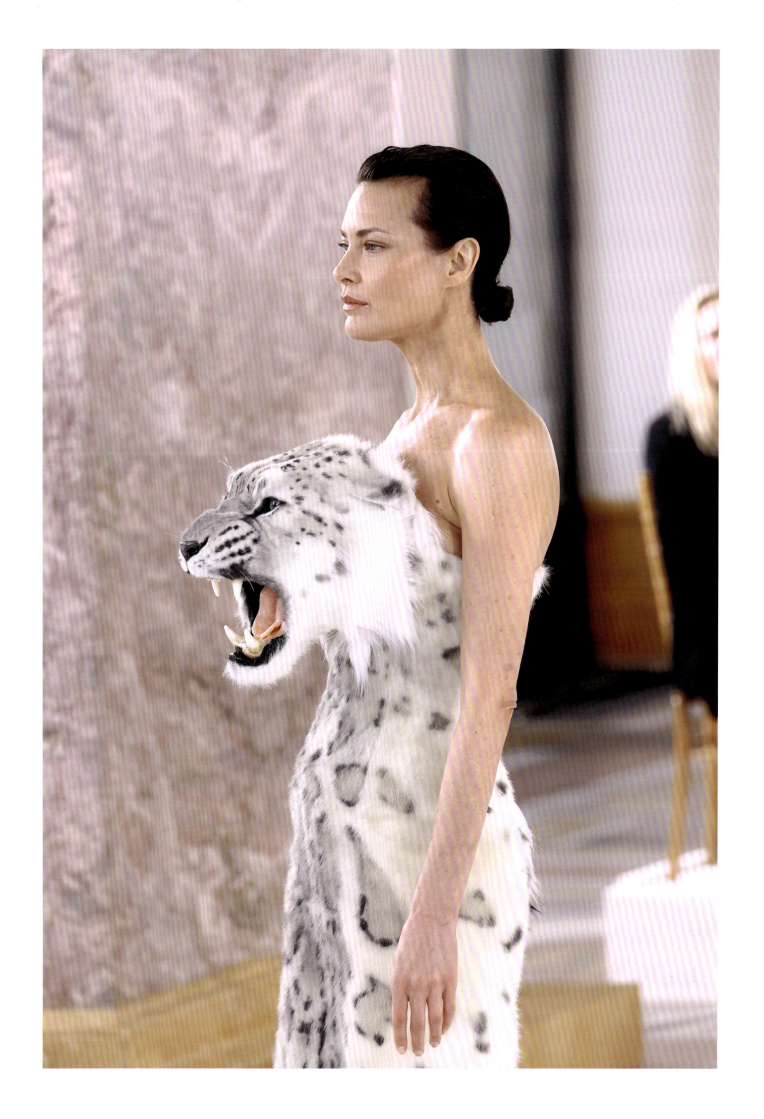

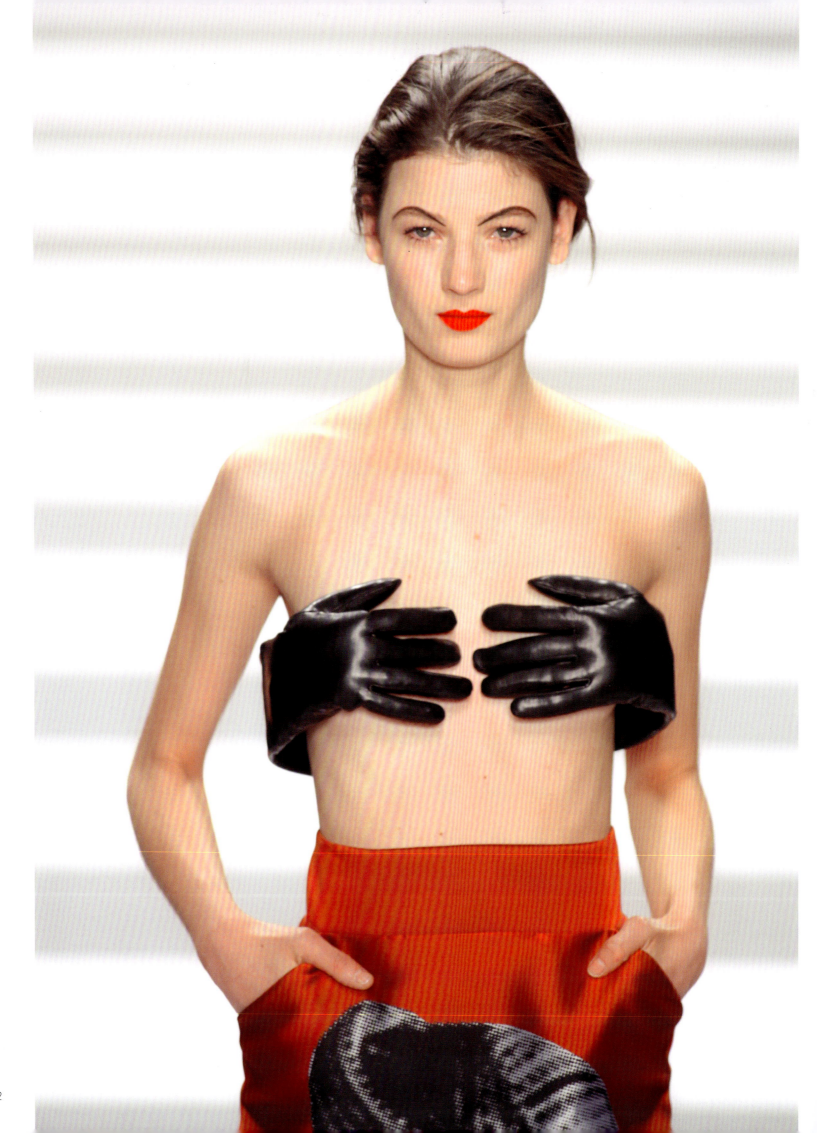

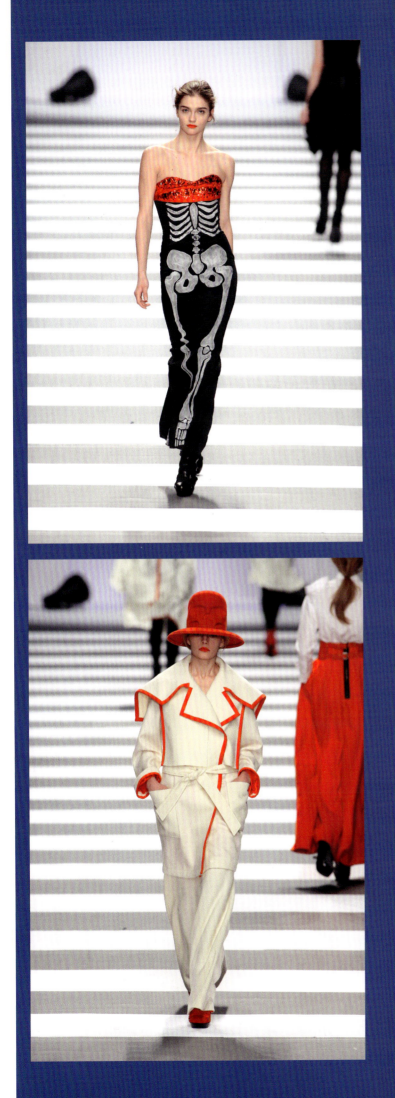
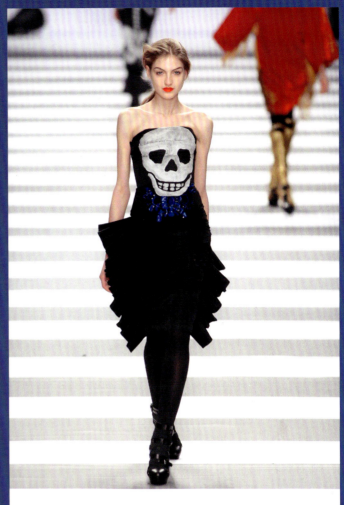
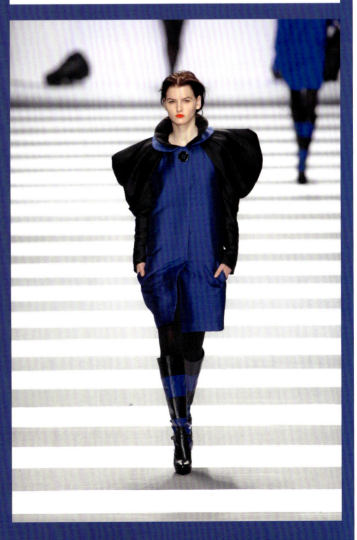

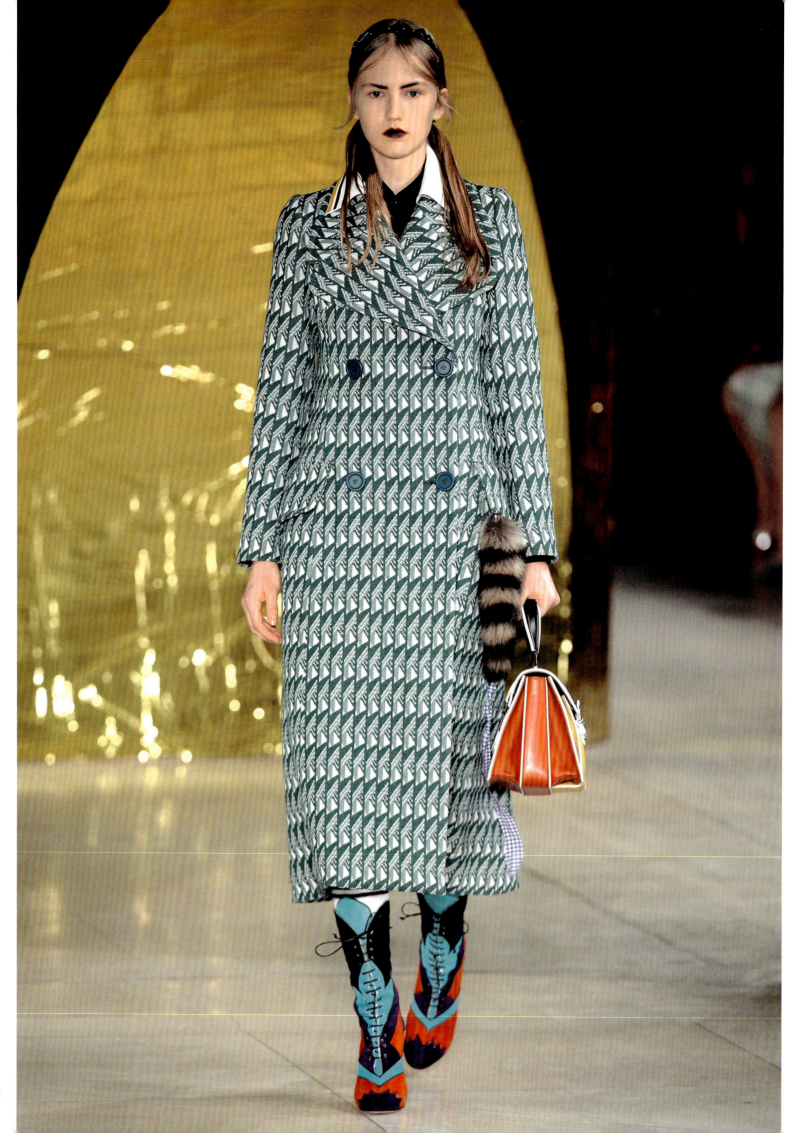

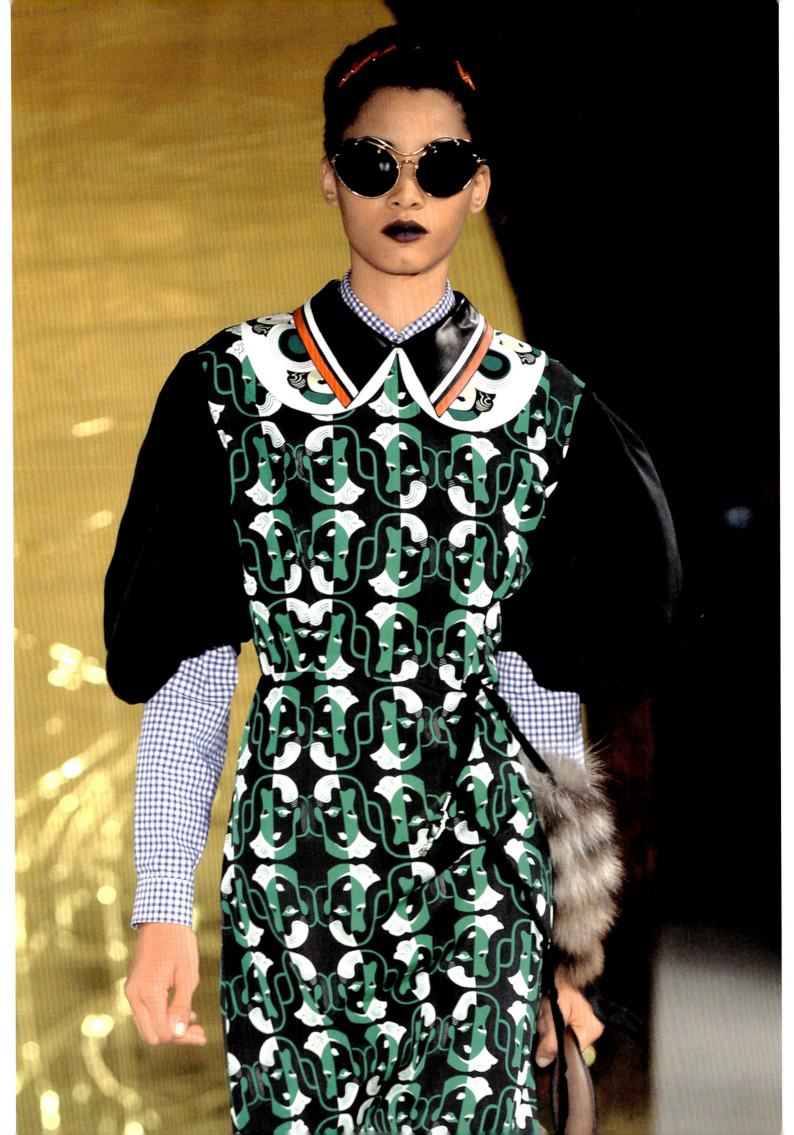

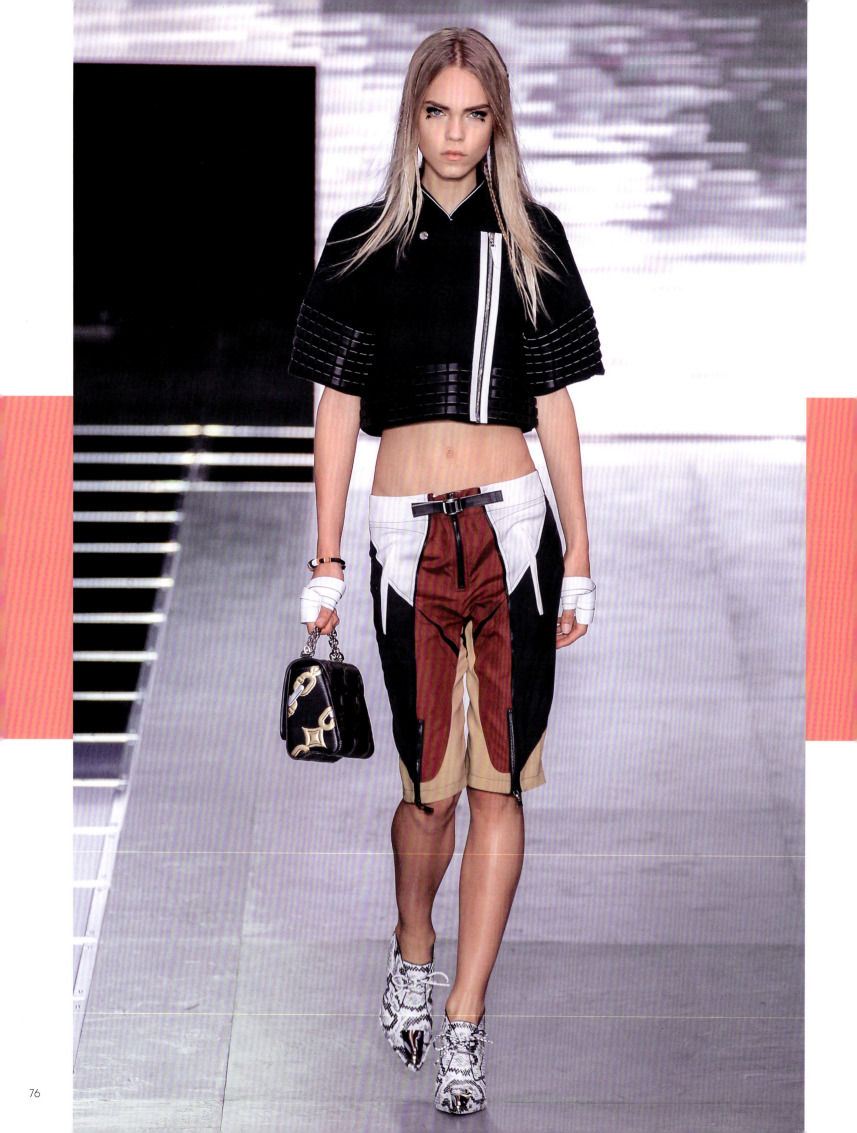

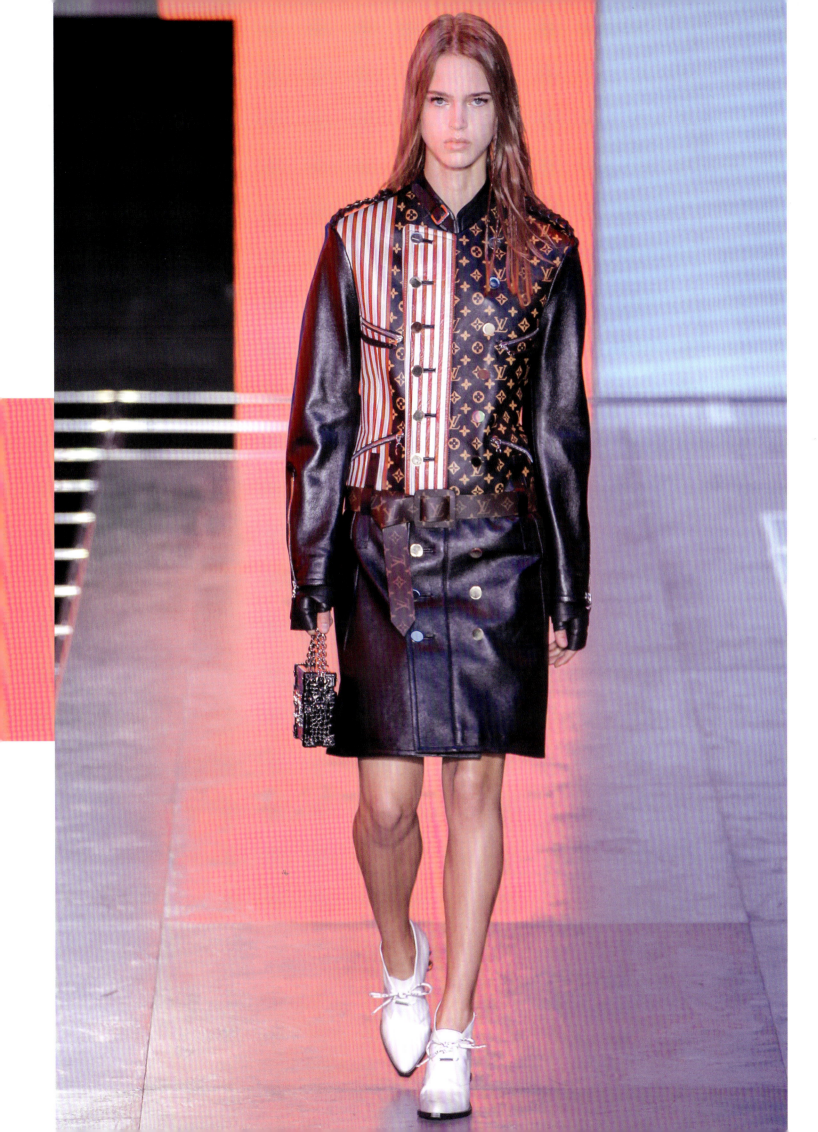

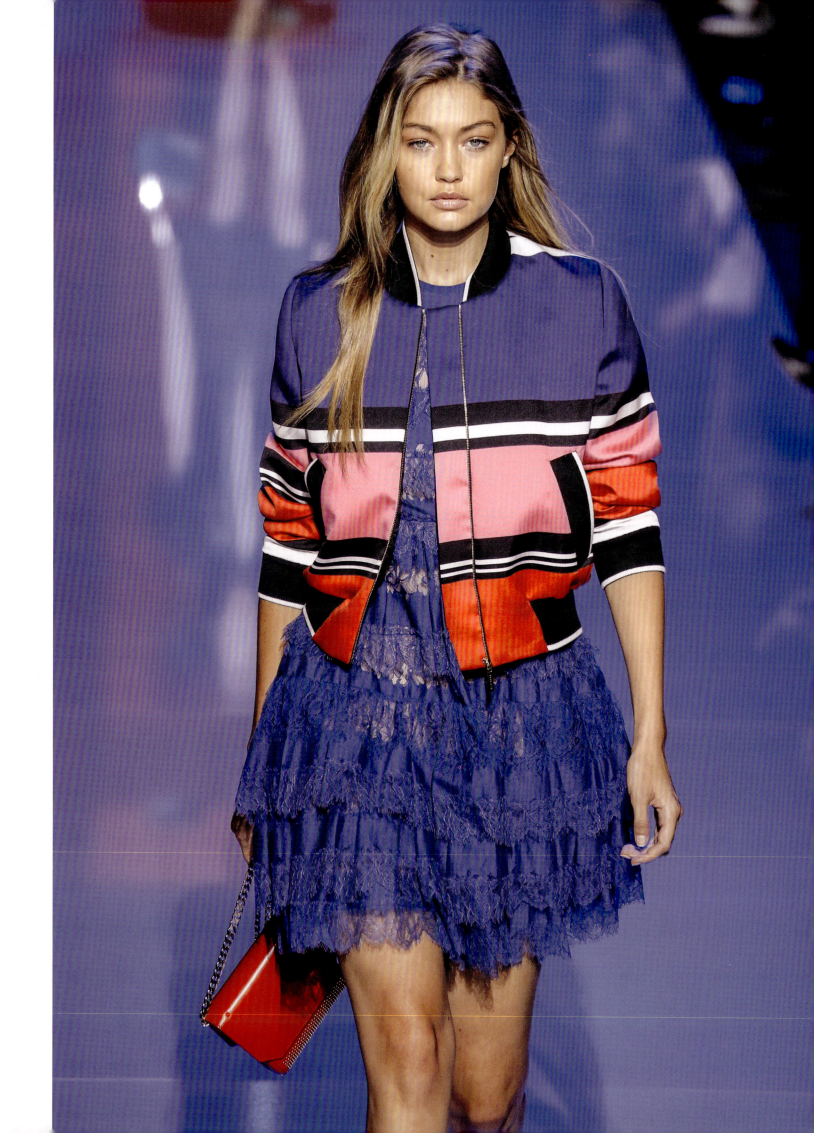

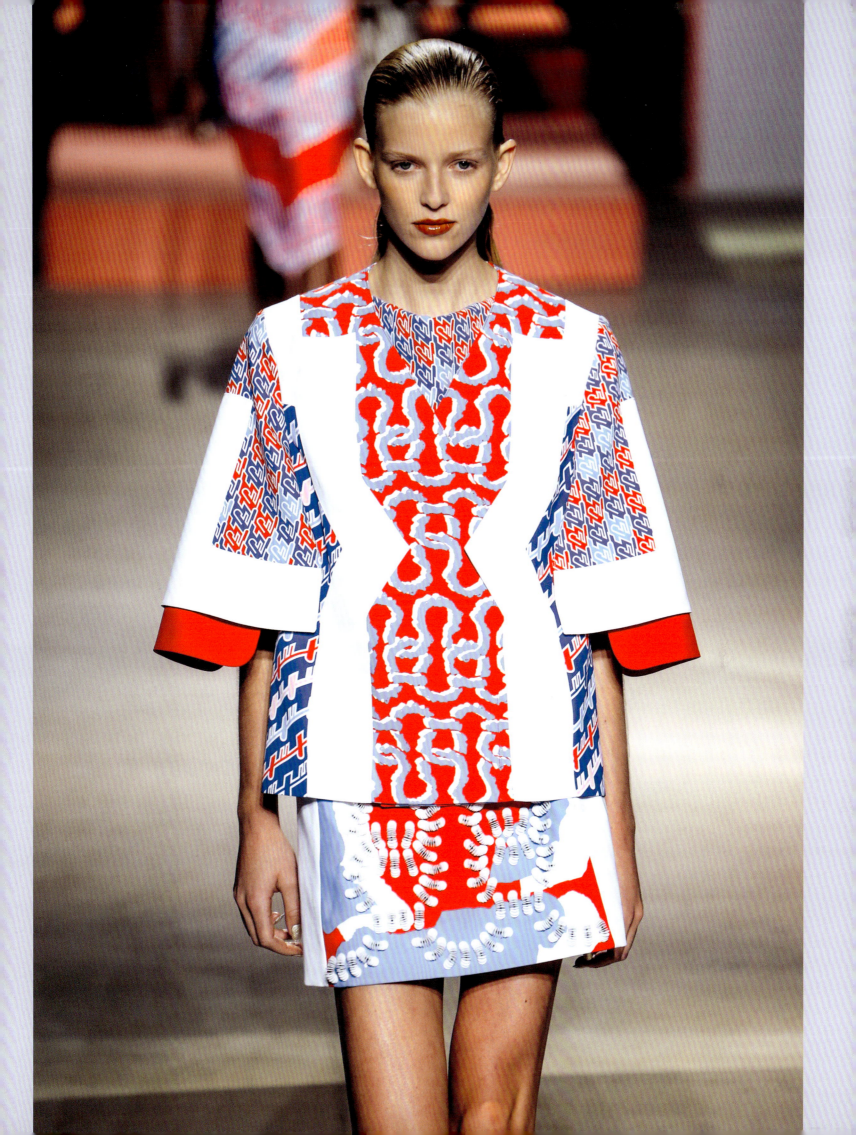

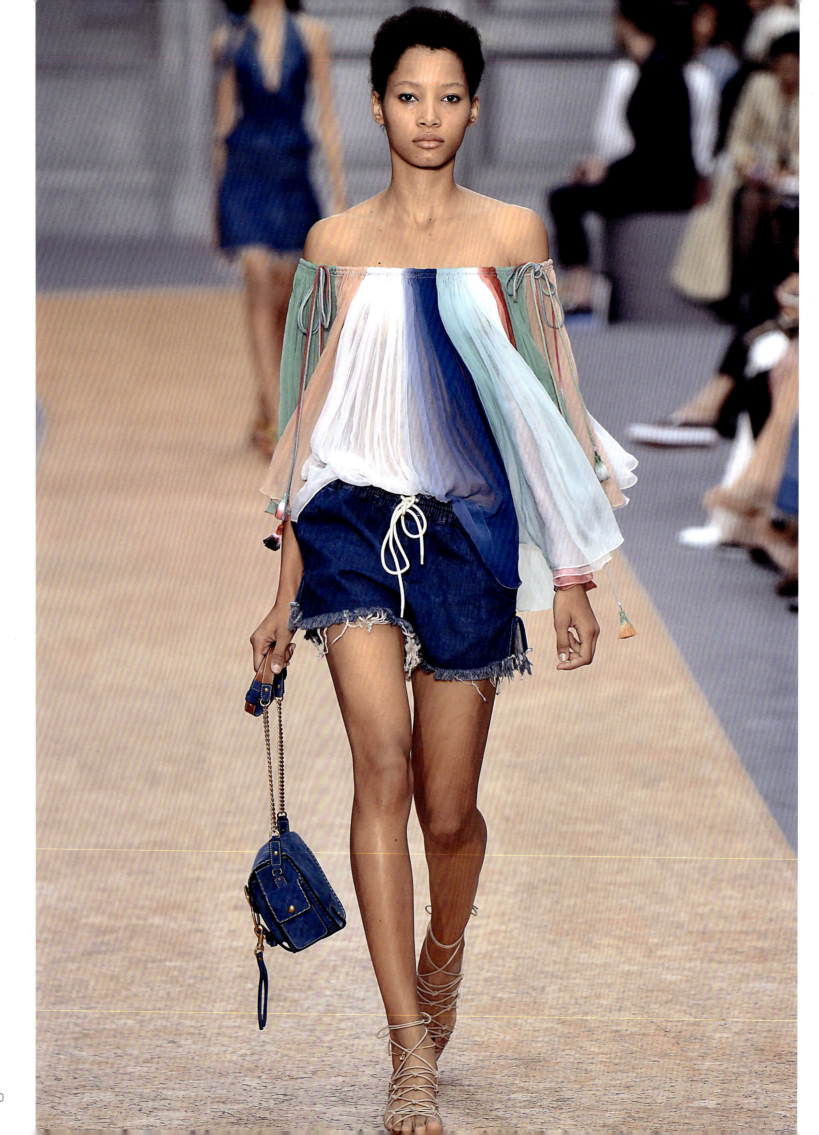

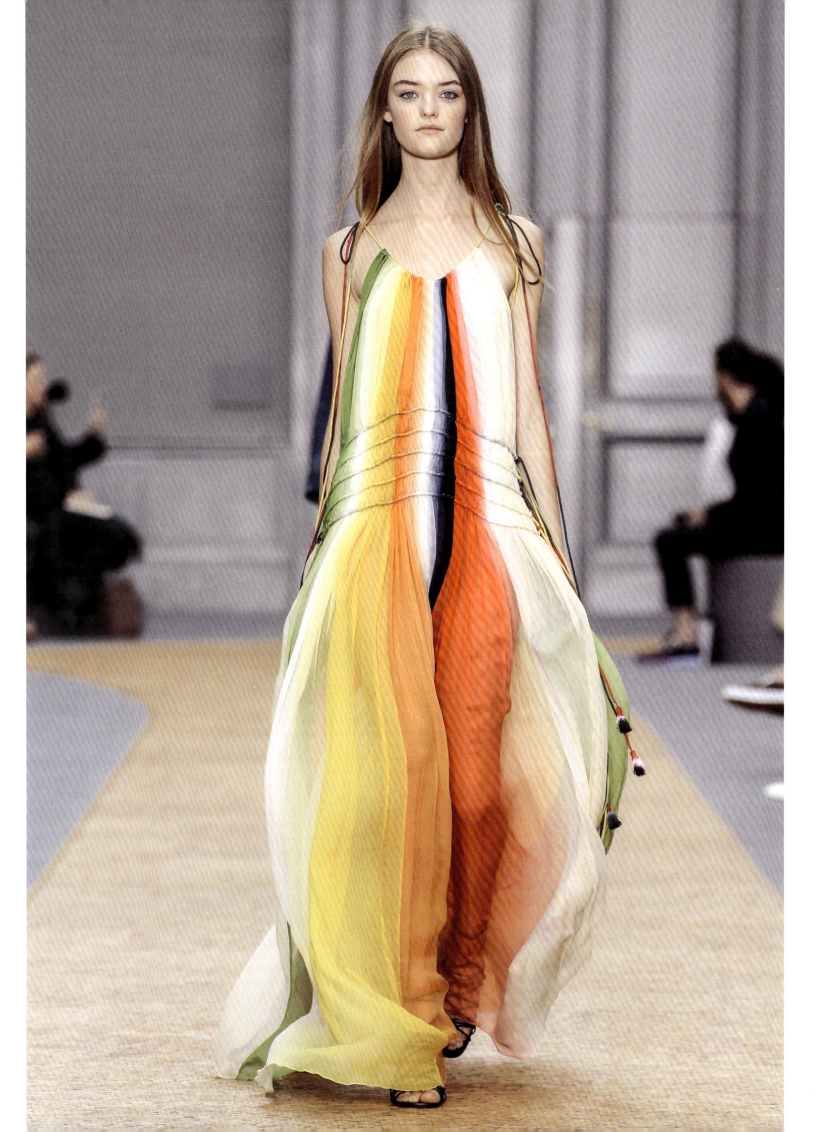

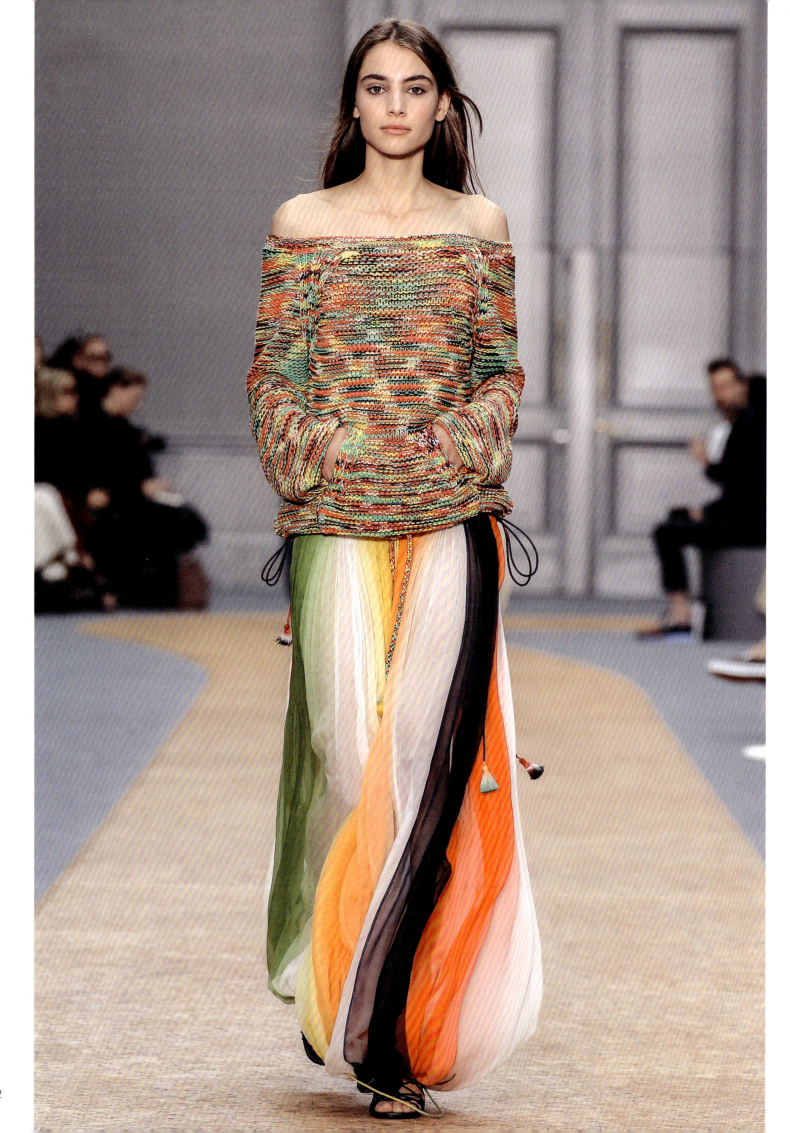

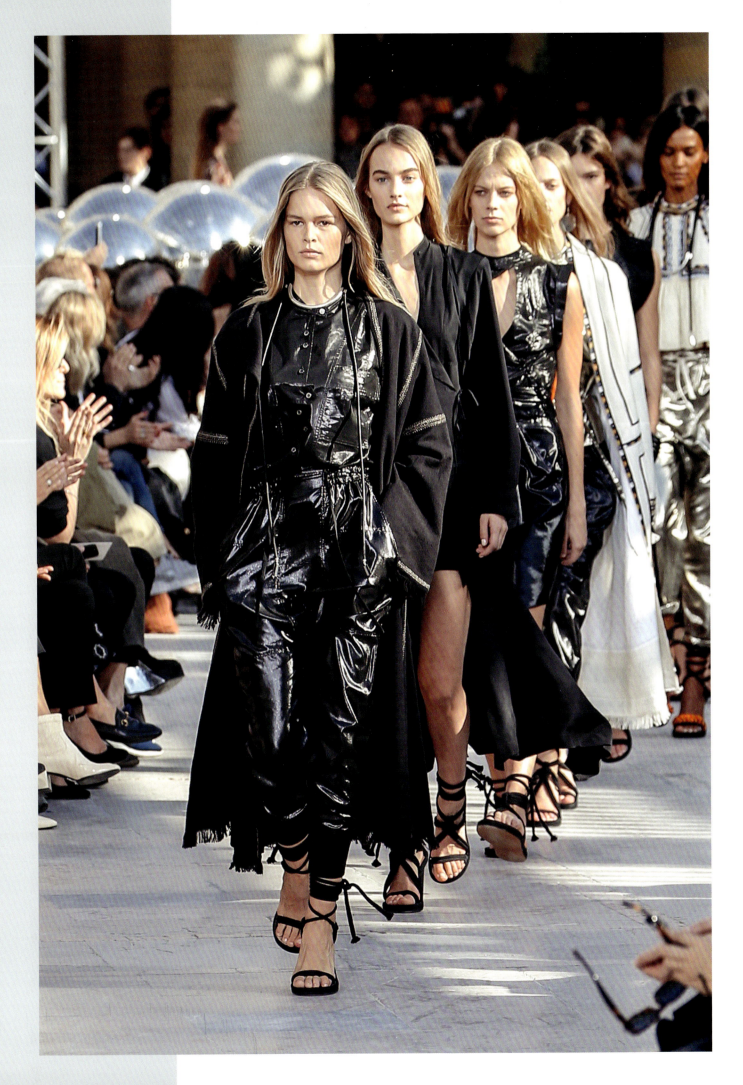

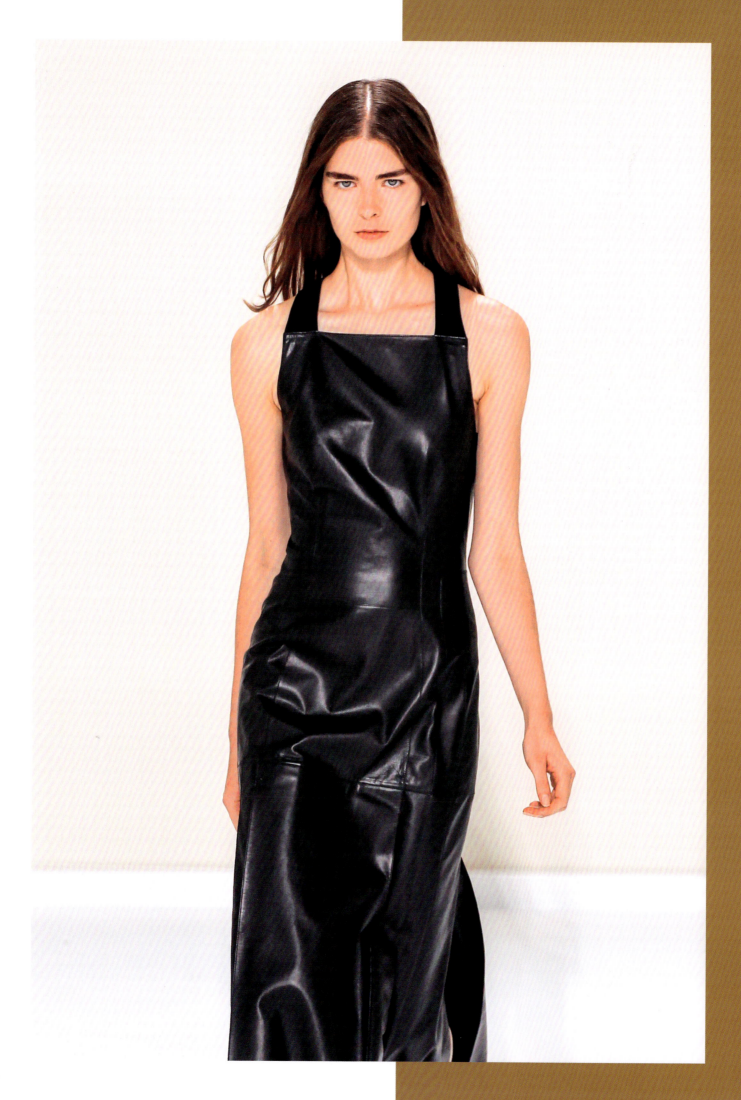

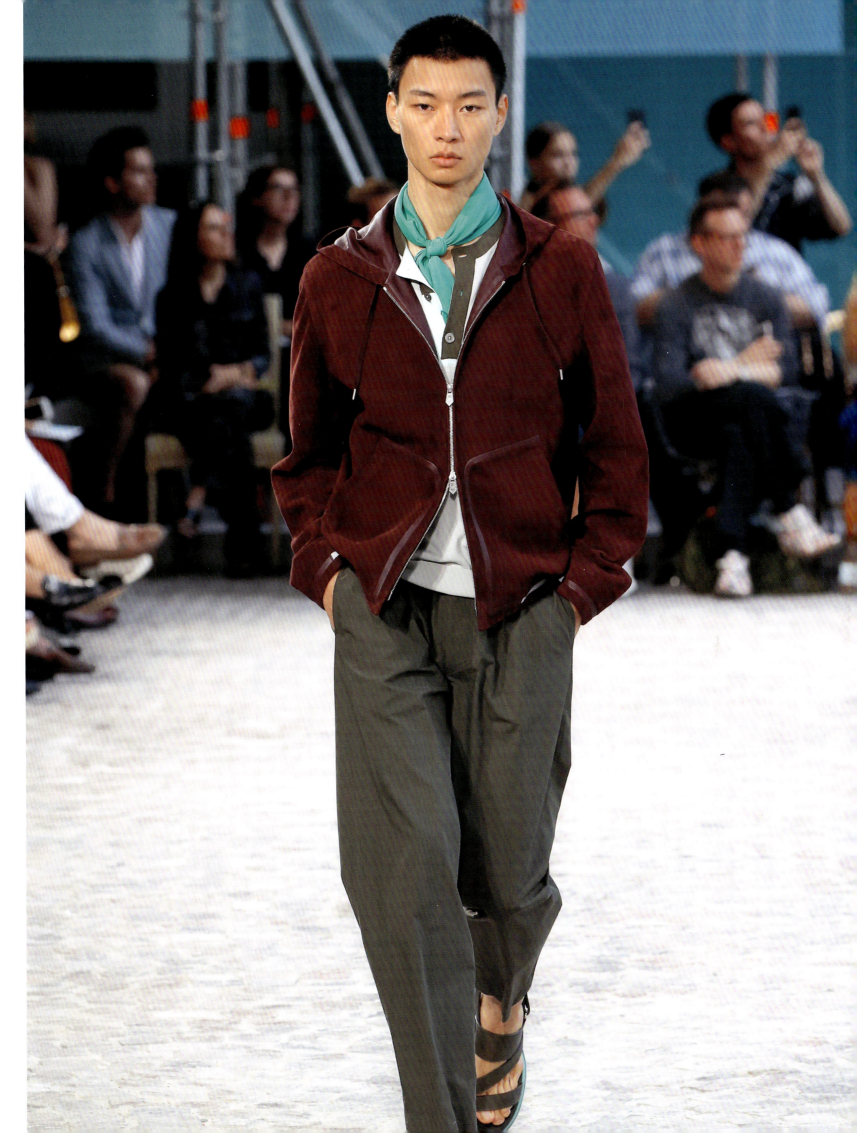

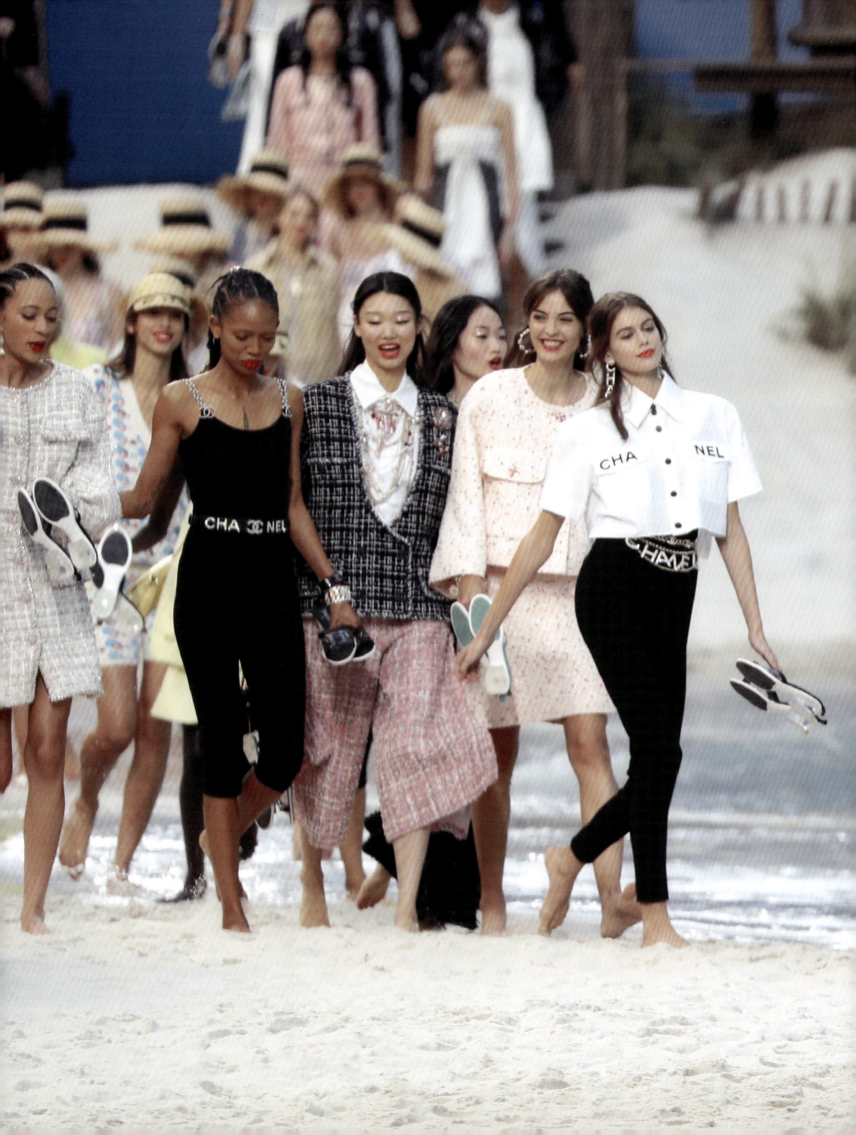

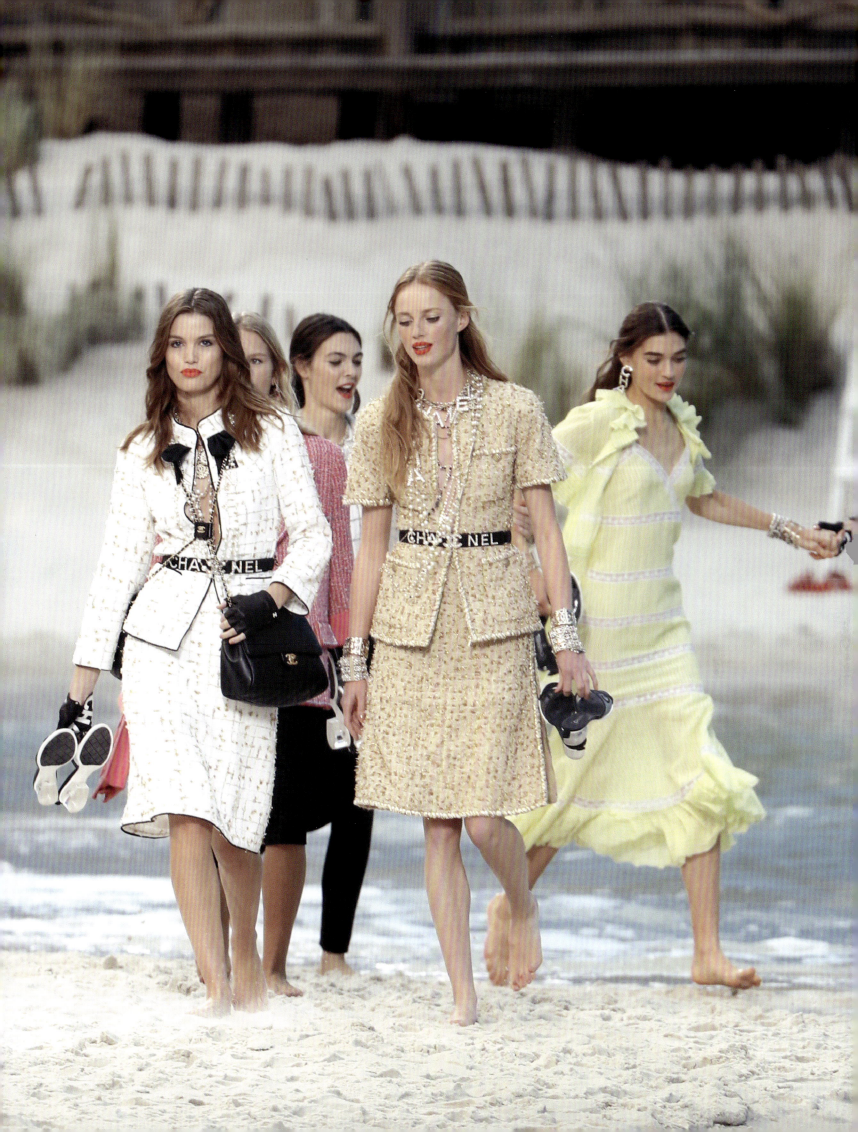

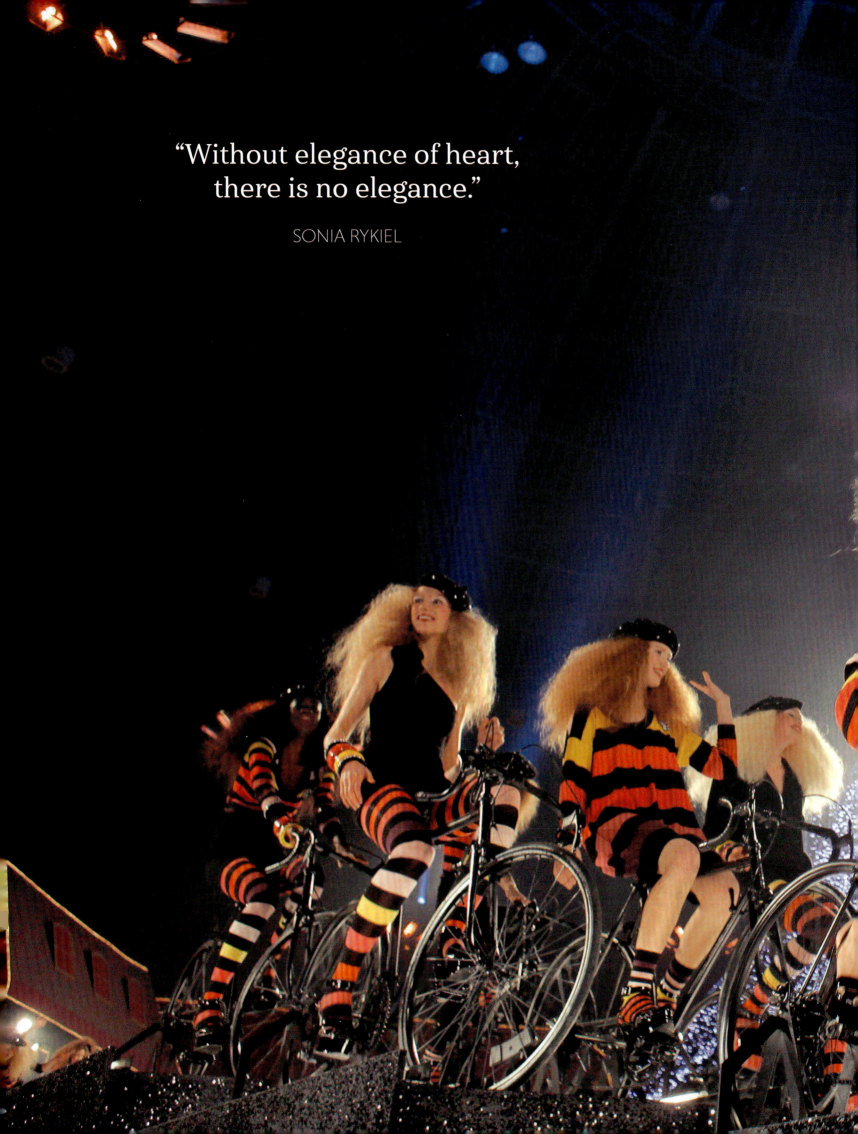

"Without elegance of heart, there is no elegance."

SONIA RYKIEL

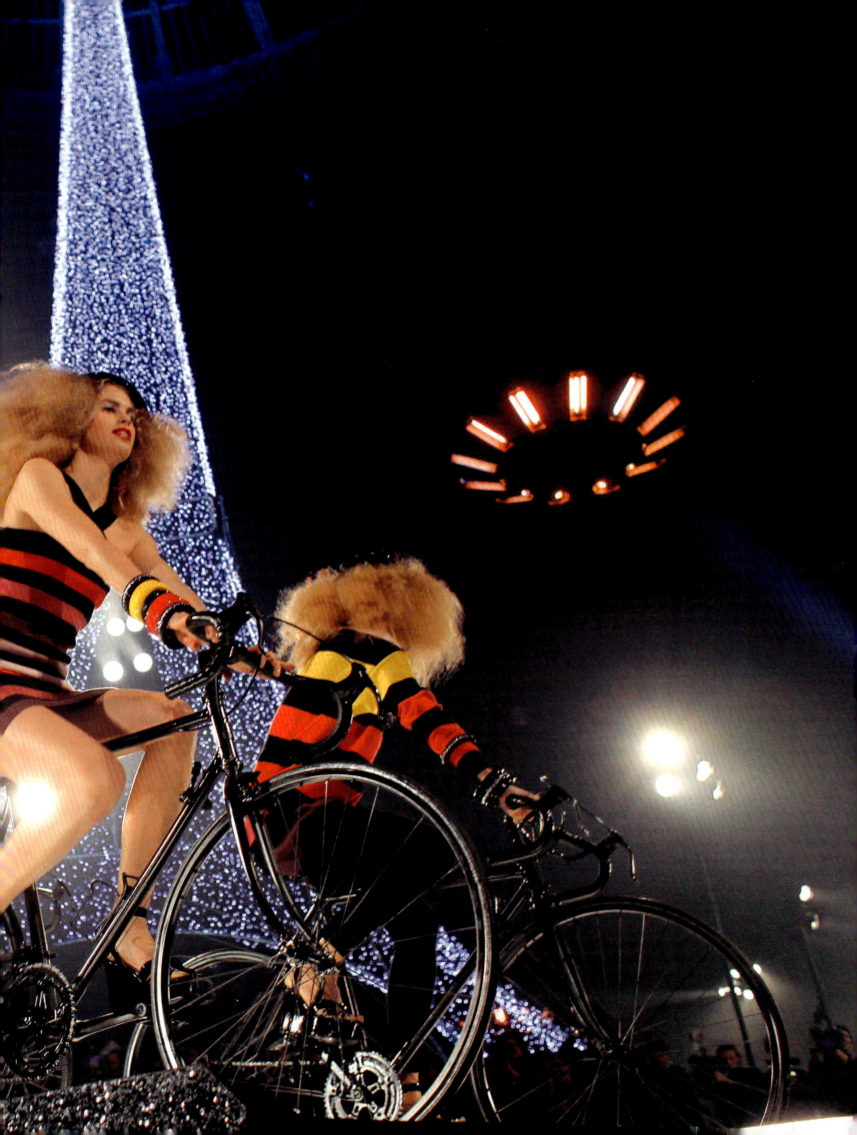

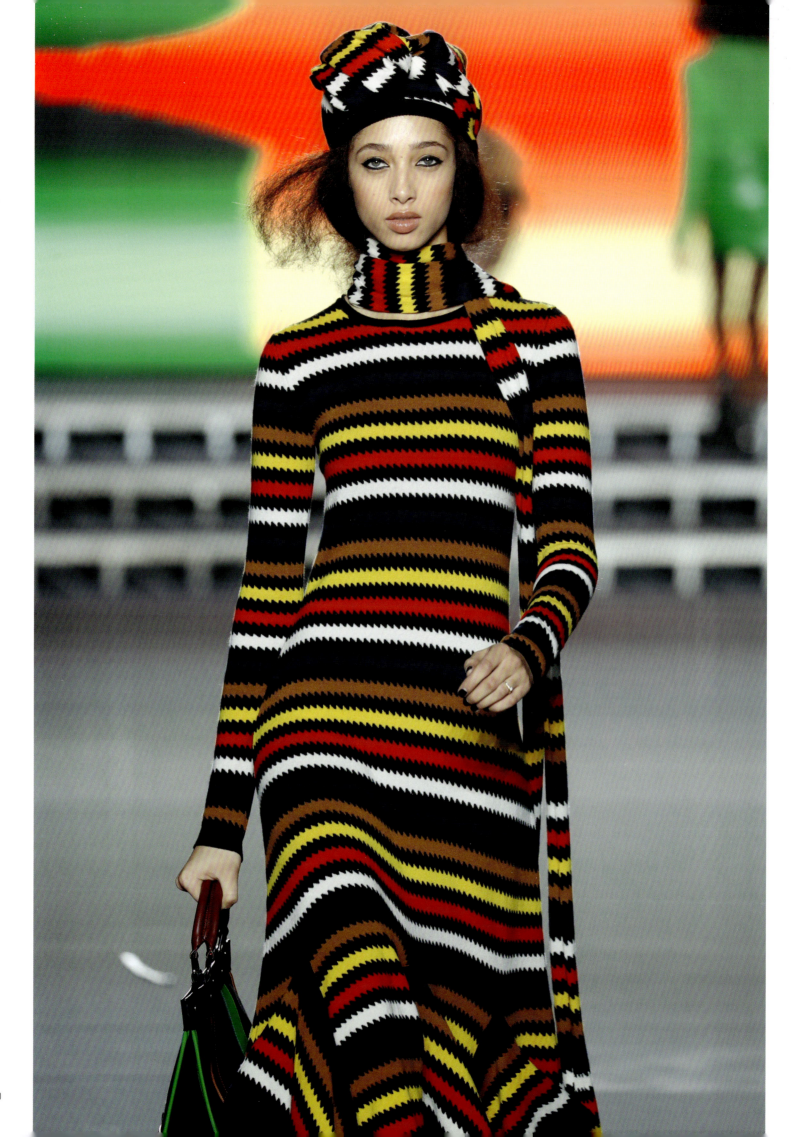

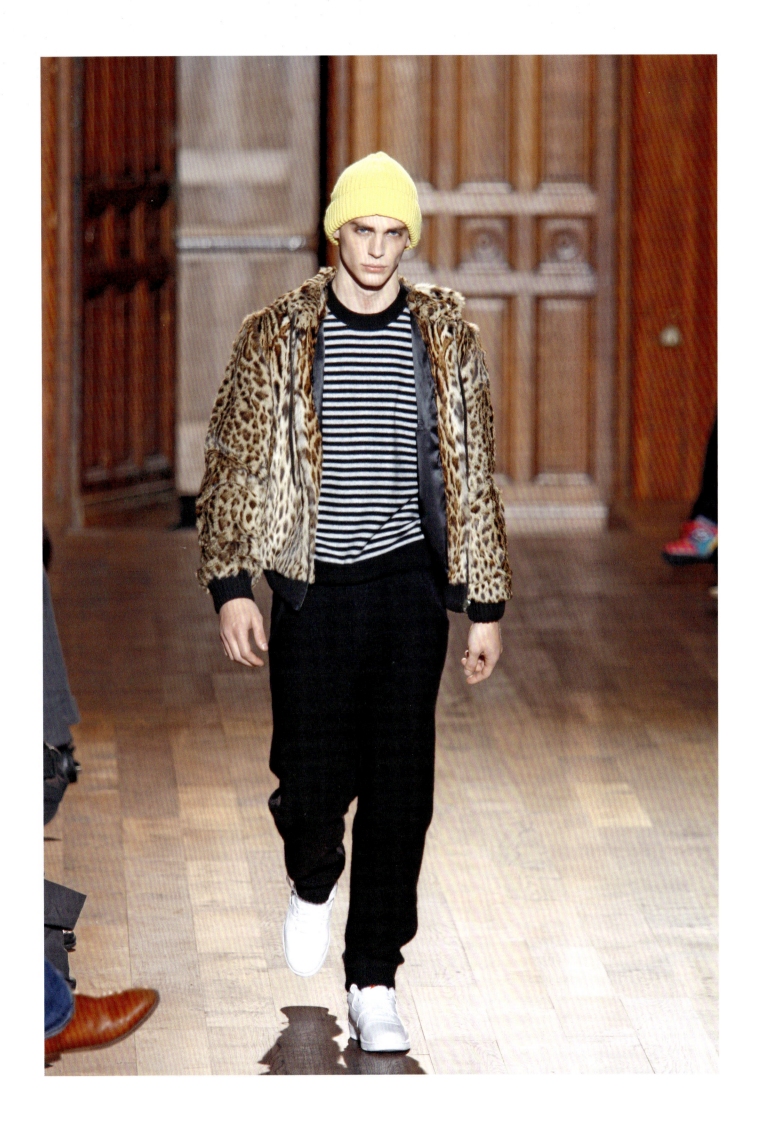

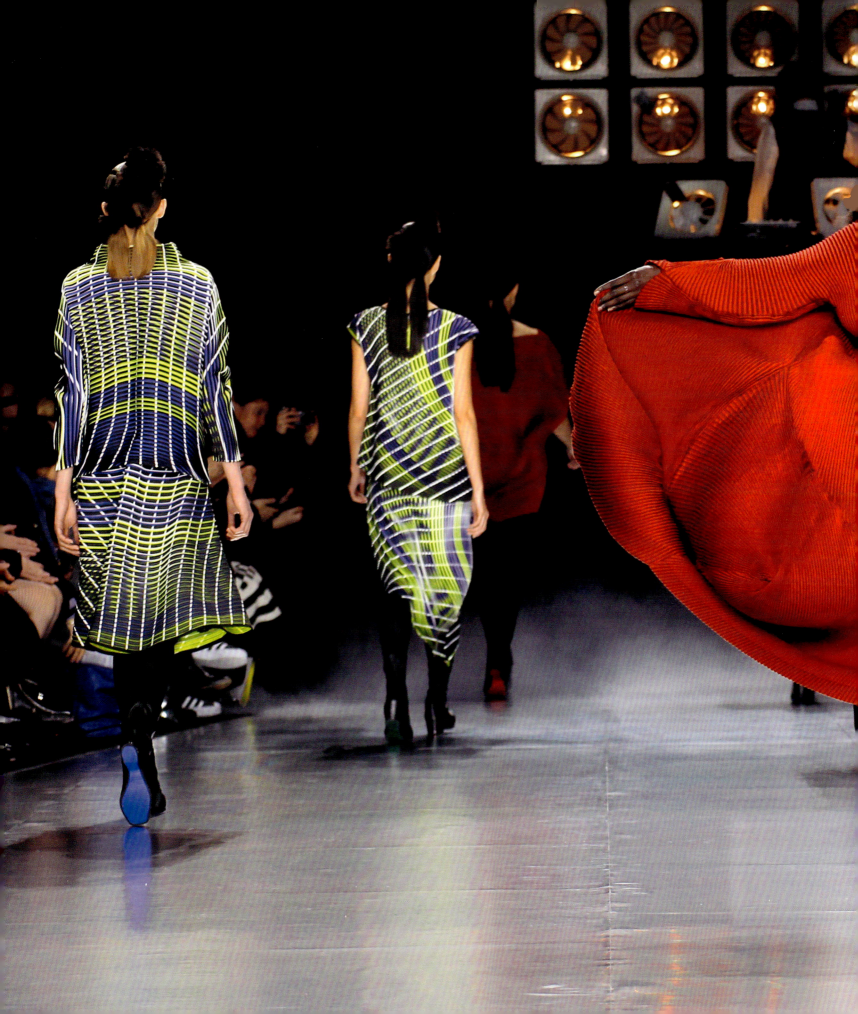

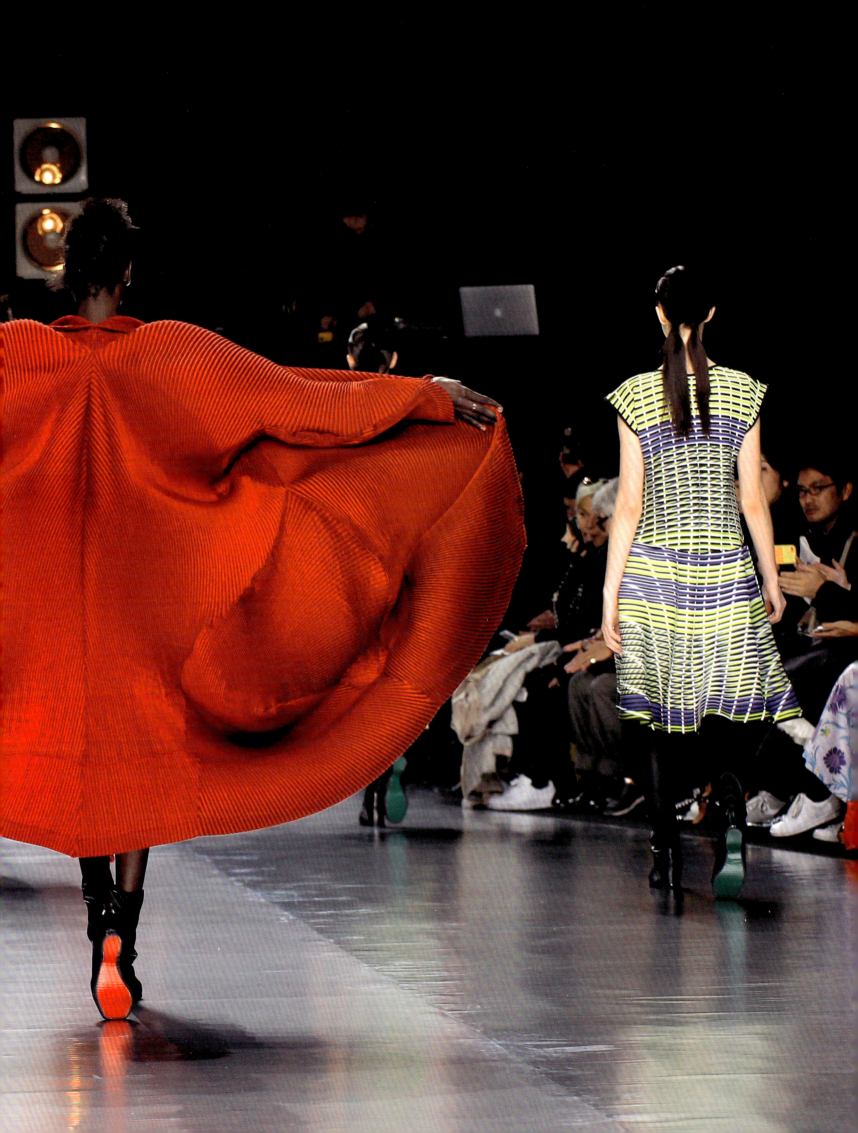

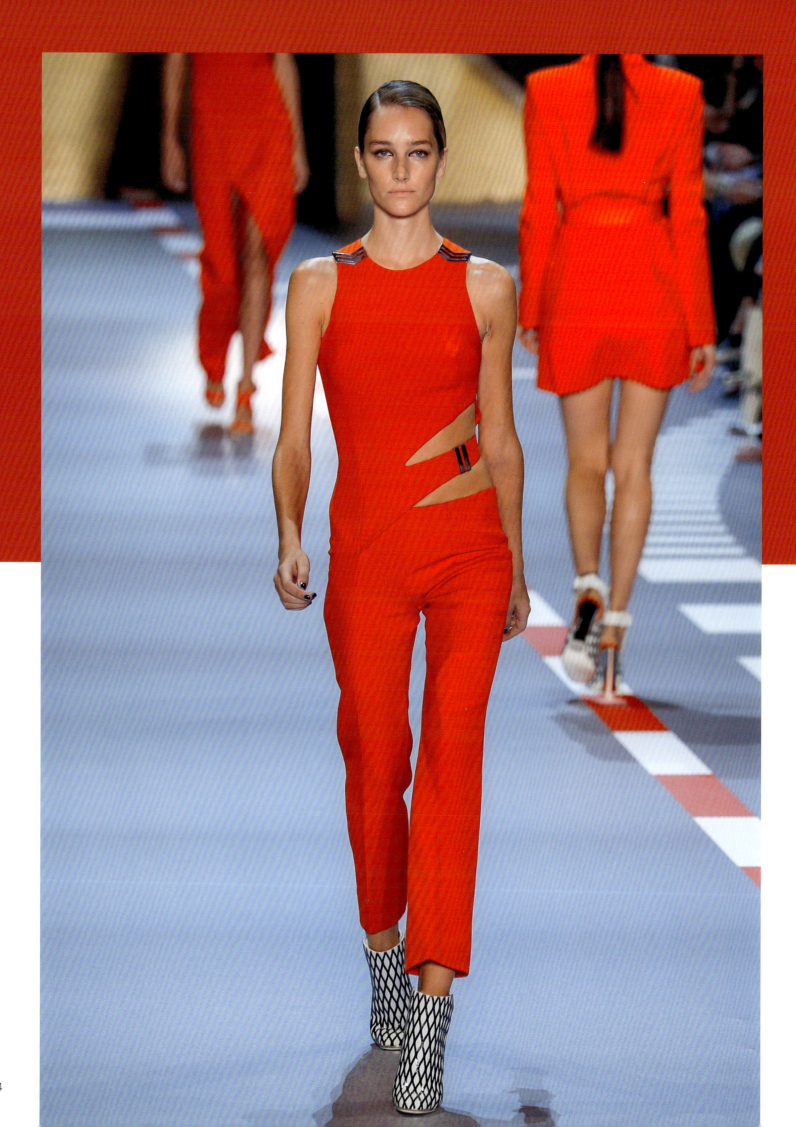

"Paris is a city that is known for putting on very sophisticated events, very beautiful exhibitions... with its sense of elegance and chic."

THIERRY MUGLER

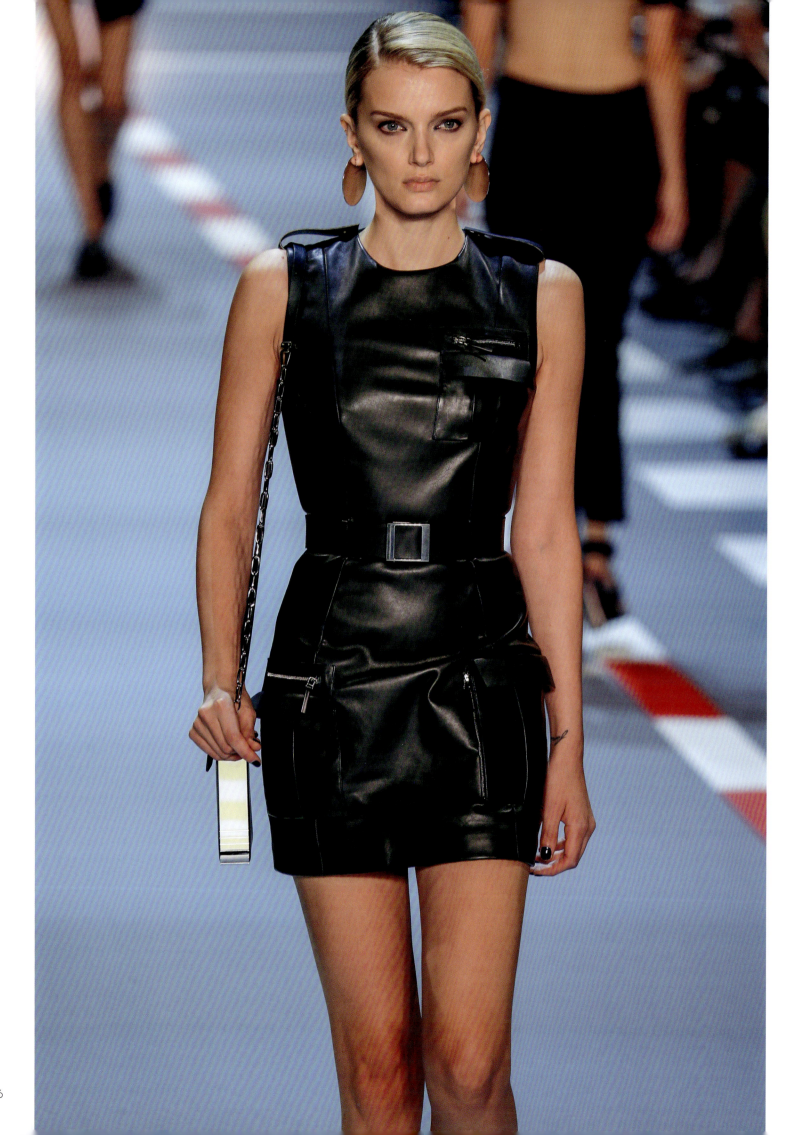

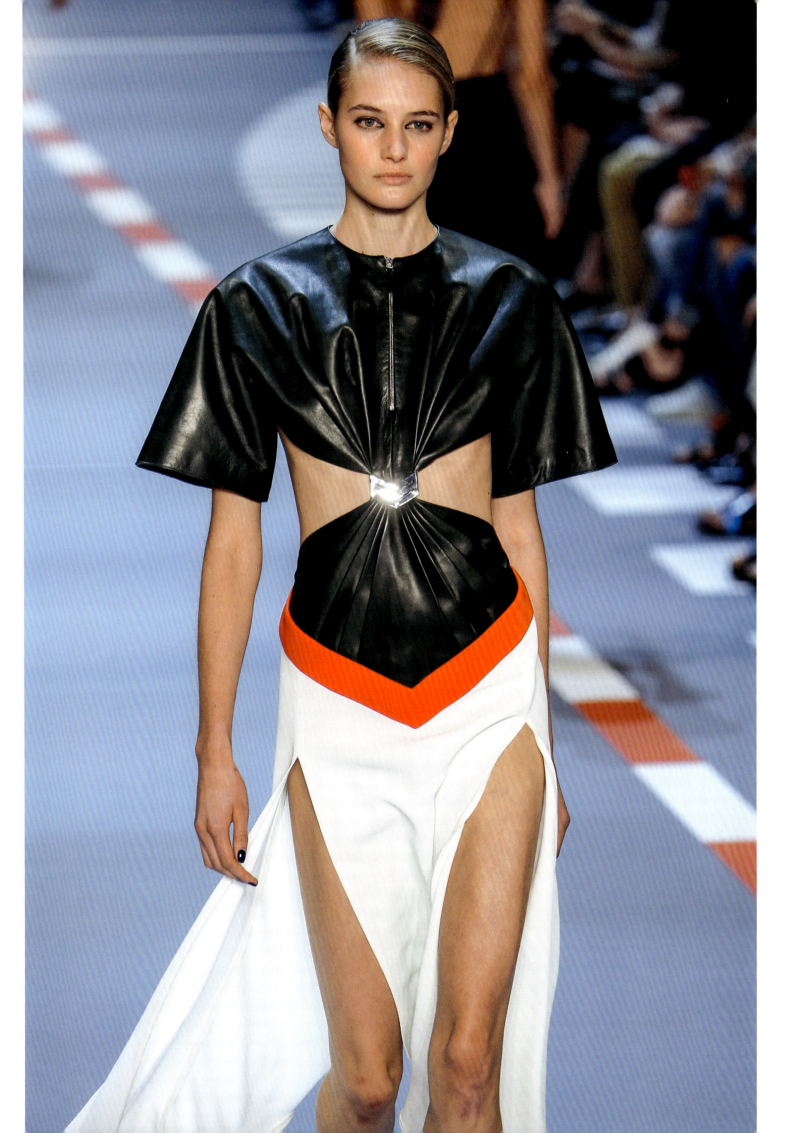

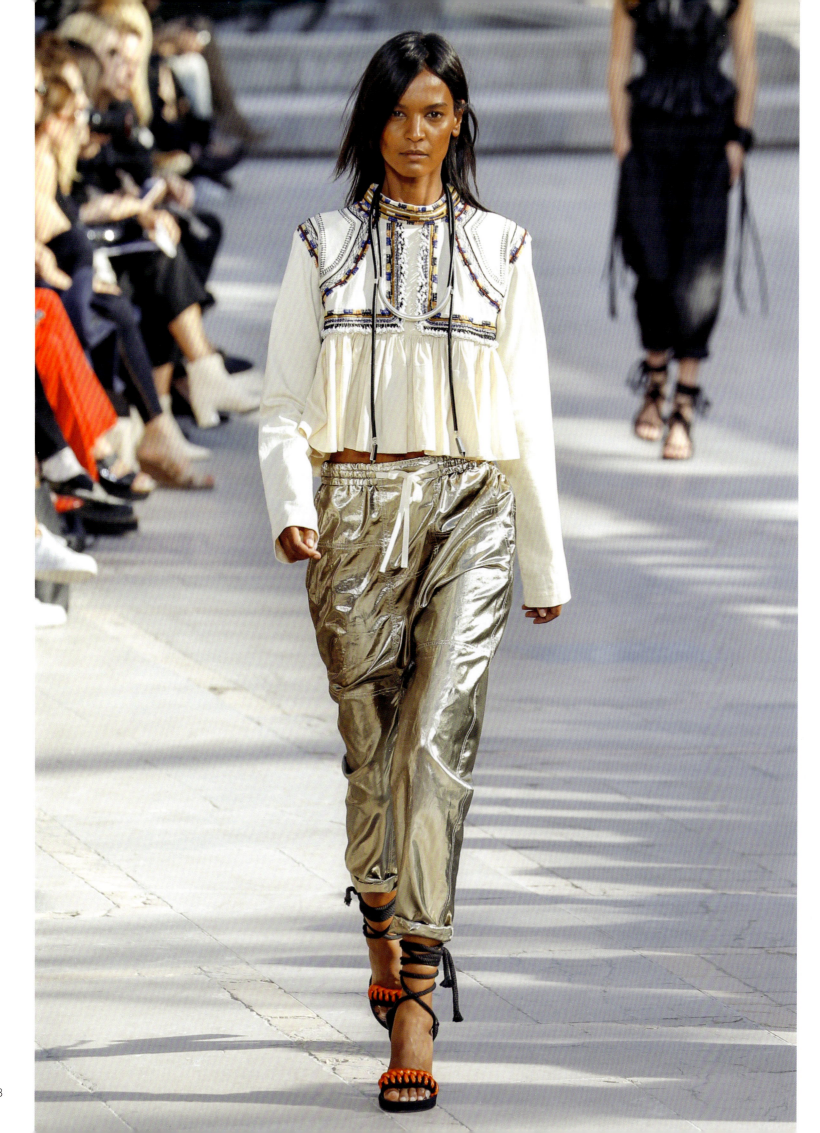

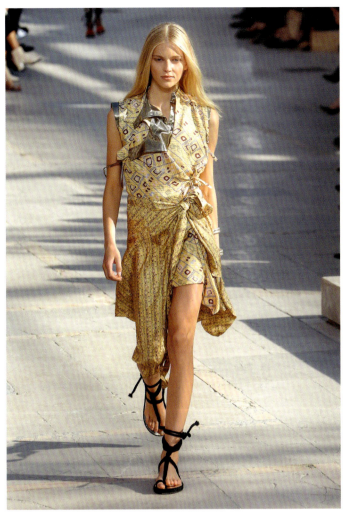
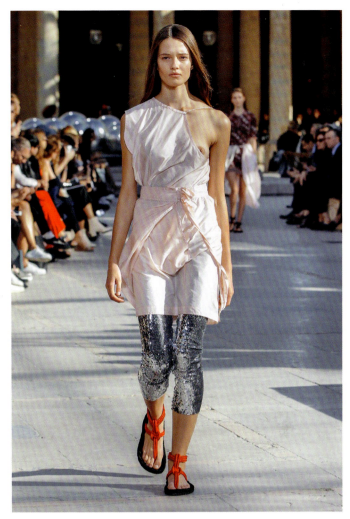
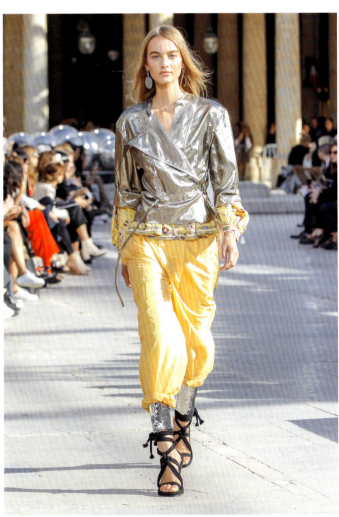
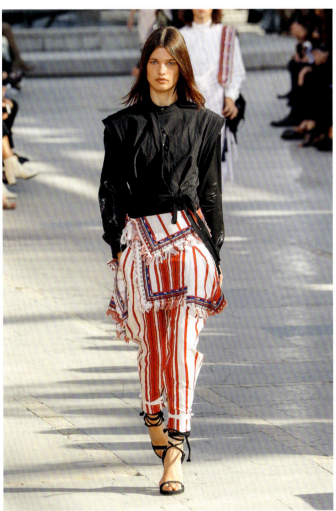

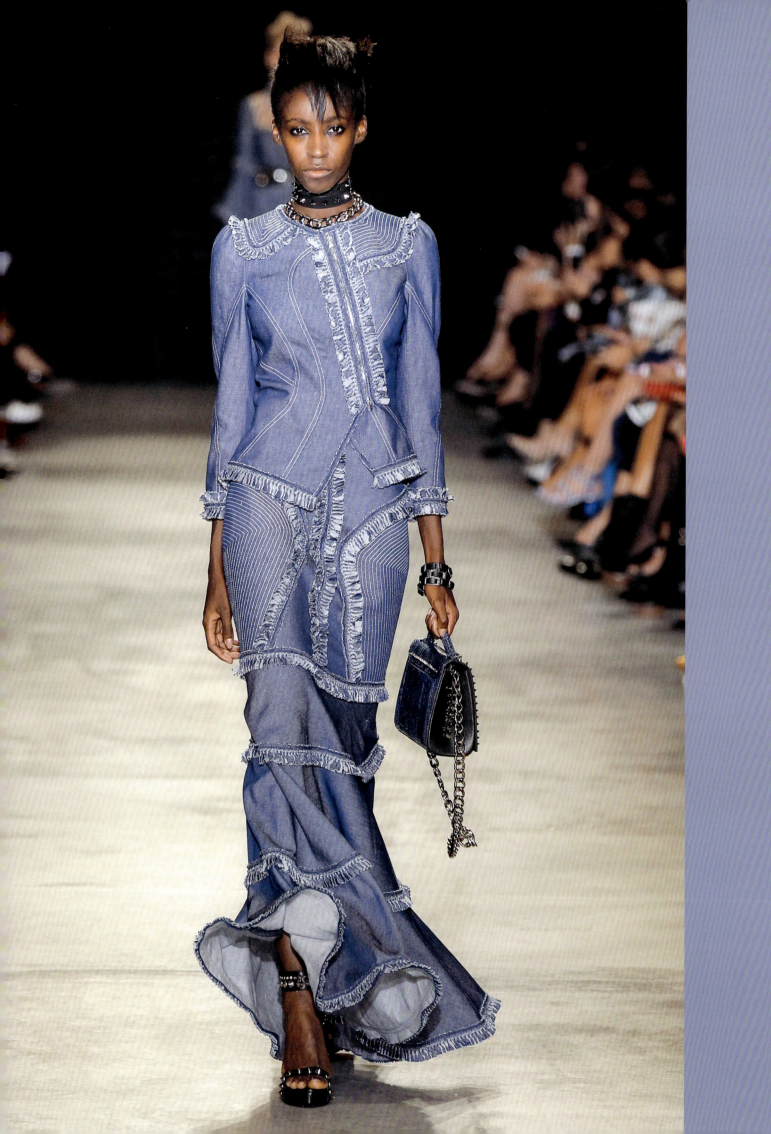

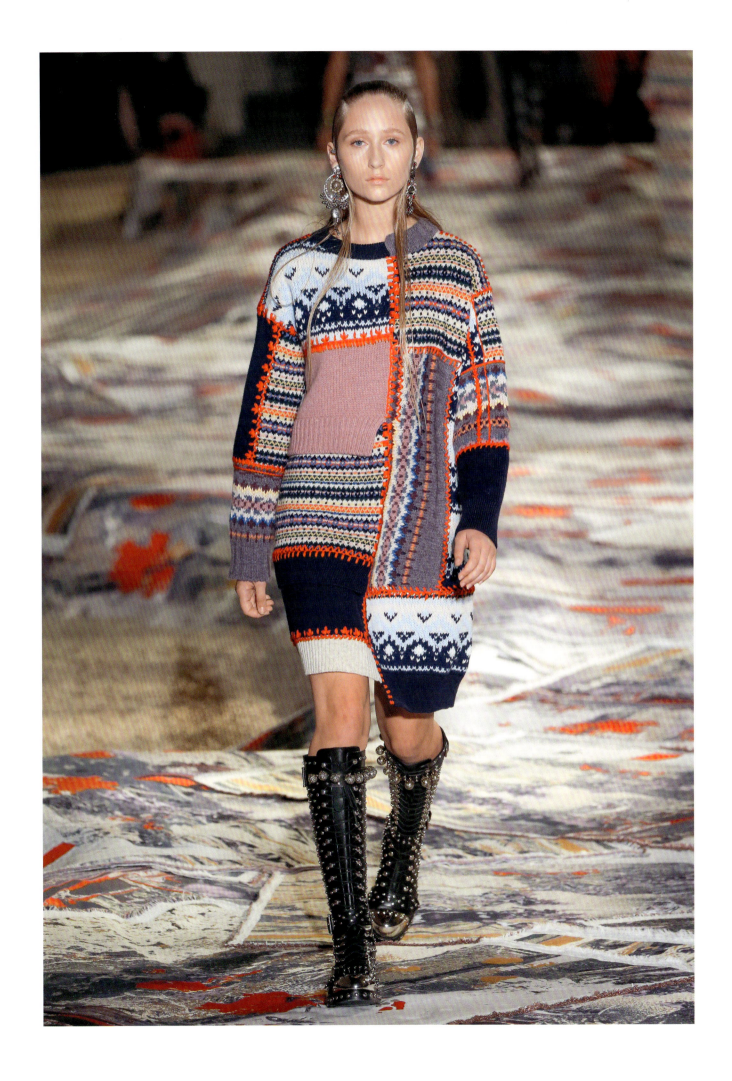

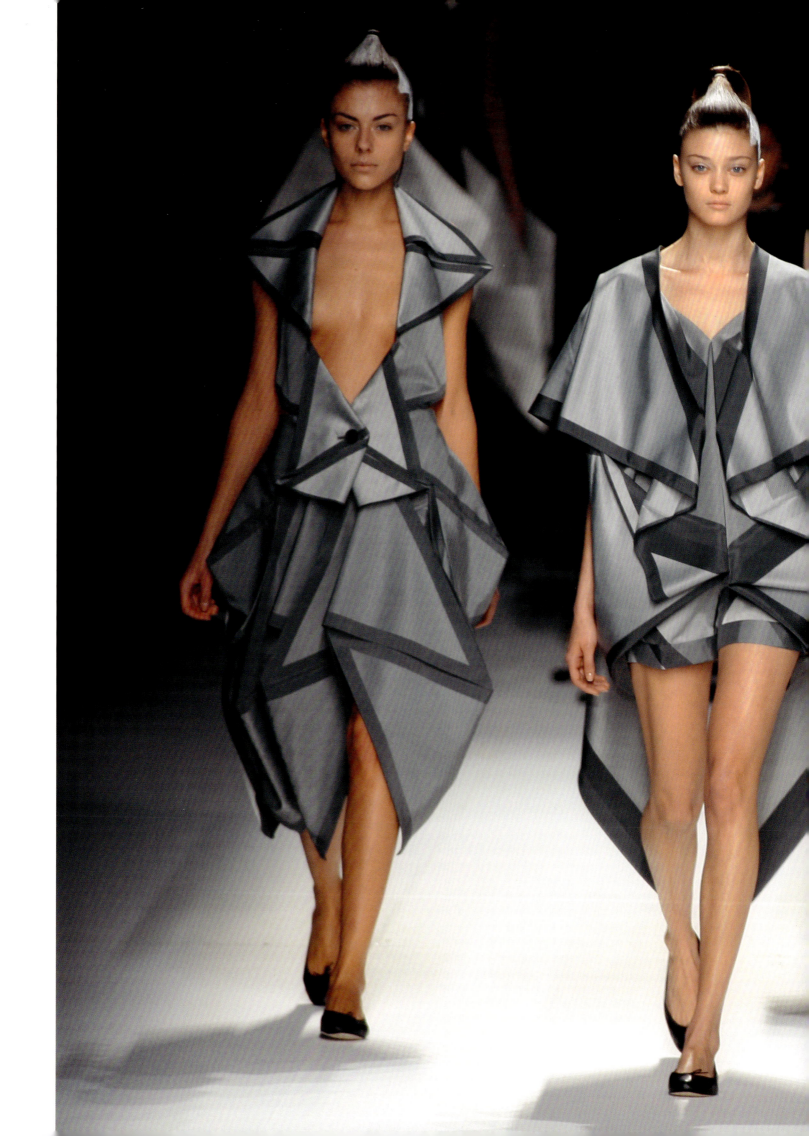

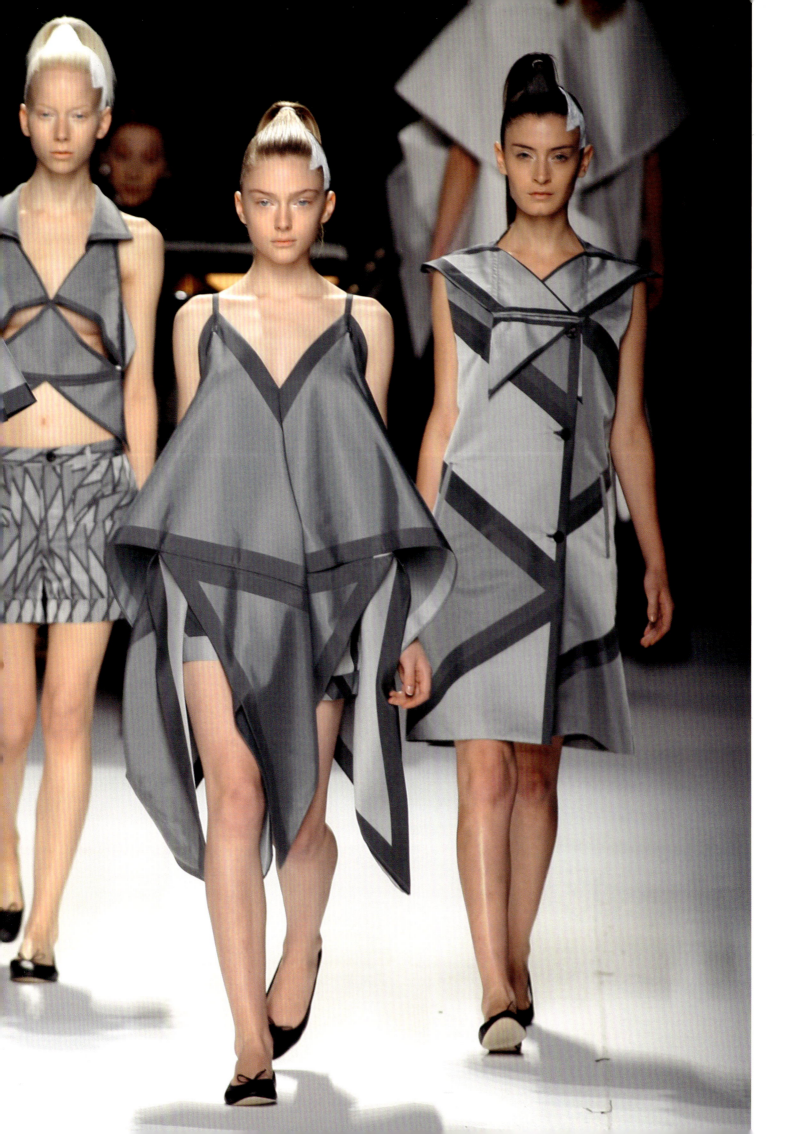

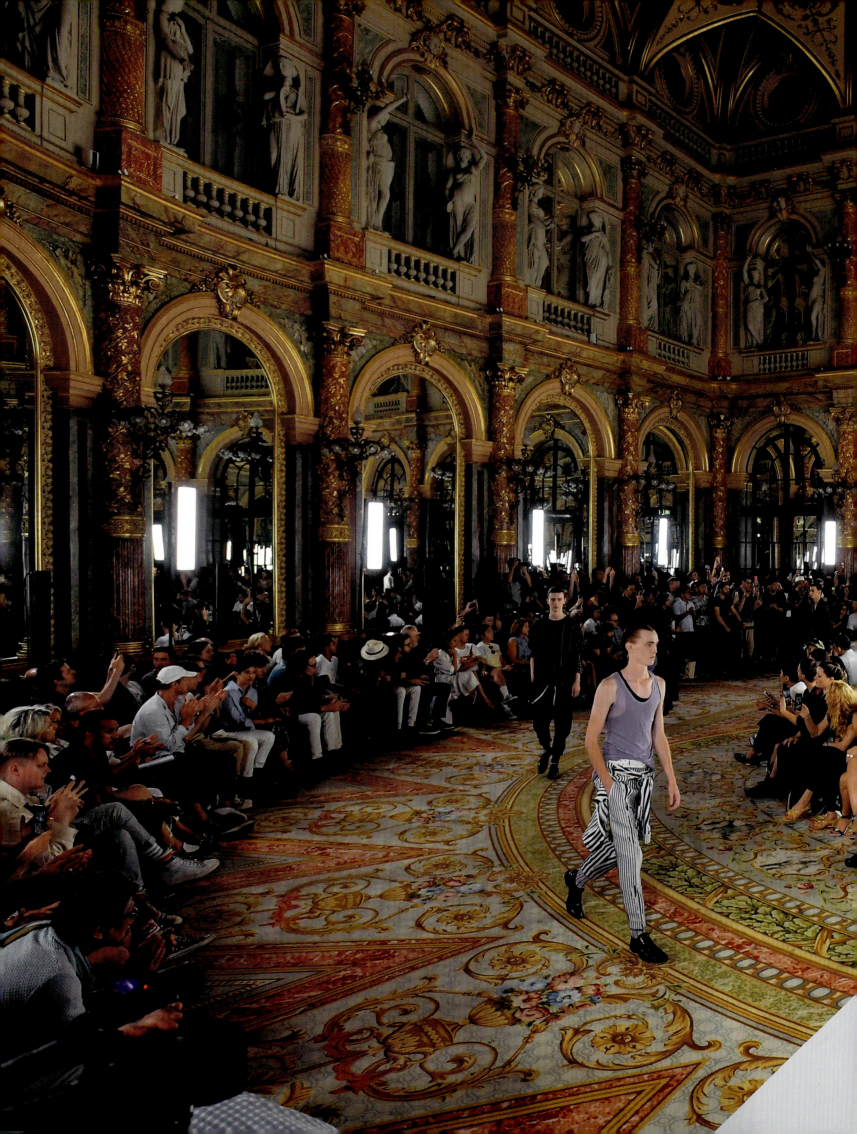

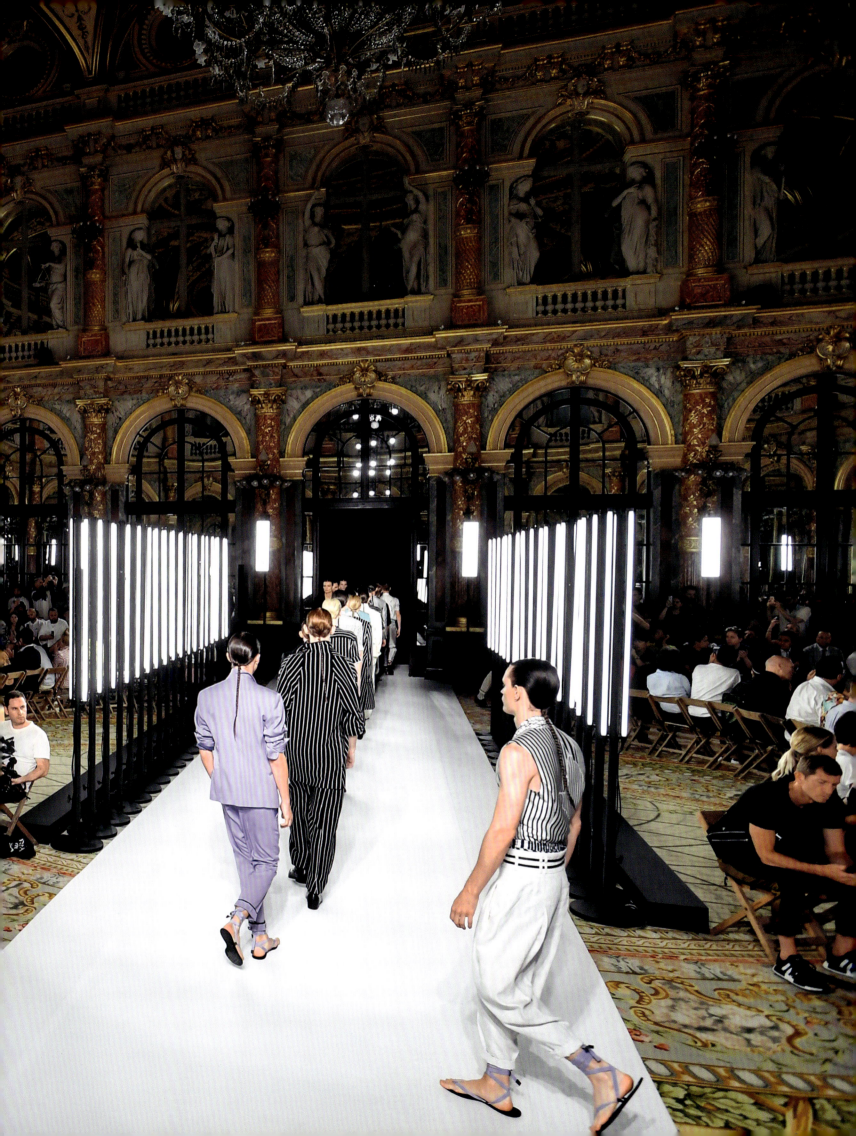

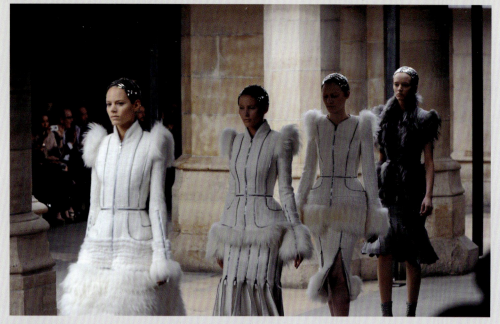
Models walking at the Alexander McQueen ready-to-wear show, La Conciergerie, March 2011.

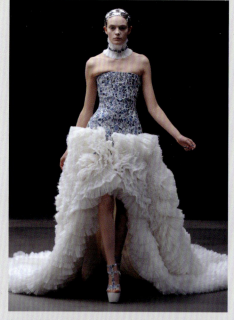
A model at the Alexander McQueen ready-to-wear show, La Conciergerie, March 2011.

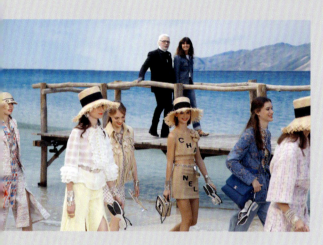
Karl Lagerfeld and models at the runway finale, Chanel ready-to-wear show, Grand Palais, October 2018.

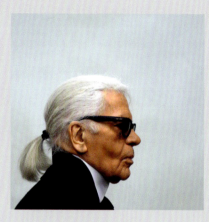
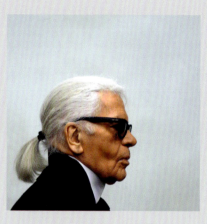
Karl Lagerfeld, 2014.

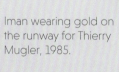
The Louis Vuitton ready-to-wear show, Pyramide du Louvre, October 2018.

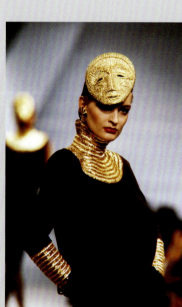
Iman wearing gold on the runway for Thierry Mugler, 1985.

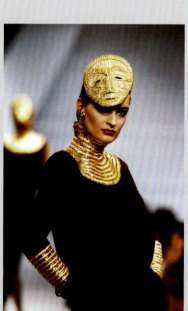
A ready-to-wear Jean Paul Gaultier collection, 1985.

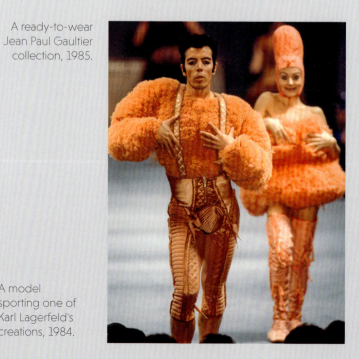
A model sporting one of Karl Lagerfeld's creations, 1984.

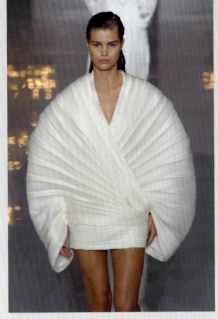

A model walking at the Balmain Spring/Summer 2019 show, September 2018.

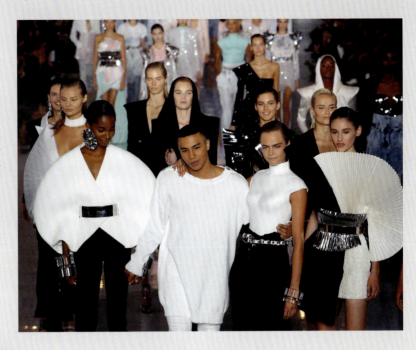

Olivier Rousteing and Cara Delevingne surrounded by models at the finale of the Balmain Spring/Summer 2019 show, September 2018.

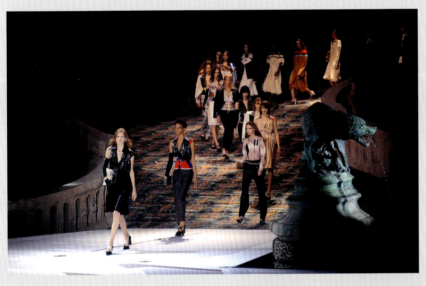

Runway finale of the Louis Vuitton Autumn/Winter 2018–2019 show, March 2018.

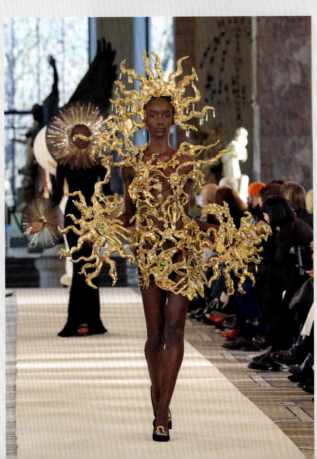

Model Maty Fall walks the runway at the Schiaparelli haute couture Spring/Summer 2022 show by Daniel Roseberry.

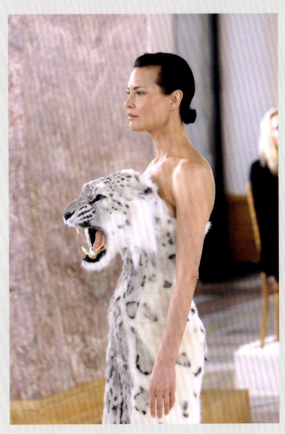

Model Shalom Harlow on the runway at the Schiaparelli haute couture Spring/Summer 2022 show.

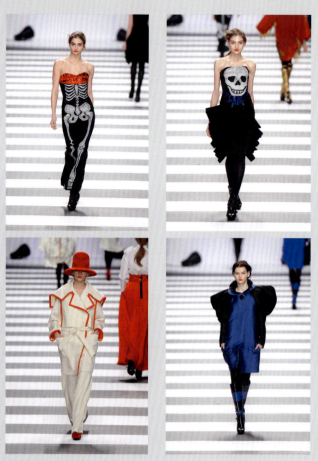

Models walking the runway at Jean-Charles de Castelbajac Autumn/Winter 2011–2012 show, March 2011.

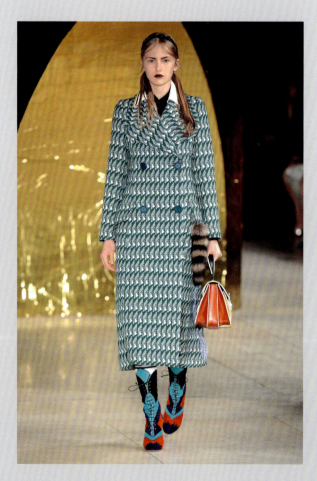
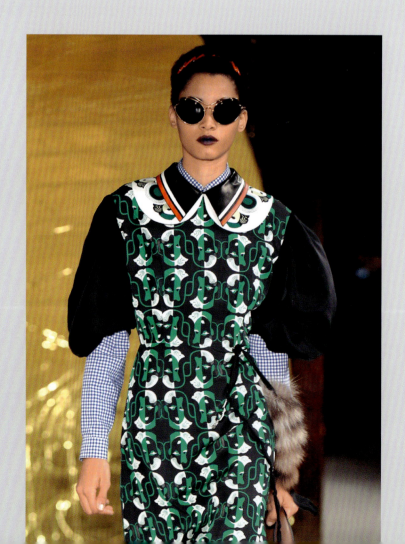

Models at the Miu Miu Spring/Summer 2016 show, October 2015.

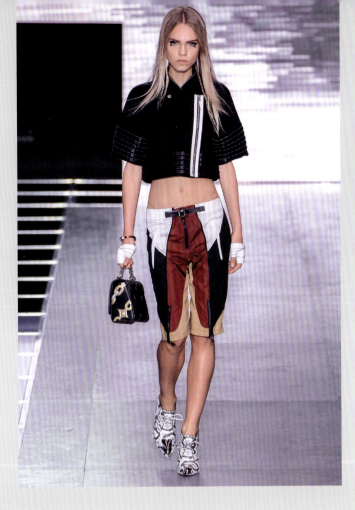
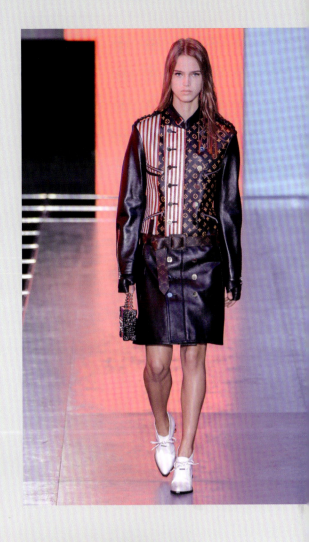

Models at the Louis Vuitton Spring/Summer 2016 show, October 2015.

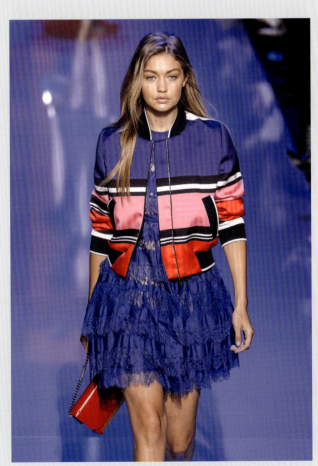

Model Gigi Hadid on the runway at the Elie Saab Spring/Summer 2016 show, October 2015.

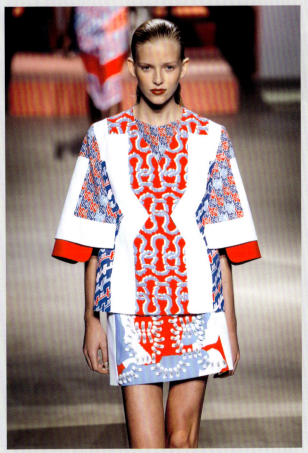

A model at the Kenzo Spring/Summer 2016 show, October 2015.

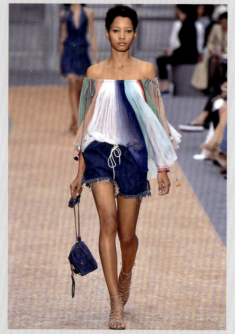

Lineisy Montero on the runway for Chloé in 2015.

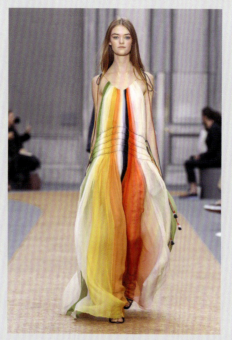
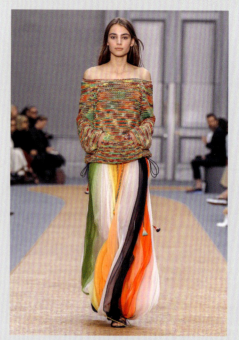

Models at the Chloé Spring/Summer 2016 show, October 2015.

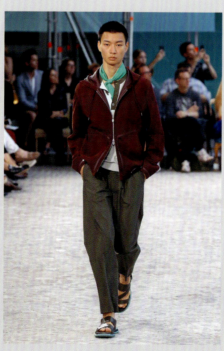

Runway finale of the Isabel Marant Spring/Summer 2016 show, October 2015.

Model on the Hermès runway, 2019.

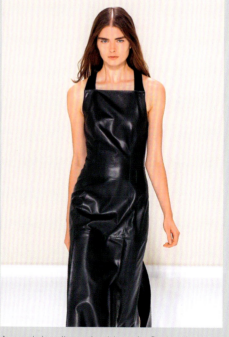

A model walks at the Hermès Spring/Summer 2016 show, October 2015.

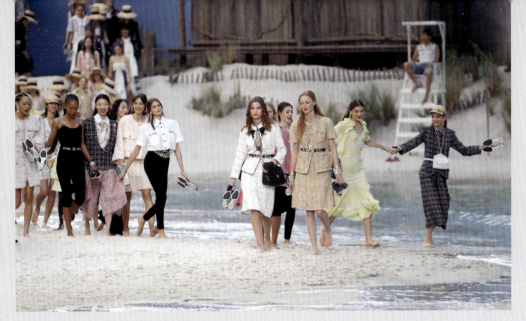

Runway finale of the Chanel Spring/Summer 2019 show by Karl Lagerfeld, Grand Palais, October 2018.

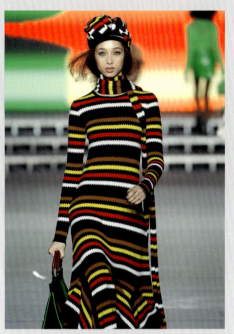

Model at the Sonia Rykiel Autumn/Winter 2018–2019 show, March 2018.

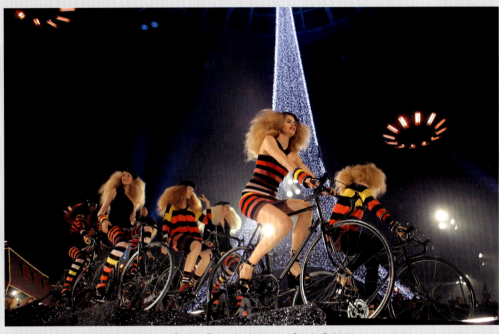

2009 H&M show in Paris, with outfits by French designer Sonia Rykiel.

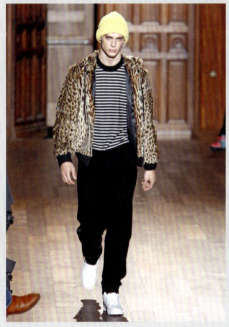

A Rykiel Homme show at École nationale supérieure des Beaux-Arts in 2008.

Finale of the Issey Miyake Autum/Winter 2016–2017 show, March 2016.

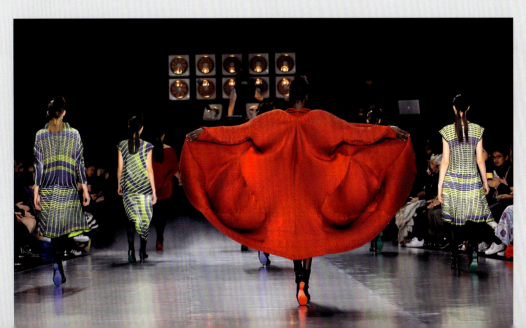

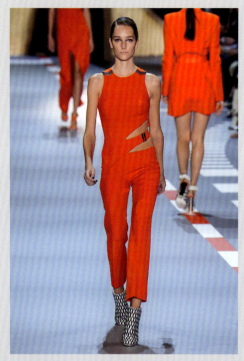 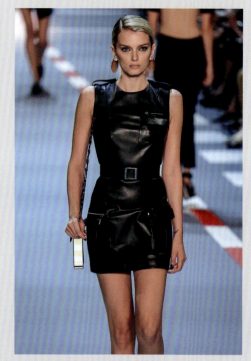 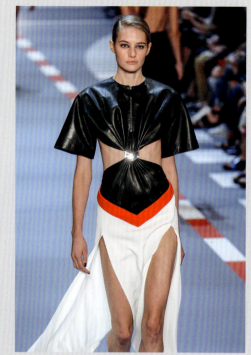

Models at the Mugler Spring/Summer 2016 show, October 2015.

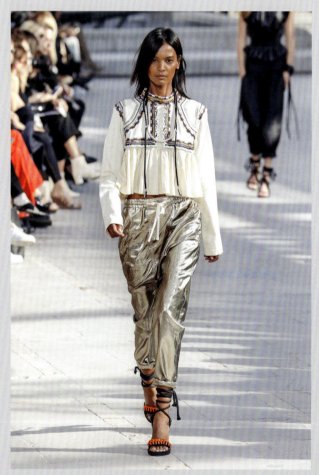 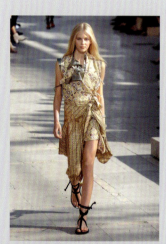 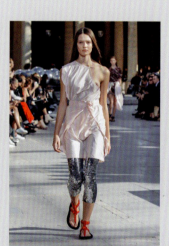 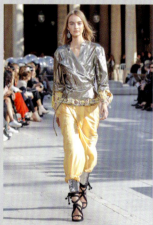 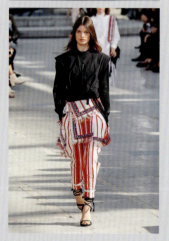

Open-air runway at Isabel Marant Spring/Summer 2016 show, October 2015.

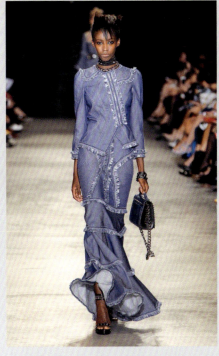

A model at the Andrew GN Spring/Summer 2017 show.

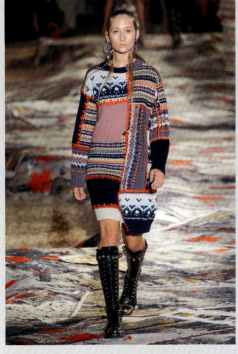

A model at the Alexander McQueen Spring/Summer 2017 show by Sarah Burton, October 2016.

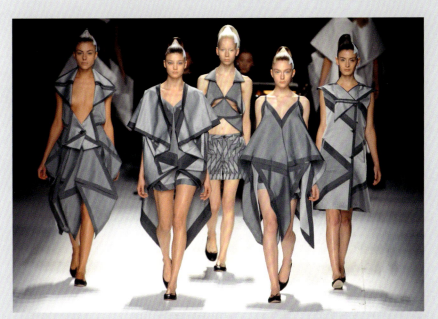

Finale of the Issey Miyake fashion show, March 2011.

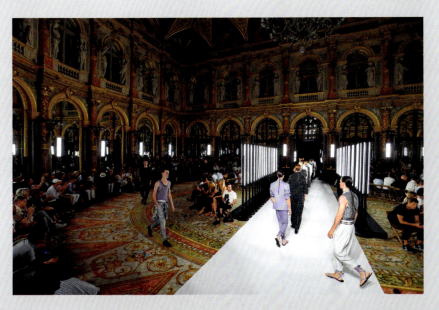

Finale of a Haider Ackermann Menswear show, 2017.

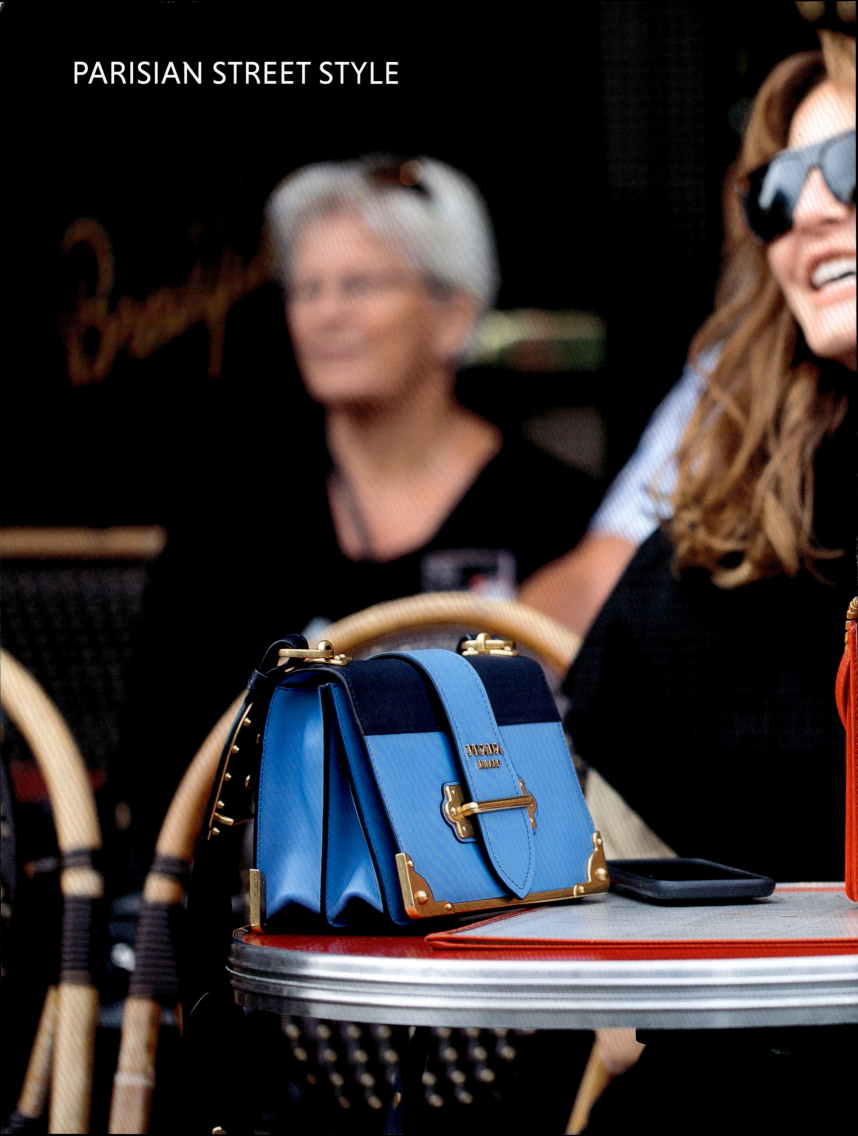
PARISIAN STREET STYLE

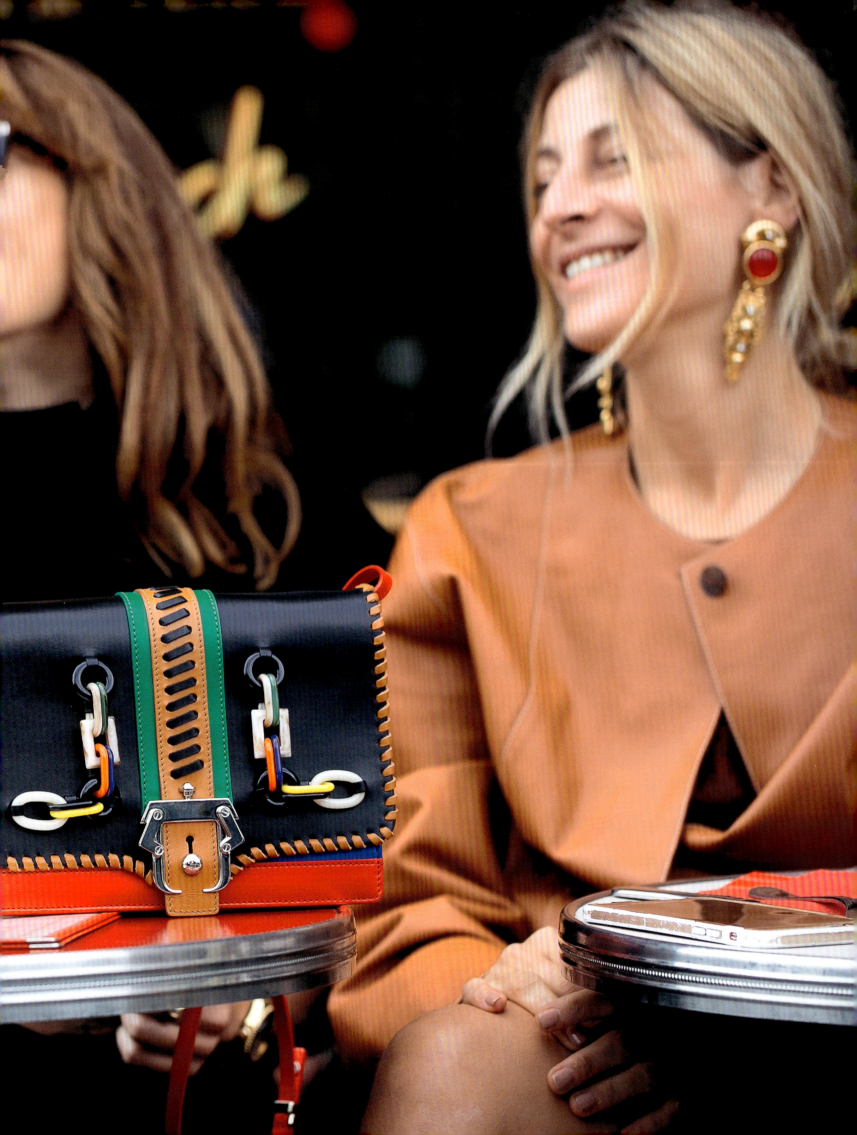

Now that fashion designers have started developing capsule collections for high-street clothing brands, it's fair to ask whether ready-to-wear is still an accessible version of haute couture, or simply an everyday consumer good. This is not necessarily as objectionable to elitist advocates of high fashion as one might imagine. Optimists among them may see it as an opportunity to promote high fashion among the general public and to share their love for elegant and well-designed clothing with as many people as possible.

One thing is certain: to be fully accepted, ready-to-wear fashion has to pass two major tests. First, on the catwalks, where the originality and creative vitality of collections is scrutinised by experts and the media, and second, on the streets, which ultimately dictate the popularity of designs. Like the gladiatorial games in Rome, it's the public – and social networks – that give the thumbs-up or thumbs-down. Street style is therefore an essential exercise in trendsetting and fad-building, because that's where fashion meets its public and where the public makes (or doesn't make) a style its own.

Street style also contributes to defining the city's look and to creating a unique atmosphere that can be easily identified with Paris: effortlessly chic, romantic and elegant, sophisticated without excess. With its emblematic monuments, parks, lively streets, and sumptuous bridges over the Seine and canals, France's capital offers a wonderful backdrop for street fashion, an invitation to dress with taste and flair. However, strange as it may sound, most Parisians would likely be unable to describe their style, and this relaxed attitude is precisely the key to the concept of Parisian elegance: the right blend of refined and careless, considered and natural, a good sense of proportion and perhaps a touch of whimsy, because why not?

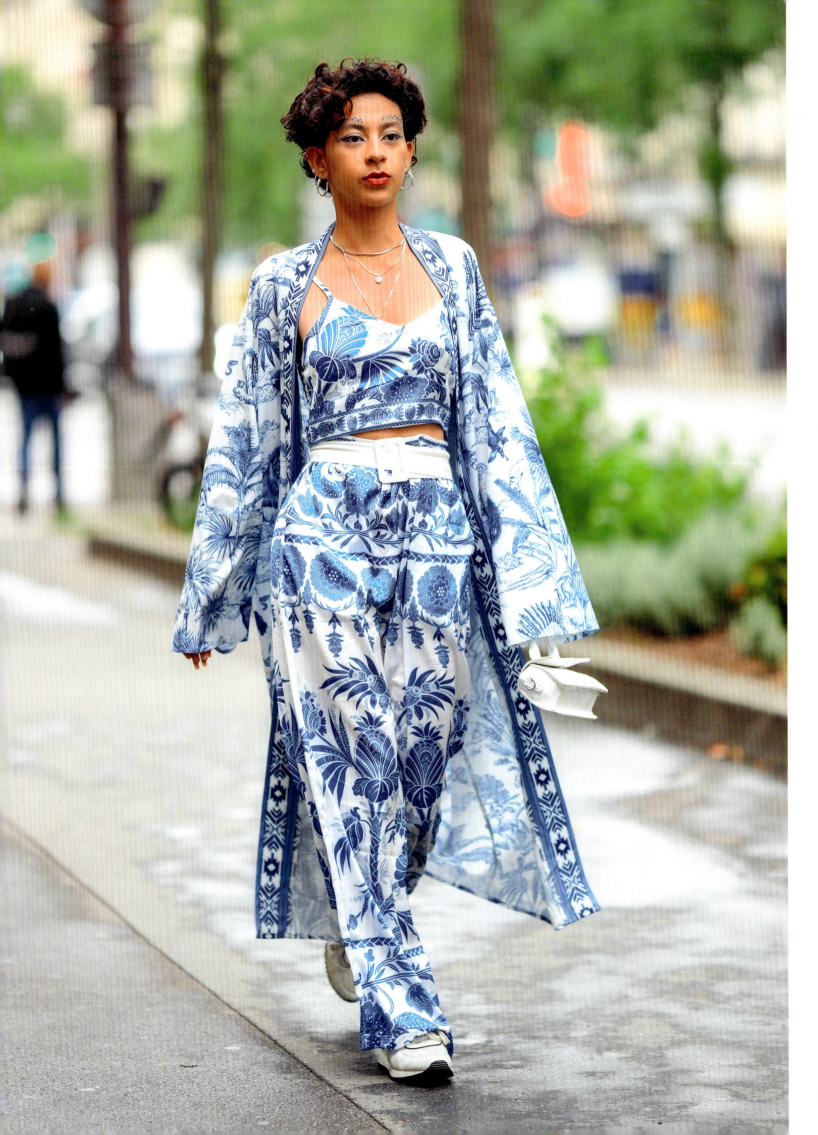

Multiculturalism is, of course, another beautiful aspect of the big-city lifestyle, with foreign and ethnic-minority populations growing in most urban centres. On the streets of Paris, many people with African, Arabic and Far-Eastern backgrounds can be seen working their own adaptations of the typical Parisian style codes. Ethnic motifs are paired with designer shoes and carried with the classic Parisian air of having been carefully thrown together. Traditional garments (saris and hijabs, for example) are chosen to complement the colourways of tailored jackets and arranged around glinting sunglasses. In turn, the rise of diversity as a fact of life and a point of political debate has come to influence the work of top-end designers. During the mid-2010s, more and more critics began scrutinising the cultural and ethnic representation at major fashion shows. And while that conversation is ongoing, it's fair to say that the Parisian houses have made a conscious effort to paint with a more inclusive palette, both in their designs and how they present them, increasingly expressing the reality of the city around them.

As Inès de la Fressange's cult book *Parisian Chic* demonstrated, being a Parisian is more than a matter of choosing clothes and accessories, it's a real way of life with its rituals, such as (slowly) drinking a coffee with steamed milk (*café au lait*) on the sun-soaked terrace of a café; shopping with friends; instinctually choosing just the right restaurant for a party or the right look for the weekend, knowing weeks in advance what you're going to buy on sale and being the first in the store on the big day; chatting with your baker before leaving their *boulangerie* (even if the queue of customers behind you is growing); or knowing where to get the best artisan chocolates in the city.

In terms of colours, black and navy blue predominate, but they are often paired with white. Grey, in all its shades, is third on the podium, but is often combined with brighter hues. In the first chilly days of Autumn, camel coats are in full bloom, adding subtle shades of beige similar to that of the stone used in most Parisian buildings, from Notre Dame to Haussmann-style apartment buildings. This ashlar, extracted from the limestone quarries of Saint Maximin, north of the capital, has been the signature material of Parisian architecture since antiquity. The choice of a beige coat appears as a gentle hint of identification with the city.

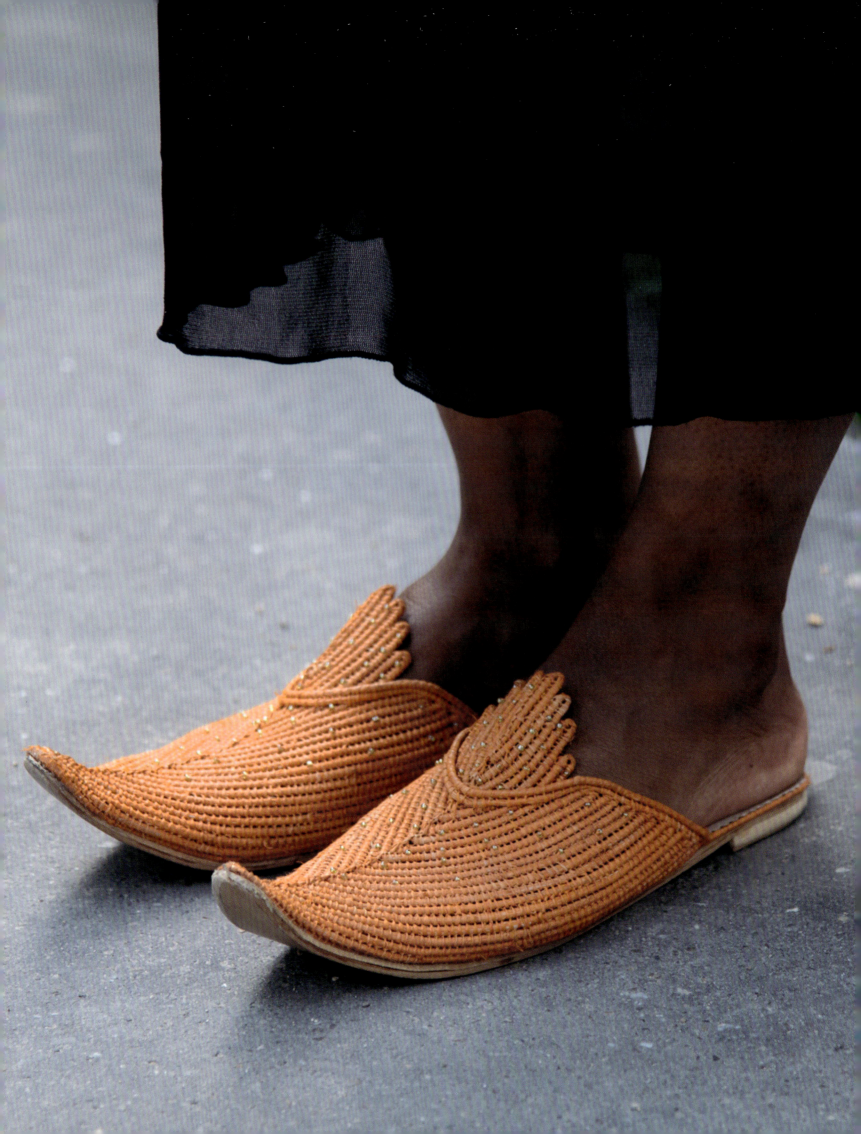

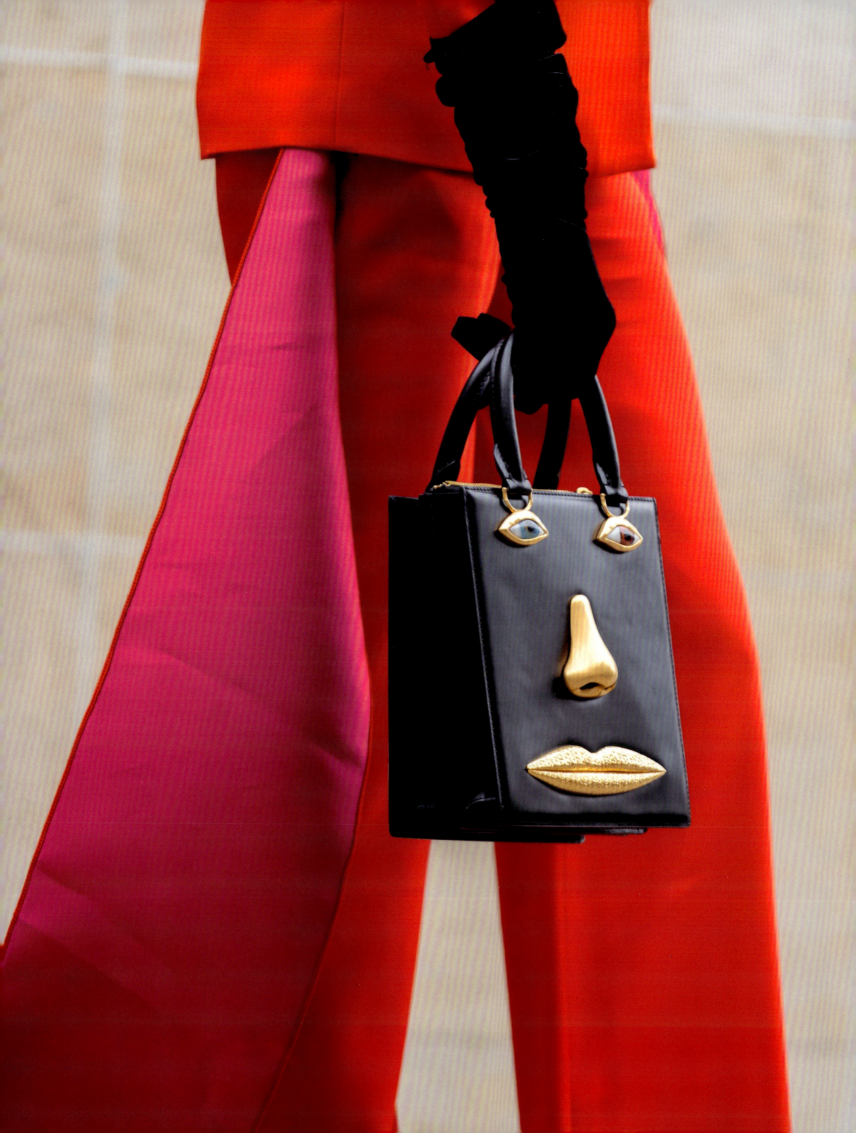

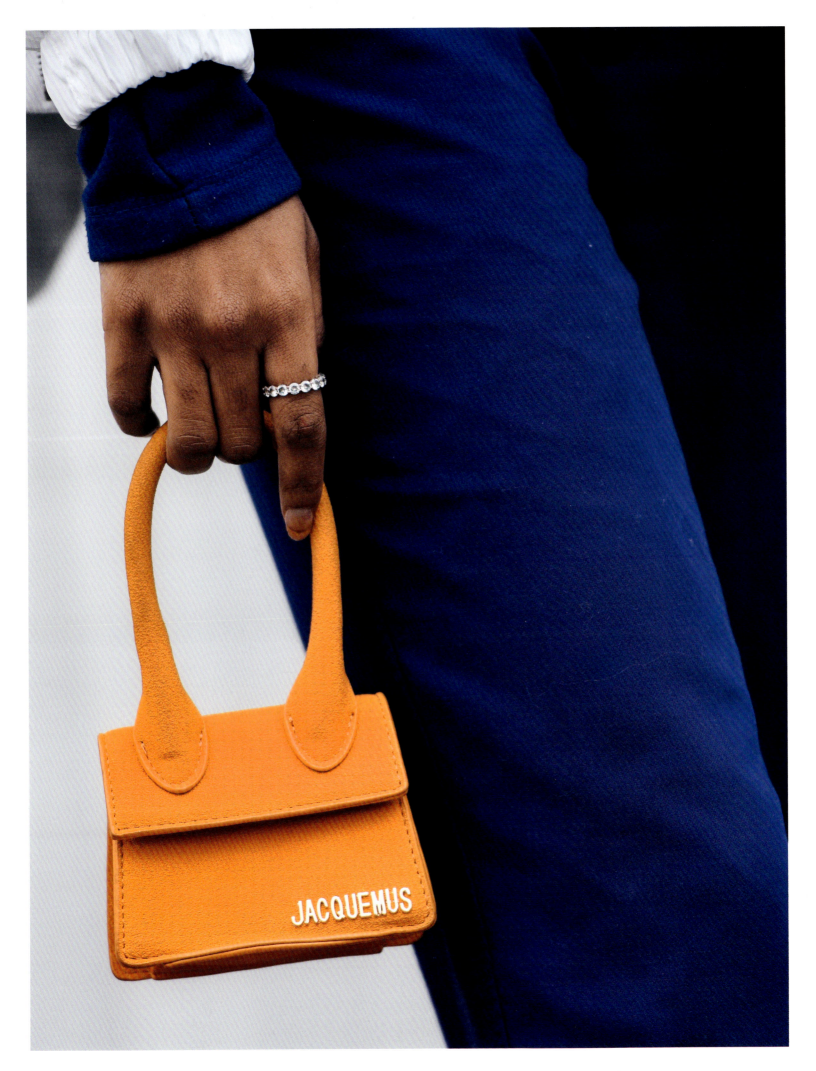

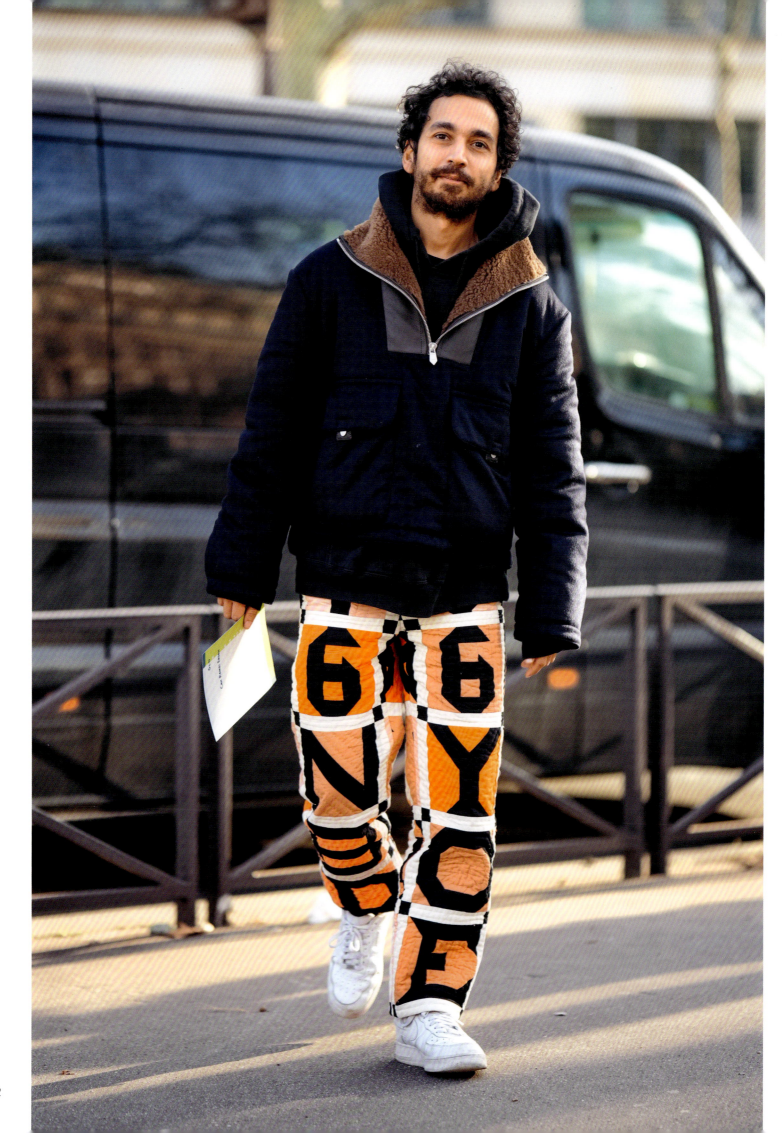

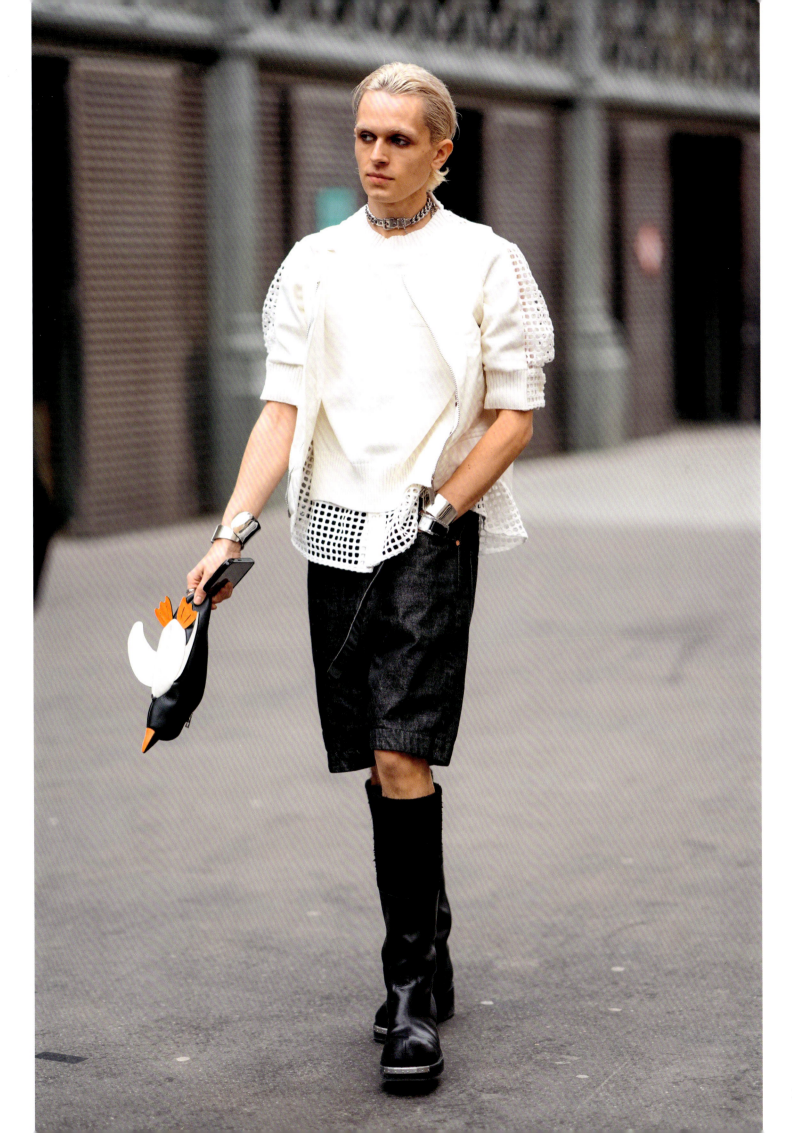

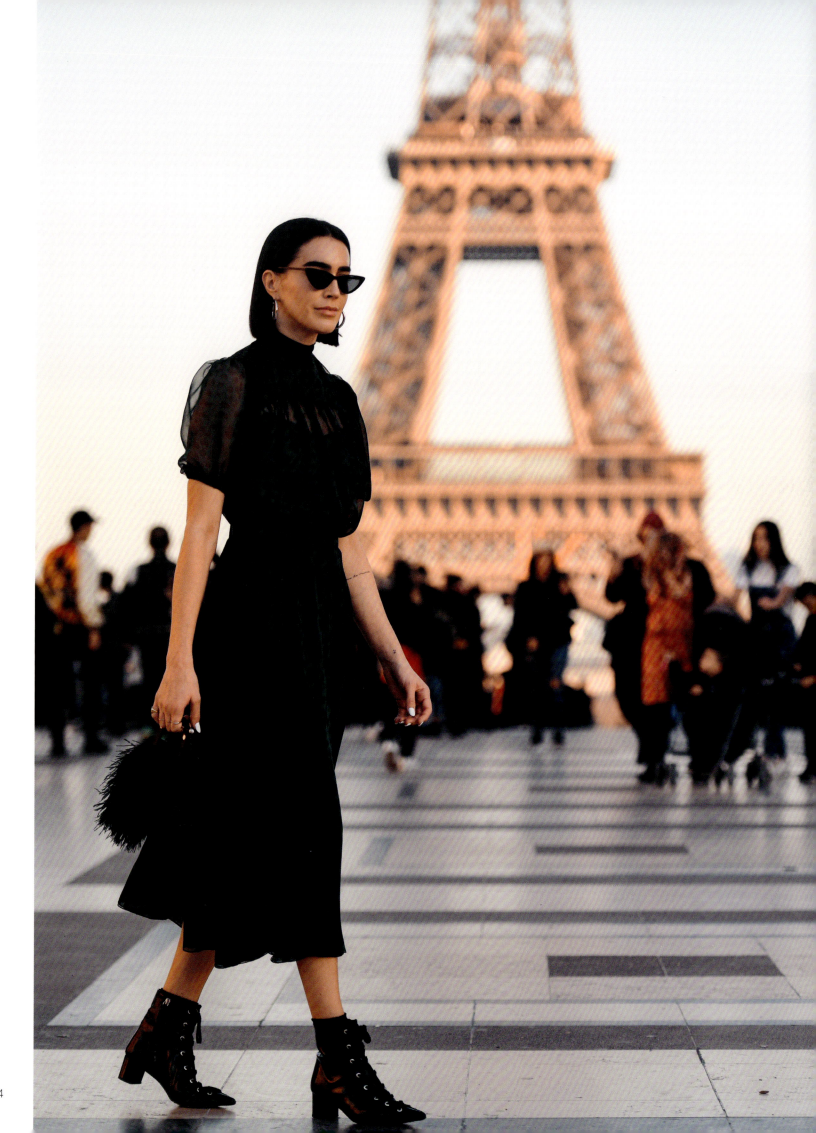

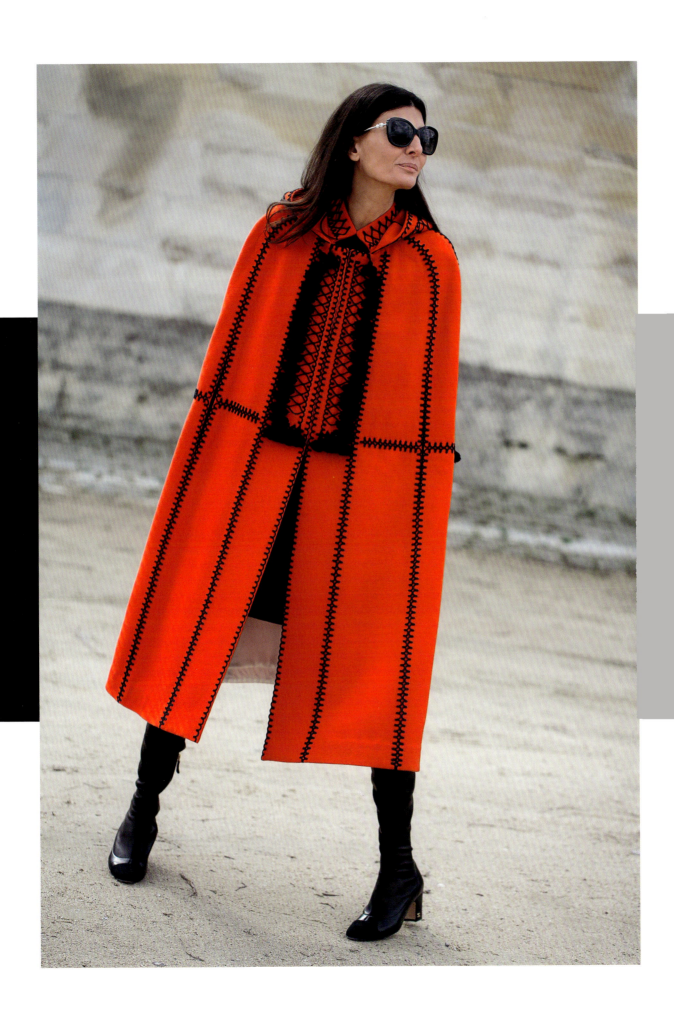

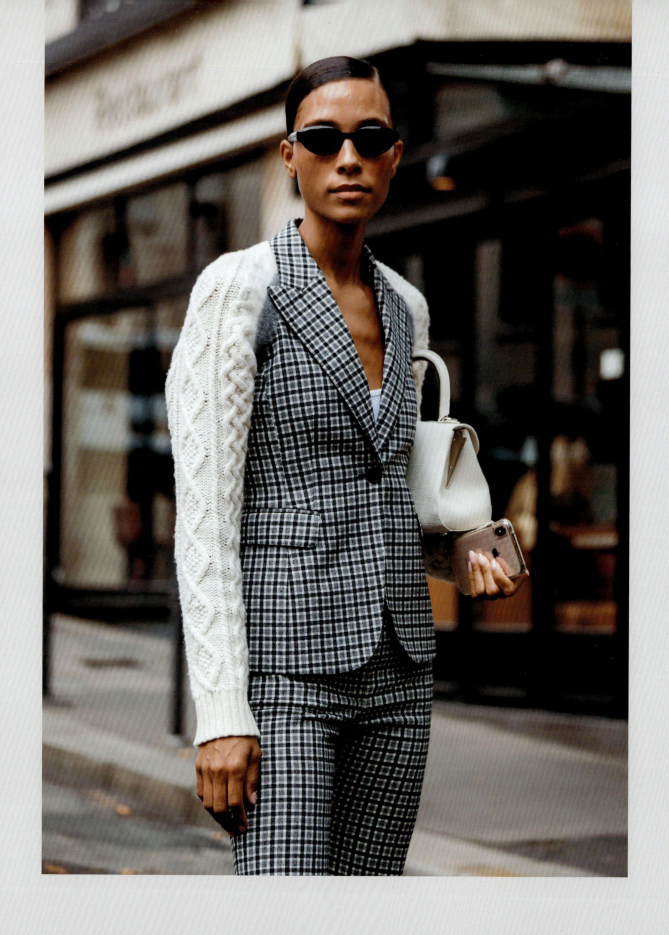

"The Parisian way to be chic is to look super sharp for everyday things and then do effortless casual for night occasions."

JEANNE DAMAS

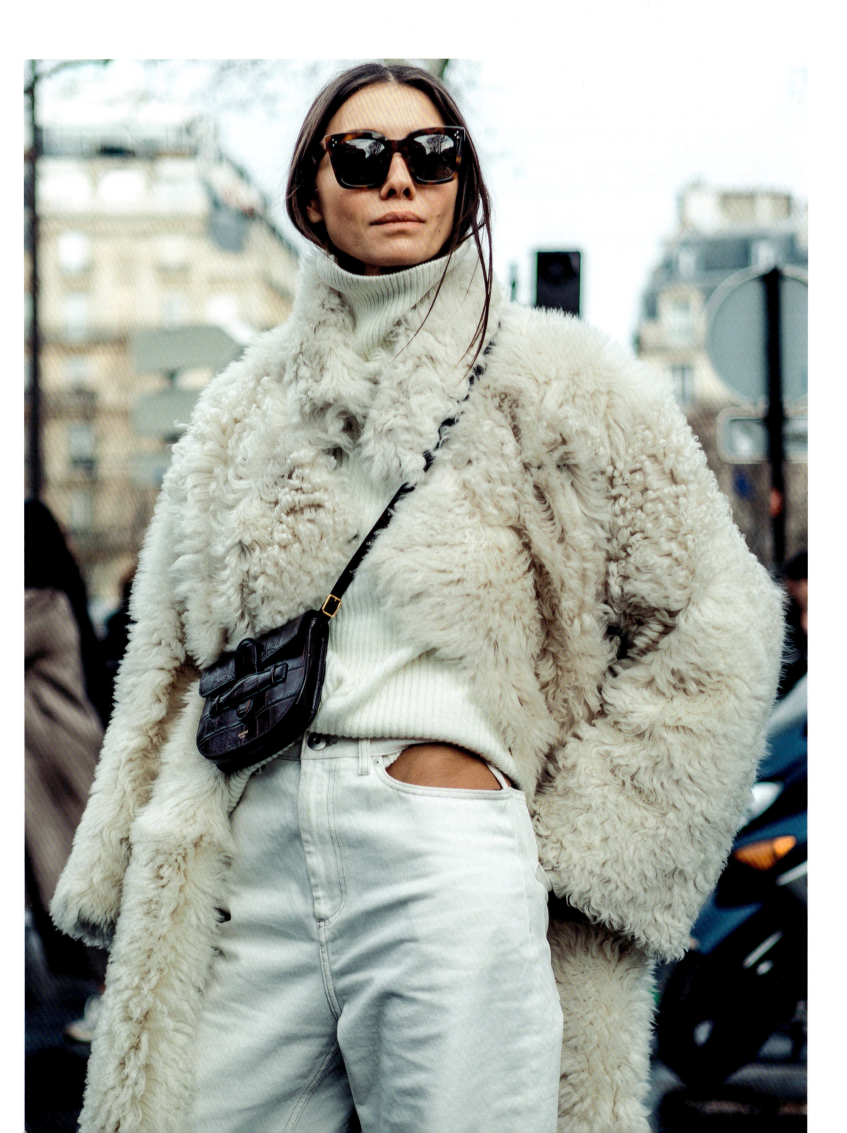

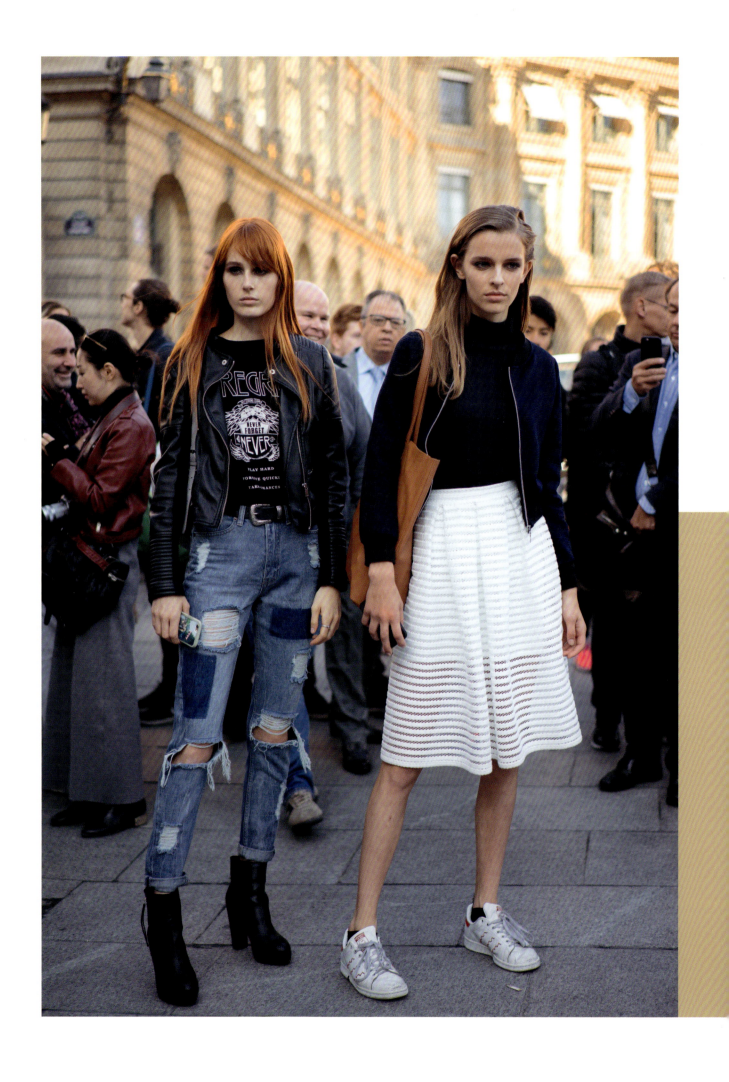

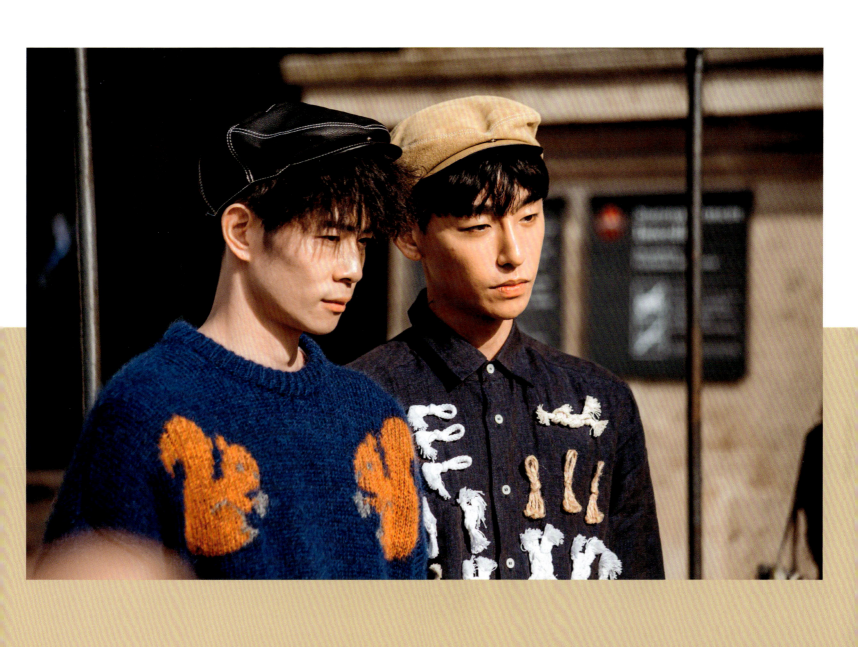

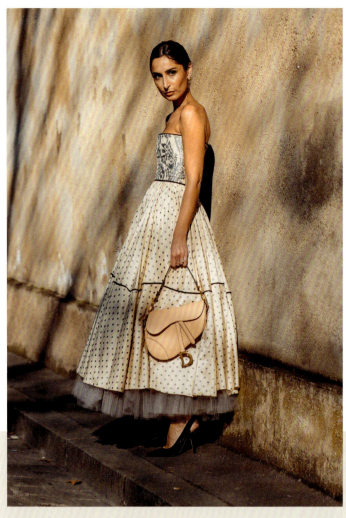
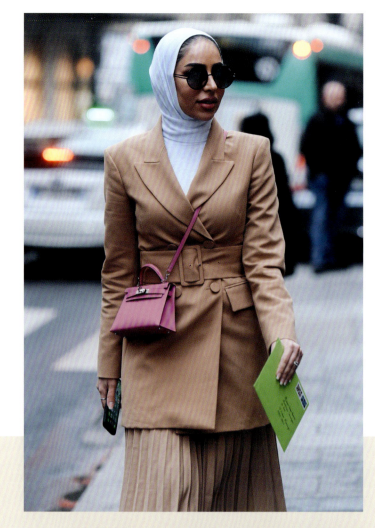
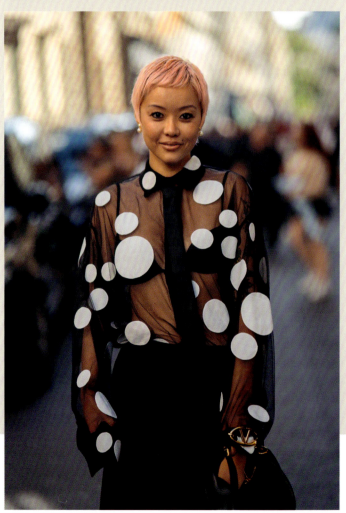
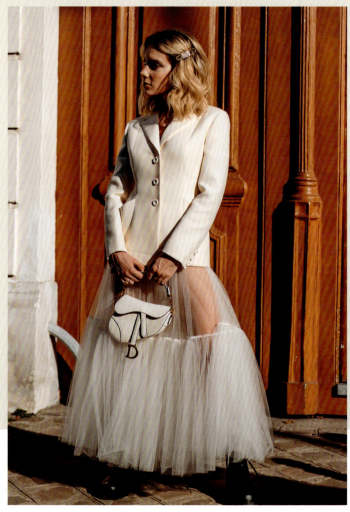

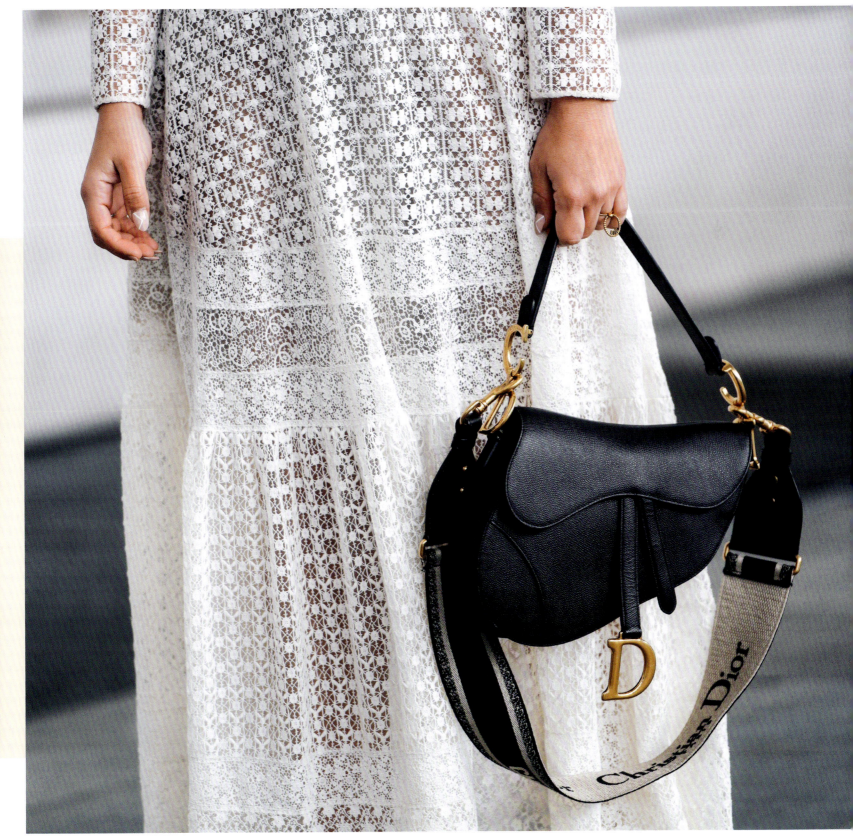

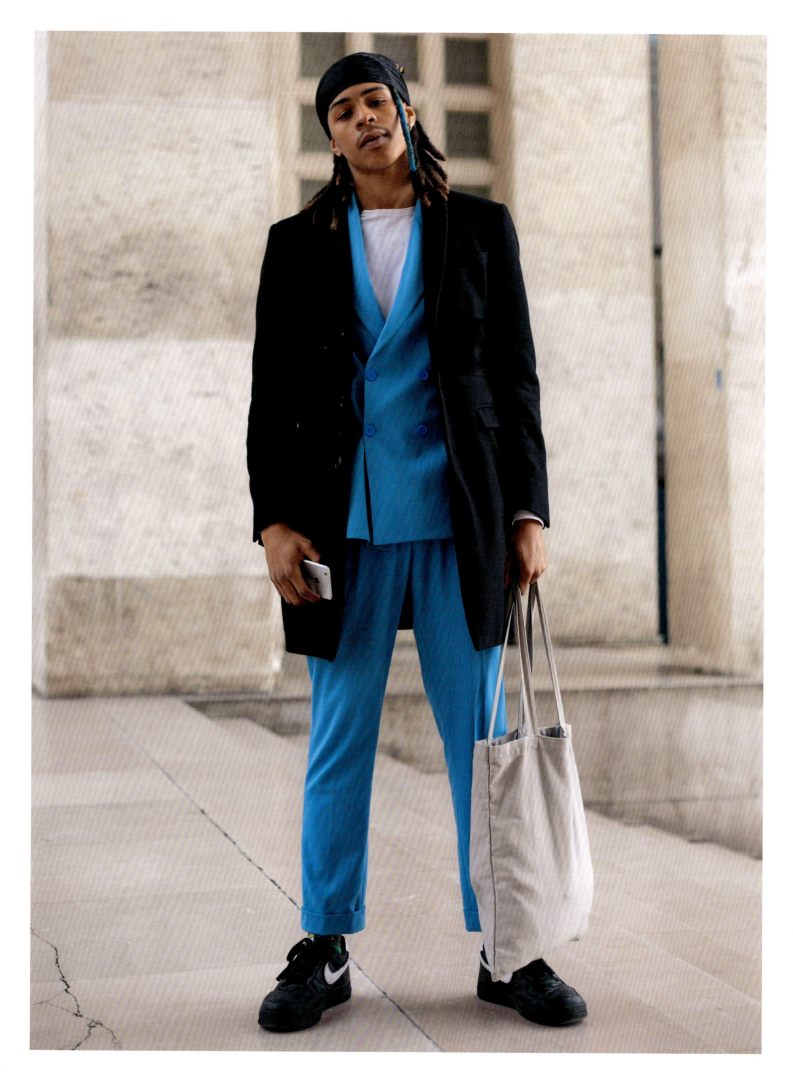

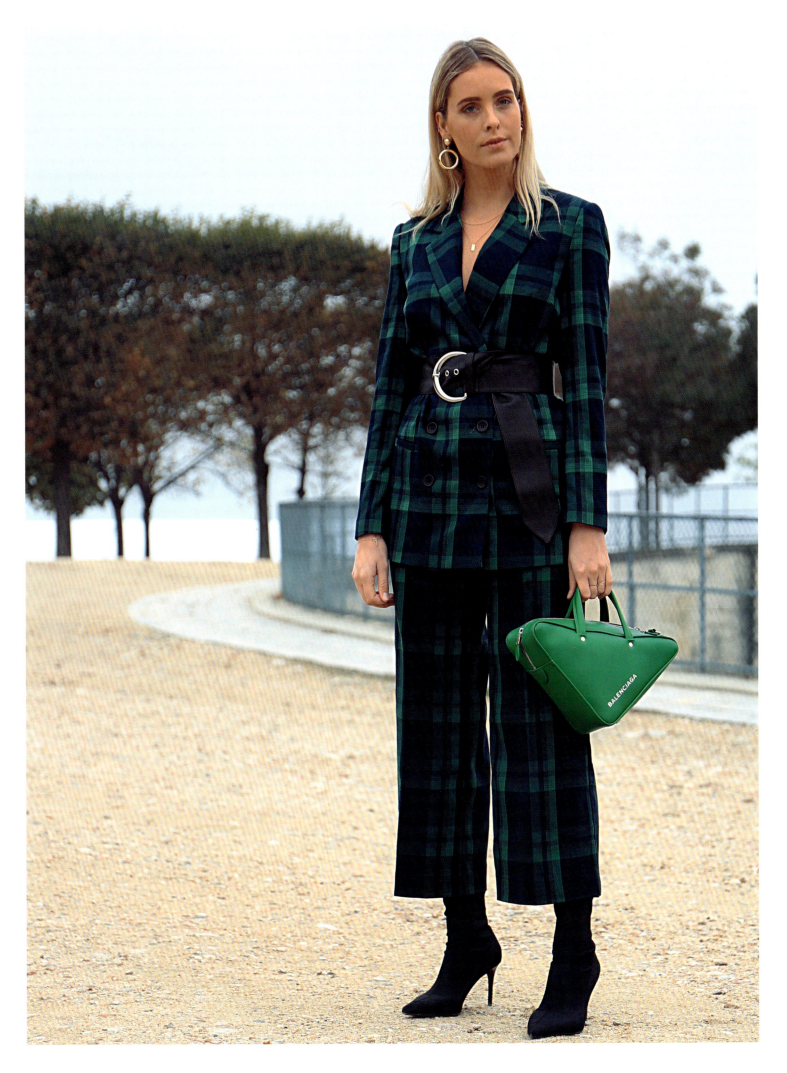

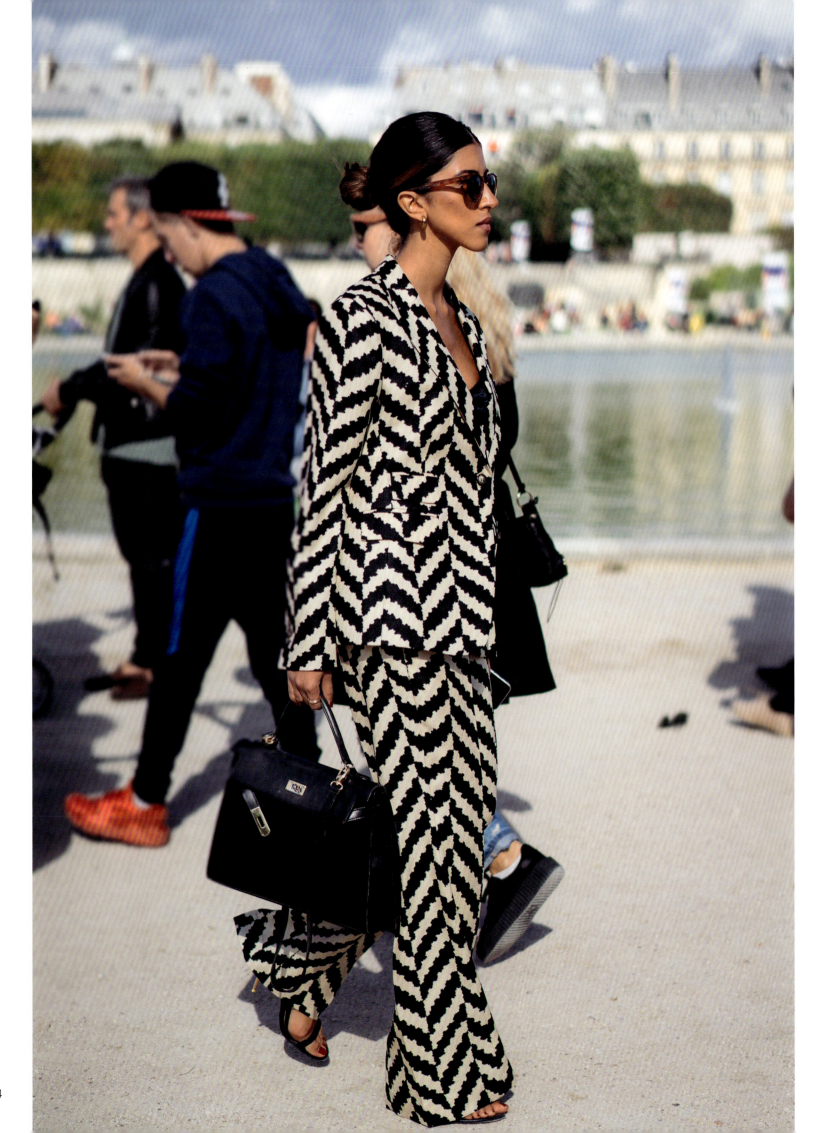

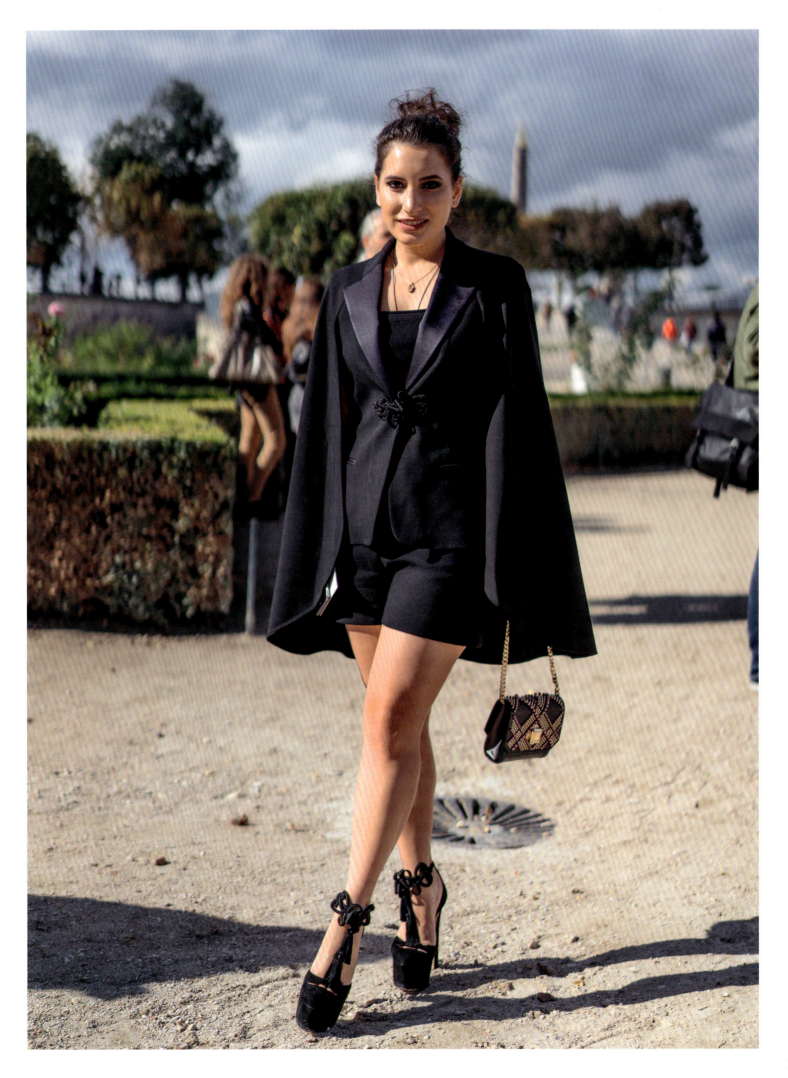

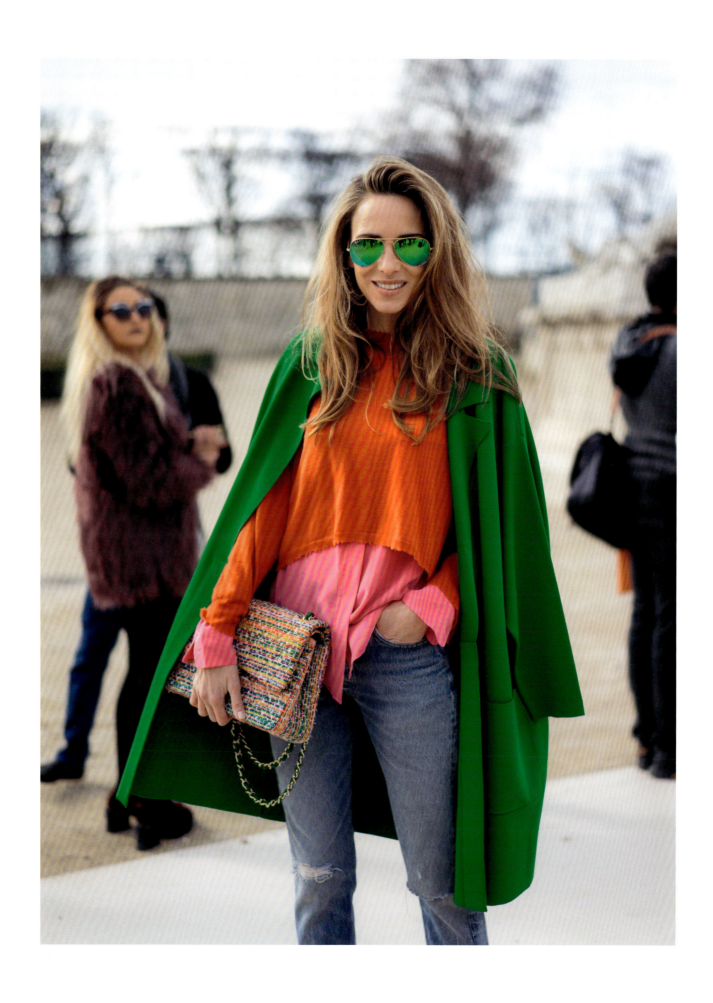

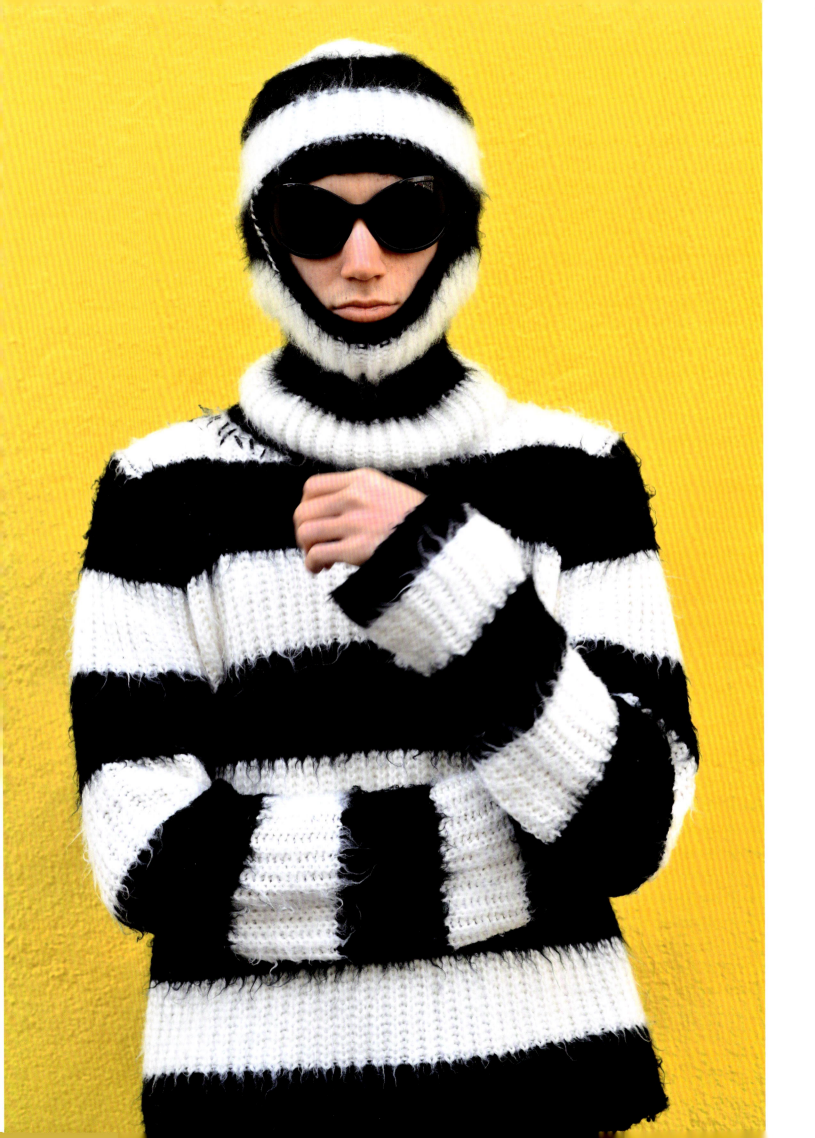

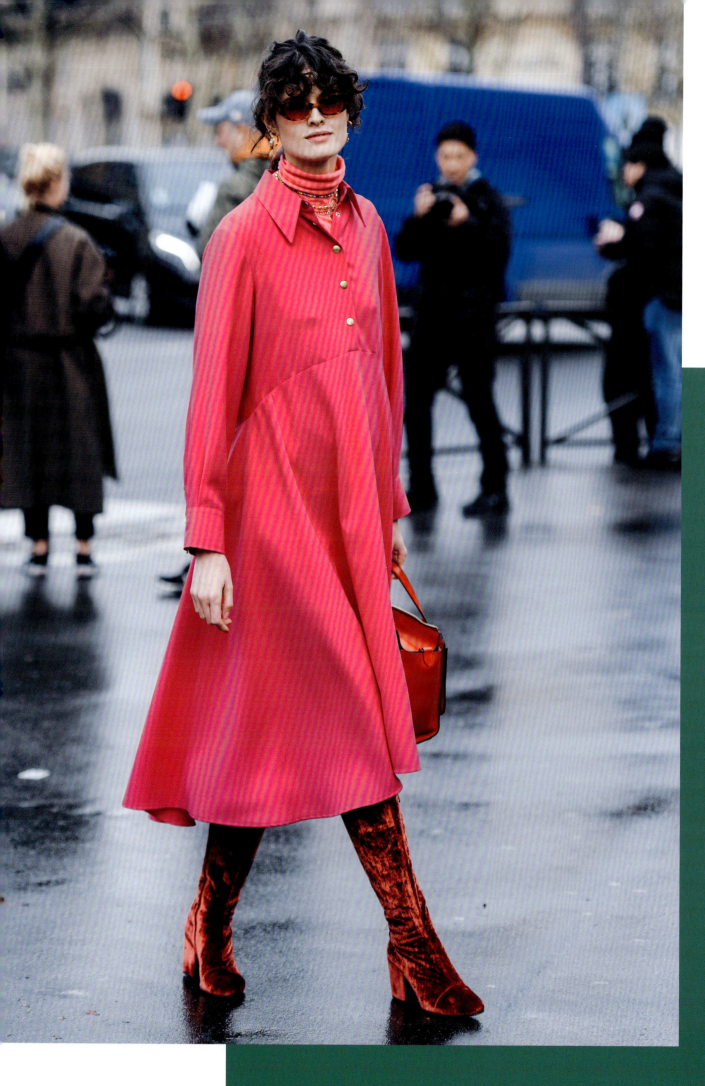

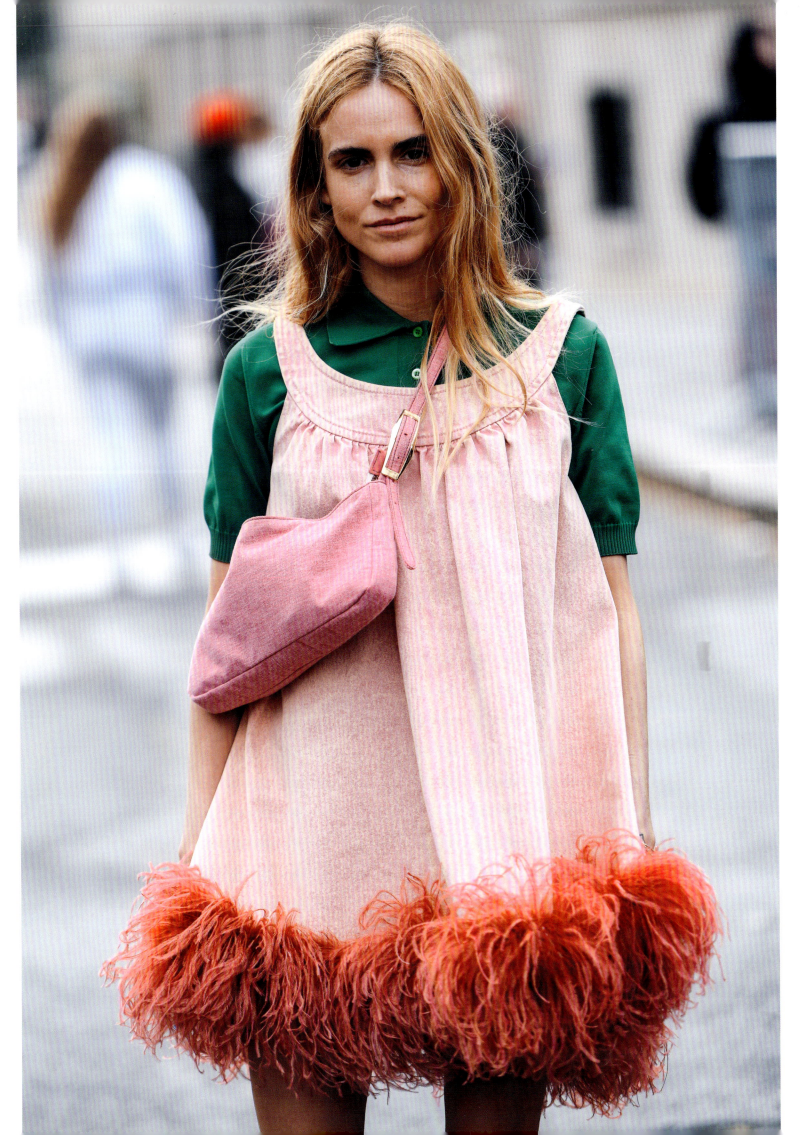

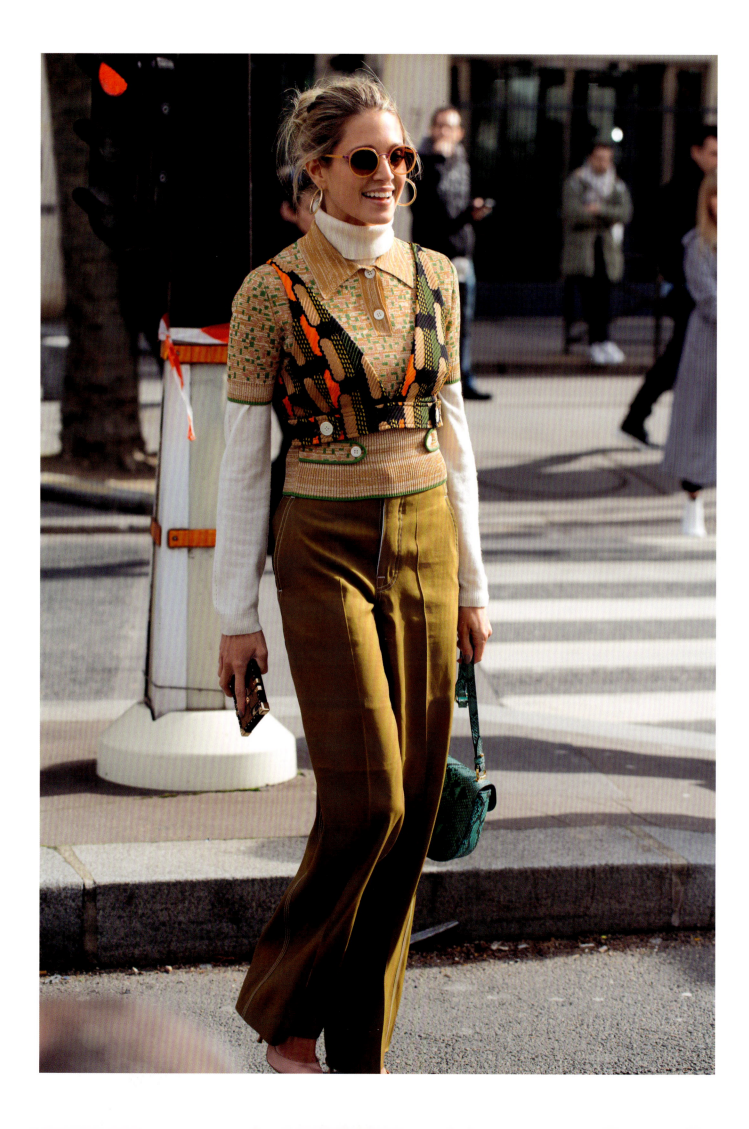

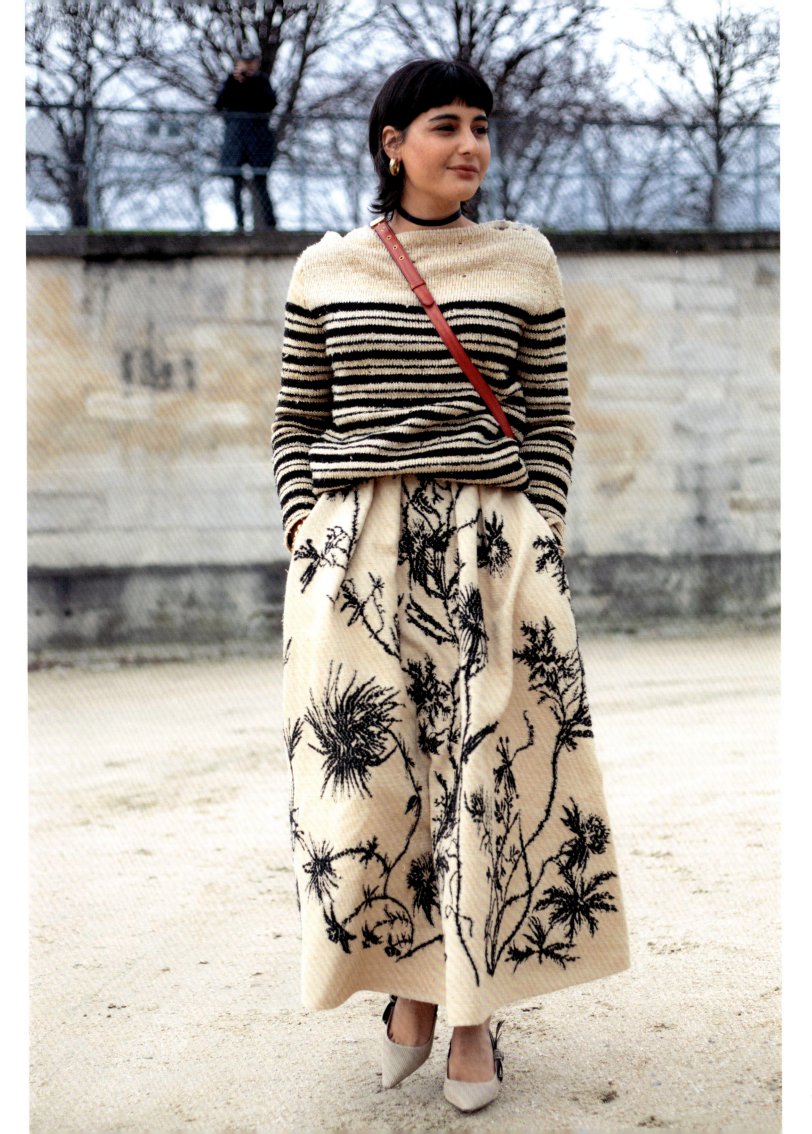

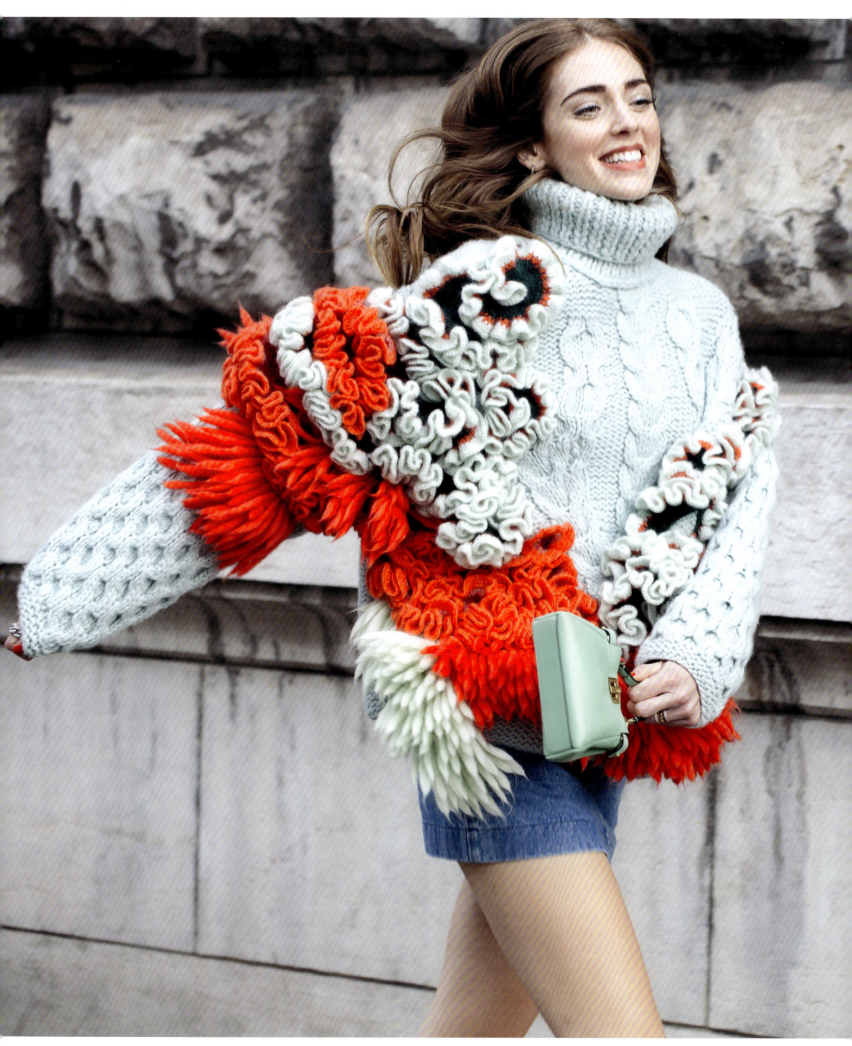

"The history of Paris fashion blurs inextricably into myth and legend."

VALERIE STEELE

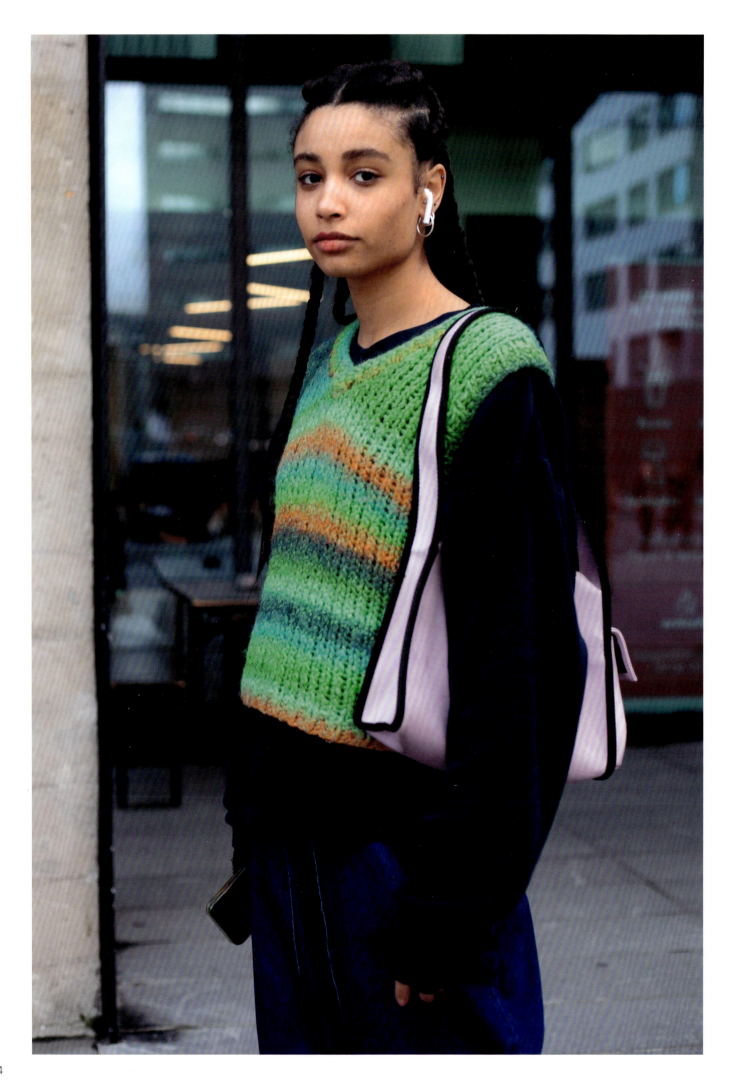

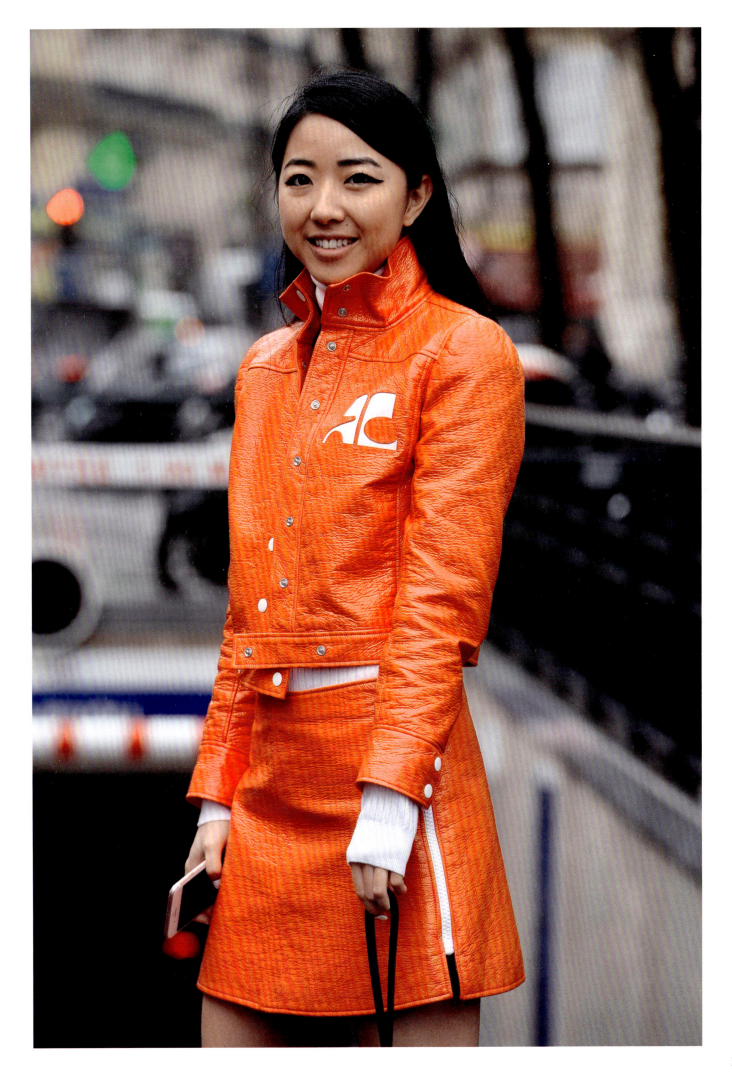

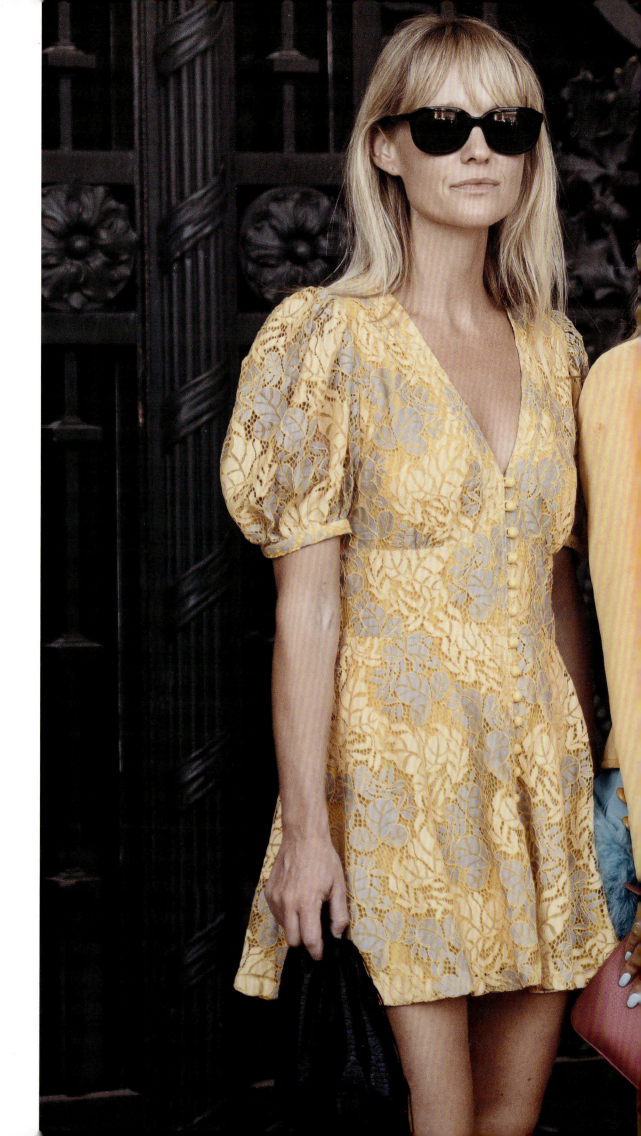

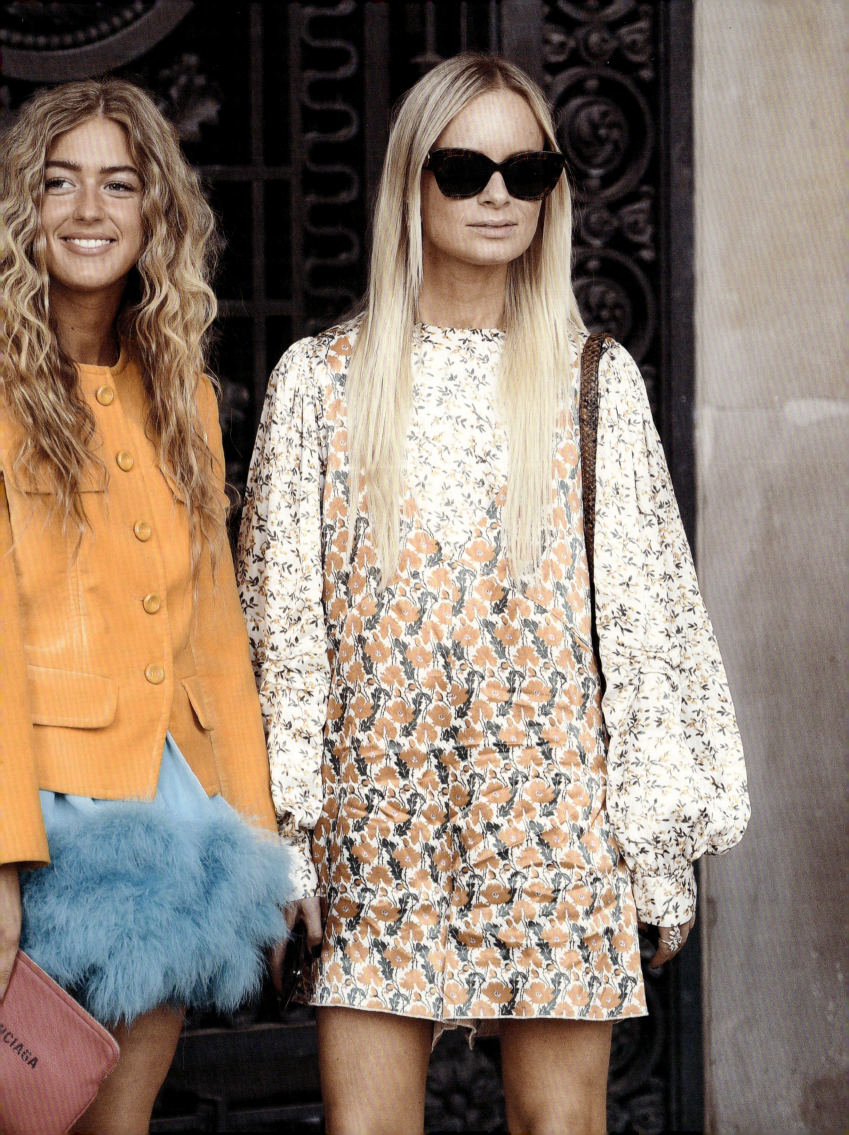

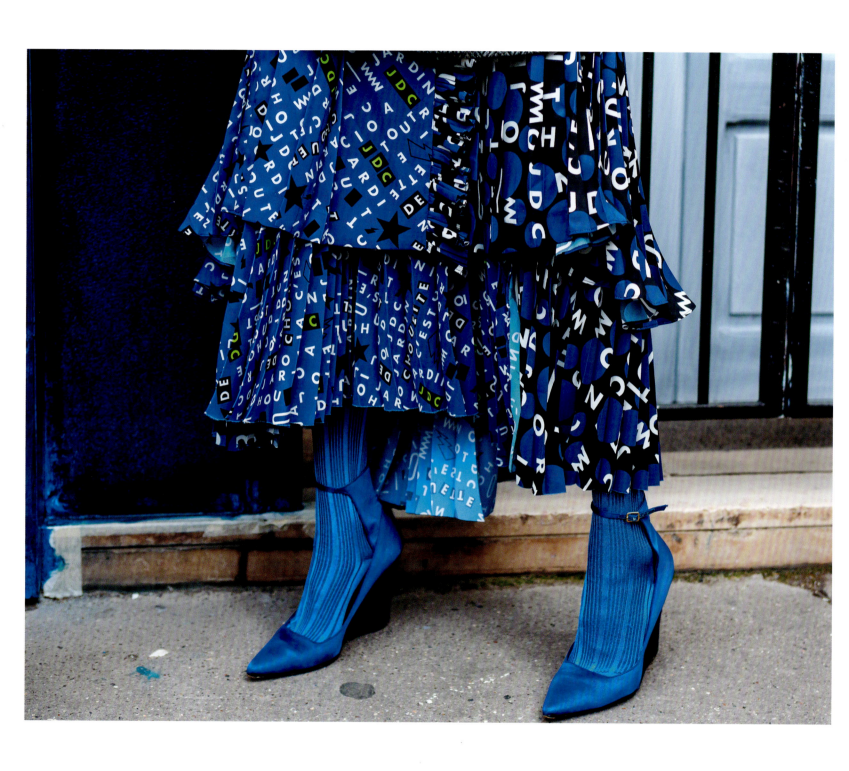

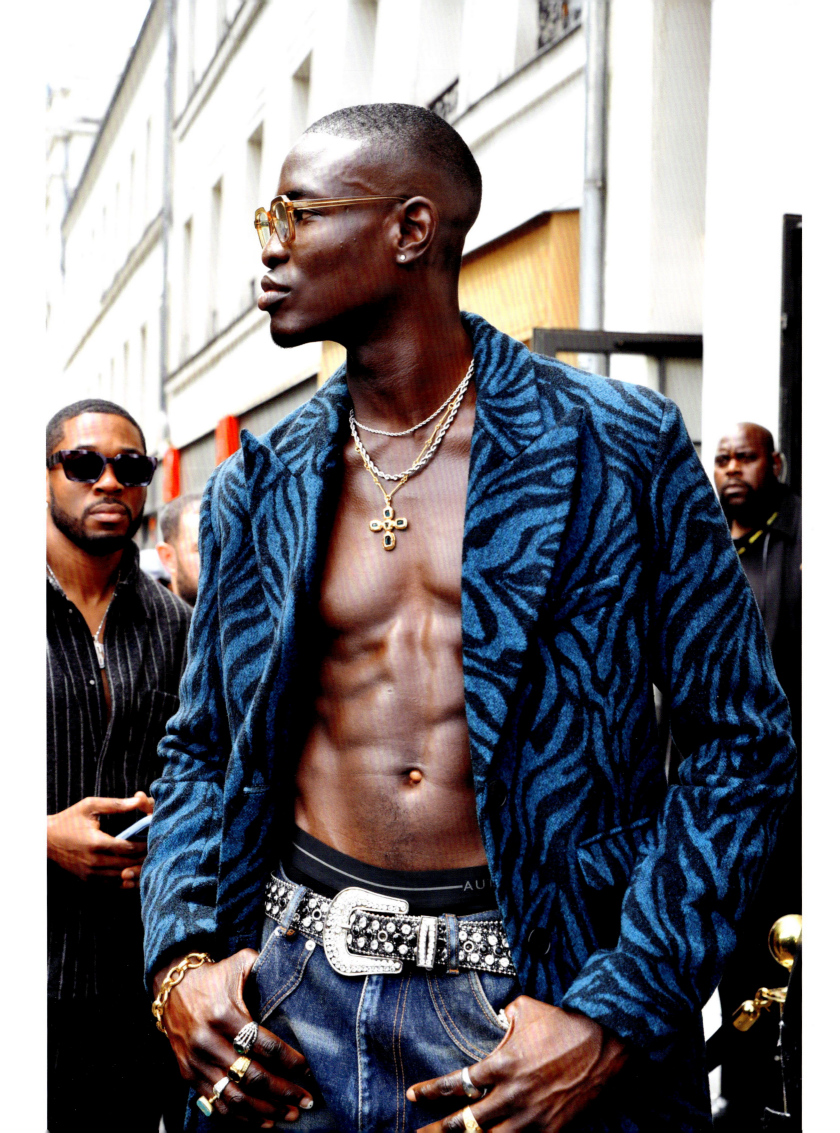

"There's no fashion if it doesn't go down the street."

GABRIELLE 'COCO' CHANEL

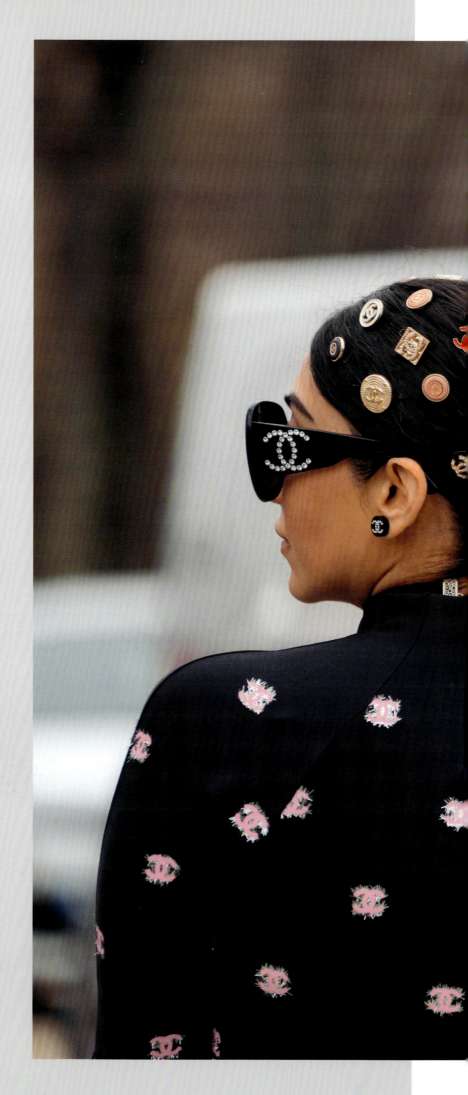

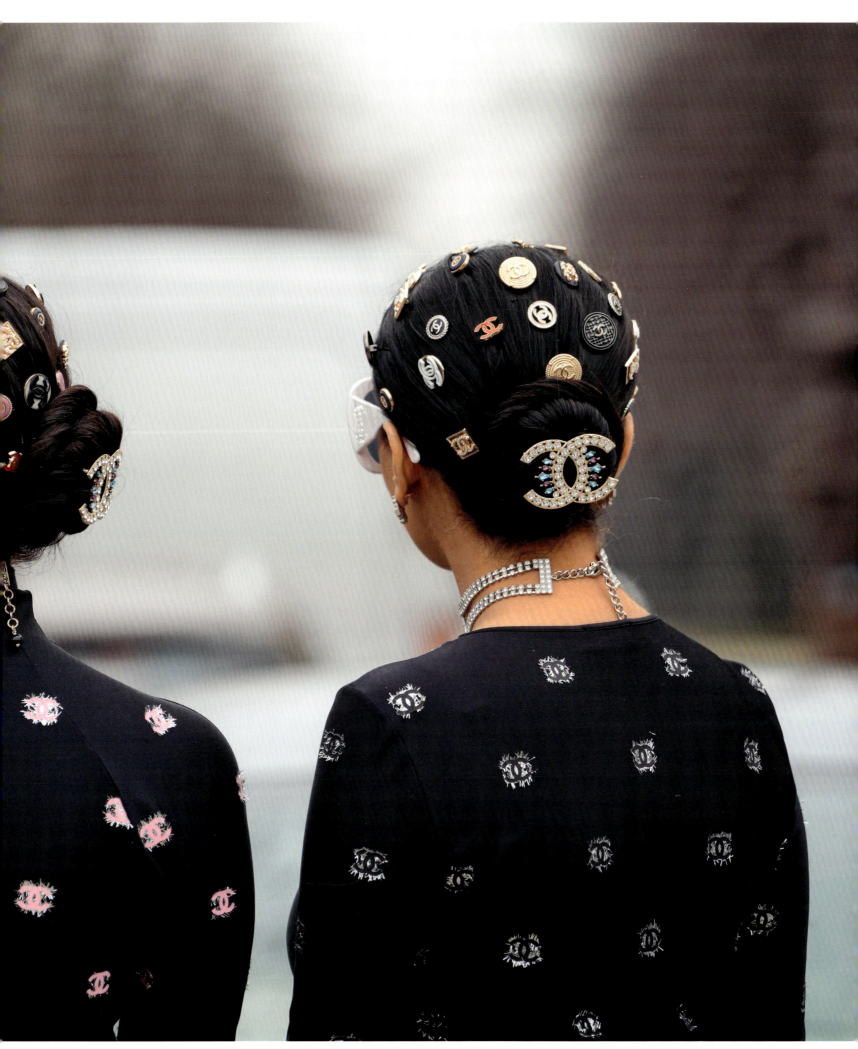

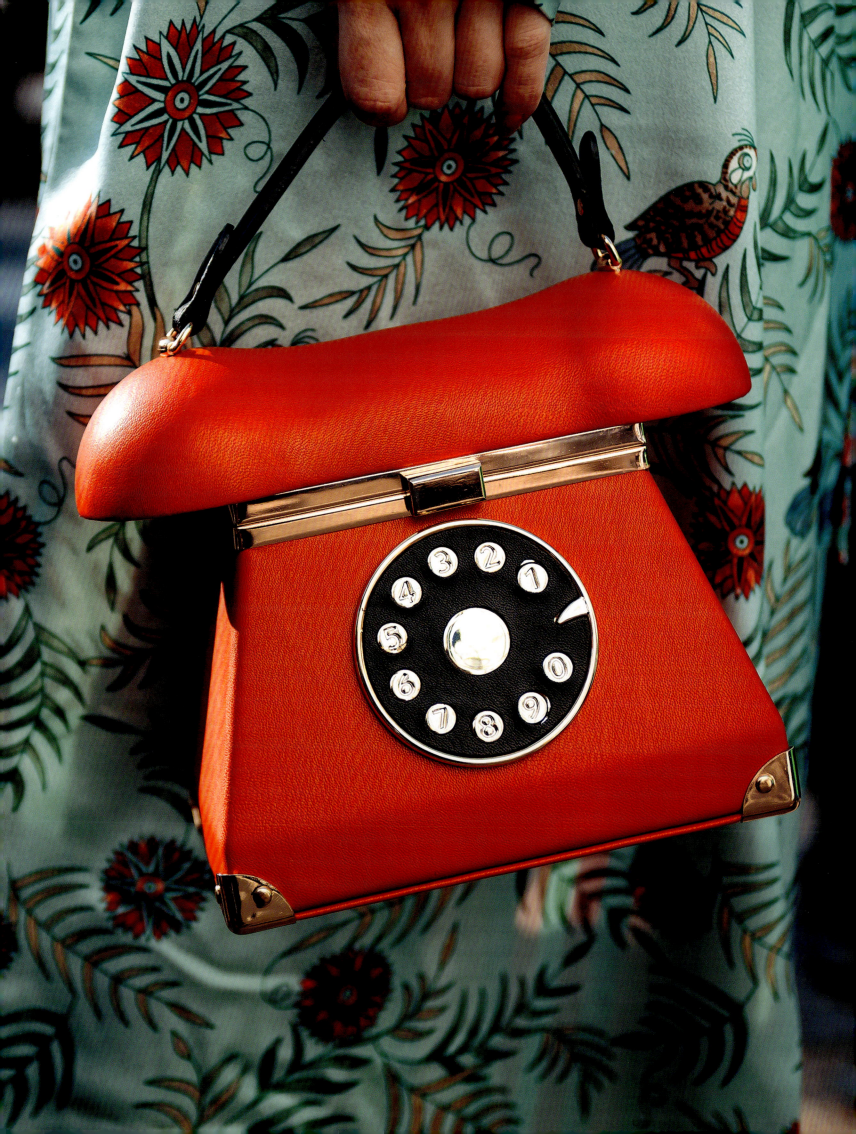

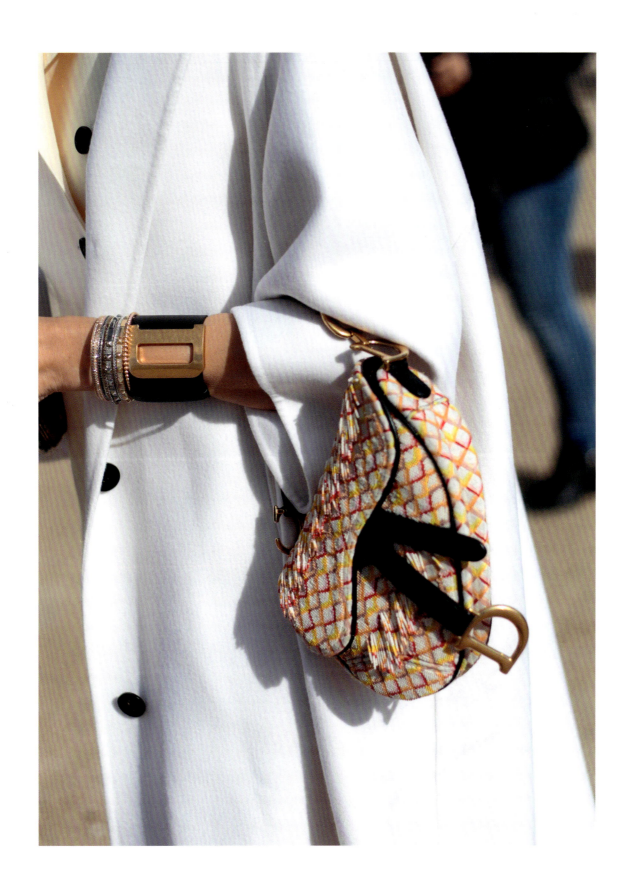

"The brightest shining stars in the Dior legacy are its bags…each design holds a history of its own."

FARFETCH MAGAZINE

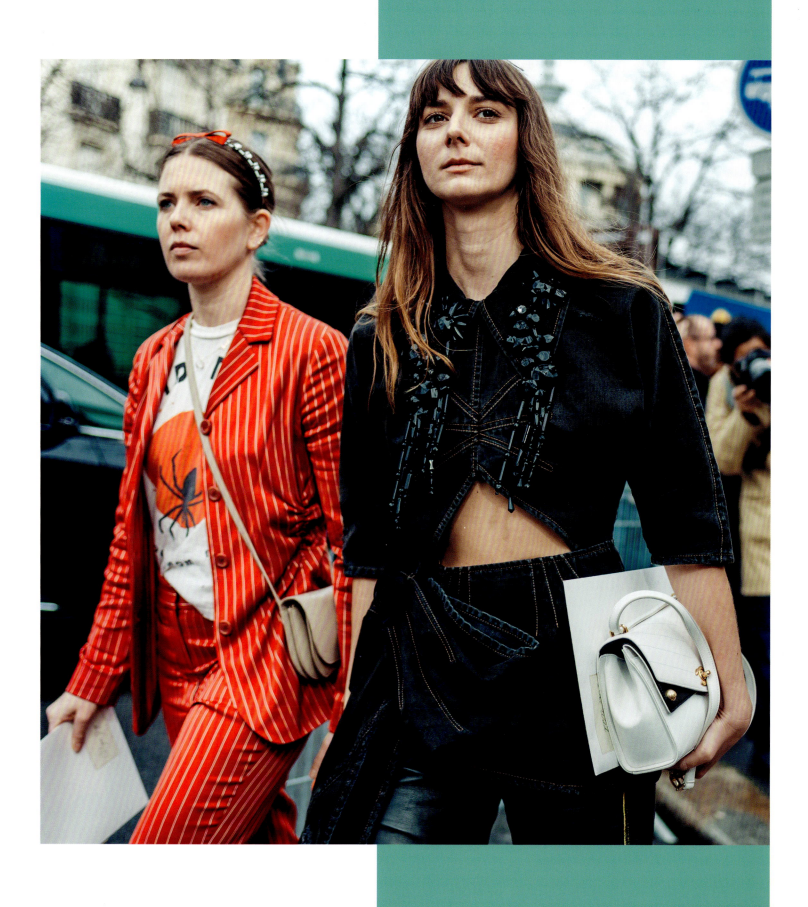

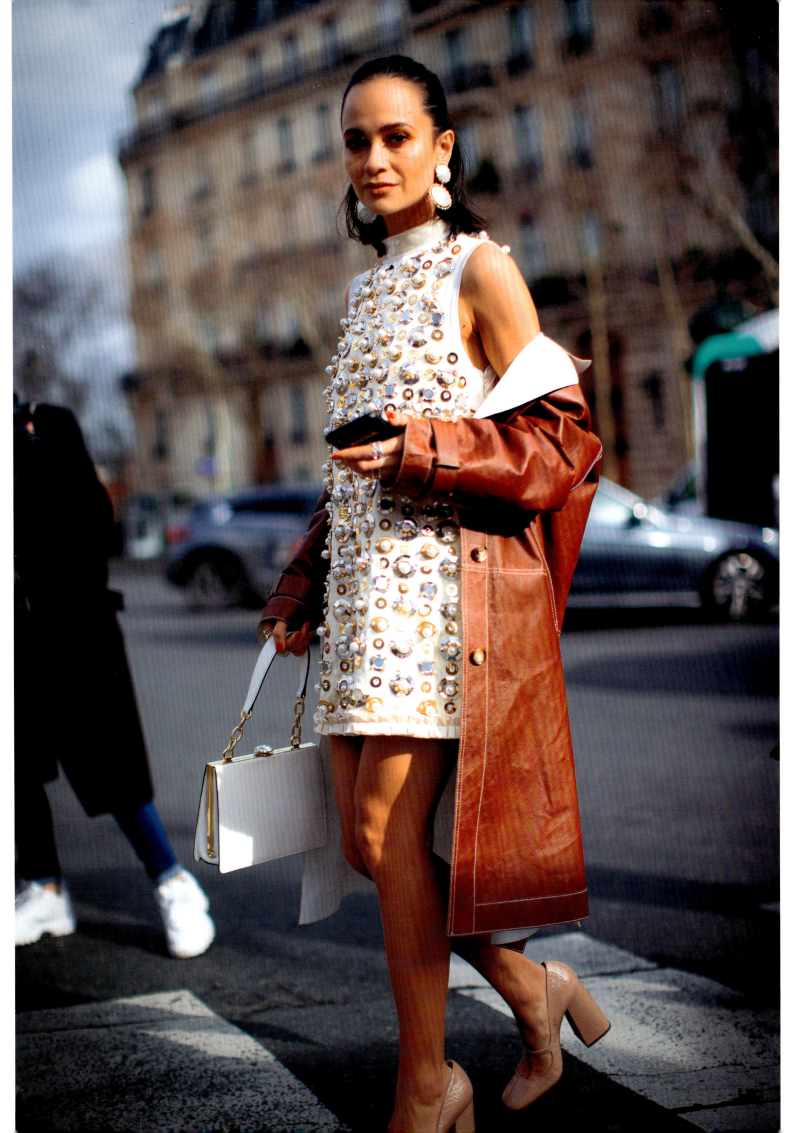

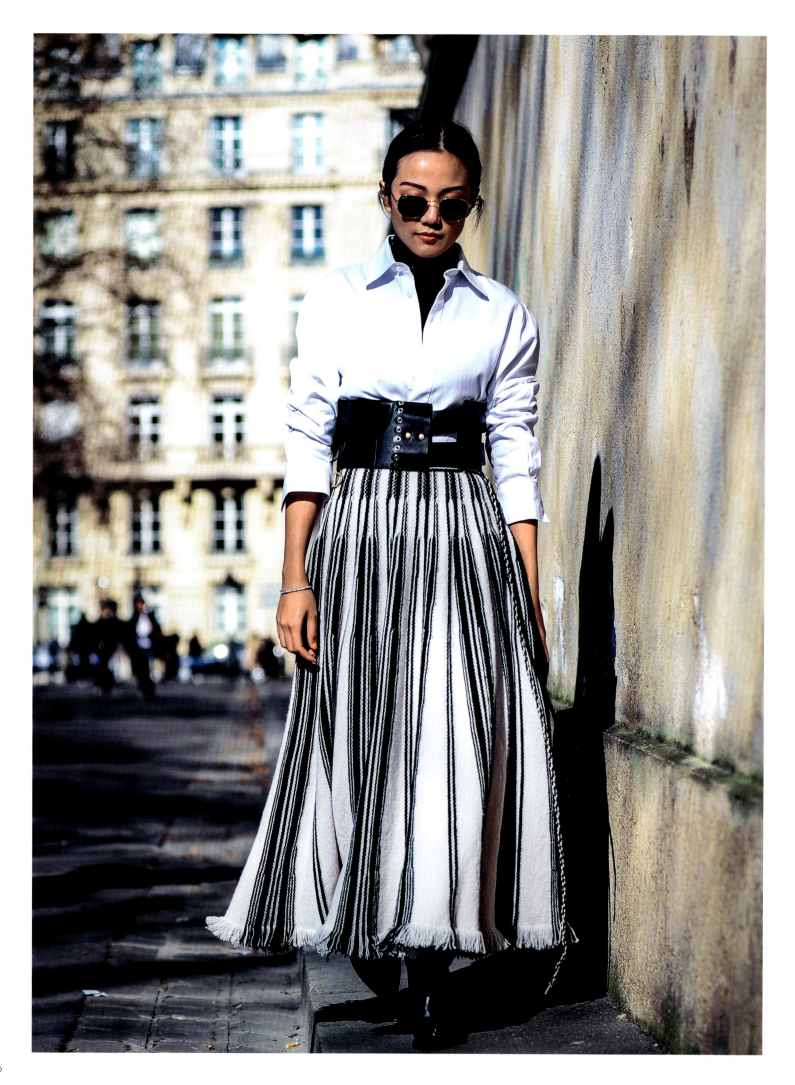

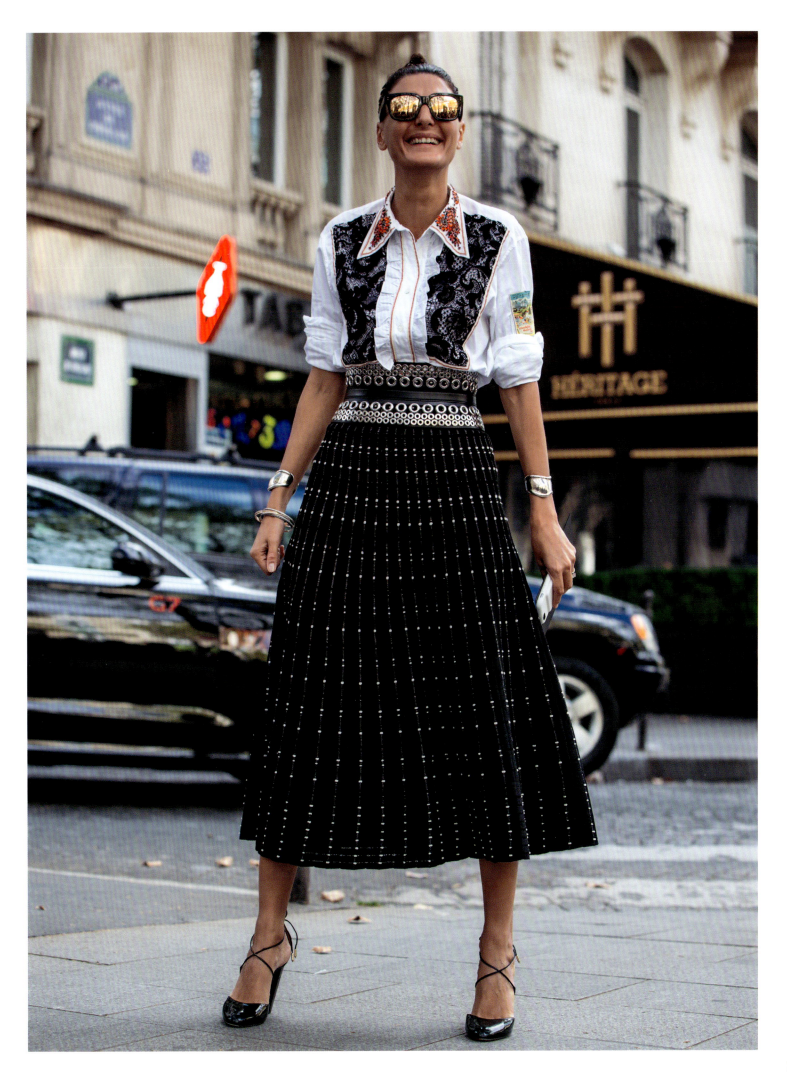

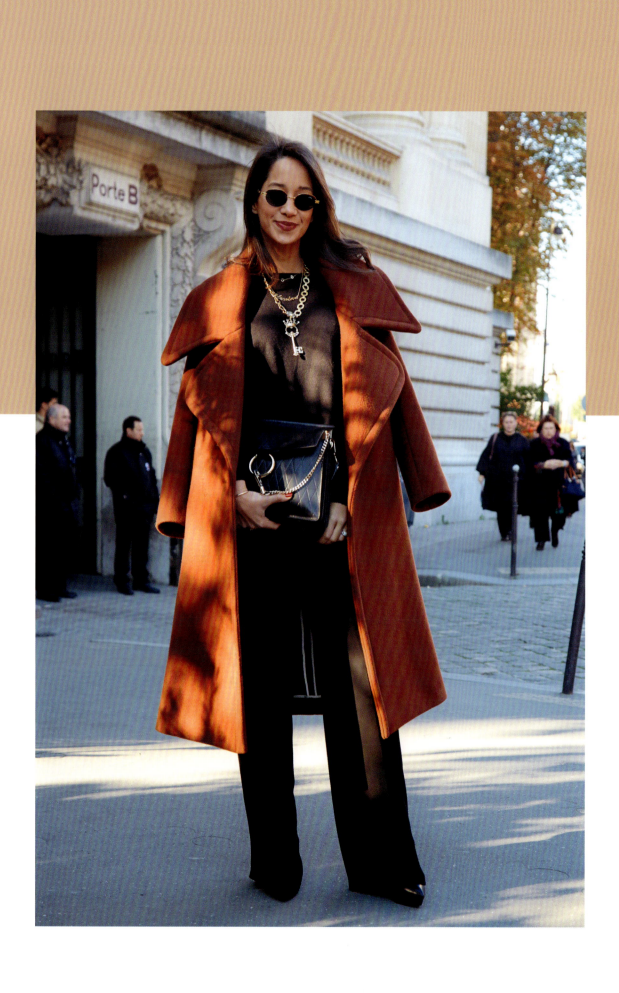

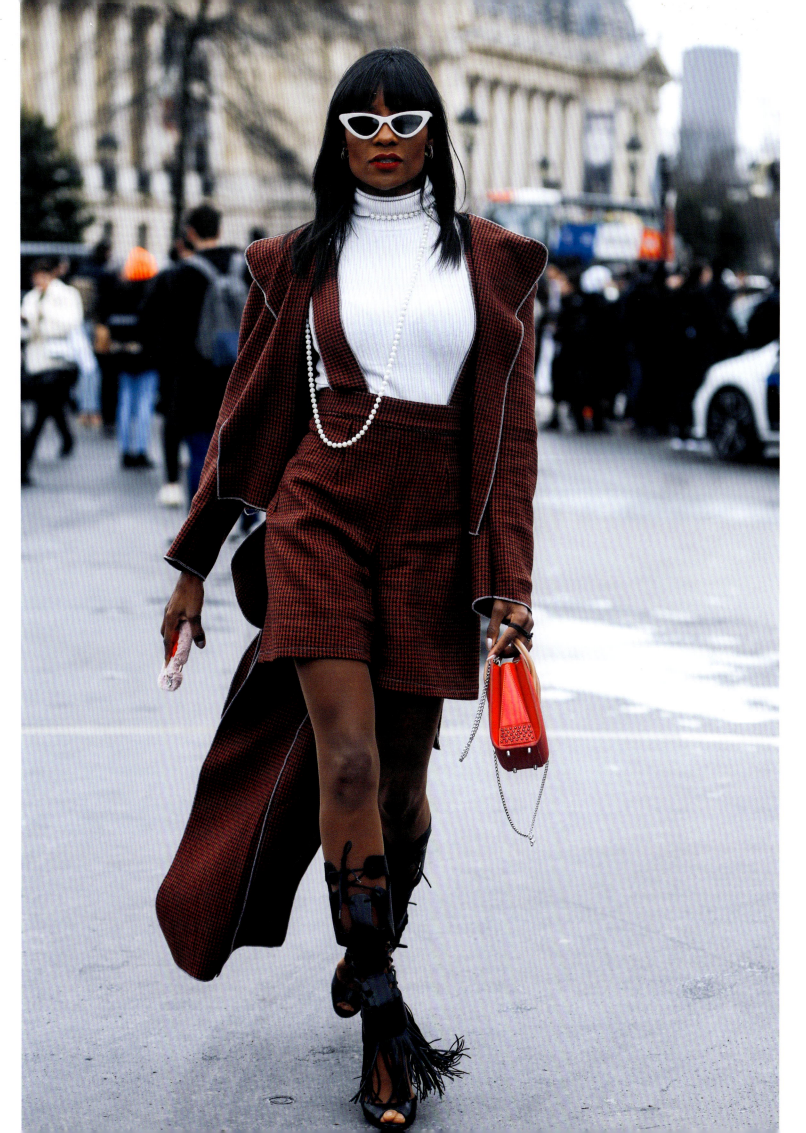

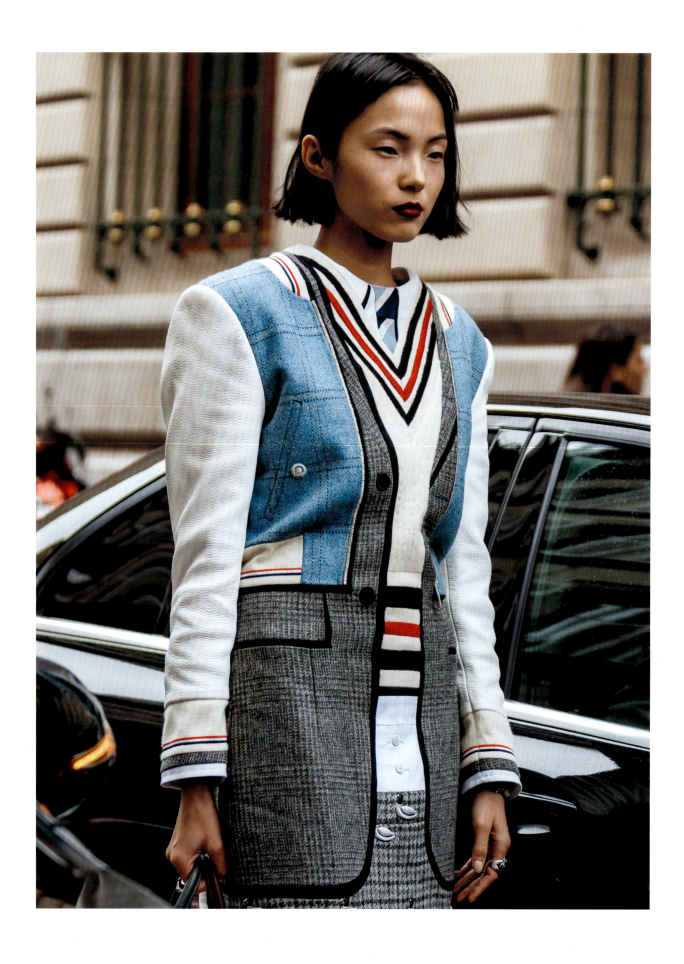

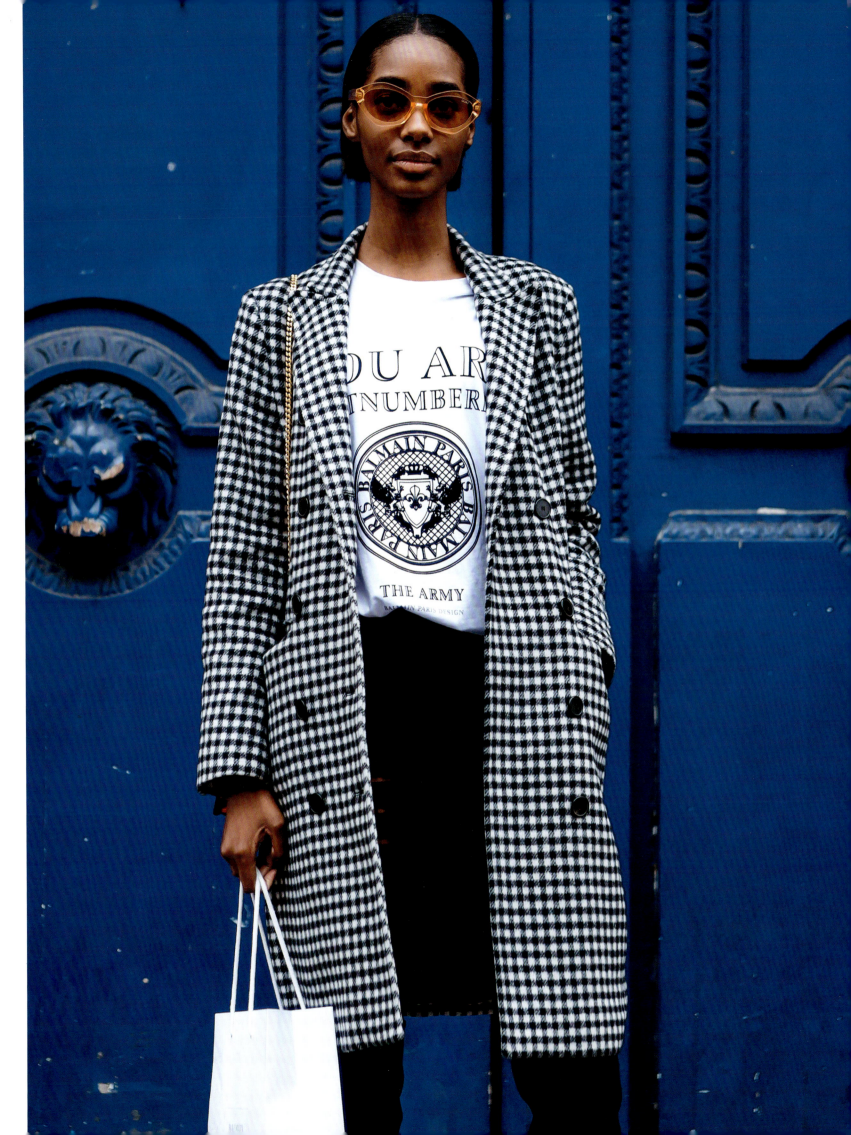

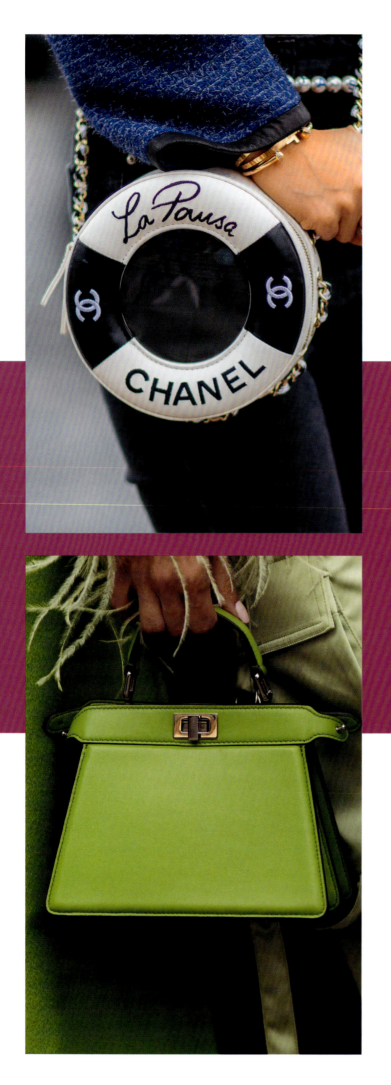
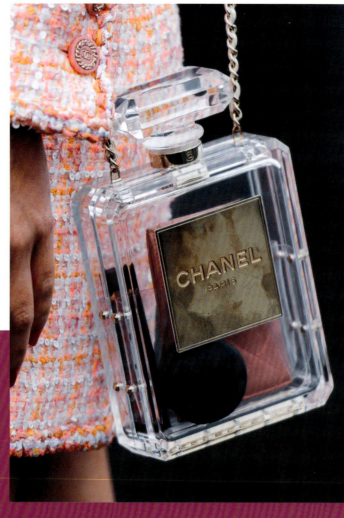
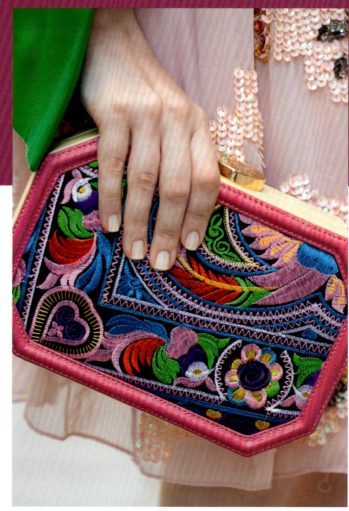

> "The best colour in the whole world is the one that looks good on you."
>
> COCO CHANEL

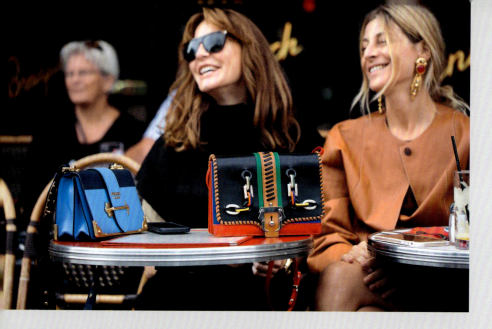

Parisian fashionistas sitting outside a café, September 2016.

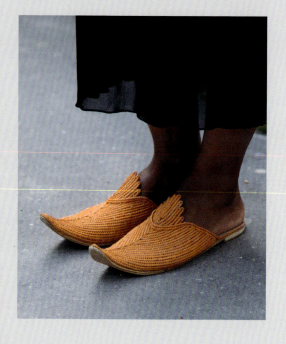

Moroccan leather slippers worn to 'Morocco Day' at the Paris haute couture Fashion Week Autumn/Winter 2016.

Woman attending a Hermès show, wearing a silk kimono with matching co-ord and matte leather handbag, 2022.

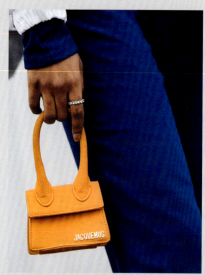

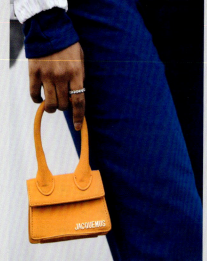

The iconic Jacquemus Chiquito handbag, March 2019.

Schiaparelli Anatomy Jewelry handbag, October 2022.

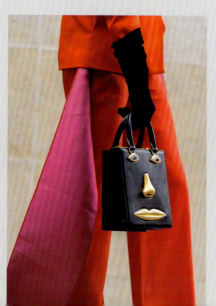

A Hermès guest, Paris Fashion Week, January 2024.

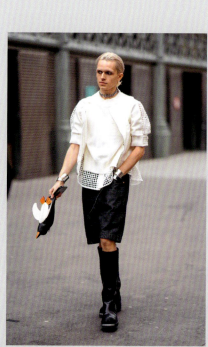

A guest at a Sacai show, 2024.

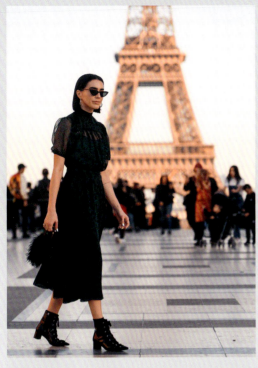

Fashionista during the Paris Fashion Week Autumn/Winter 2019–2020, February 2019.

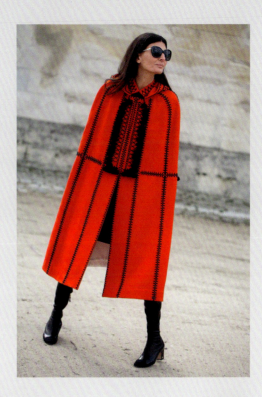

Swarovski's creative director Giovanna Battaglia Engelbert, during the Paris Fashion Week, March 2016.

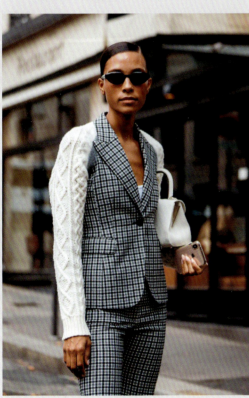

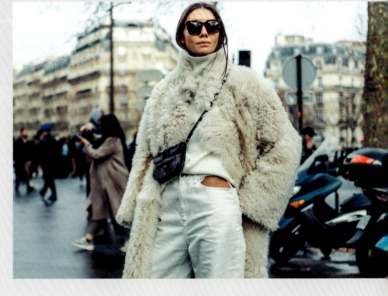

Ukrainian stylist and fashion editor Julie Pelipas outside a Miu Miu show, March 2019.

An attendee leaving a Paris Fashion Week show in 2019.

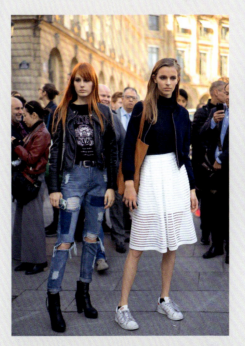

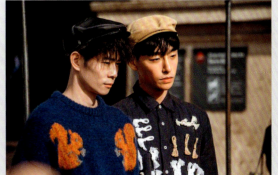

Guests of a fashion show at Place Vendôme, Paris Fashion Week, October 2016.

Fashion week, September 2018.

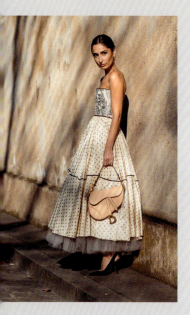
A guest of the Christian Dior Autumn/Winter 2019–2020 show, February 2019.

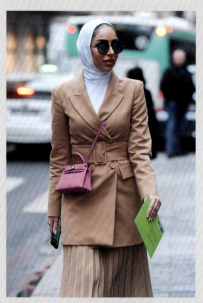
Classic Parisian street style during Paris Fashion Week in March 2019.

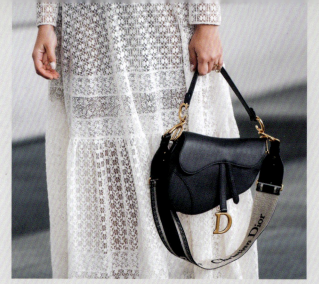
Spanish influencer Aida Domenech with a Christian Dior bag, March 2019.

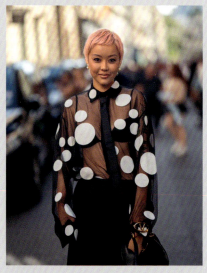
Stylist Mia Kong during Paris Fashion Week in 2023.

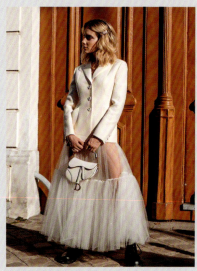
American influencer Sira Pevida wears all Dior ahead of the Christian Dior Autumn/Winter 2019–2020 show, 2019.

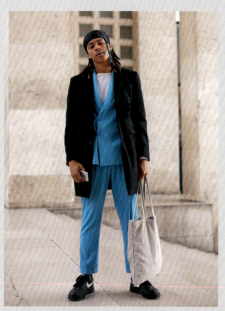
Chic Victoria Tomas show guest, February 2020.

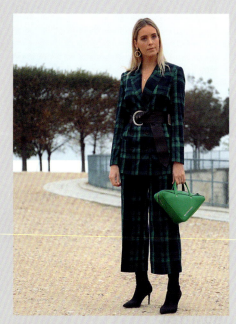
Effortless Parisian street style.

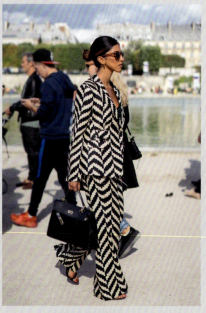
Fashionistas at Jardin des Tuileries, 2016.

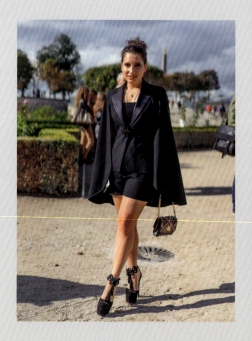

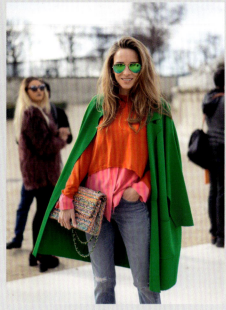

A fashionista at Jardin des Tuileries, 2016.

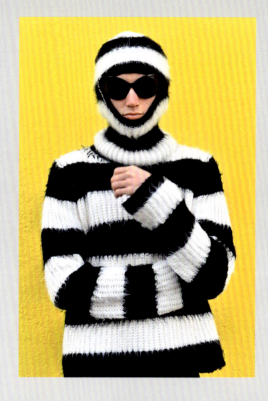

Paris Fashion Week, February 2024.

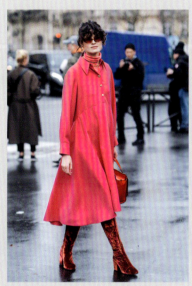

New Zealand stylist, photographer and blogger Chloe Hill during Paris Fashion Week Autumn/Winter 2019–2020.

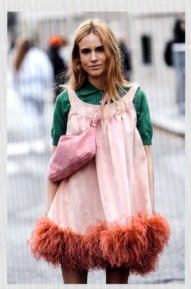

Spanish stylist and blogger Blanca Miró during Paris Fashion Week Autumn/Winter 2019–2020.

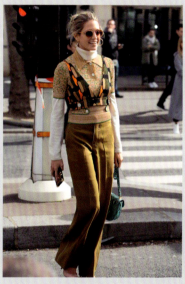

Brazilian influencer Helena Bordon during Paris Fashion Week Autumn/Winter 2017–2018.

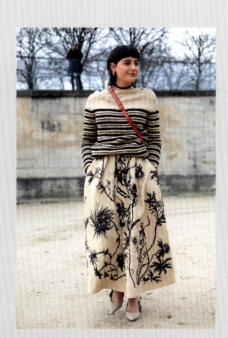

Paris-based Spanish influencer Maria Bernard attending a Dior show in February 2020.

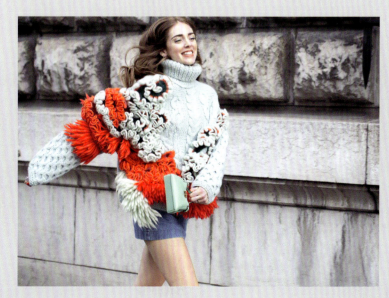

A fashionista, Paris, March 2015.

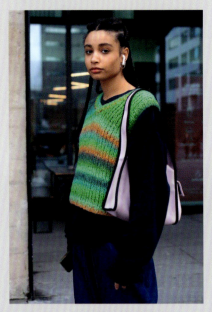
Stylish show-goer, Fashion Week, February 2025.

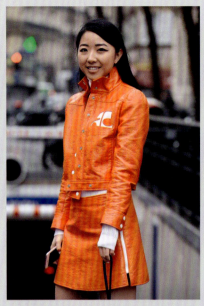
A Fashion Week guest at the Hôtel de Ville, 2017.

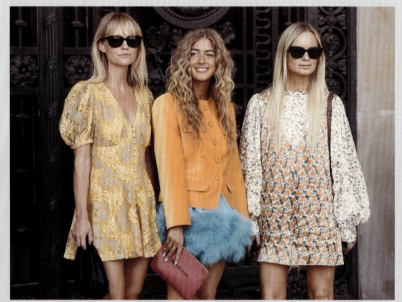
Guests of a fashion show, September 2018.

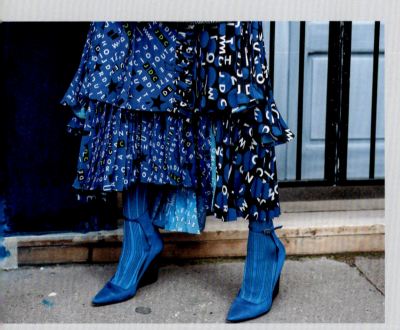
Details of a guest's look after the Thom Browne Autumn/Winter 2019–2020 show.

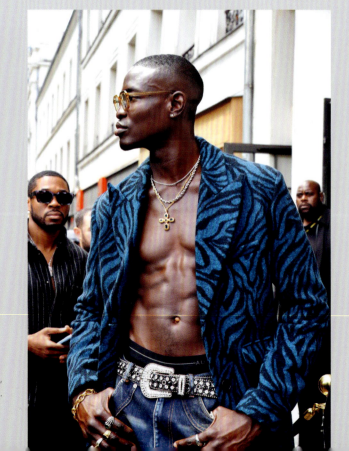
Street style pour homme, Montmartre, June 2024.

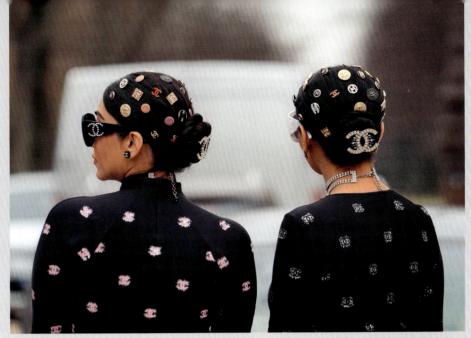

Synchronised Chanel, 2023.

Dior bag and bracelet, February 2020.

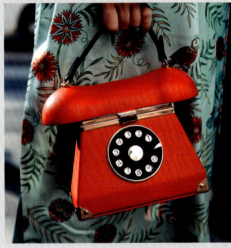

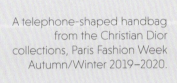

A telephone-shaped handbag from the Christian Dior collections, Paris Fashion Week Autumn/Winter 2019–2020.

Guests heading for the Miu Miu Autumn/Winter 2019–2020 show.

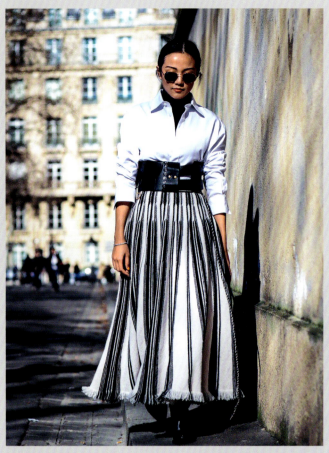

Singaporean blogger and influencer Yoyo Cao, February 2019.

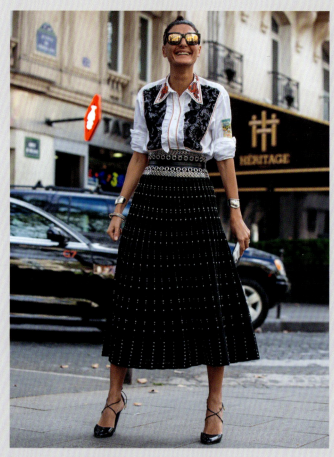

Swarovski's creative director Giovanna Battaglia Engelbert, heading to the Balmain Spring/Summer 2017 show, October 2016.

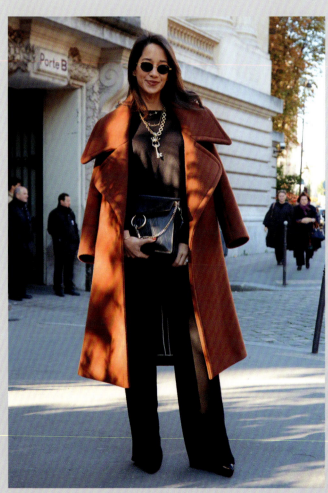

A guest of the Chloé Spring/Summer 2016 show, October 2015.

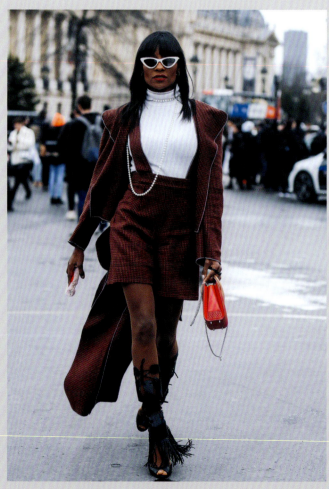

Stylish exit from a fashion show, 2019.

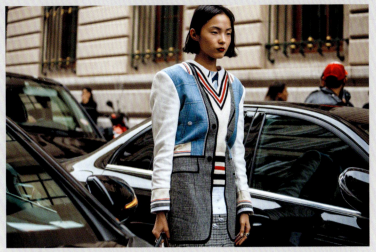

Chinese model Xiao Wen Ju heading to the Thom Browne Spring/Summer 2020 show, September 2019.

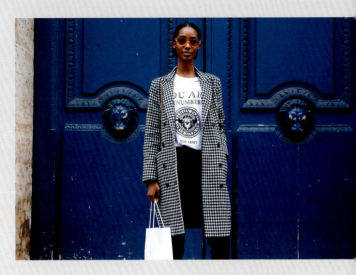

Jamaican model Tami Williams after the Balmain Autumn/Winter 2018–2019 show, March 2018.

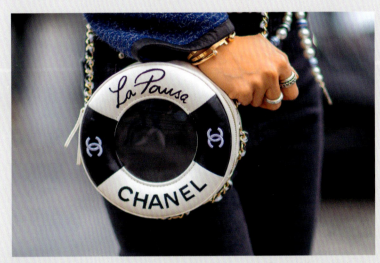

Chanel handbag worn by blogger Faye Tsui at the Chanel Autumn/Winter 2019–2020 show, March 2019.

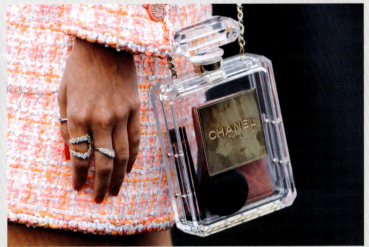

Chanel handbag worn by Brazilian model, blogger and entrepreneur Lala Rudge, at the Chanel Autumn/Winter 2019–2020 show, March 2019.

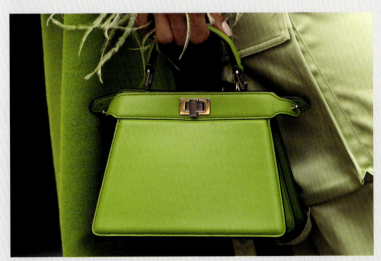

A pop of colour on the street, January 2024.

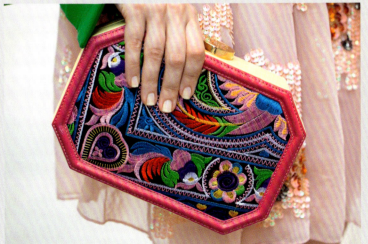

Decorative handbag, July 2016.

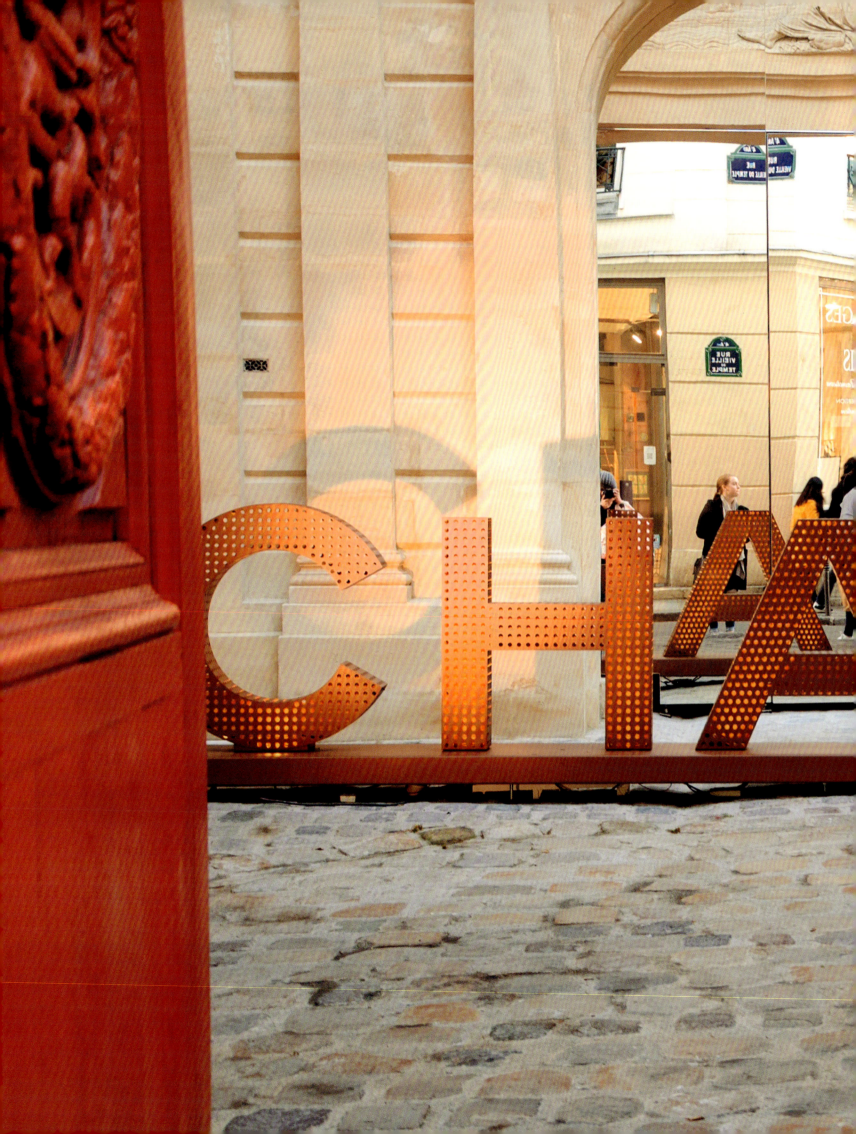

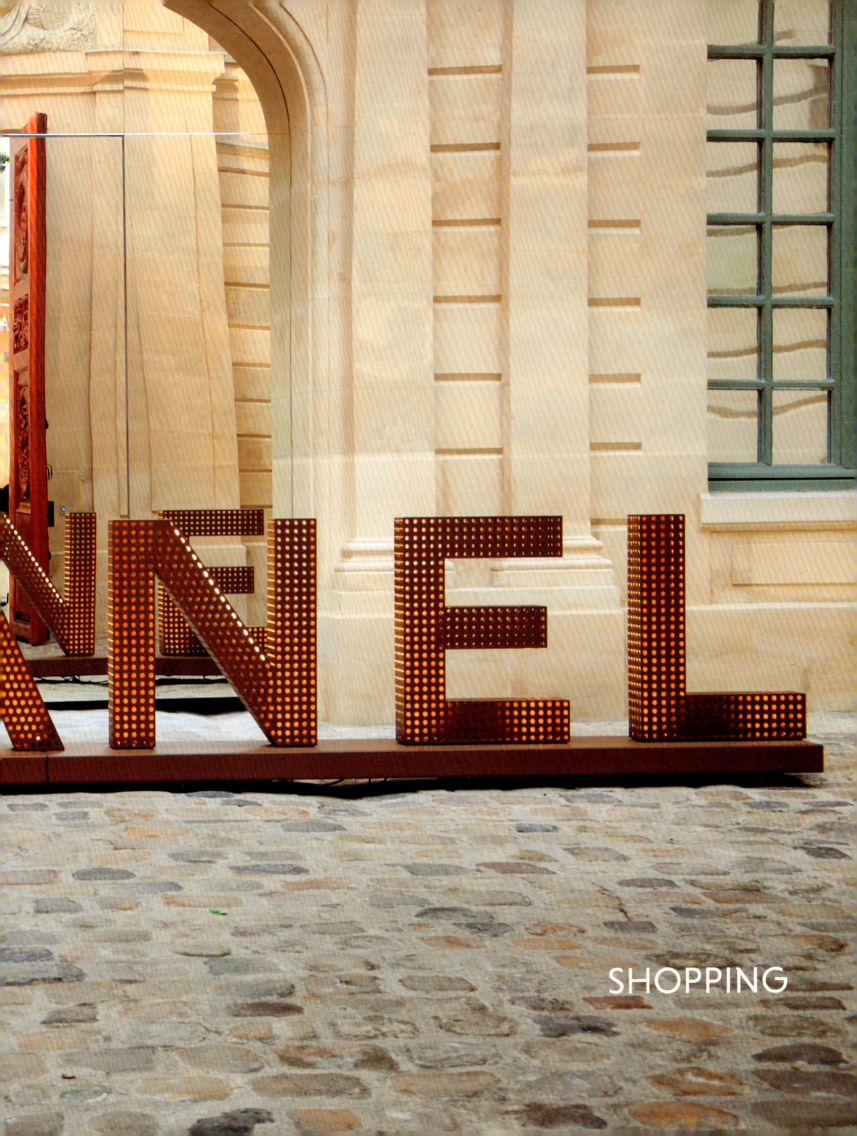
SHOPPING

In the historic heart of Paris, you're never far from a fashion boutique, as the French capital is said to host almost 3,000 of them. Several districts are known as fashion hotspots, and each has its own style. The most prestigious and chic district is certainly the **Triangle d'Or** (Golden Triangle) comprising rue Montaigne, avenue des Champs-Elysées, and avenue George V. The luxury industry has been present here for a good while and fashion designers have been investing in the area ever since Christian Dior set up his first boutique at 30 rue Montaigne in 1946, next door to the Plaza Athénée hotel, where some of his clientele stayed. Since then, all the major brands have swarmed onto avenue Montaigne and the neighbouring streets, with shops of imposing dimensions set up and decorated by the most renowned architects and designers. In 2012, Chanel opened a new flagship store at 42 avenue Montaigne, with a surface area of 380m^2, designed by star New York architect Peter Marino. The Triangle d'Or is home to fashion labels such as Balmain, Chloé, Givenchy, Gucci, Kenzo, Hugo Boss, Louis Vuitton, Prada, Ralph Lauren and Yves Saint Laurent. It is to Paris what Rodeo Drive is to Los Angeles: the place to be seen shopping.

Not far from there, **rue du Faubourg Saint-Honoré** (where the Élysée Palace is located) was the heart of fashion at the beginning of the 20th century. Jeanne Lanvin set up her boutique at 22 rue du Faubourg Saint-Honoré (still the headquarters of the House of Lanvin), right next to the Hermès saddlery, and Paul Poiret lived in a luxurious mansion at 107 rue du Faubourg Saint-Honoré. All the major fashion brands can be found here, or on the almost-namesake street, rue Saint-Honoré, including Alexander McQueen, Chanel, Chloé, Colette, Fendi, Louboutin, Moncler, Prada, and Valentino, among many others.

Christian Dior

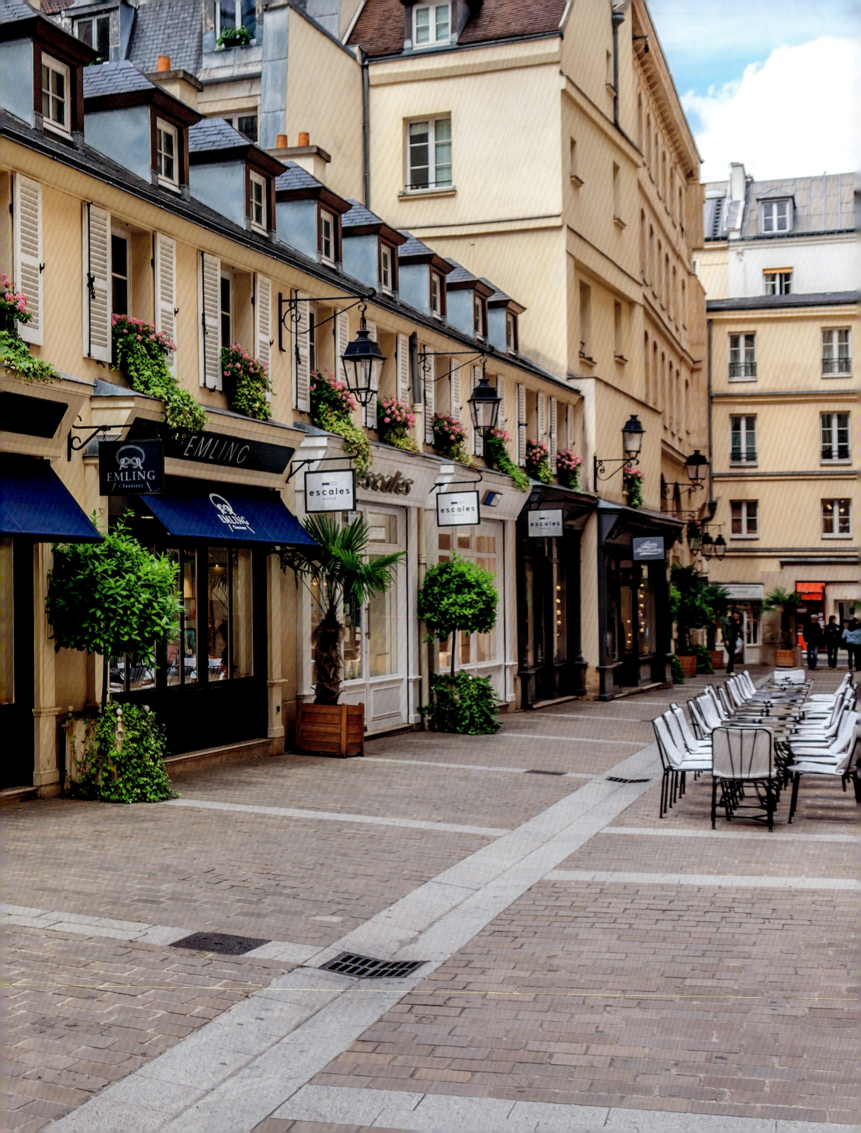

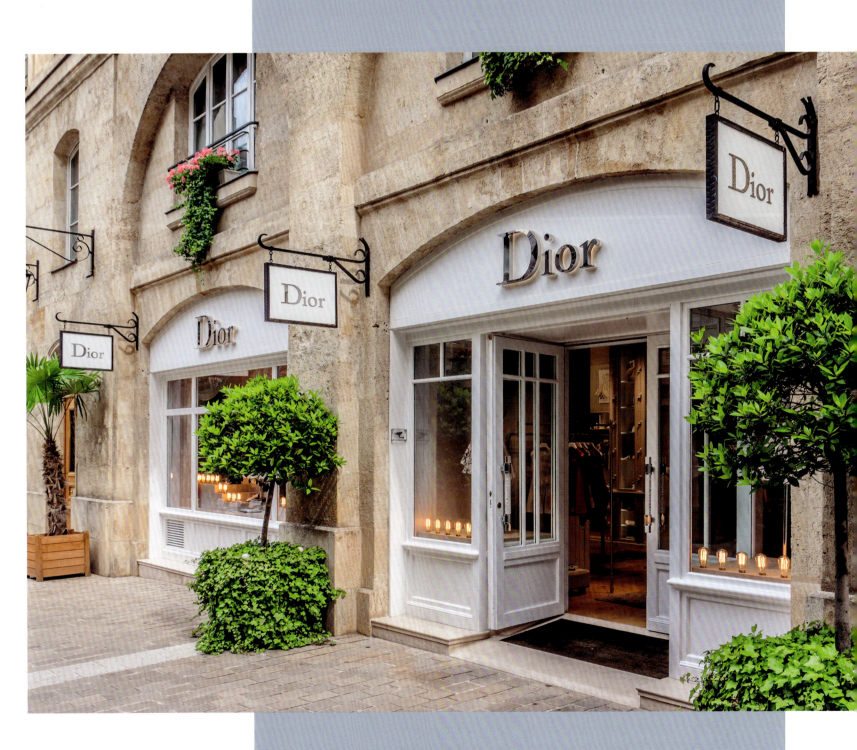

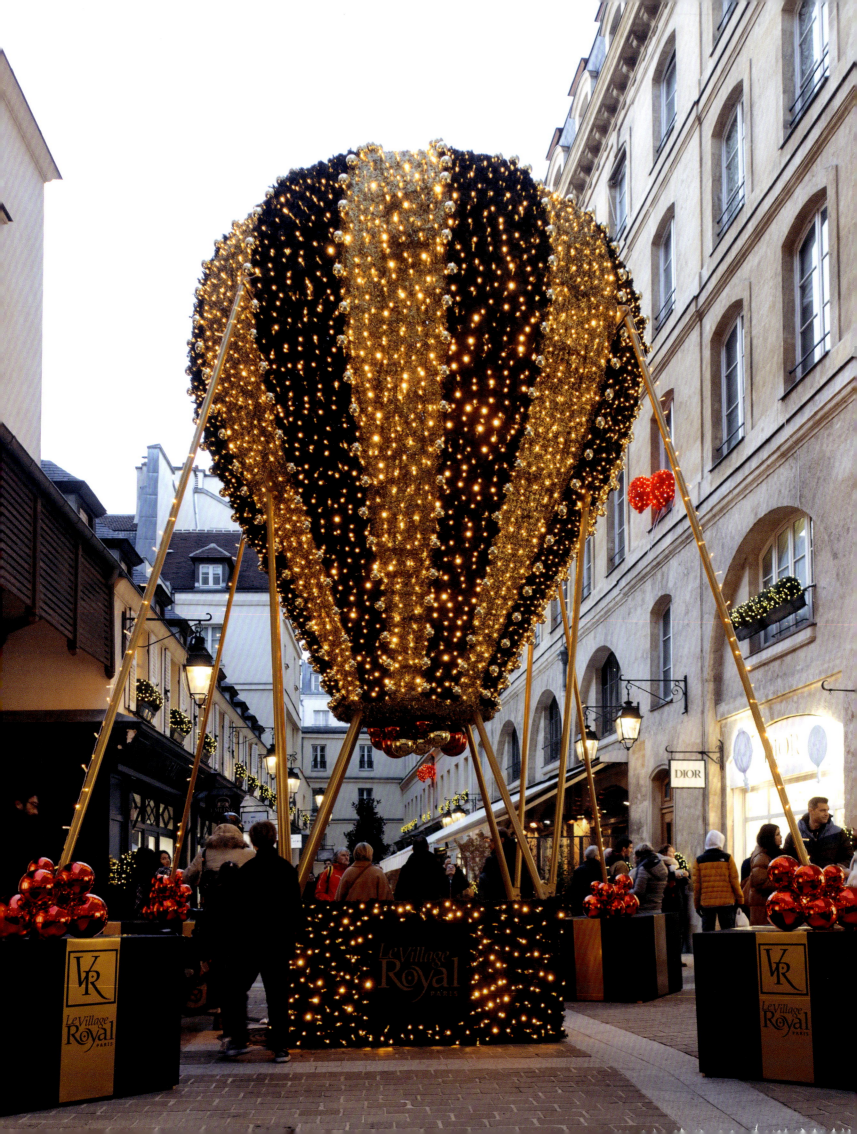

The rue Royale, perpendicular to the rue du Faubourg Saint-Honoré, is home to a quiet oasis of luxury in the heart of Paris – the Village Royal (25 rue Royale) and its exquisite boutiques invite you to indulge in shopping, in a setting where time seems to have stood still.

Much noisier and buzzing with life, **boulevard Haussmann**, behind the old Opera House, is home to two world-renowned department stores: Galeries Lafayette and Printemps Haussmann. Their immense premises house all the major brands in sumptuous shops within shops.

On the other side of the Seine, on the Left Bank, Le Bon Marché, at 24 **rue de Sèvres**, is the oldest department store still in operation worldwide. Owned by the LVMH group, it keeps alive the tradition of impeccable elegance associated with the surrounding aristocratic district, while offering contemporary art installations and fashion exhibitions under its spectacular glass roof.

High-end fashion has also congregated around **boulevard Saint-Germain**, which was once lined with mansions housing the old French nobility, before becoming the district of intellectuals, publishers, and booksellers. This major thoroughfare on the Left Bank is home to a growing number of high-quality ready-to-wear brands.

The Marais, once a poverty-stricken neighbourhood near the Bastille, with an atmosphere similar to that of New York's old fashion district, is now a trendy locale where boutiques by young, visionary designers are side by side with gay bars and restaurants serving traditional French cuisine.

Last but not least, the **Canal Saint-Martin**, another nascent trendy hot spot, is home to fashion and design boutiques in the bourgeois-bohemian style that makes it so charming, particularly along Quai de Valmy.

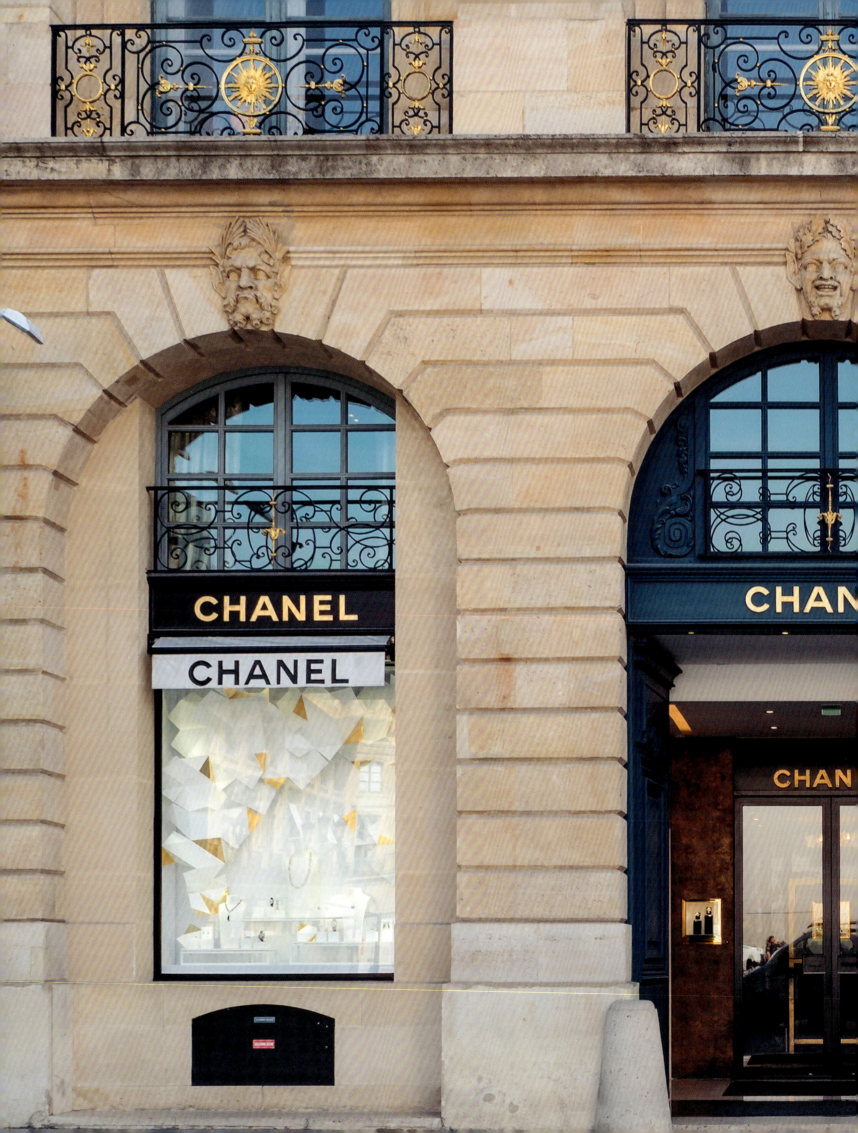

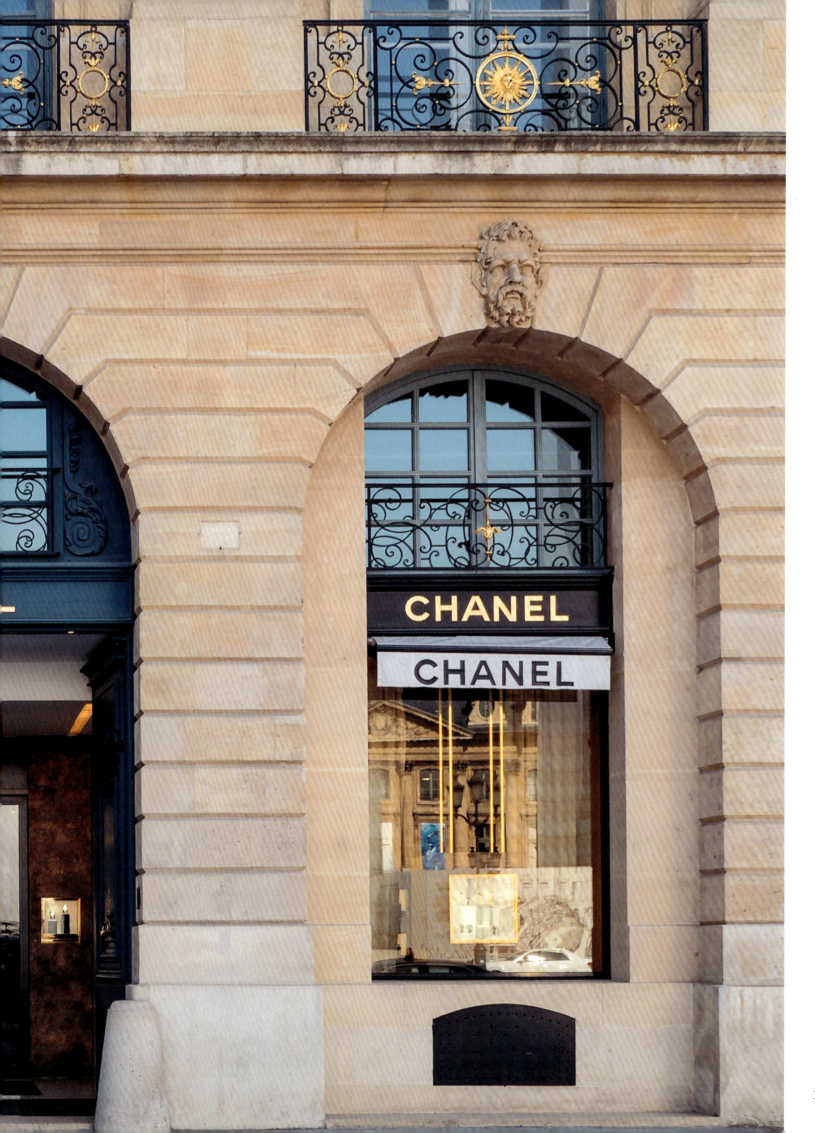

8e Arrt

AVENUE MONTAIGNE

(1533 - 1592)

ÉCRIVAIN

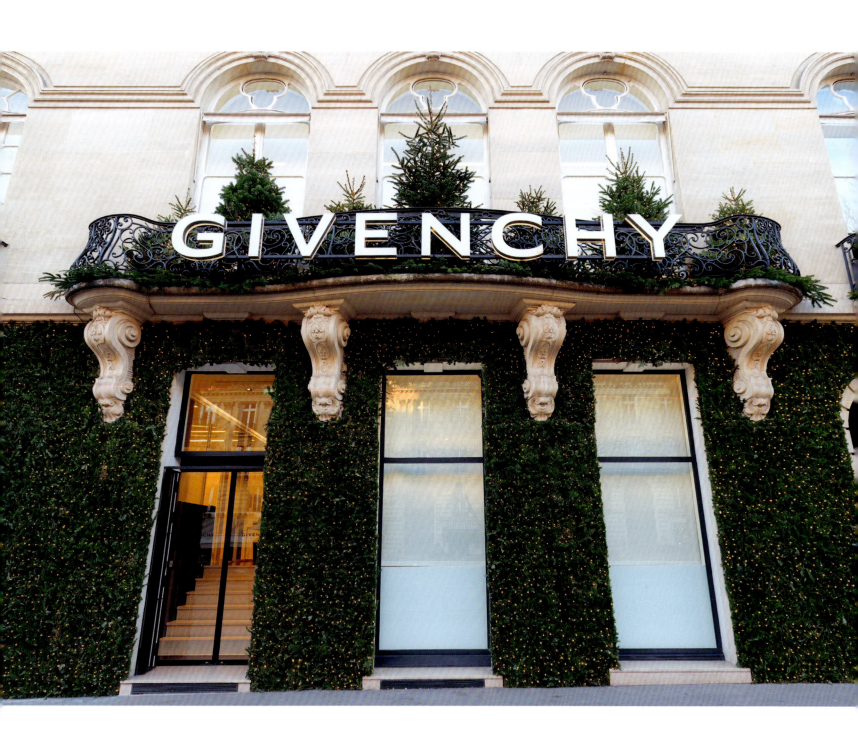

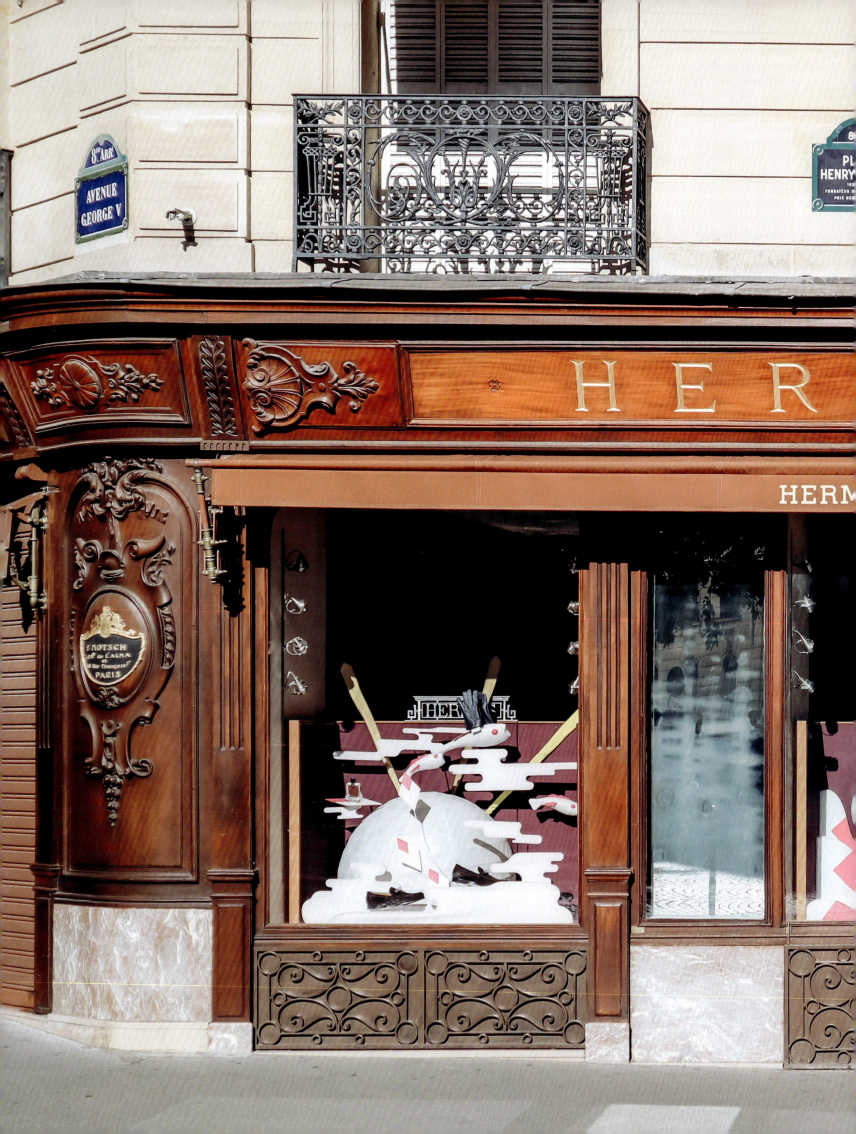

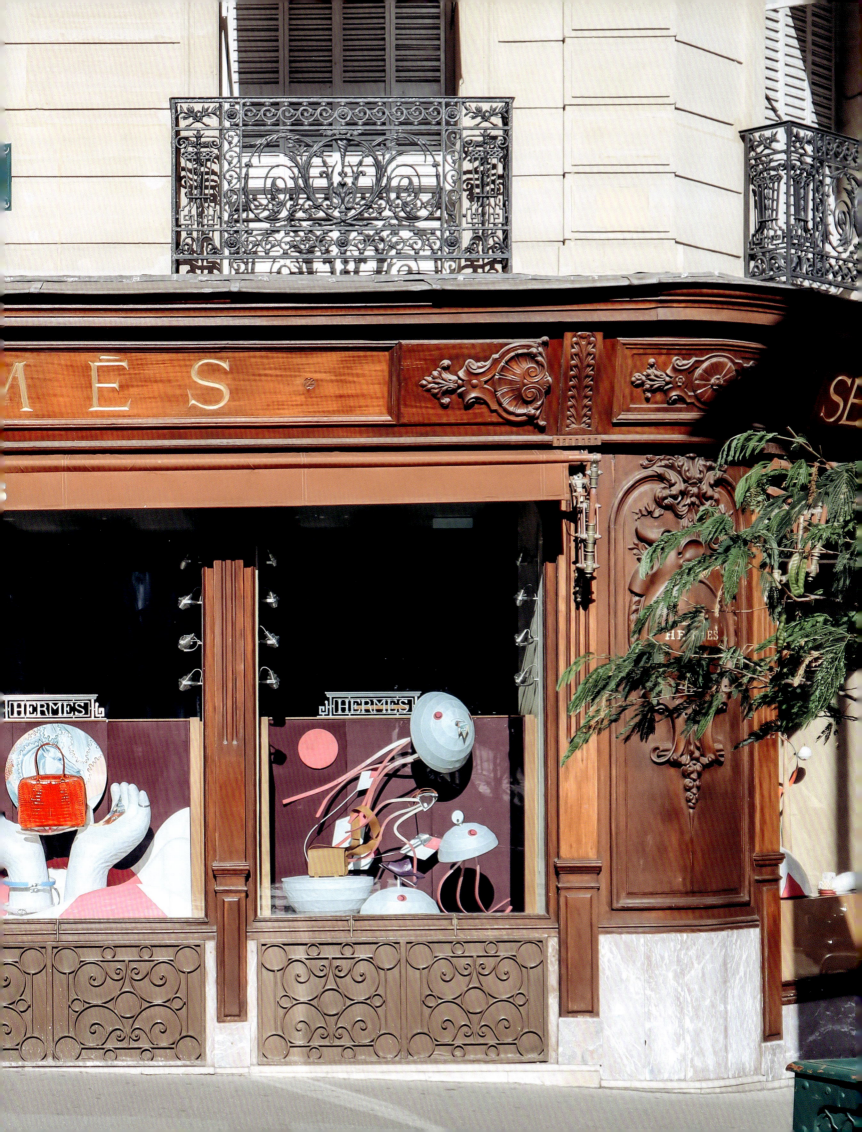

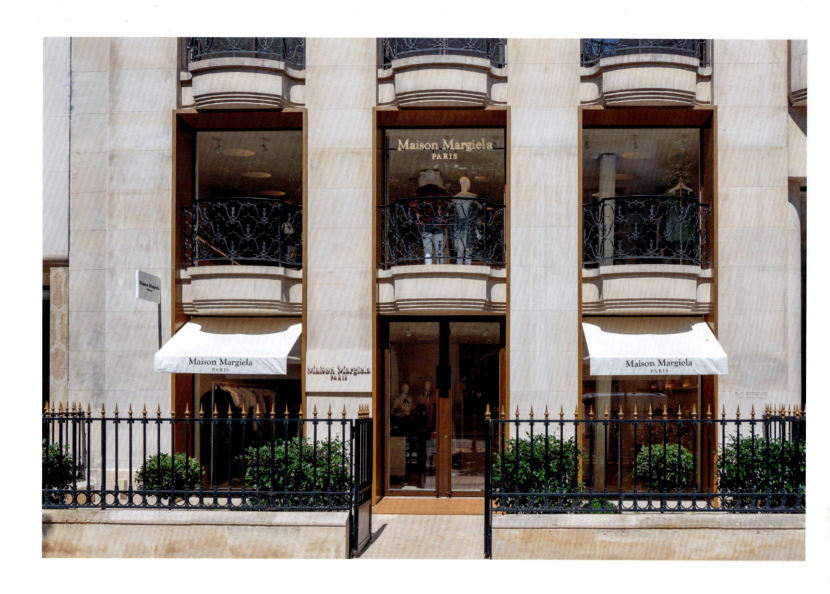
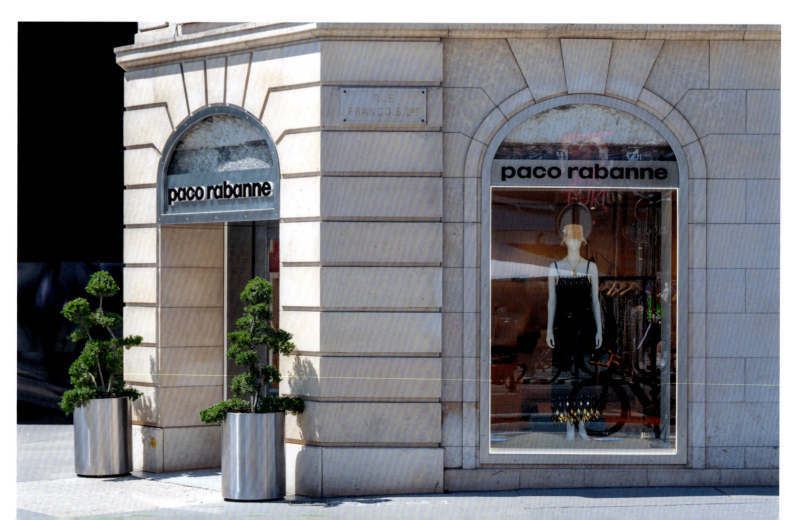

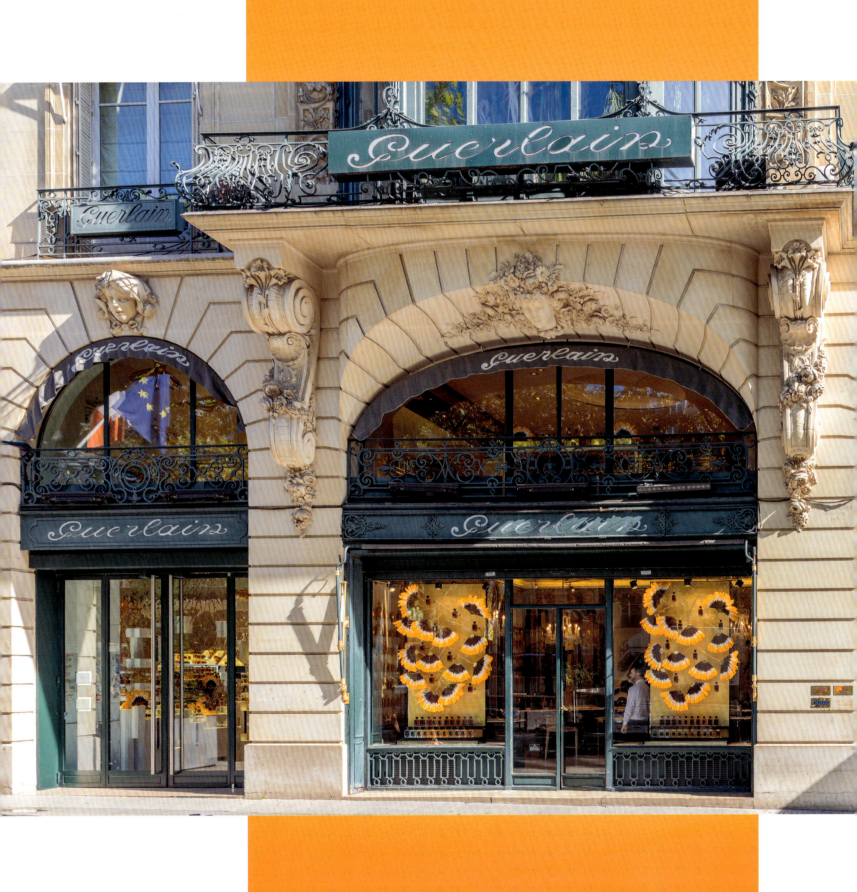

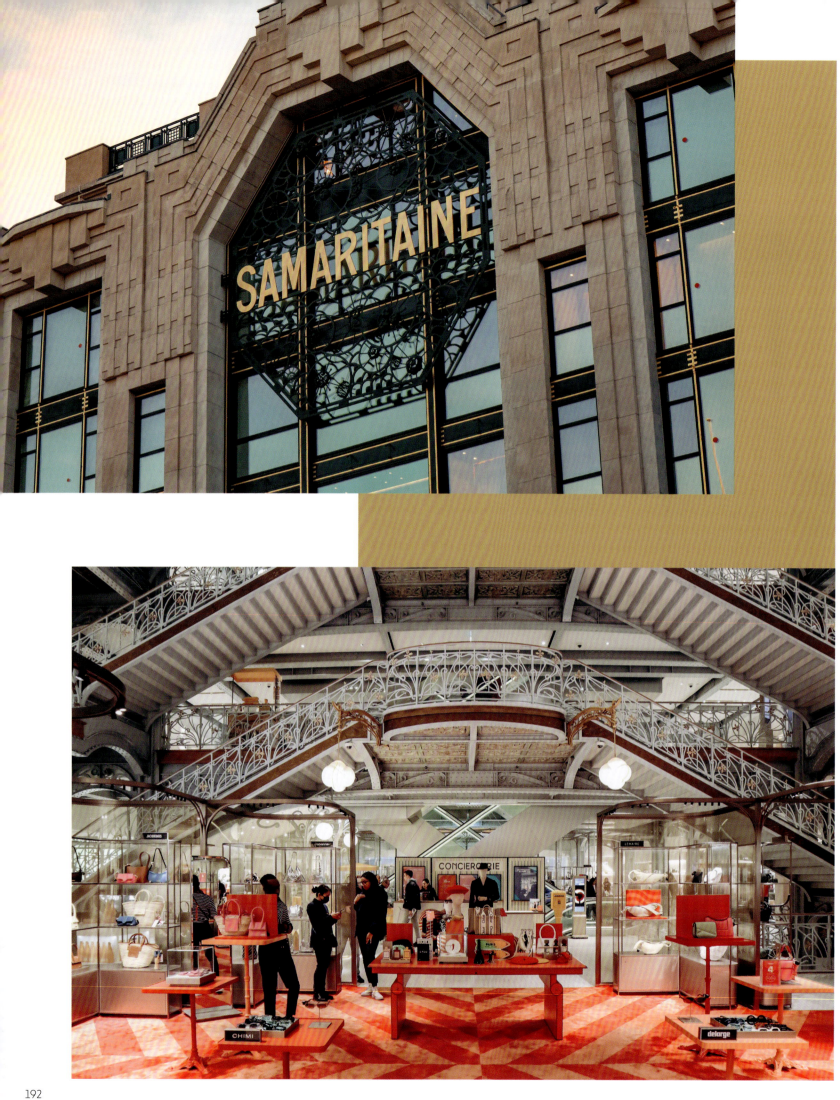

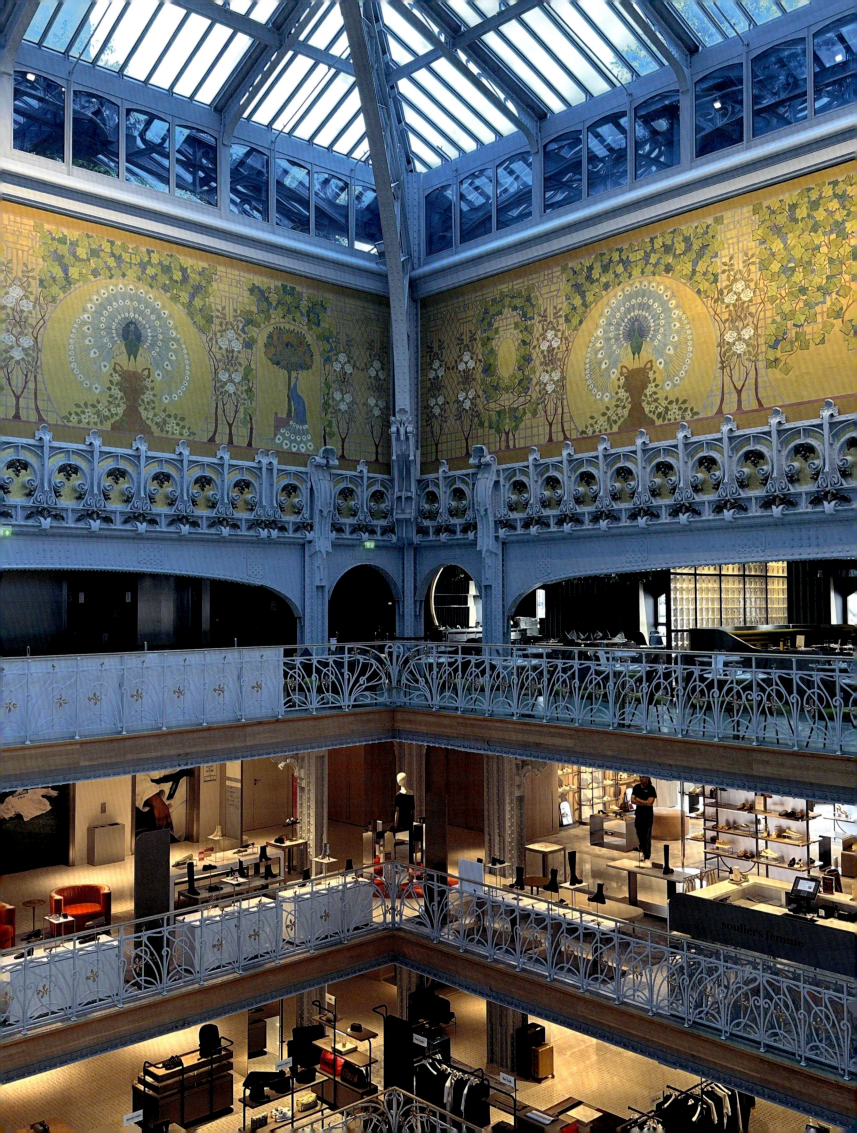

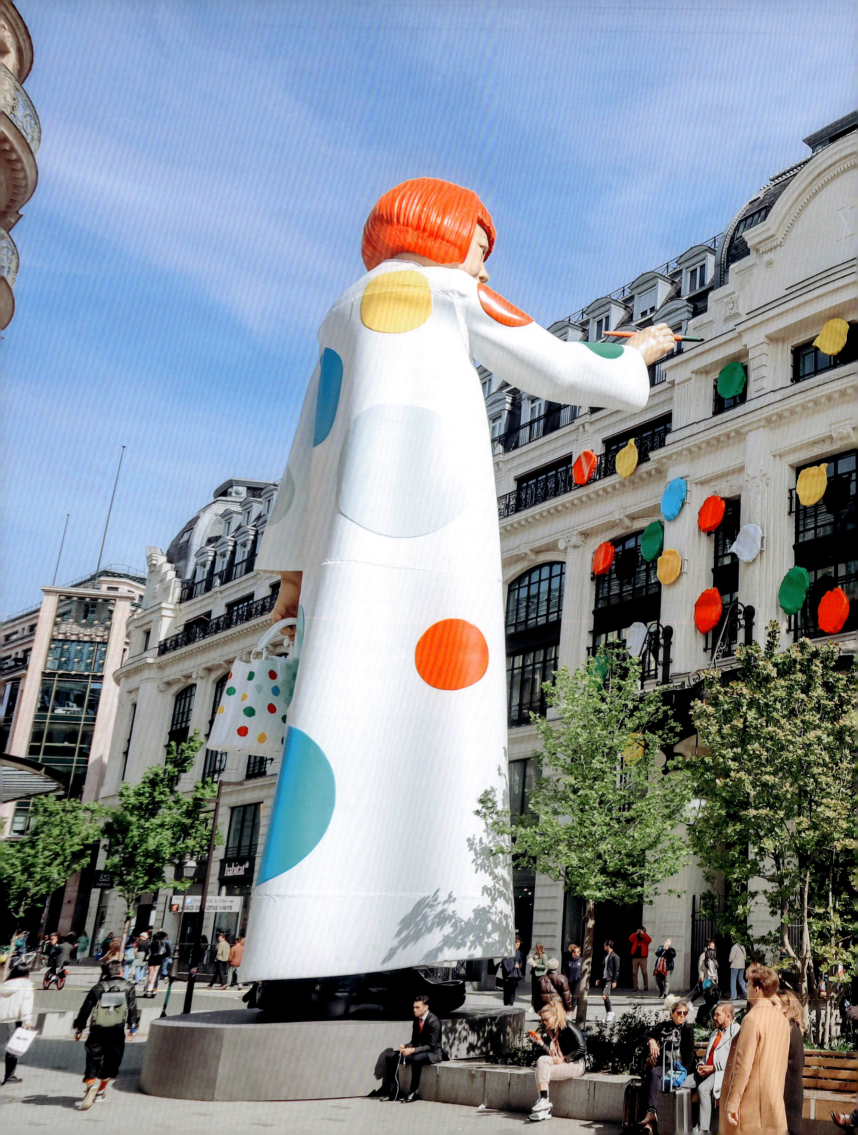

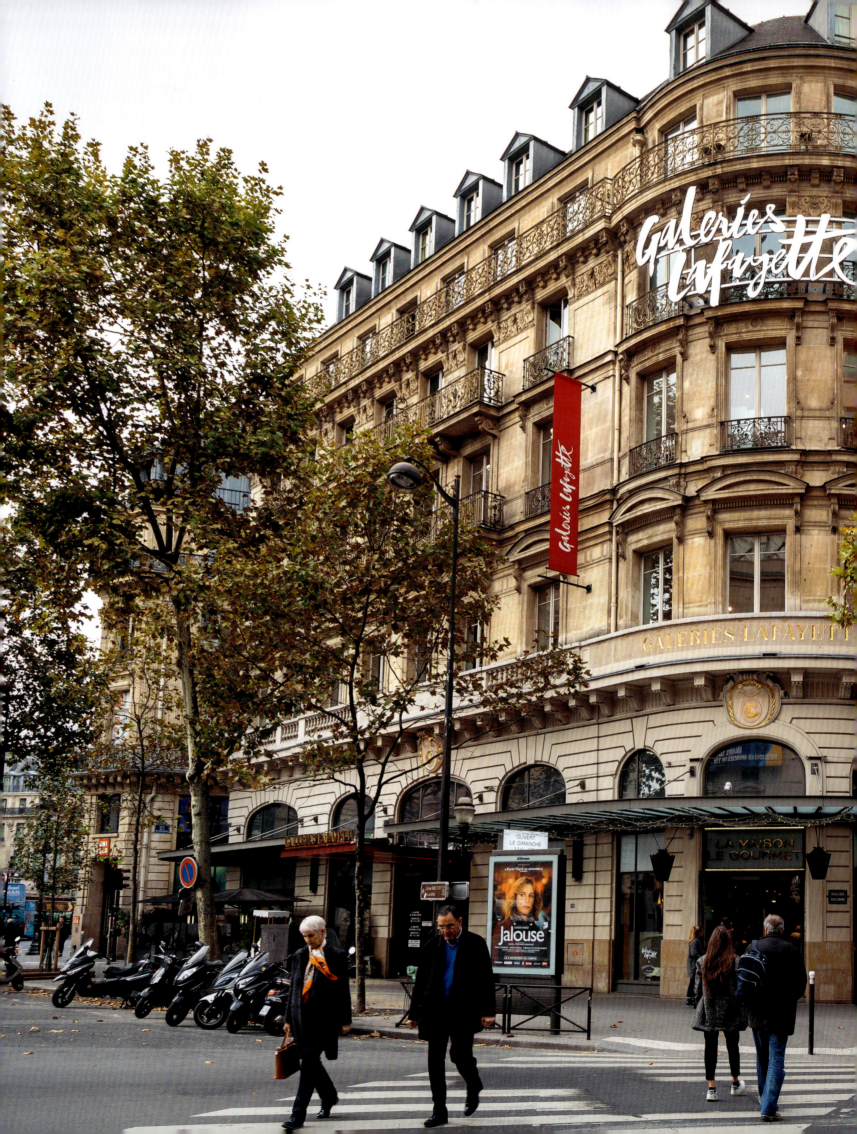

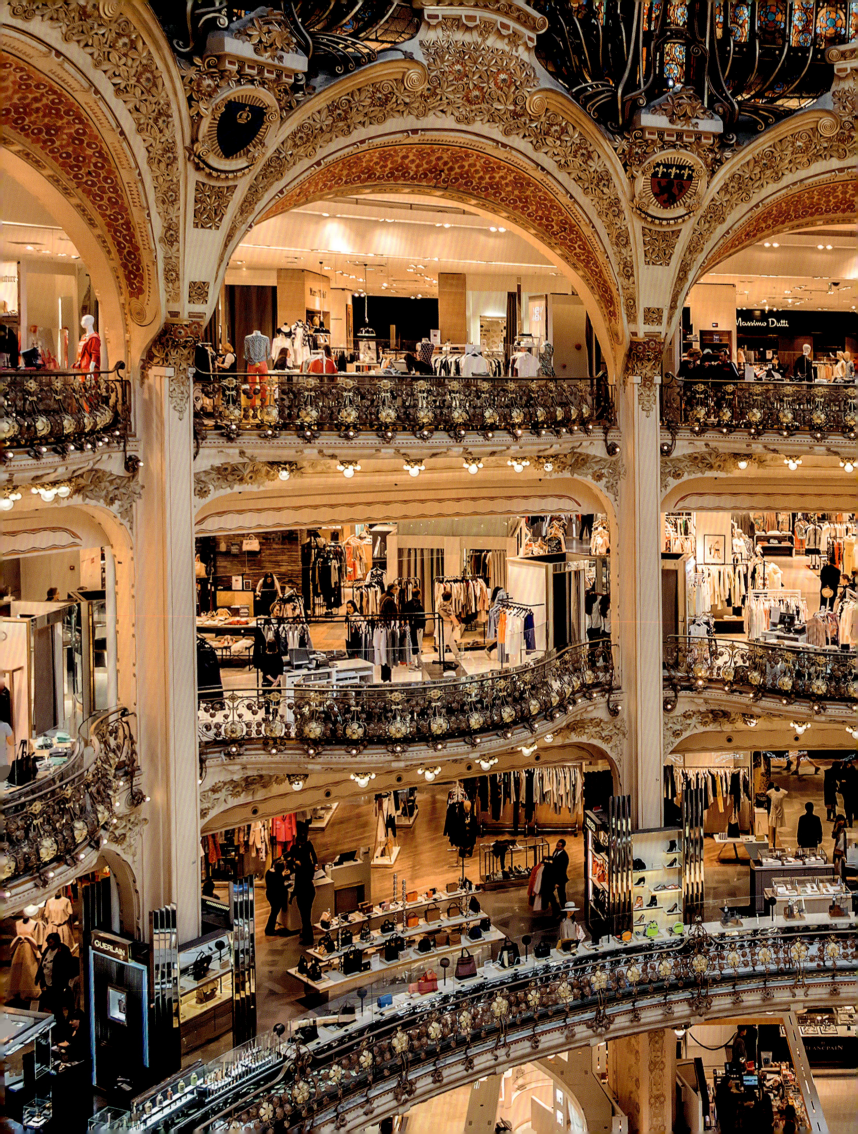

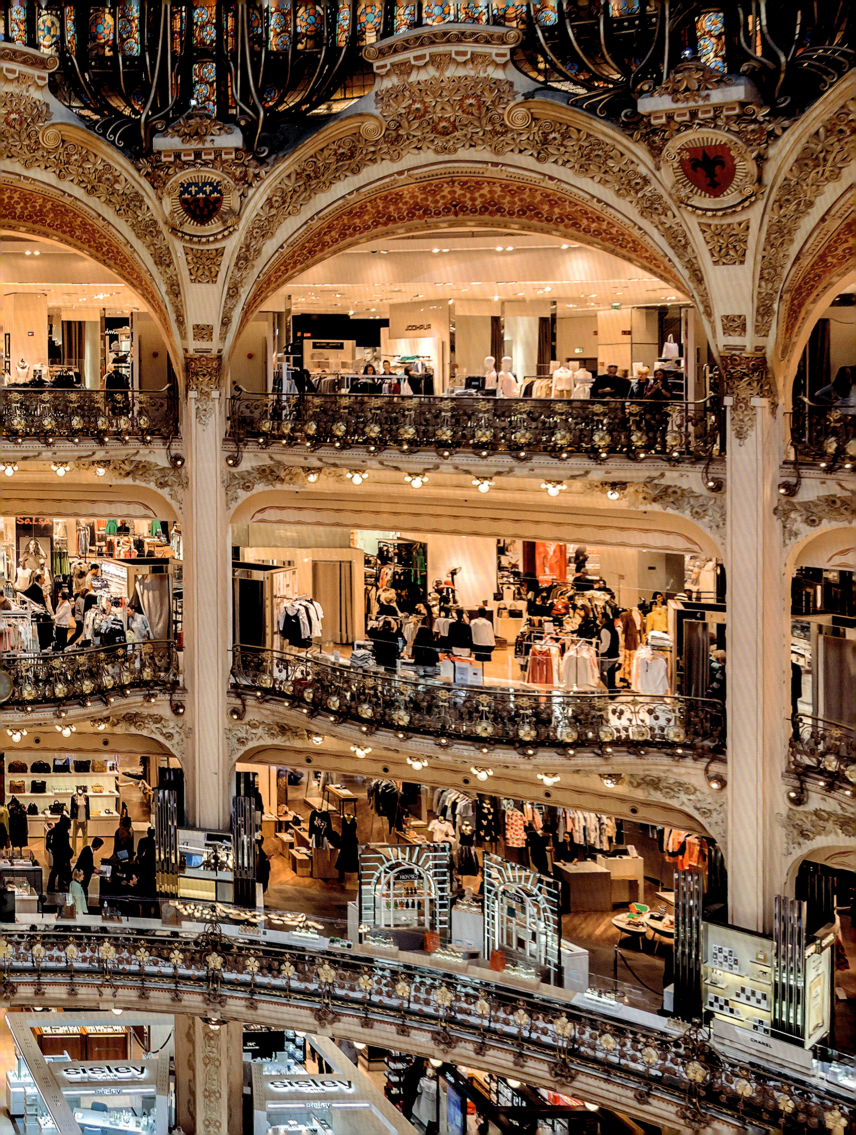

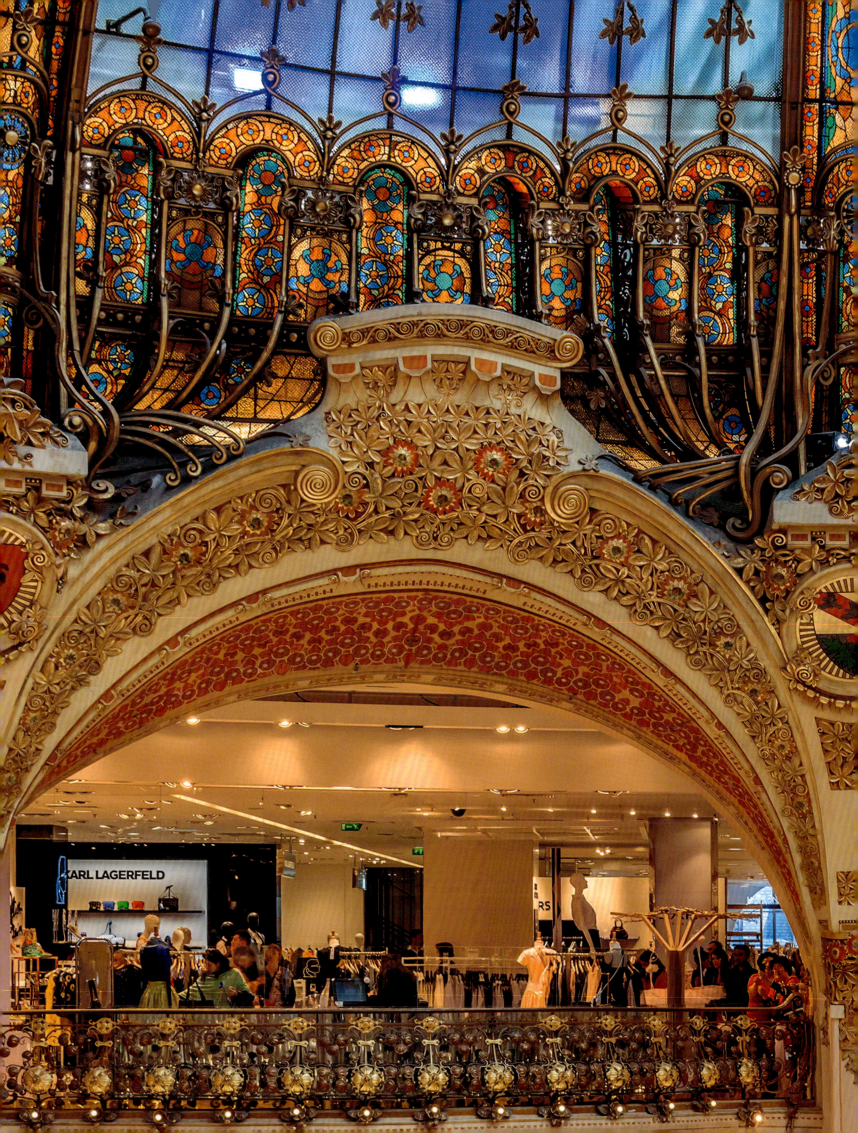

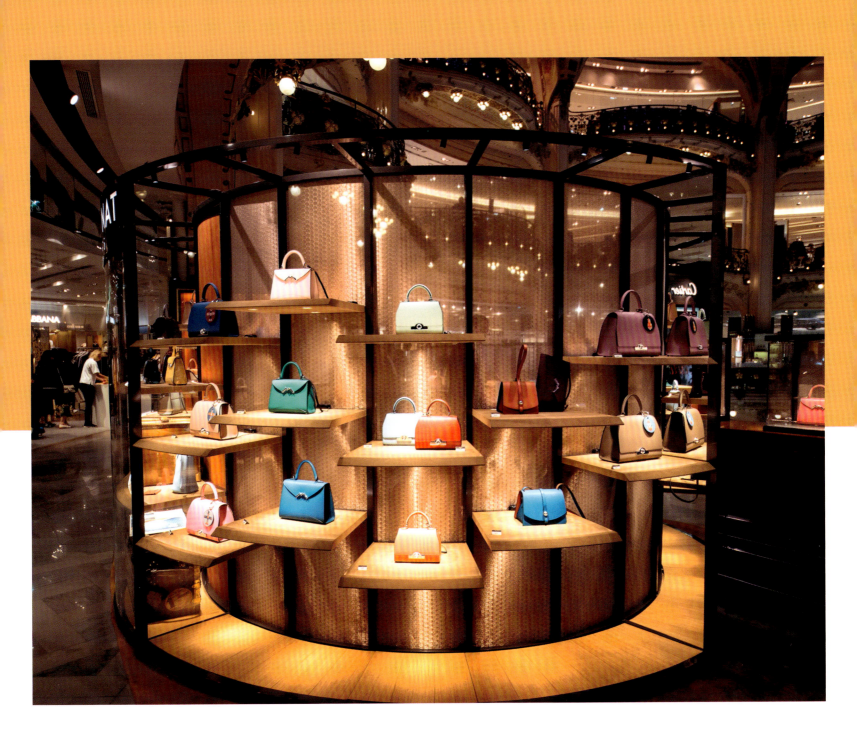

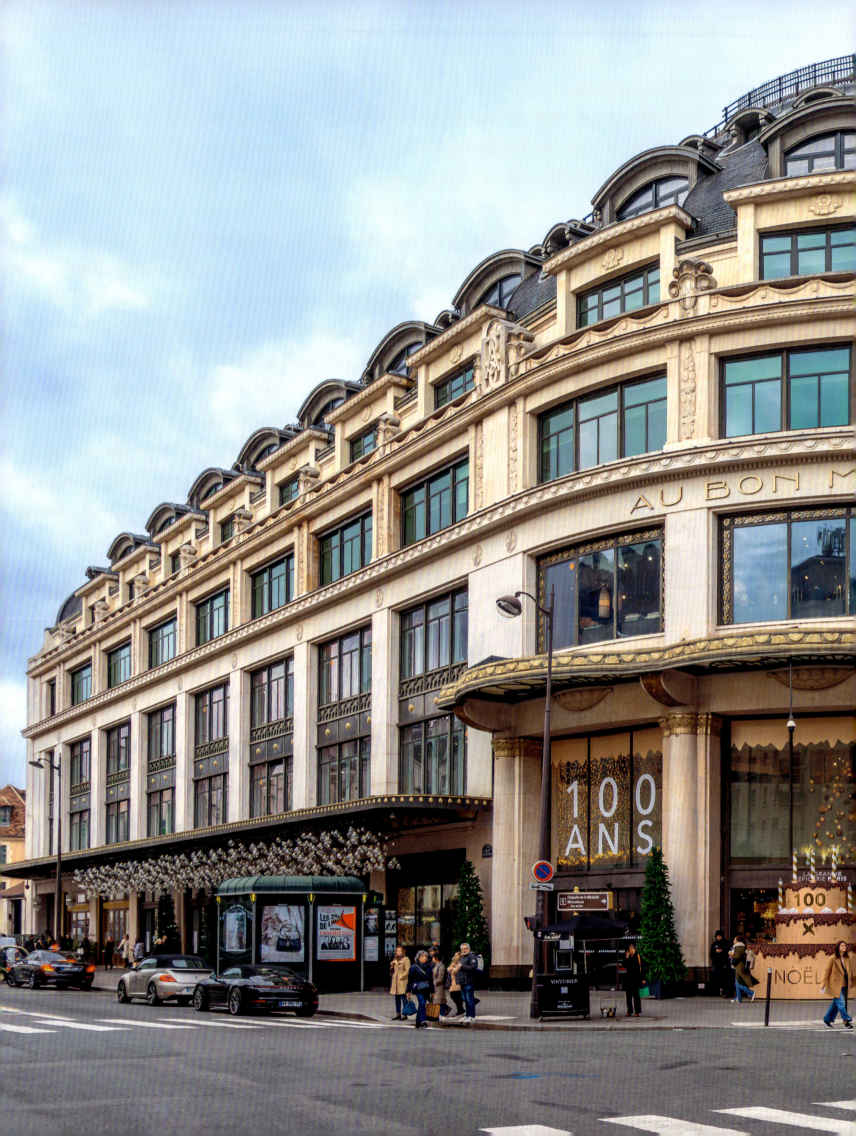

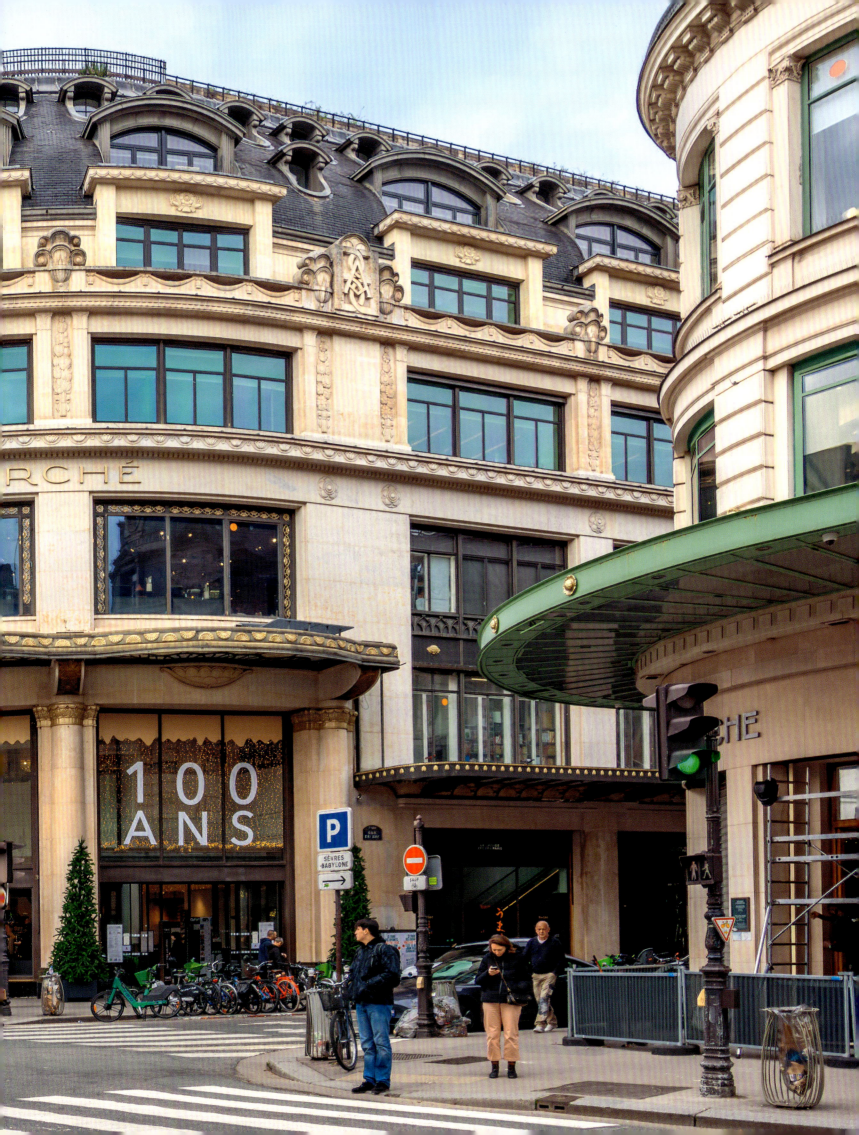

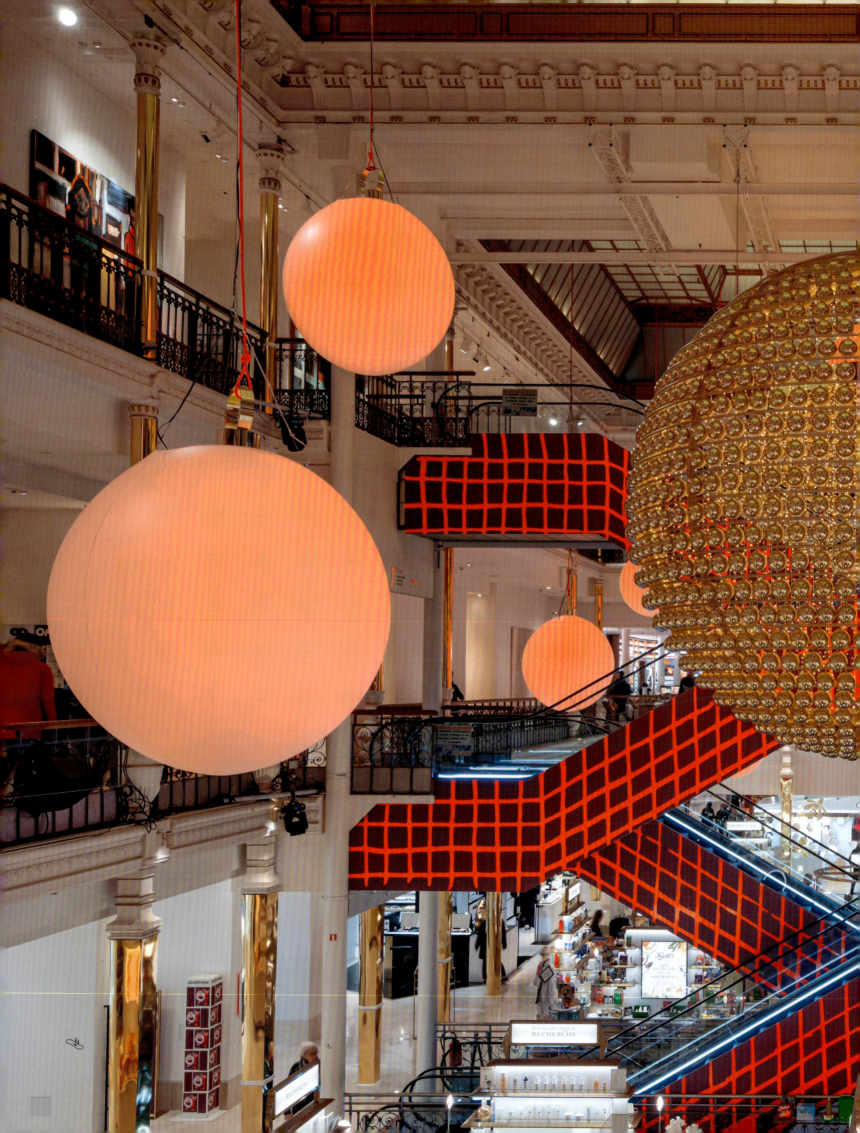

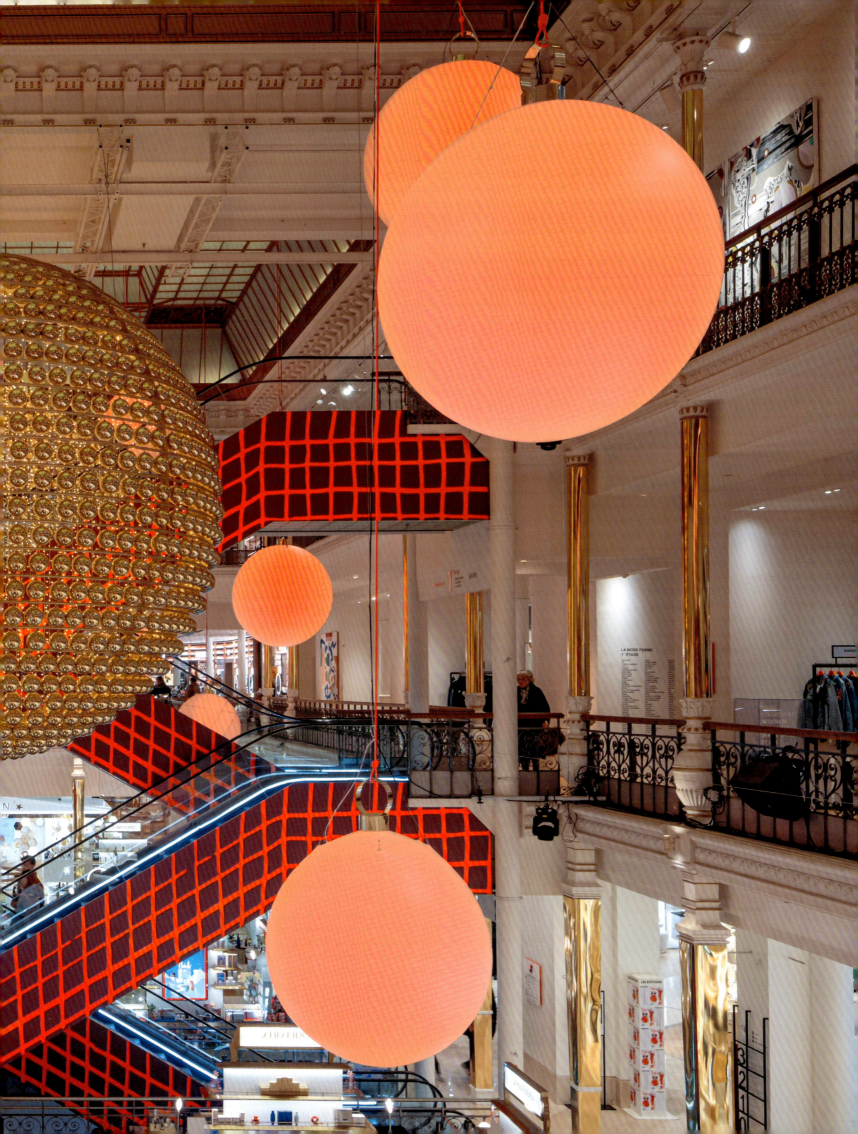

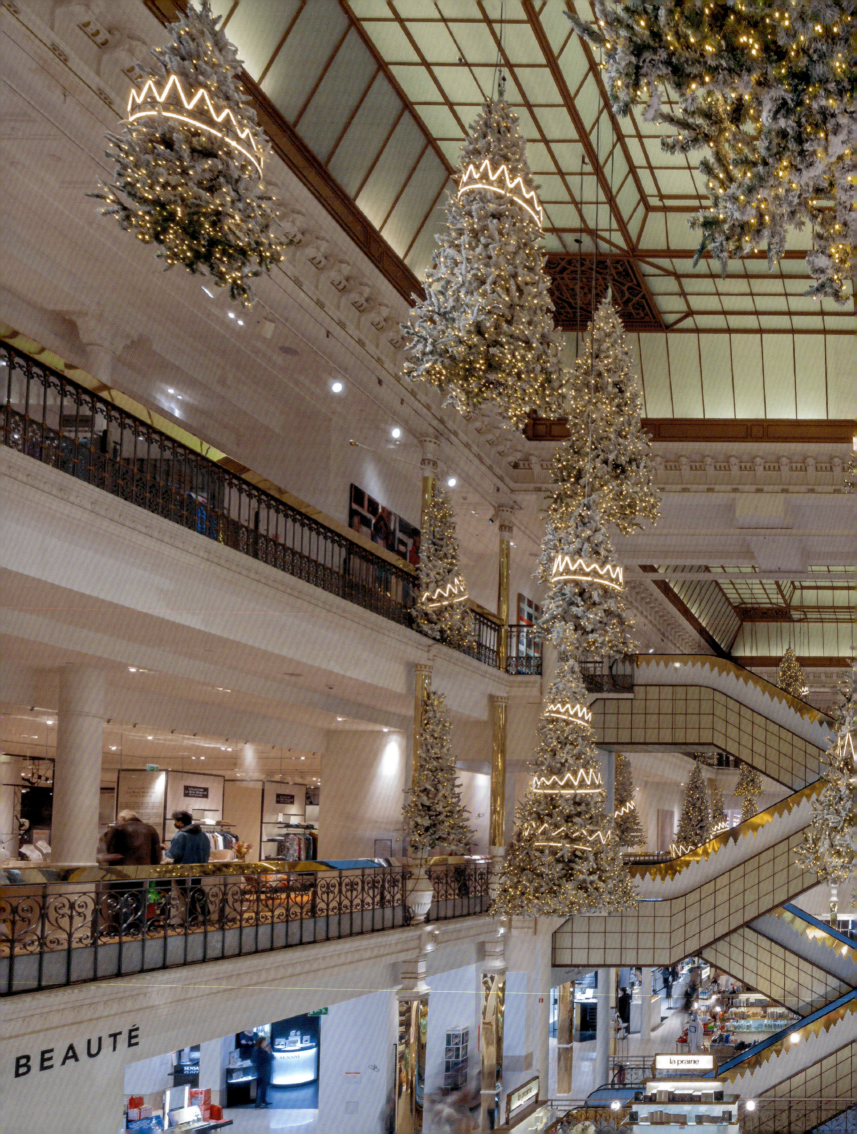

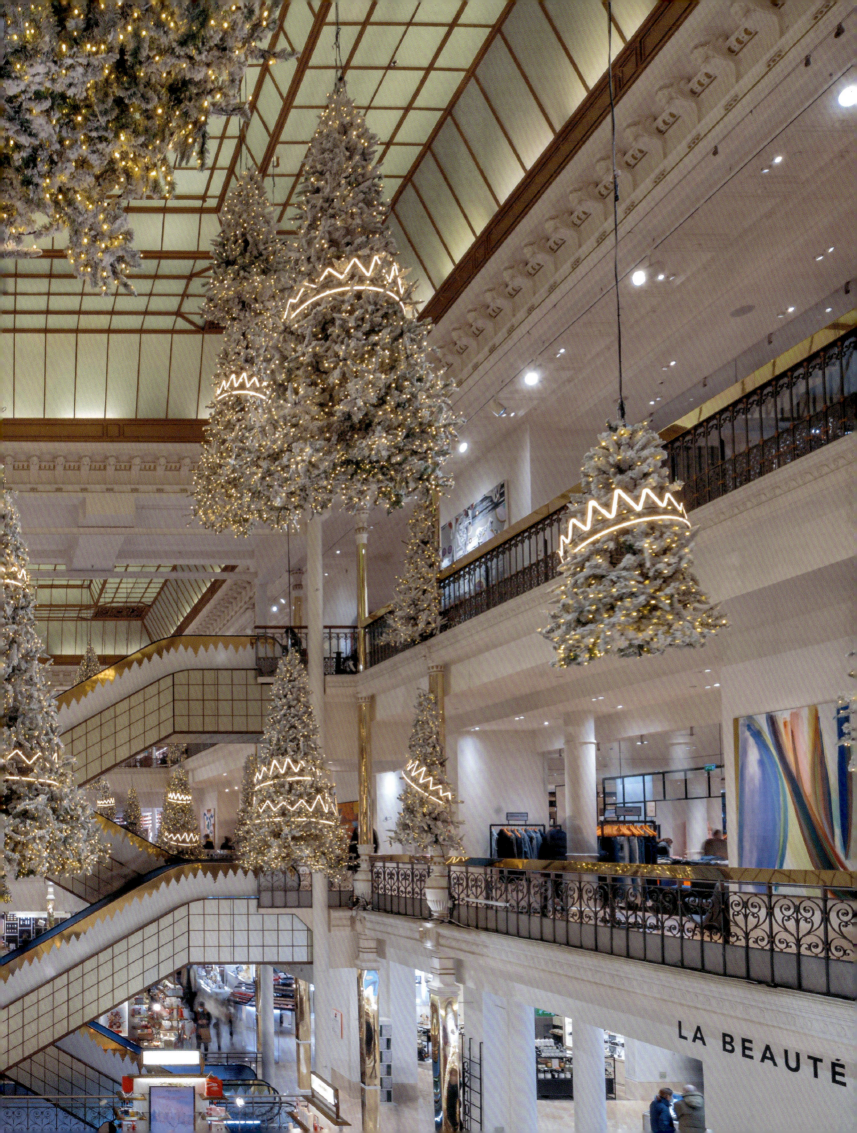

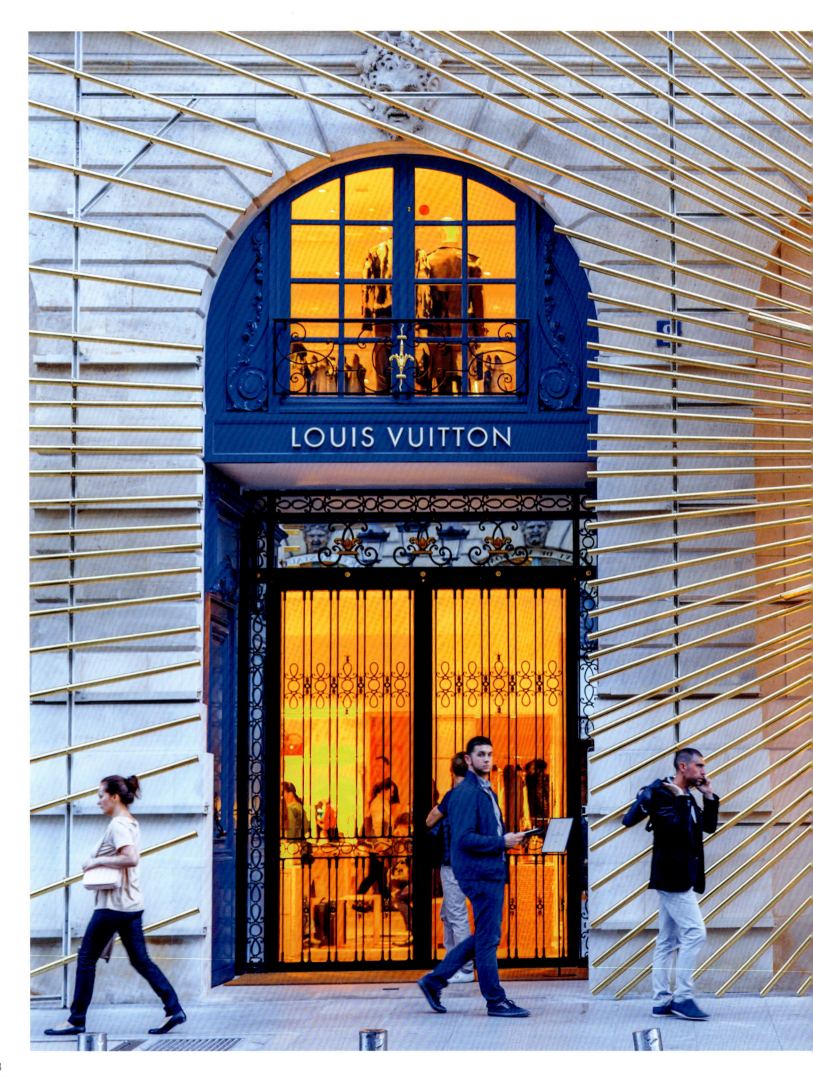

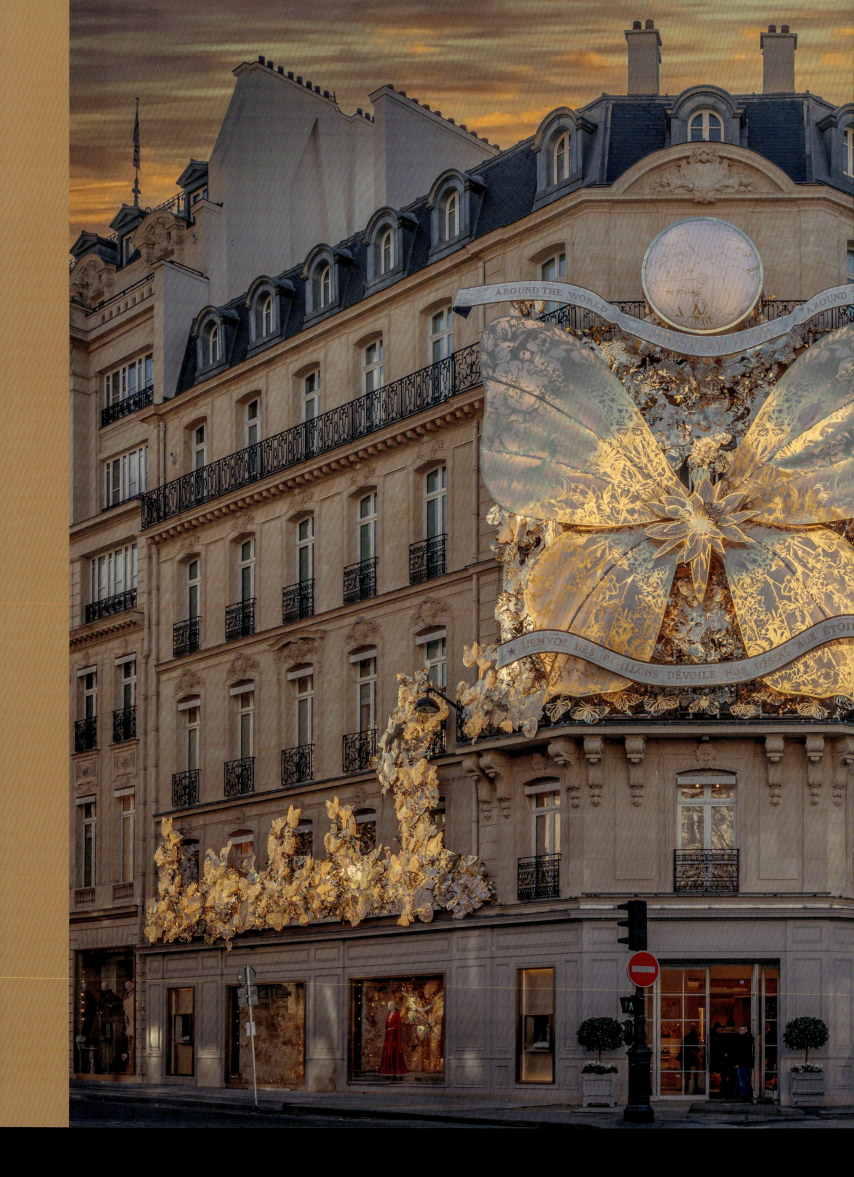

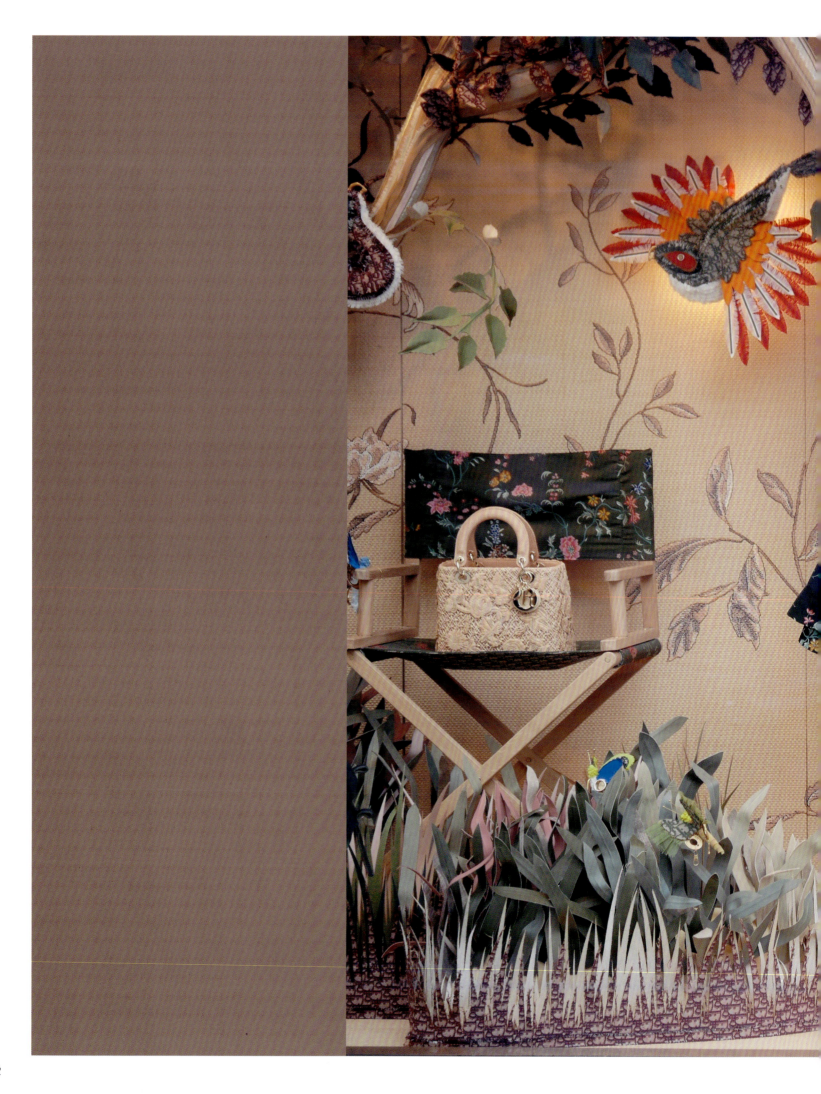

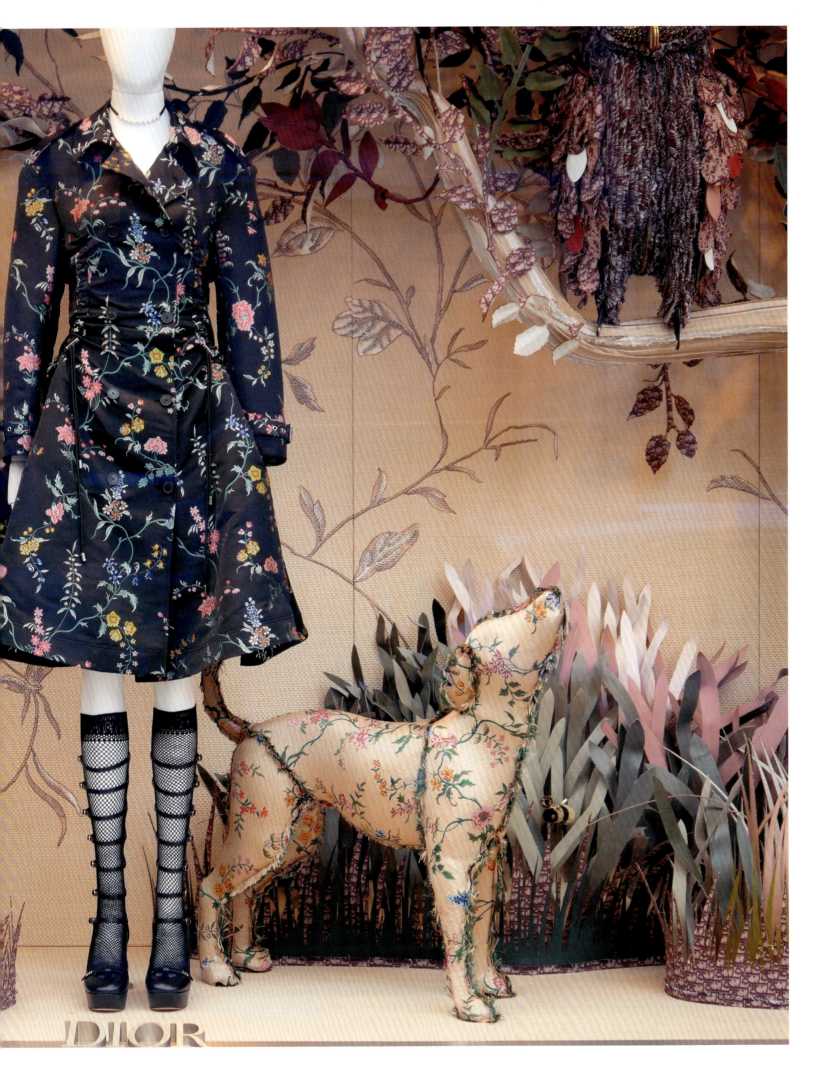

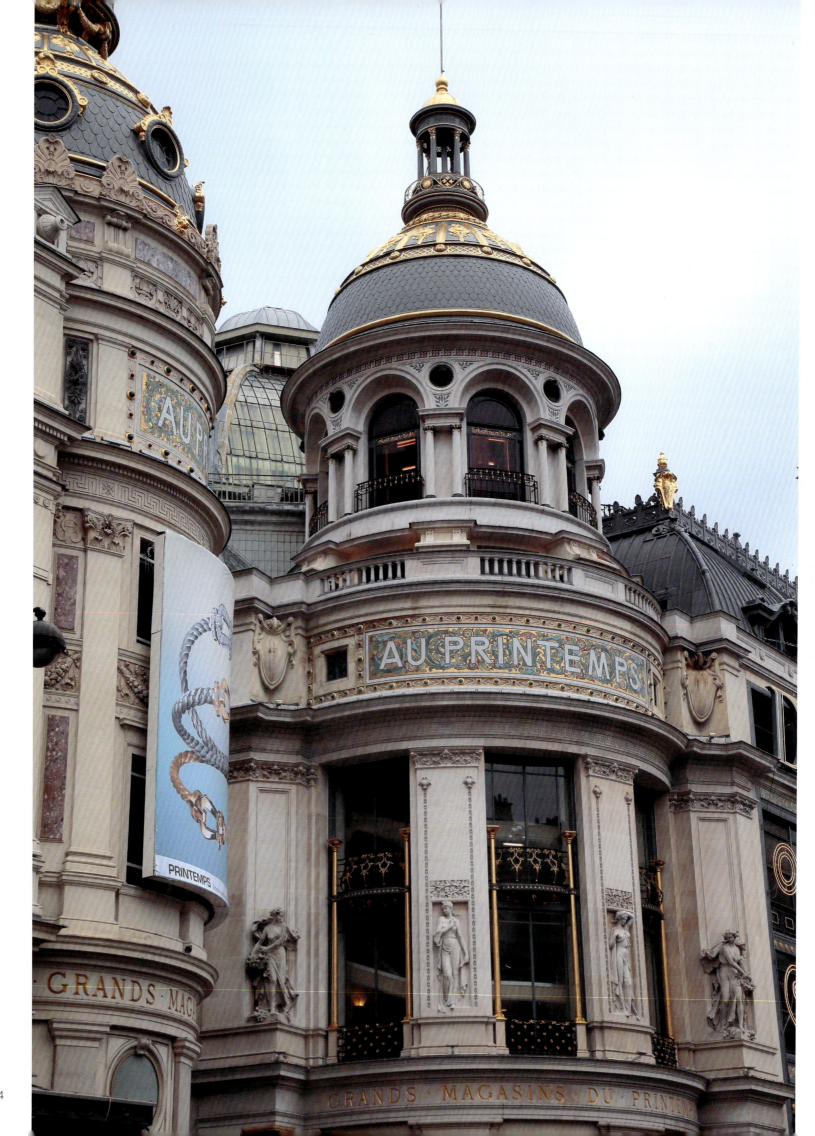

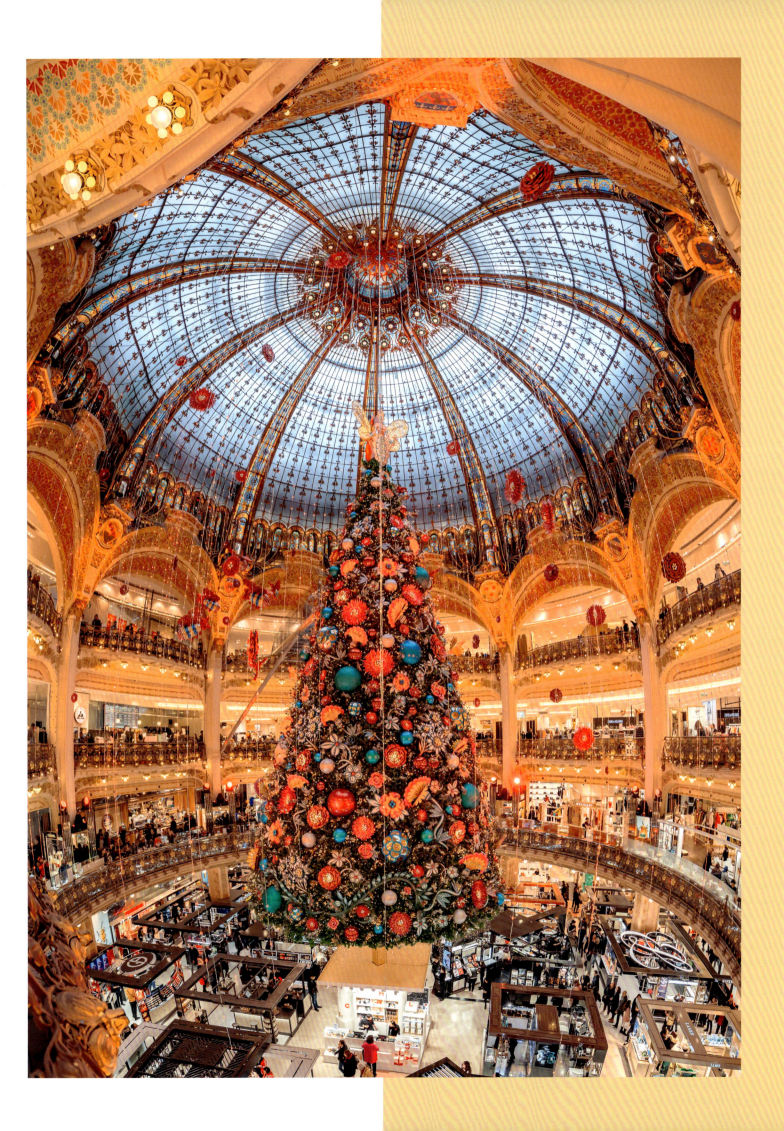

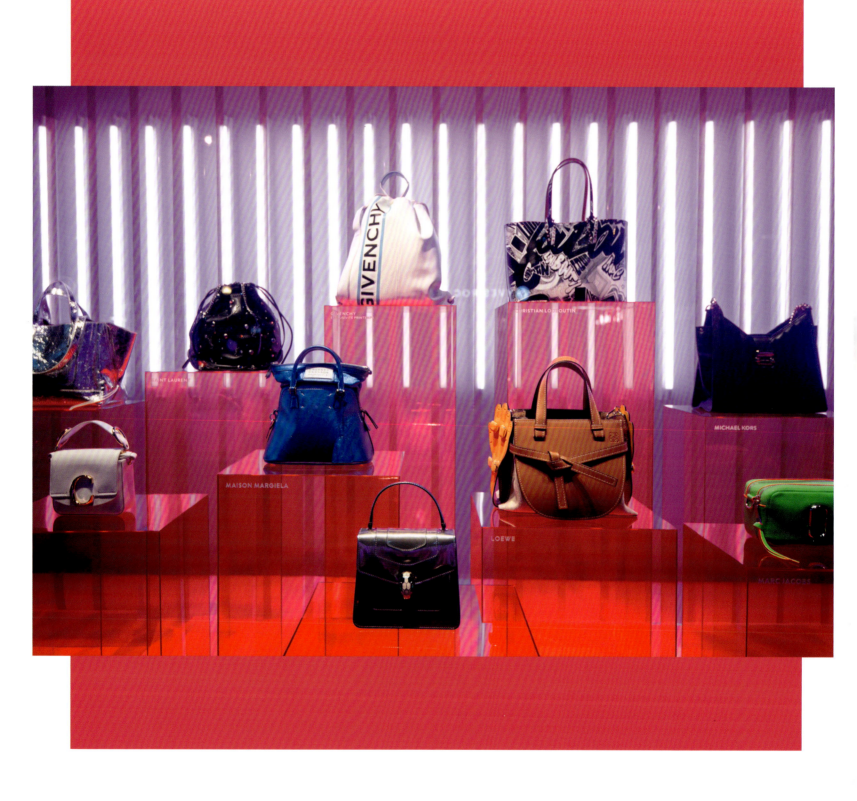

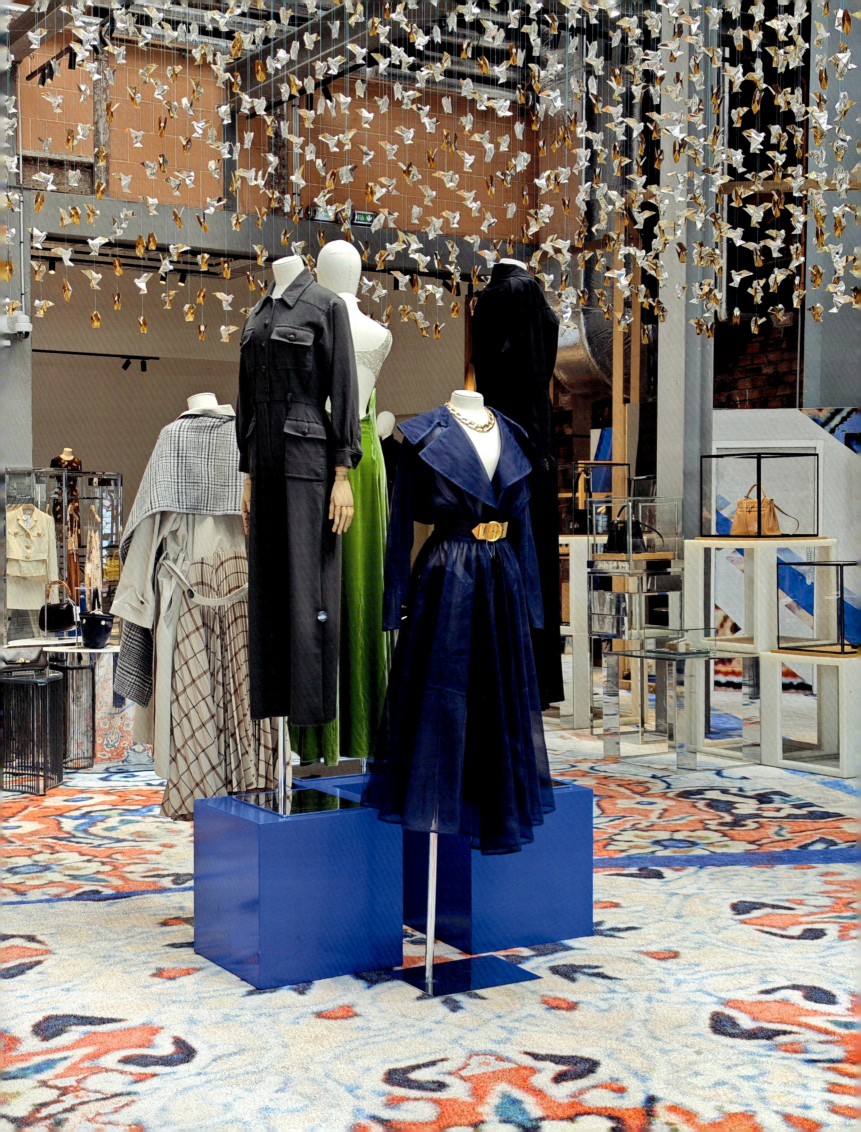

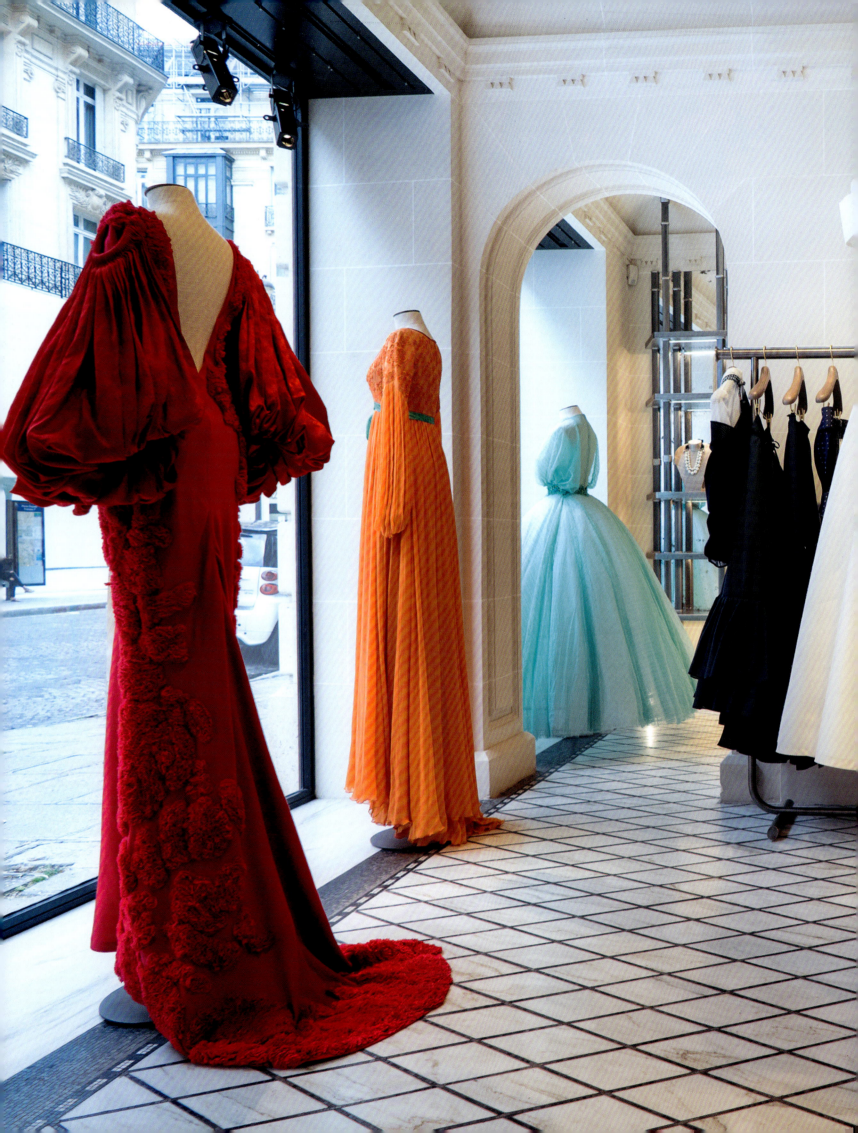

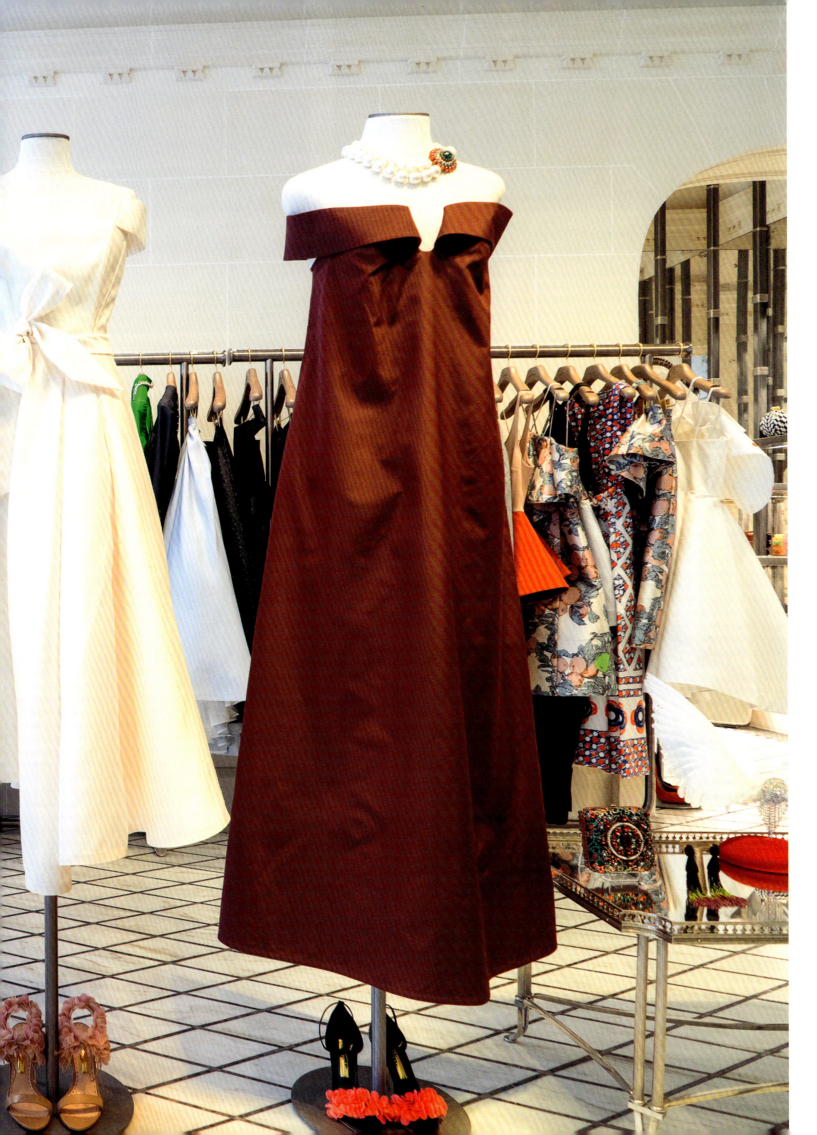

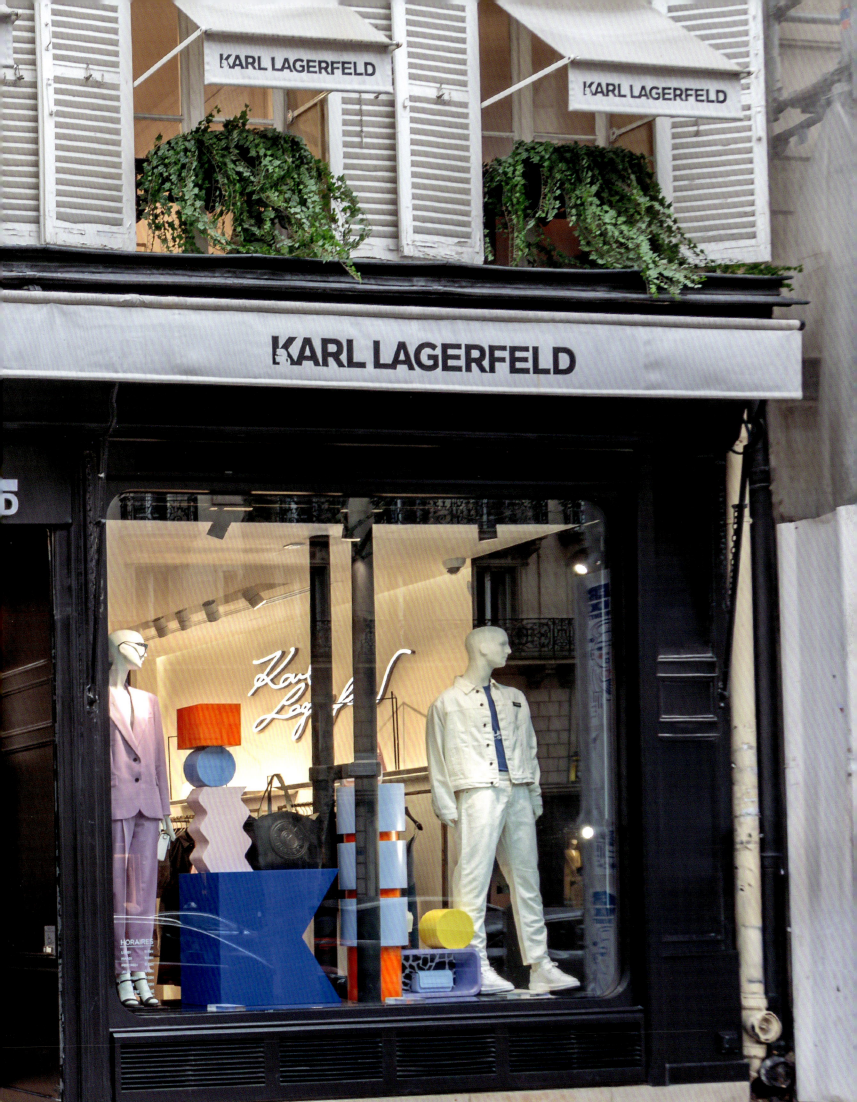

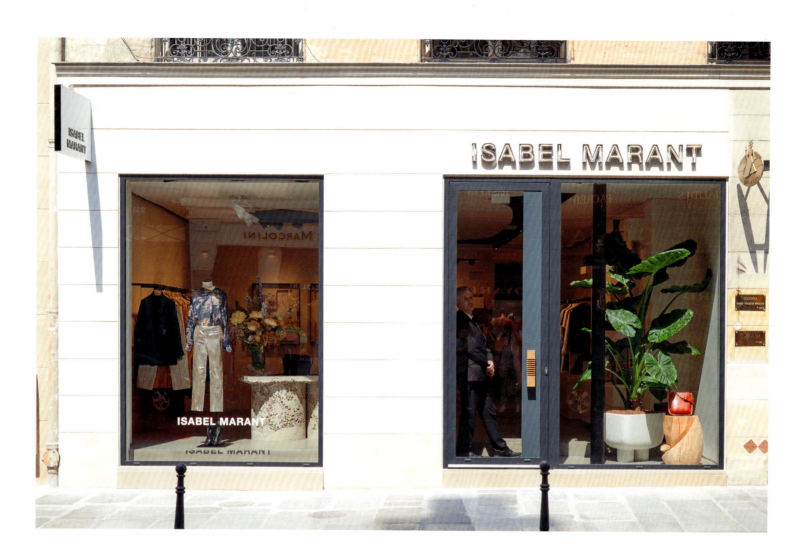

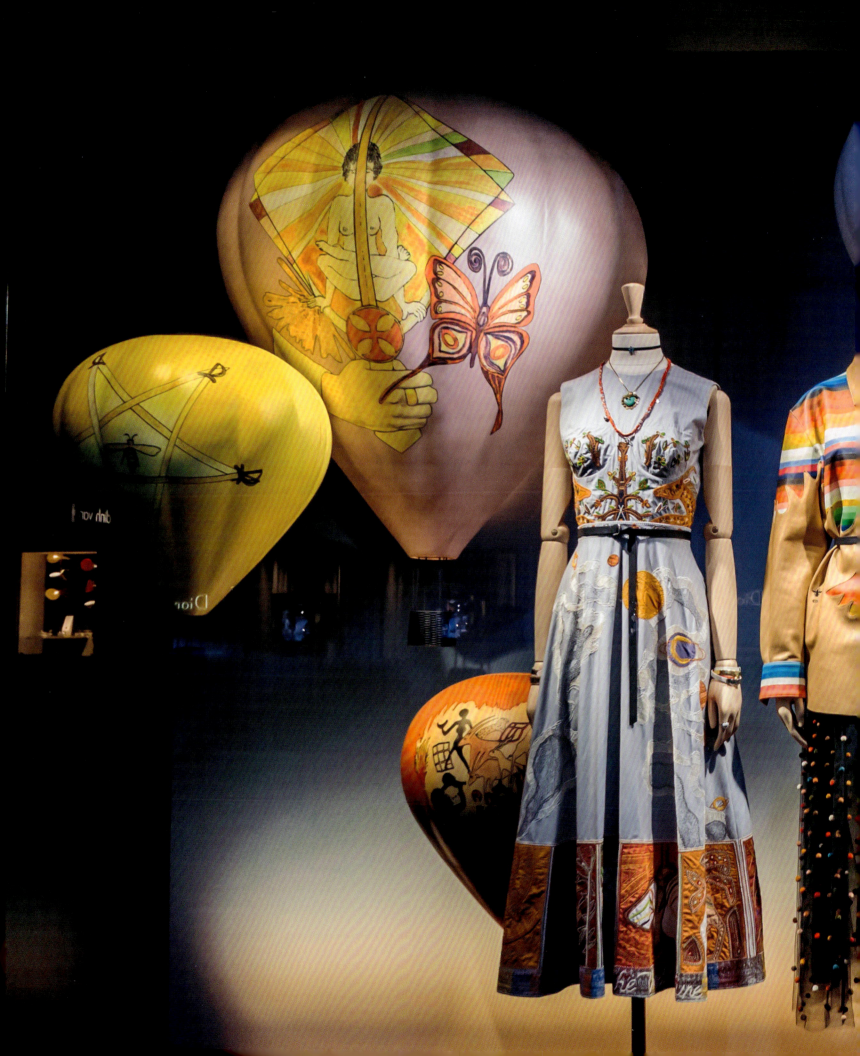

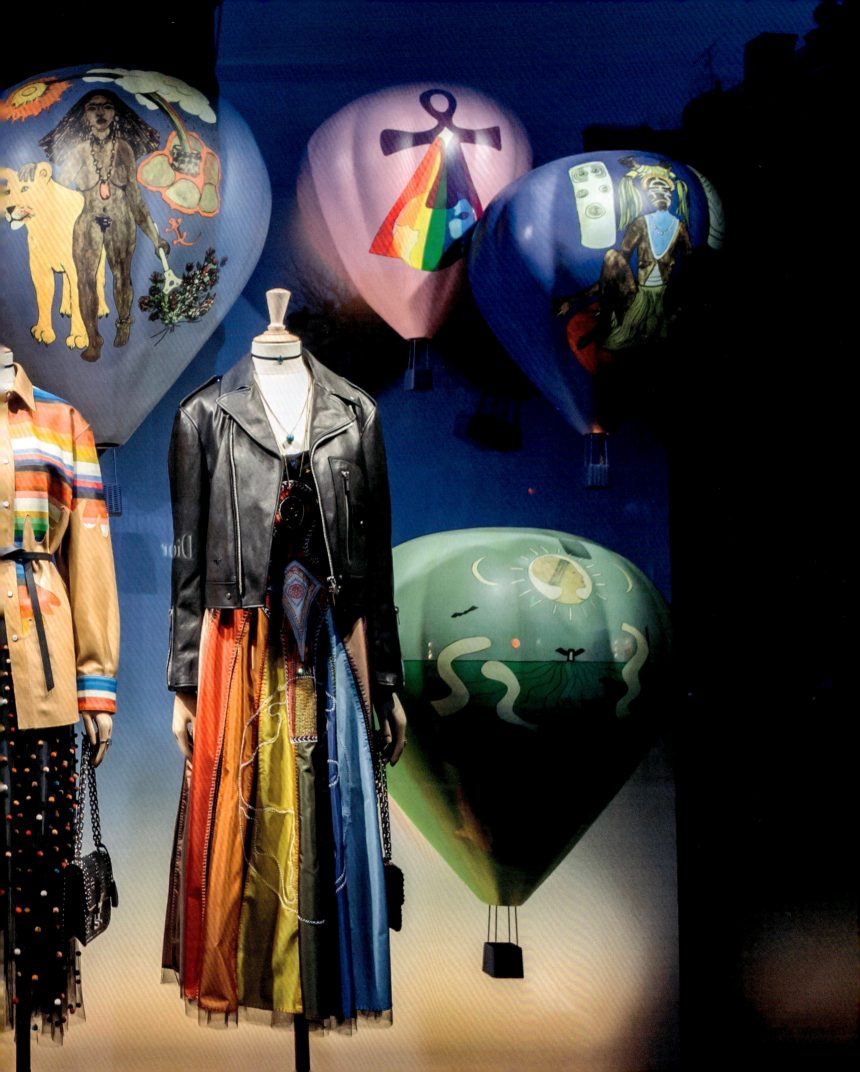

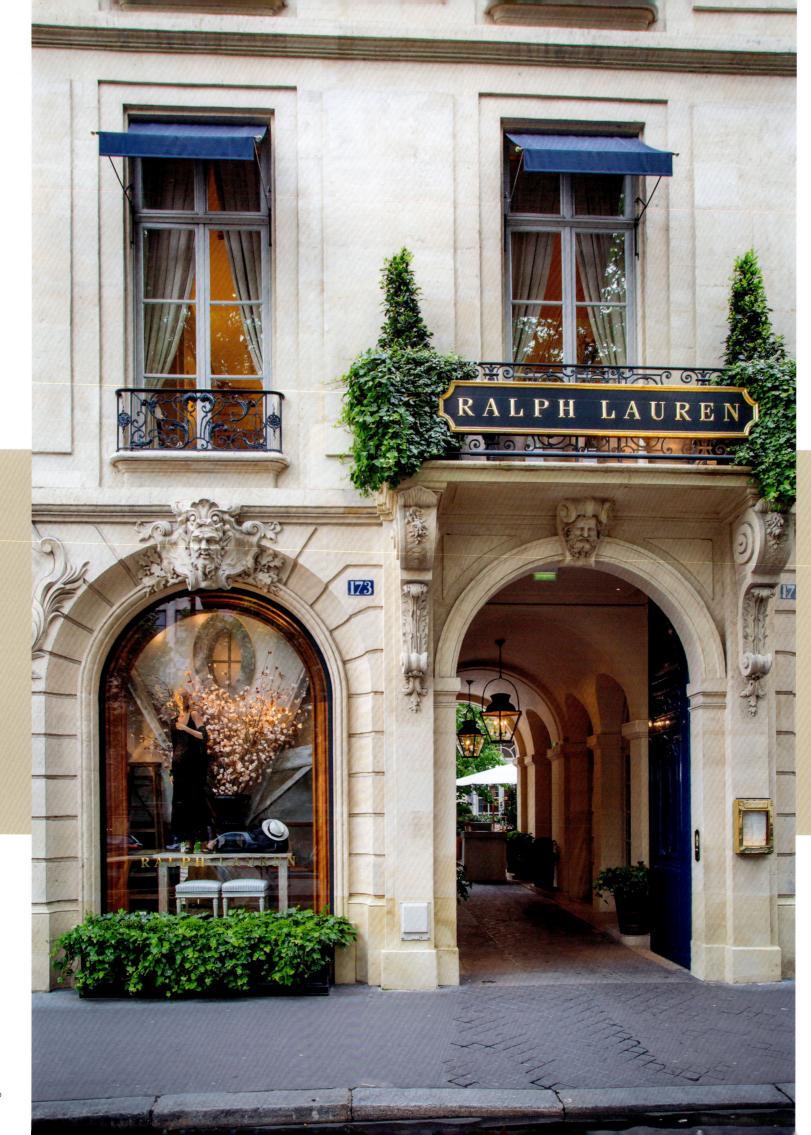

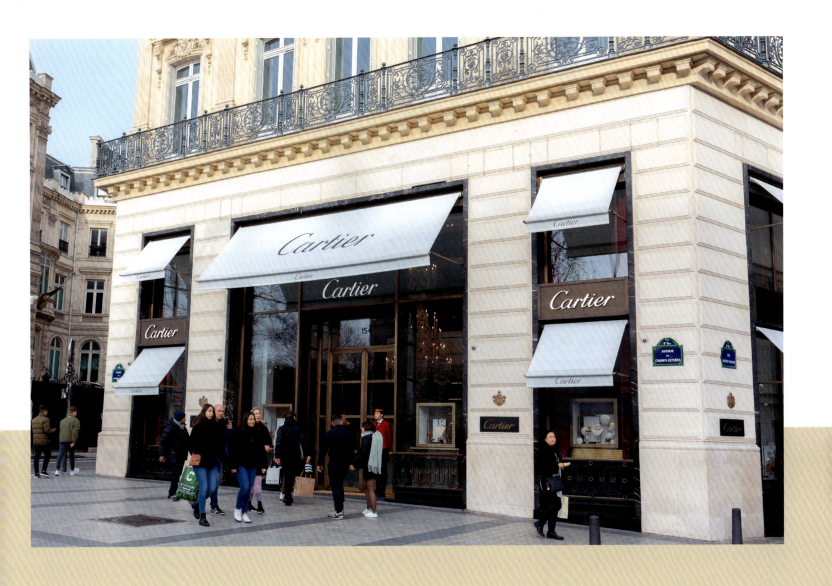

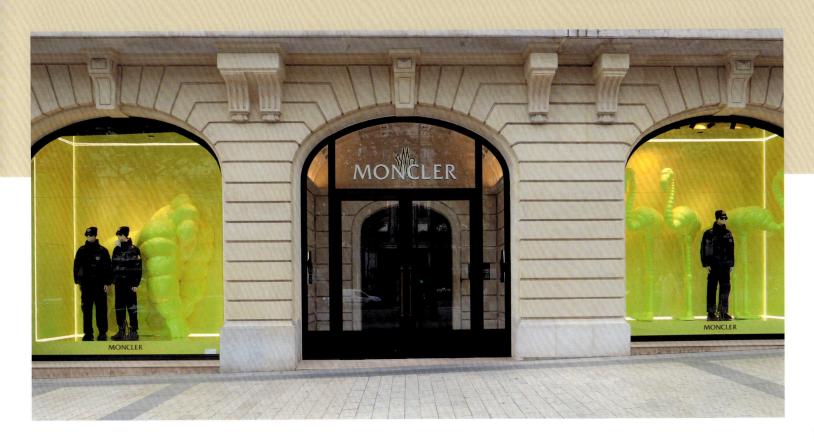

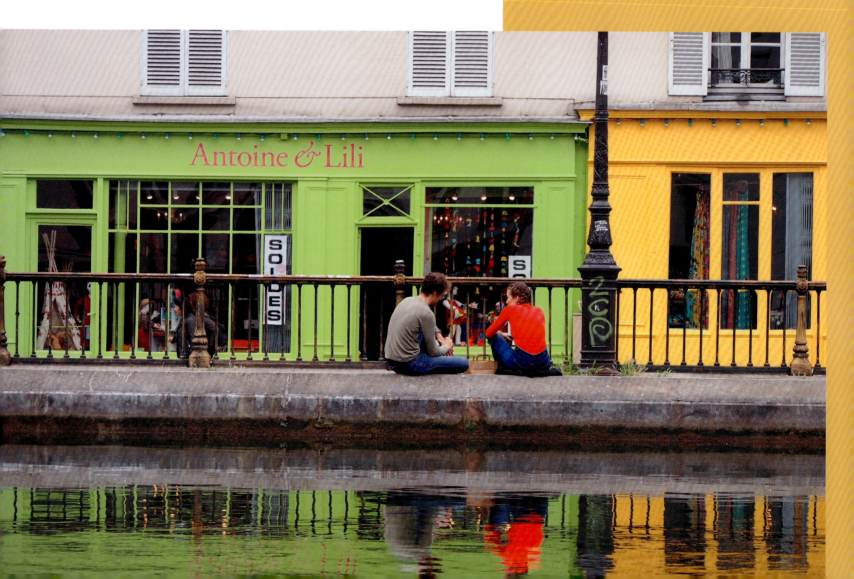

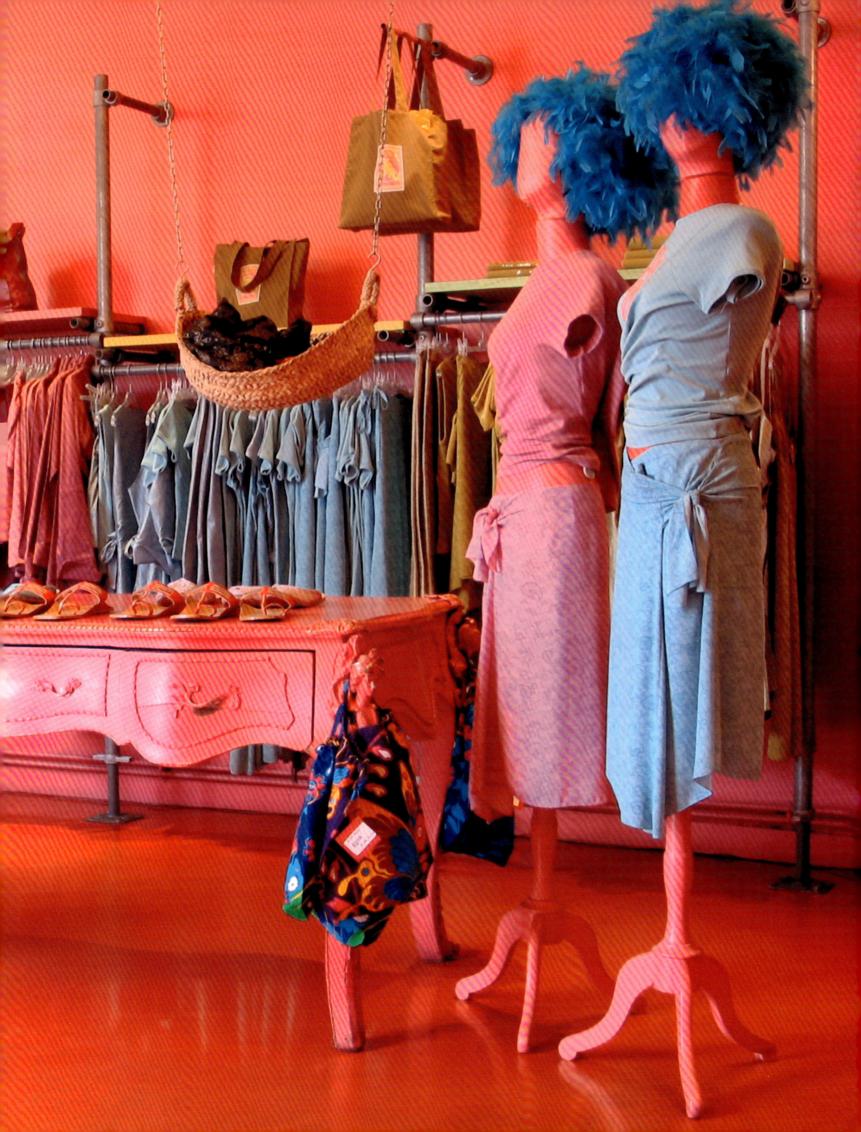

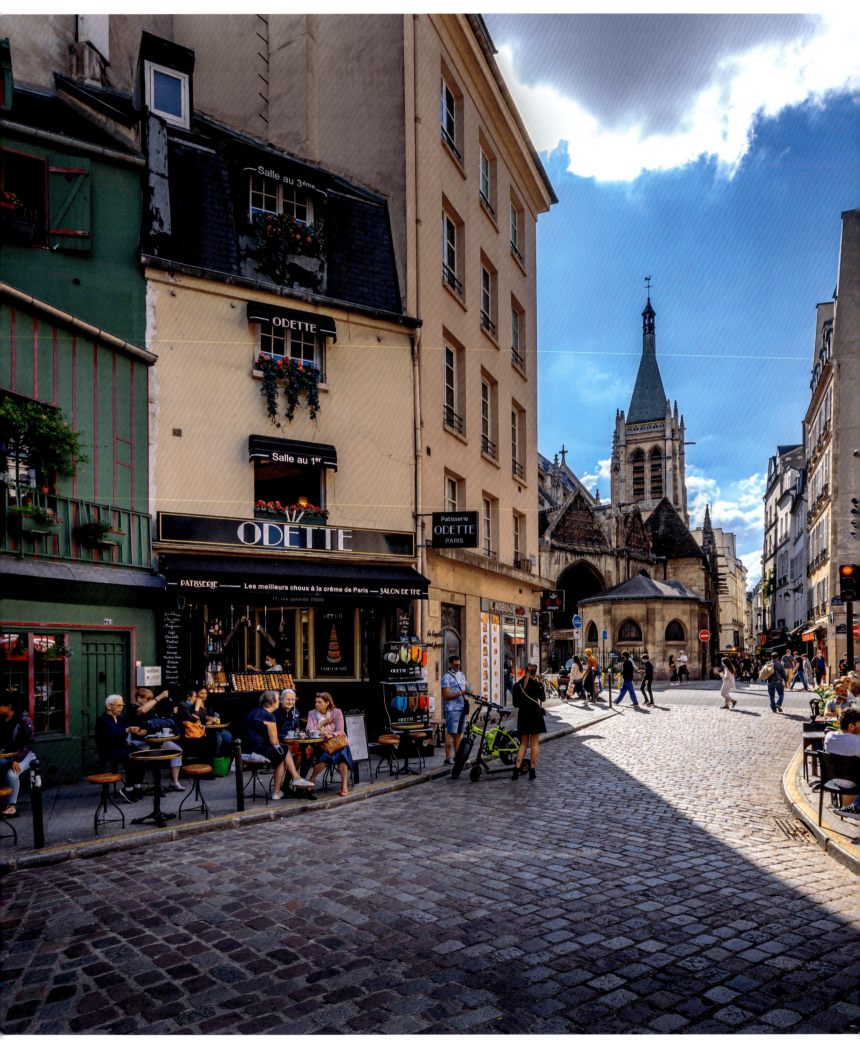

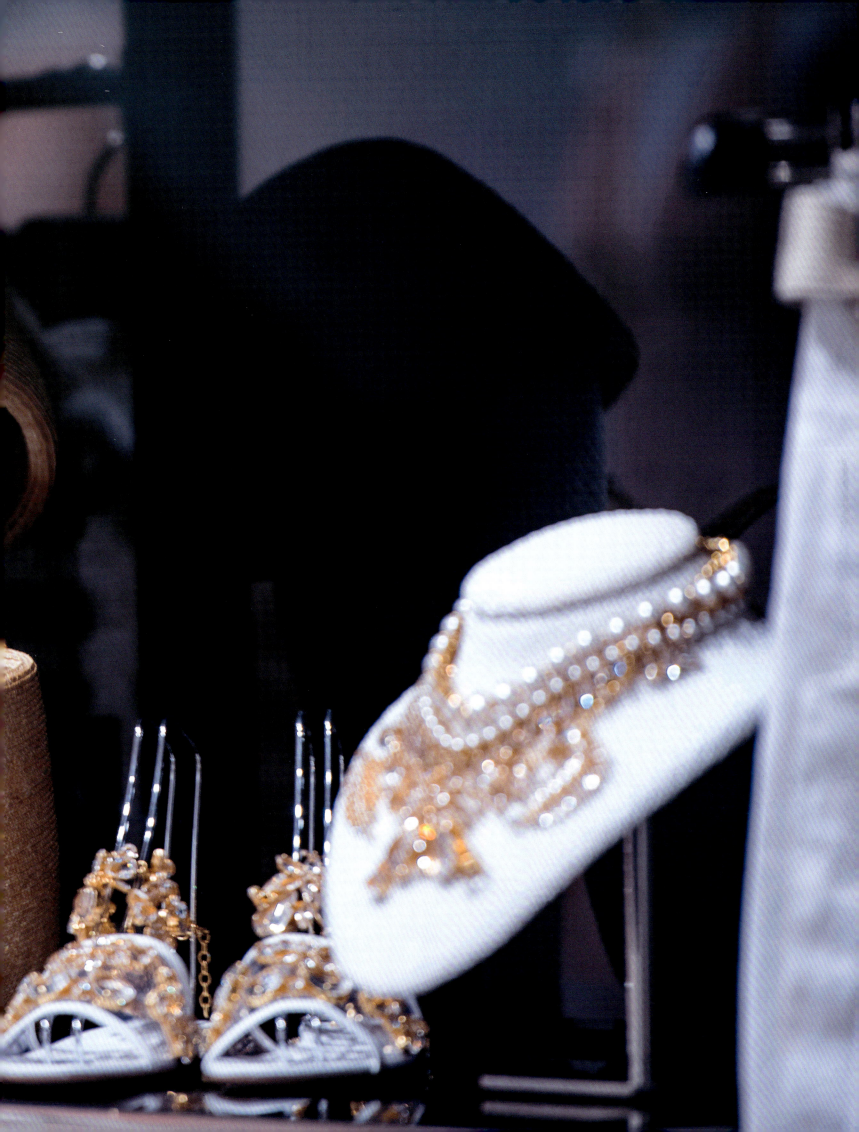

Chanel's pop-up boutique at Hôtel Amelot de Bisseuil, Marais district, January 2017.

At the Christian Dior headquarters, 30 avenue Montaigne.

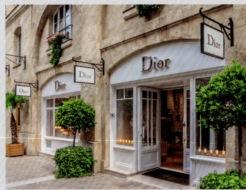

A hotspot for high-end shopping: The Village Royal, 25 rue Royale.

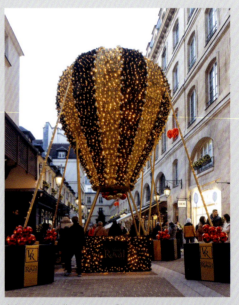

A hot-air balloon as a Christmas decoration: the start of the festive season at Village Royal, December 2023.

An inventive window display.

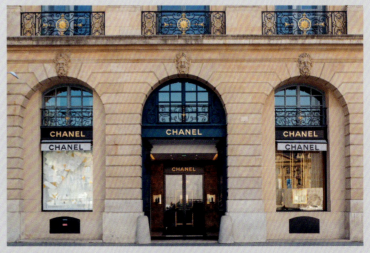

The Chanel boutique at Place Vendôme.

Avenue Montaigne is home to some of the most exclusive fashion boutiques in Paris.

Rue du Faubourg Saint Honoré is the epicentre of luxury fashion in Paris.

Givenchy's headquarters, avenue George V.

A hidden gem for celebrities: the five-star Château des Fleurs boutique hotel and spa, rue Vernet.

Maison Margiela, avenue Montaigne.

Paco Rabanne, avenue Montaigne.

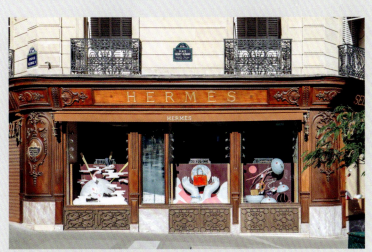

The historic Hermès boutique on avenue George V.

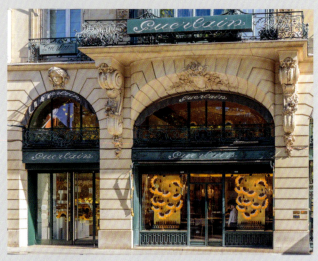
The Guerlain flagship store on avenue des Champs-Elysées.

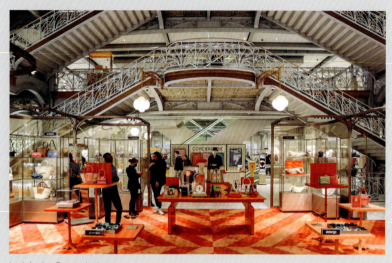
Detail of the Art Nouveau façade of La Samaritaine.

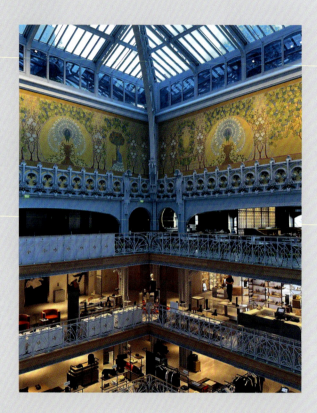

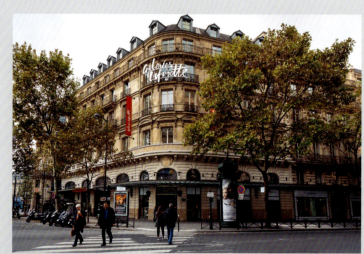
Inside La Samaritaine.

The atmosphere of the Parisian Belle Époque survives in the Art Nouveau decoration of La Samaritaine.

Giant, temporary sculpture of Japanese pop artist Yayoi Kusama painting the Samaritaine to celebrate her collaboration with Louis Vuitton.

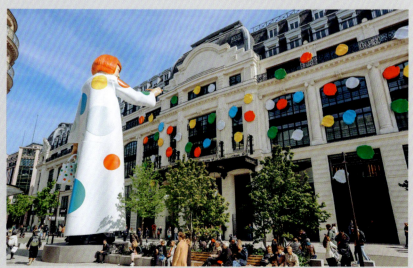

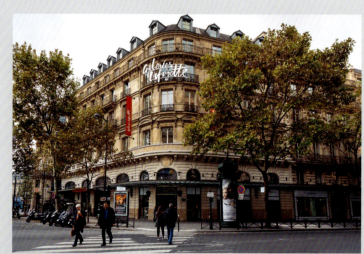
Galeries Lafayette.

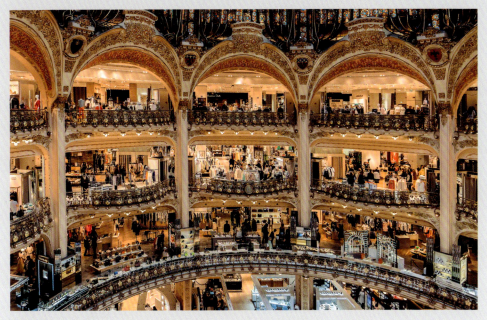
View of Galeries Lafayette's main hall.

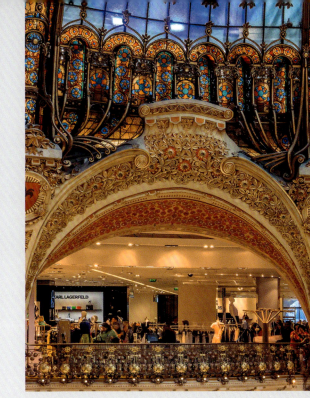
Detail of the decoration, Galeries Lafayette.

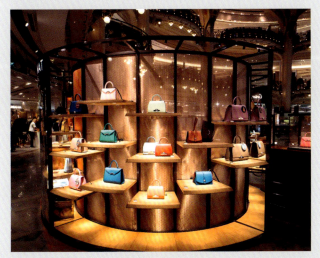
Handbags on display, Galeries Lafayette.

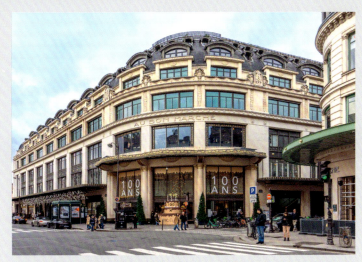
The Bon Marché storefront in the 7th arrondissement.

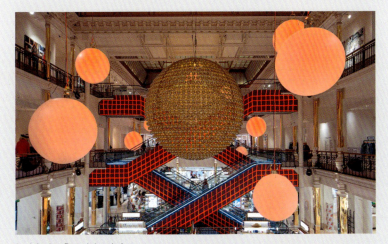
Inside Le Bon Marché.

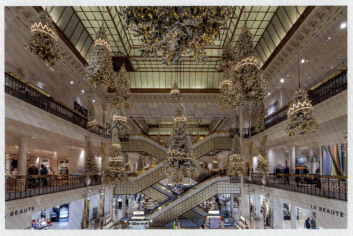
Christmas decoration at Le Bon Marché.

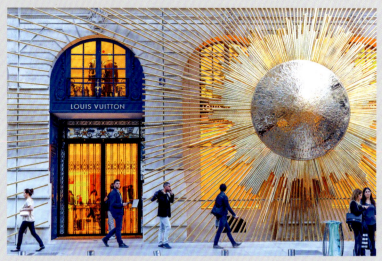

Louis Vuitton Maison Vendôme at Place Vendôme.

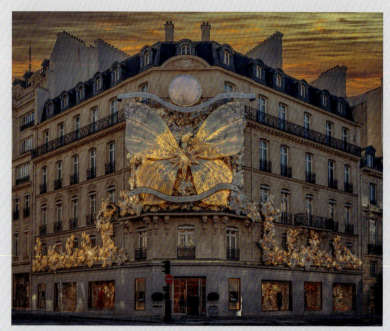

The newly renovated 10,000 square-metre Christian Dior flagship store on avenue Montaigne also houses a gallery dedicated to the brand's history, a restaurant and a pâtisserie.

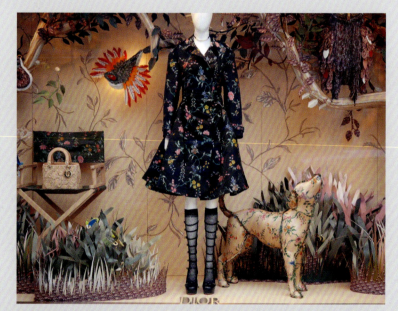

A display window at the Christian Dior flagship store on avenue Montaigne.

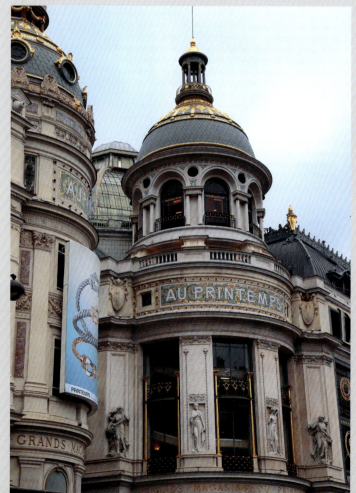

One of the corner rotundas that characterise the Printemps building on boulevard Haussmann.

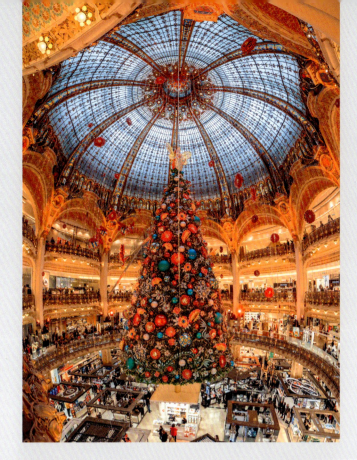

Printemps's giant Christmas tree under the glass roof.

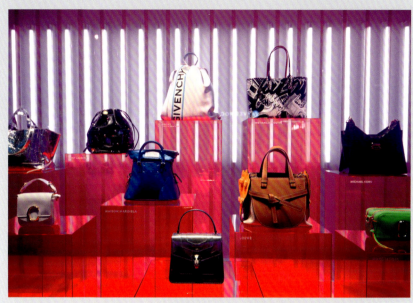

Handbags on display at the Printemps department store on boulevard Haussmann.

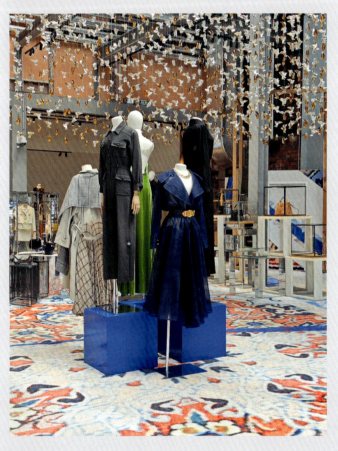

Inside the Printemps Paris fashion department.

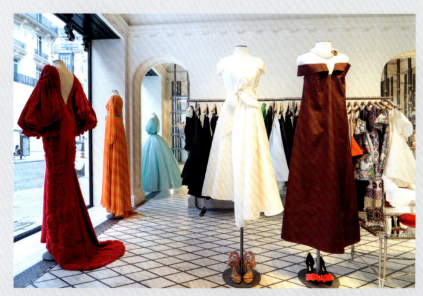

Inside the exclusive fashion boutique Les Suites, rue Pierre Charron.

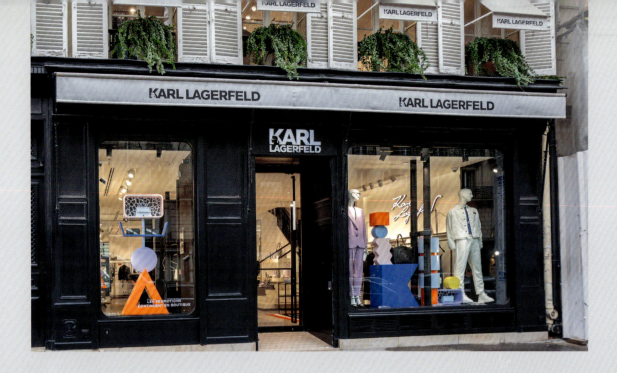

Karl Lagerfeld store at boulevard Saint-Germain.

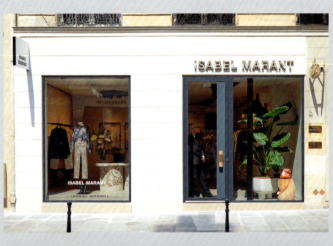

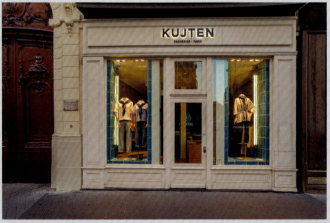

The old district of Le Marais, near Bastille, is home to many fashion stores.

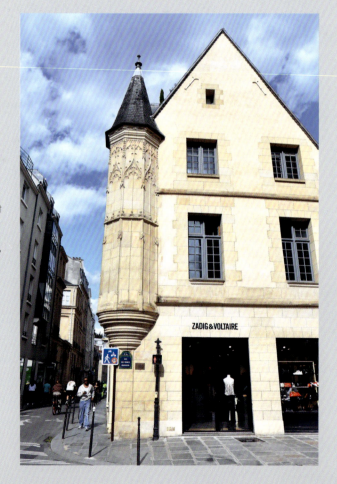

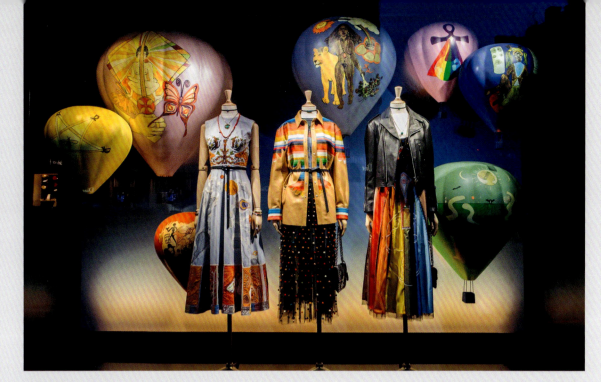

Dior window display,
avenue Montaigne, 2017.

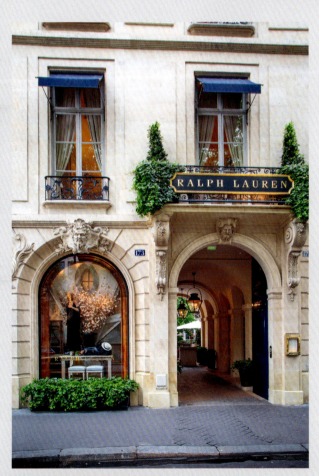

Ralph Lauren shop and restaurant in St-Germain.

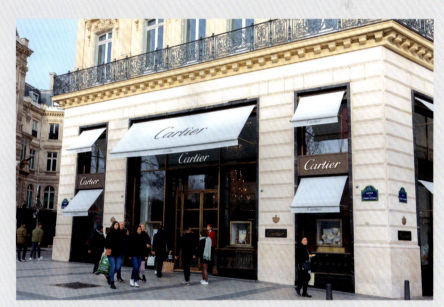

Cartier store at Champs-Elysées.

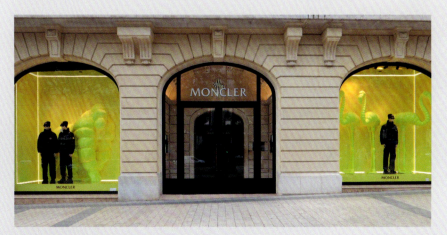

Moncler flagship store at Champs-Elysées.

Quai de Valmy is a peaceful walkway along the Canal Saint-Martin.

The trendy, bohemian-chic atmosphere of Canal Saint-Martin.

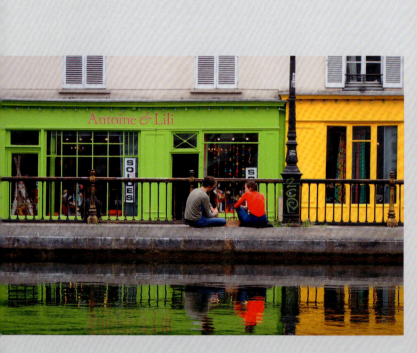

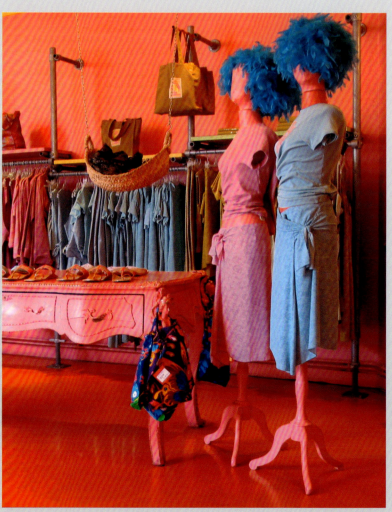

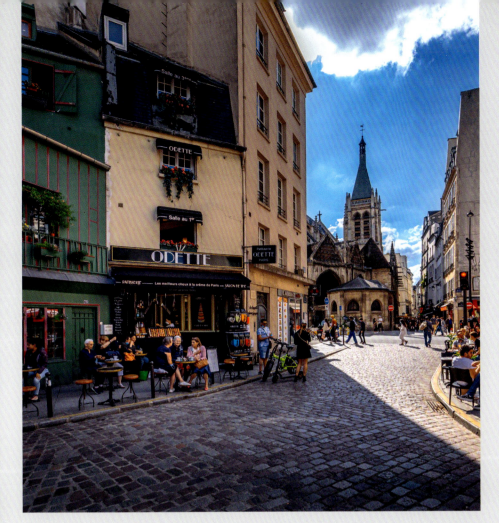

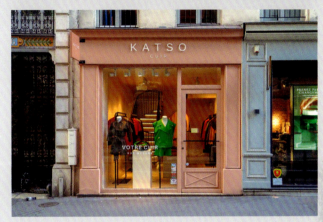

Once a lively student's district, Quartier Latin is now home to avant-garde fashion stores.

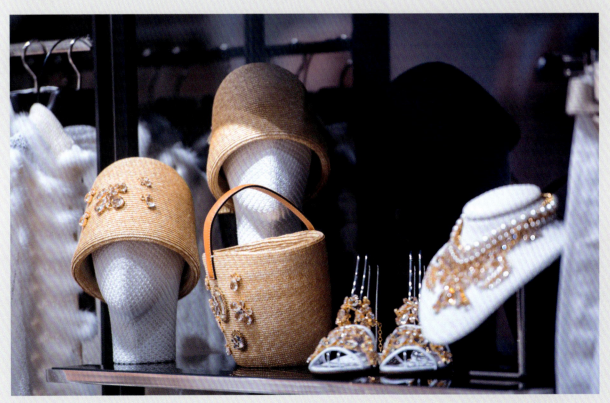

Another beautiful Parisian window display.

ONLY IN PARIS

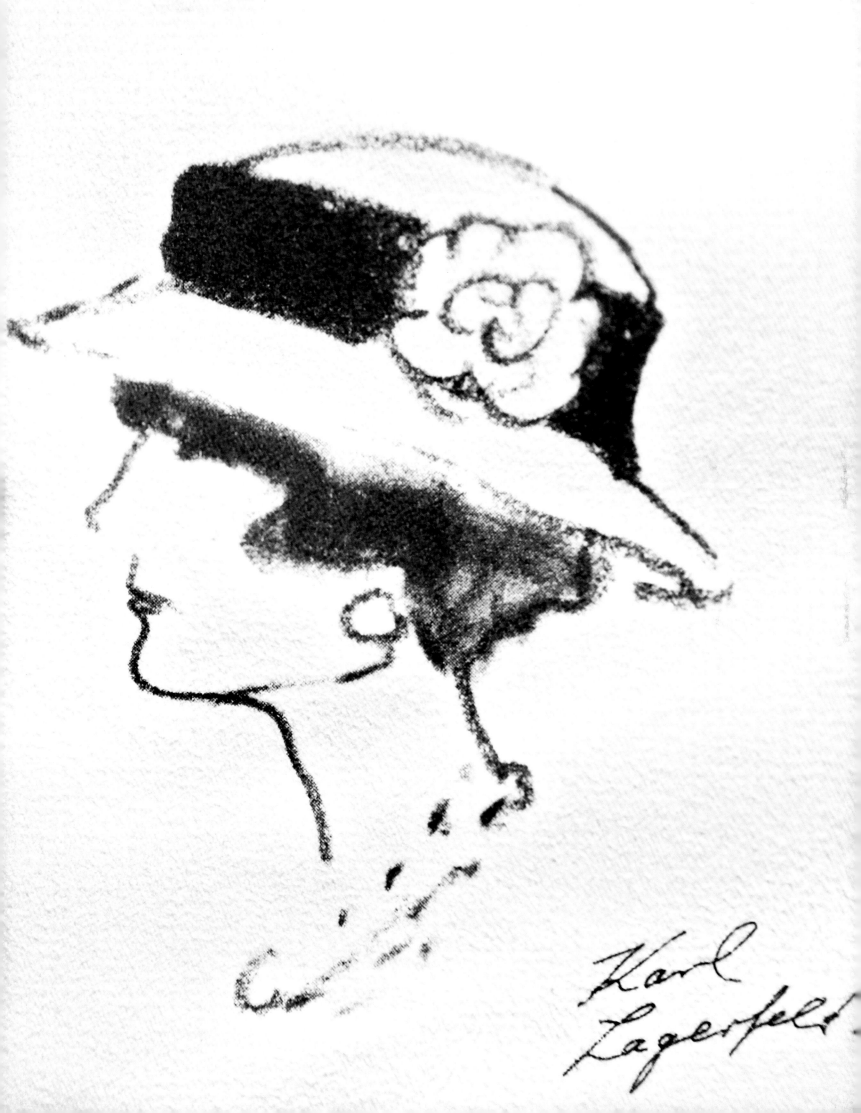

So, what makes Paris truly unique in the fashion world? Beyond the prestigious Parisian couture brands that have forged the world of fashion as we know it today, the City of Light is a creative powerhouse, driven by the spirit of perfection that the great couturiers of the past have passed on to the next generation. You only have to visit Yves Saint Laurent's workshop, which has become a museum, to feel the atmosphere of constant artistic excitement that reigned there. It's a place where you realise that the imaginative genius, eccentricity, and exuberance that characterise most of the Parisian fashion designers is based on immense hard work and on an exceptional attention to detail and understanding of textiles, patterns, and the zeitgeist.

Paris's appeal and unique flair very much lies in its strong organic link between past and present. It's almost as if you could imagine bumping into Coco Chanel on the corner of the Place Vendôme. The aura of the legendary Parisian couturiers lives on in their brands and the collections that, season after season, pay faithful homage to them, while (and perhaps by) remaining at the forefront of today's tastes and trends. To see it for yourself, all you need to do is walk through the door of the Dior Gallery, at 11 rue François 1er in Paris's fashionable 8th district. Christian Dior's former mansion now hosts the brand's collections since its beginnings in a truly magical atmosphere, as if echoing Dior's own words: "Fashion designers offer one of the last refuges of the marvellous. They are, in a way, the masters of dreams..."

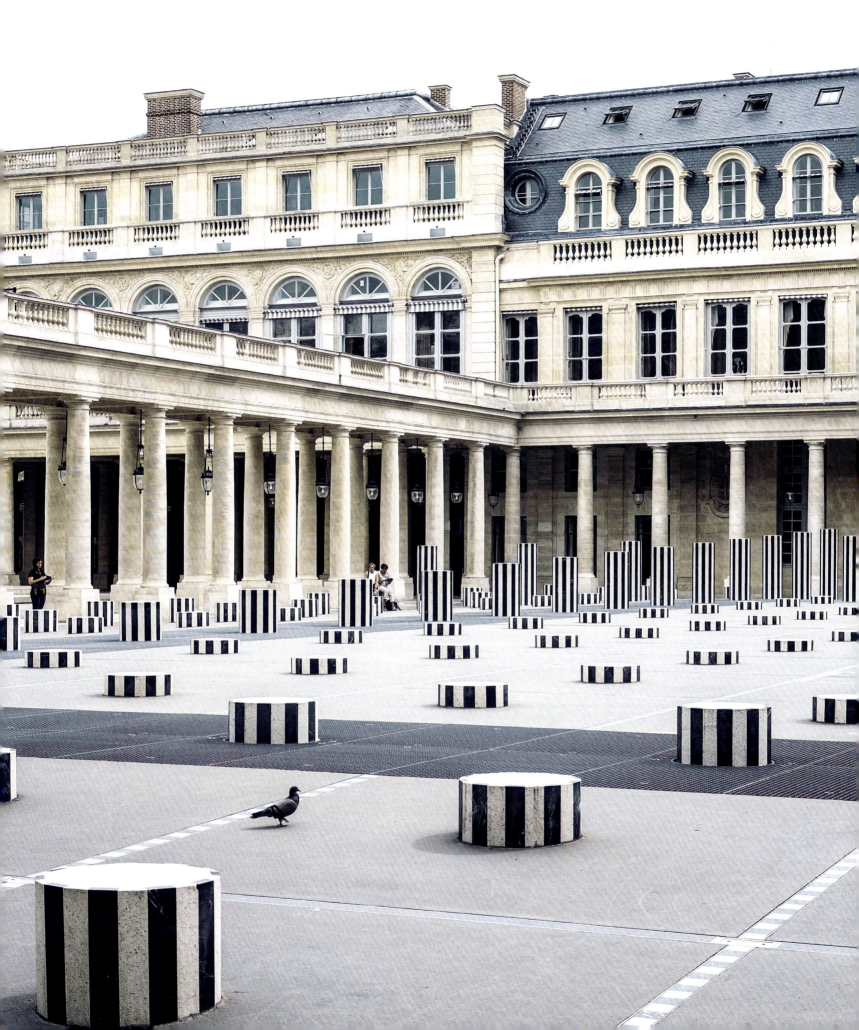

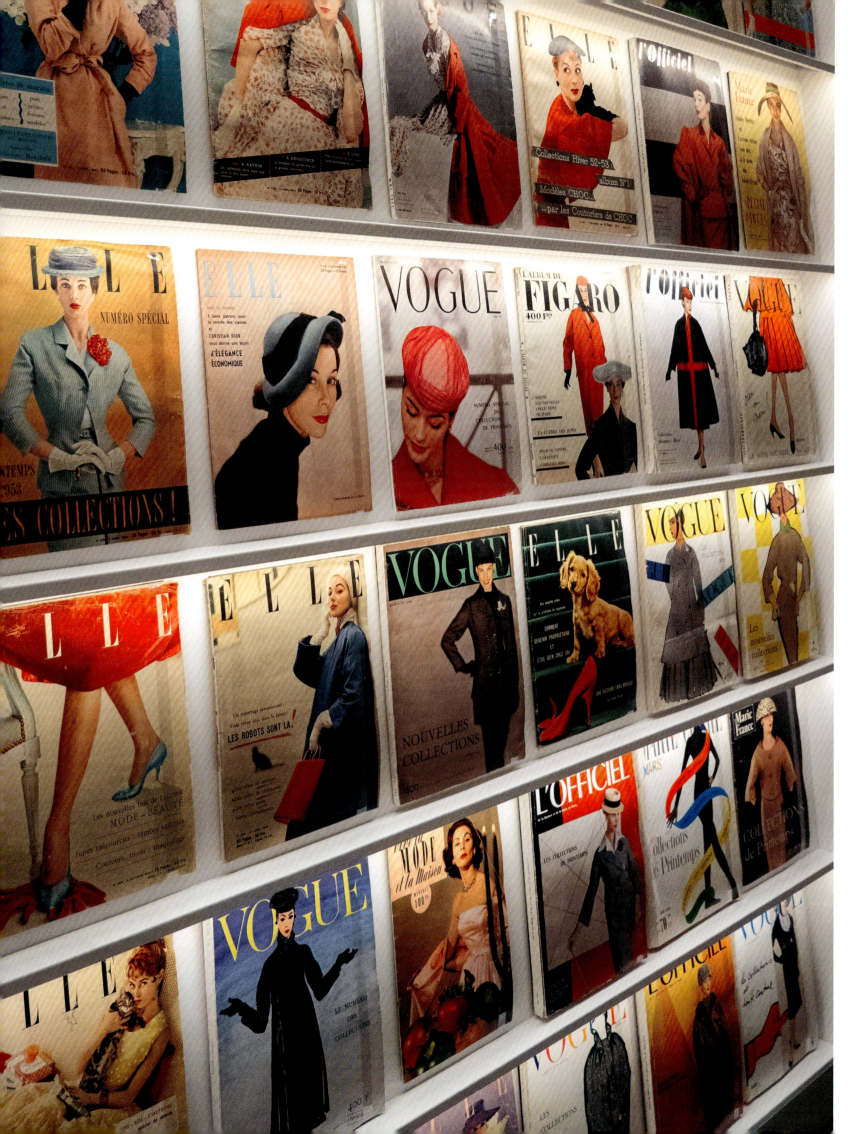

It would be wrong, however, to reduce the city's importance to its historical fashion success stories. The city continues to play a dominant role in perpetuating the wider culture of fashion – the very Parisian concepts of couture and a sense of style, for example. As leading influencer Caroline de Maigret wisely put it, "fashion gets boring to talk about after five minutes, but style is so much more. I can go on about style for hours. Style is everything—culture, your personality, and what you do—that's what makes style. It's who you are, and how you want to be perceived by others". Where there's style, there are *Parisiennes*, Parisian women, living icons who have become one of France's national treasures. The natural grace and nonchalance surrounding the archetypal *Parisienne* seems to flow freely and effortlessly, like an intuitive sense of good taste. While couturiers invent new trends and launch fashions, it is the *Parisiennes* who, along with celebrities, contribute to their enduring success and appeal. The credo of the 'authentic' Parisian woman, who doesn't shy away from contradiction, is best illustrated by Caroline de Maigret's most famous line: "Nowadays, we want to be effortless—but looking effortless takes effort! So we weave a story—create an illusion of effortlessness."

The classical elegance of Parisian architecture and the splendour of its monuments are also essential ingredients in the city's charm, as the lively streets and districts provide a unique backdrop for creative inspiration and a sophisticated lifestyle. The refined effortlessness of the *Parisienne* echoes the city's formal beauty and joyful atmosphere; a symphony wherein the ephemeral and the eternal fuse their voices. This aesthetic unity has not escaped the attention of some film directors who have captured the Parisian lifestyle and its irresistible appeal on the screen. Even in a thriller like Roman Polanski's *Frantic* (1988), Harrison Ford, who plays an American doctor unwillingly embroiled in a drug affair during a stay in Paris, ends up succumbing to the charms of a *Parisienne* played by Emmanuelle Seigner. The critical success of *Coco Before Chanel* (2009), with Audrey Tautou in the lead role, and the biopic *Yves Saint Laurent* (2014), starring Pierre Niney, helped put these two key figures of 20th-century French fashion back into the spotlight.

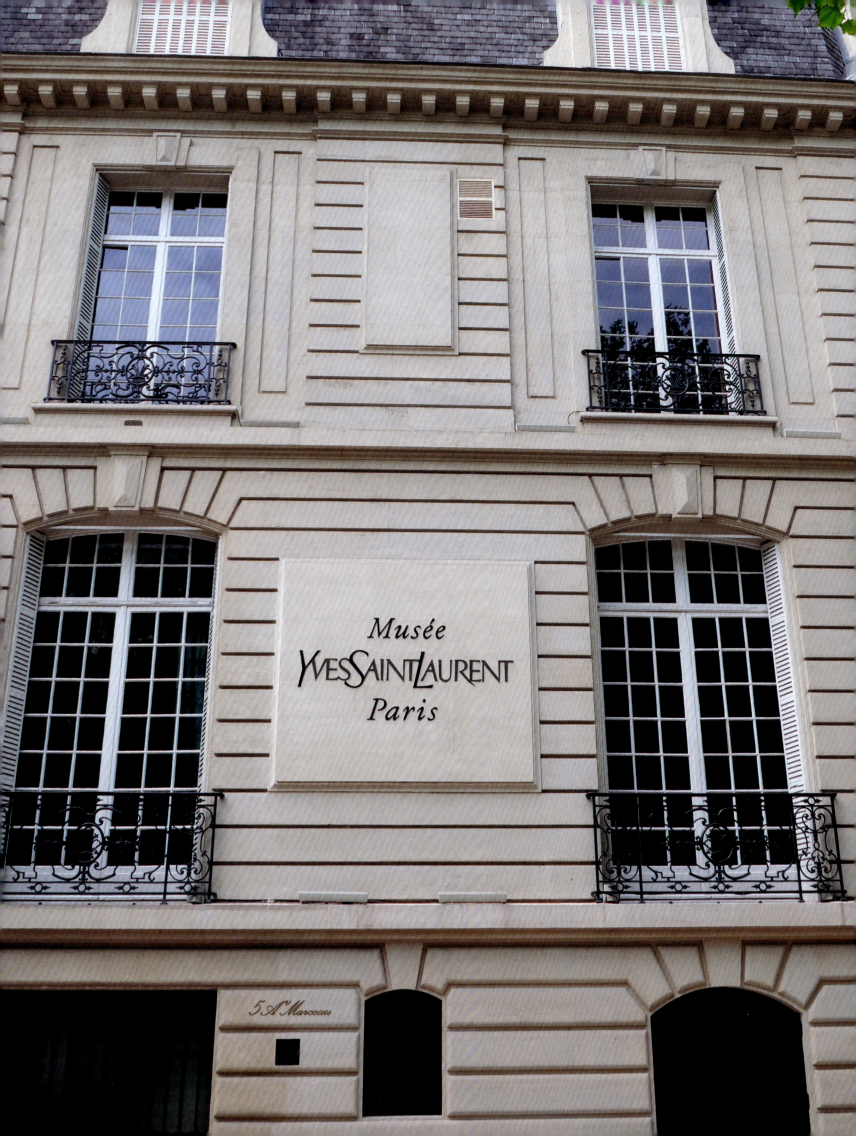

"What is wonderful about my art is that dream and reality can become one. There is just one step between the two."

YVES SAINT LAURENT

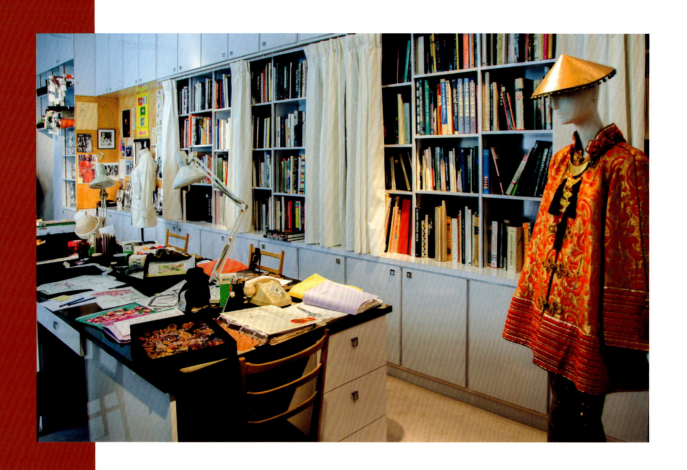

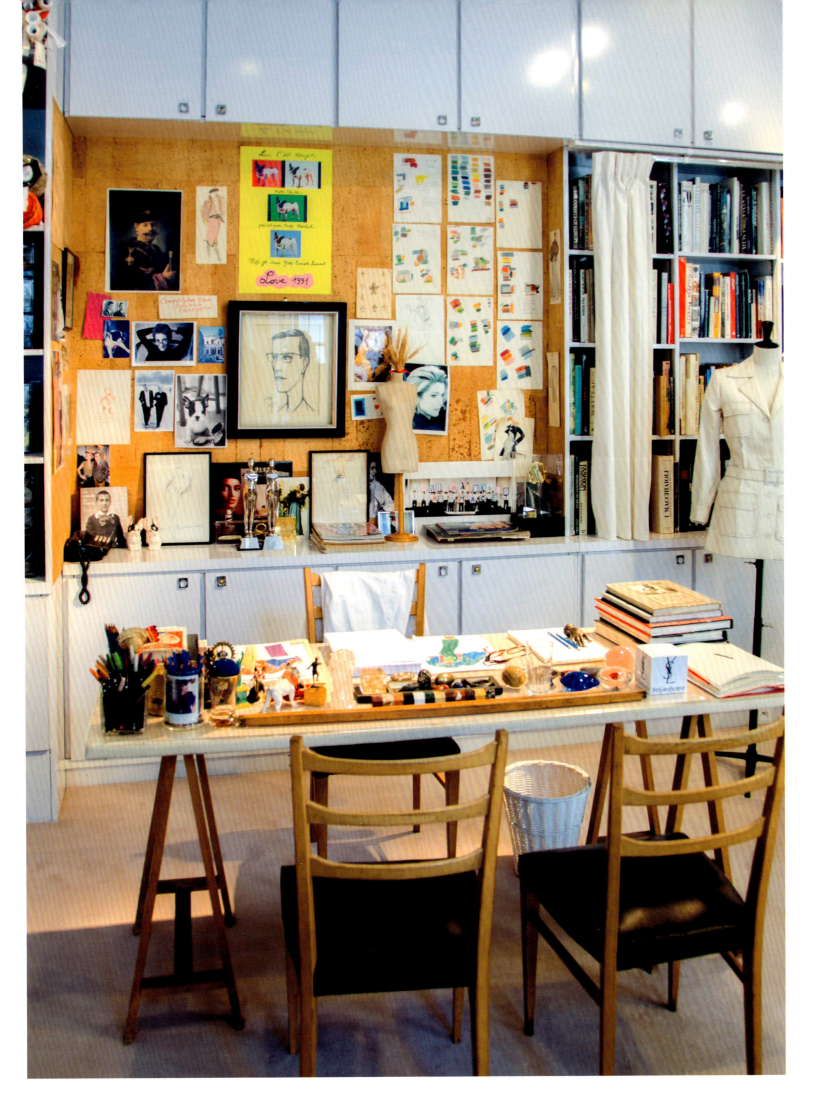

"After so many years of exploring,
my art still fascinates me.
I know of no greater exaltation.
You think there is no going further,
that everything is forever fixed
and finished—and then, suddenly,
depths and vistas reveal themselves
that you thought out of reach
and that your wealth of experience
now fully opens to you."

YVES SAINT LAURENT

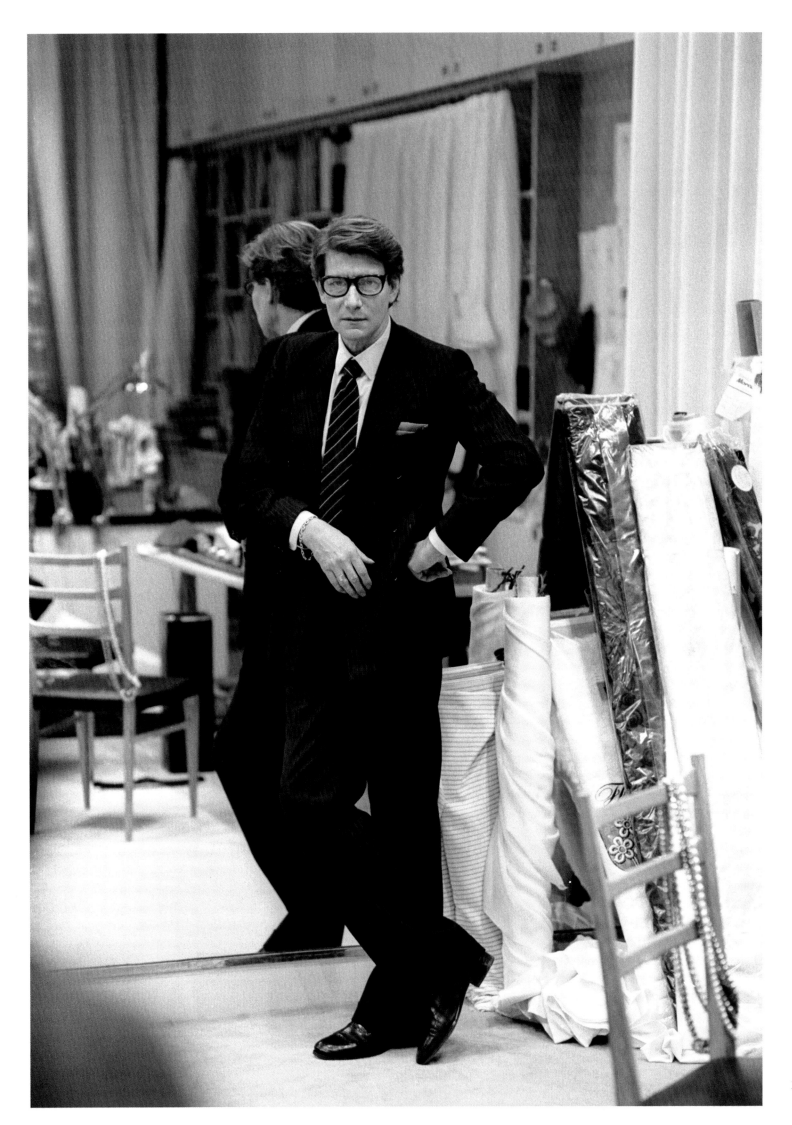

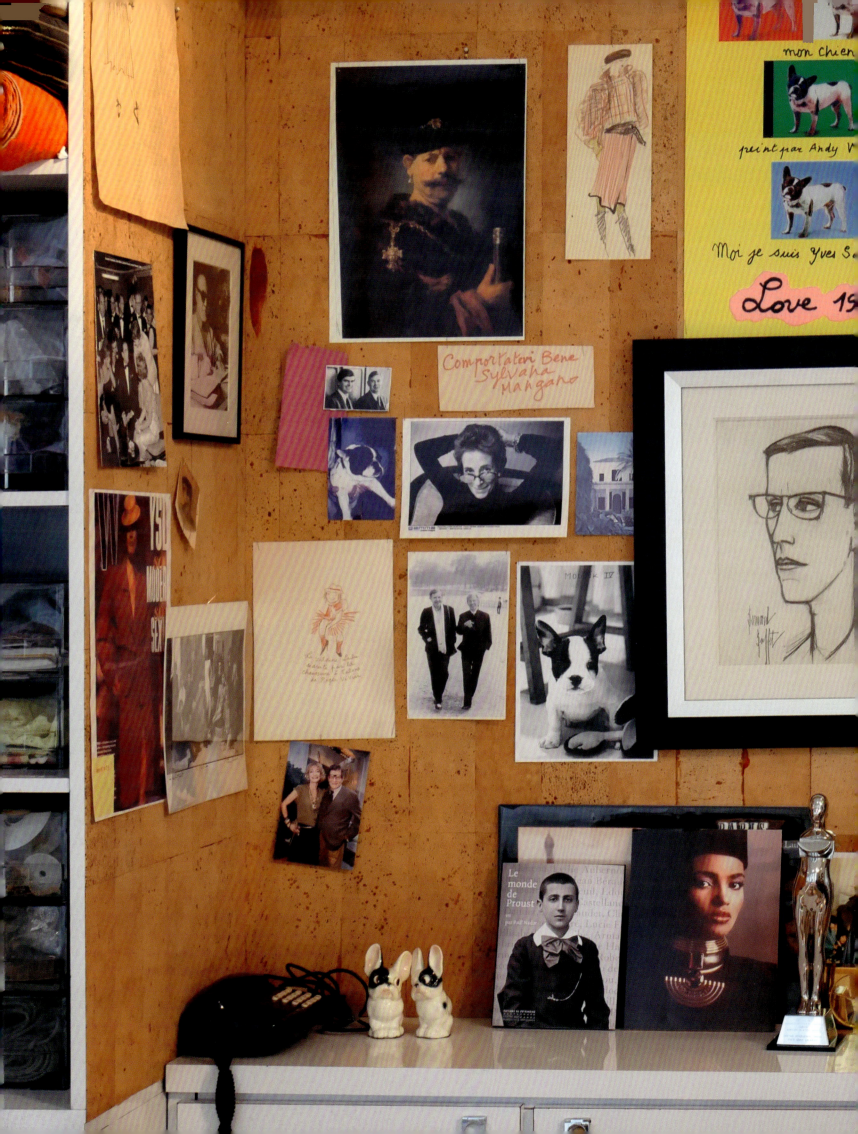

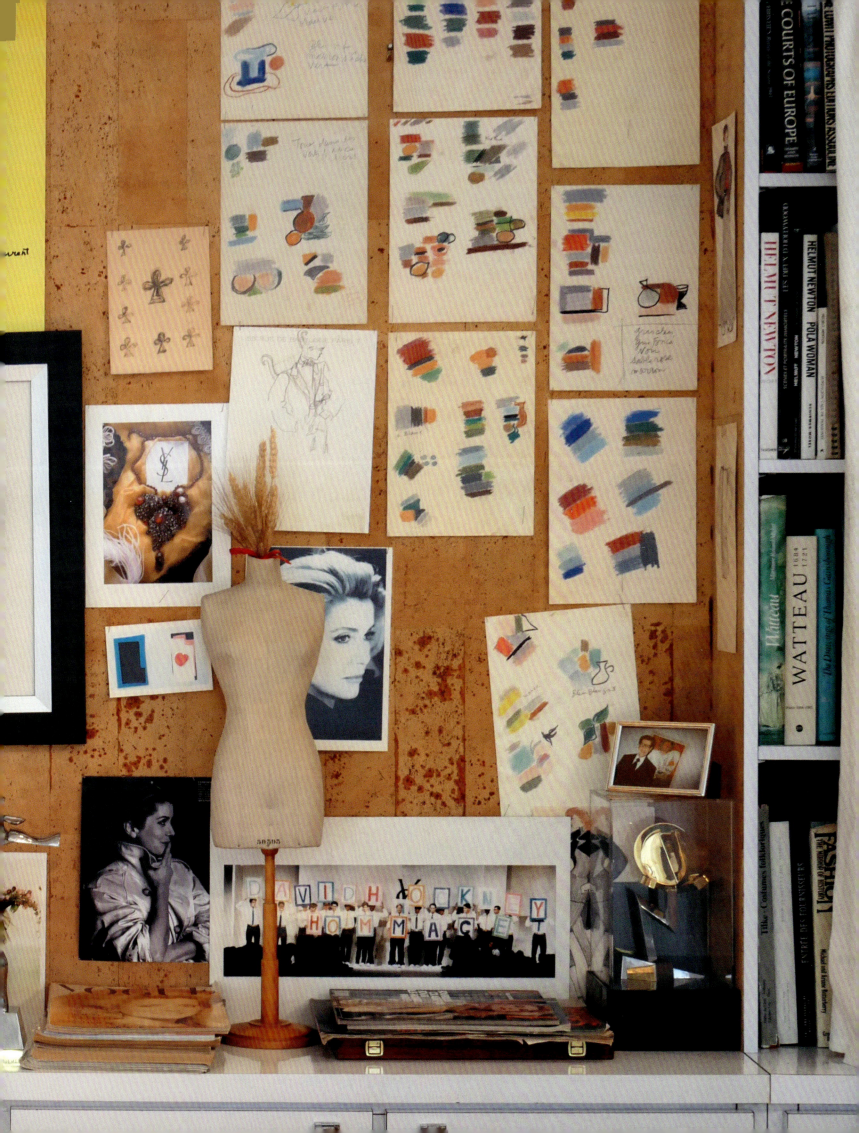

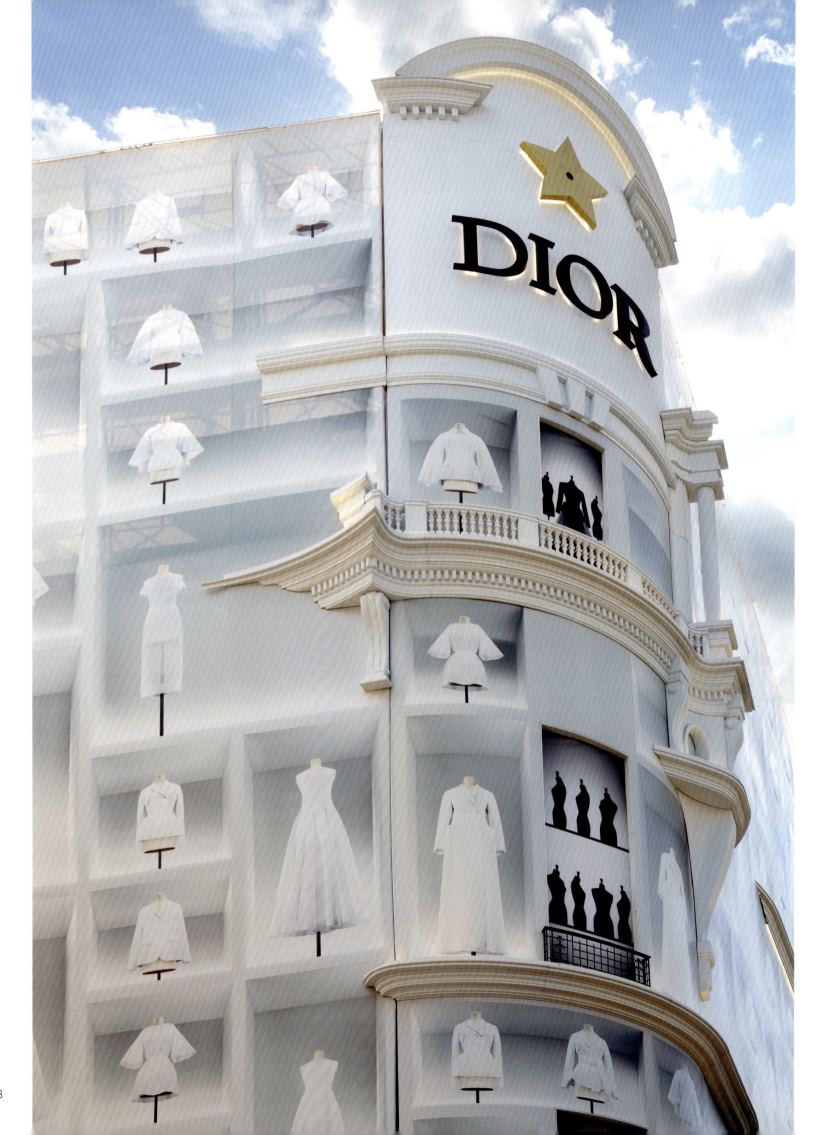

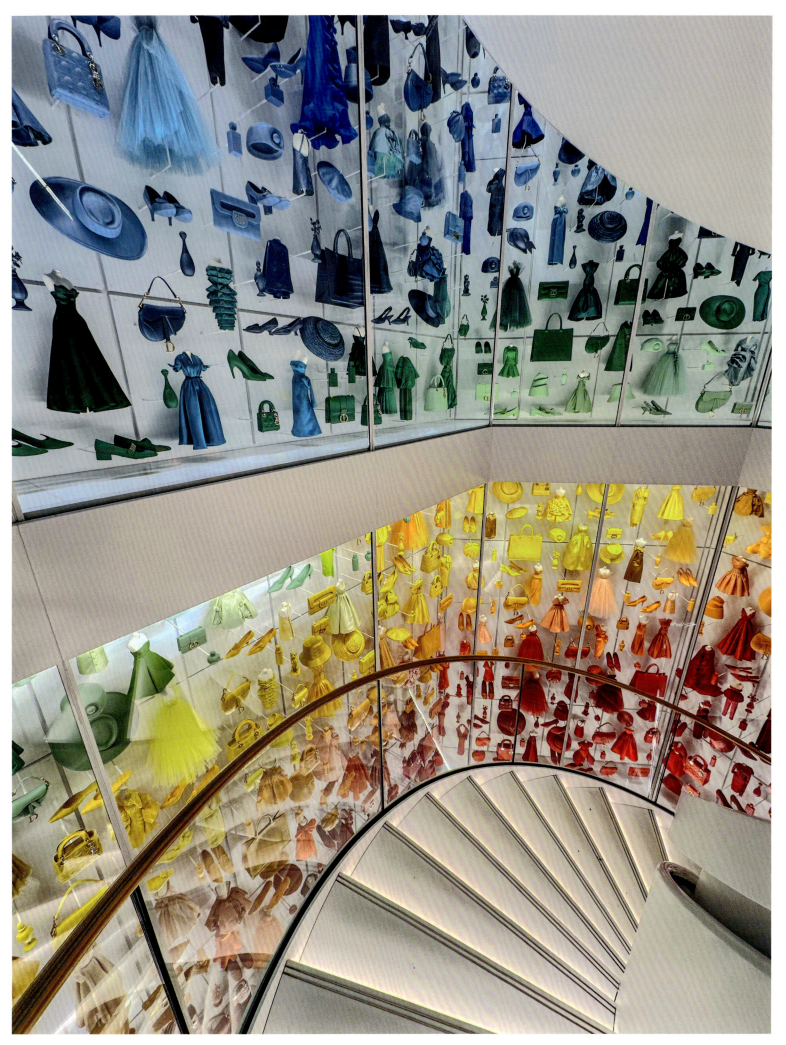

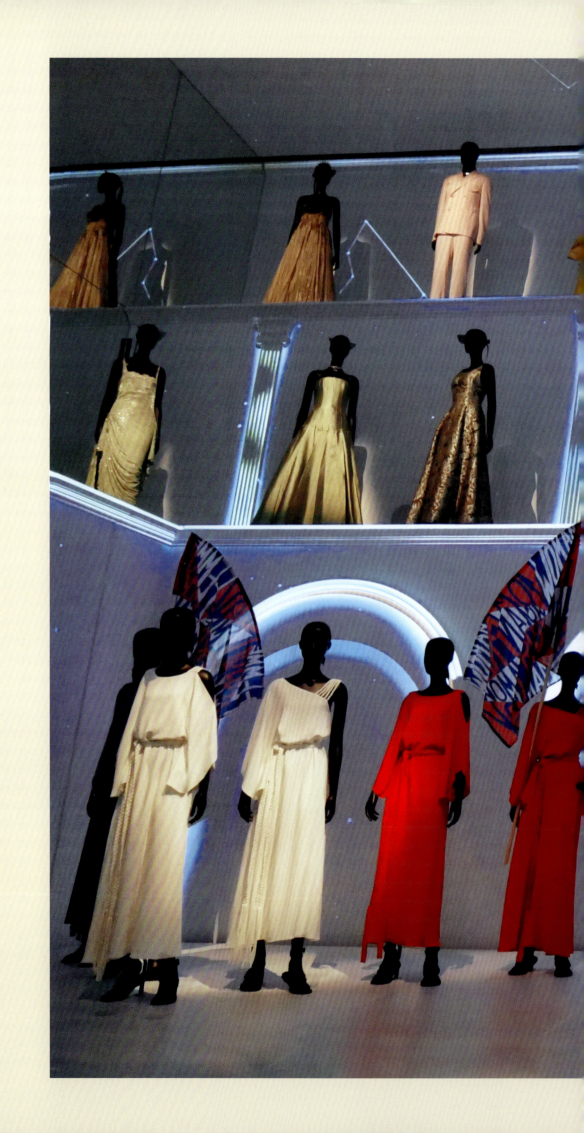

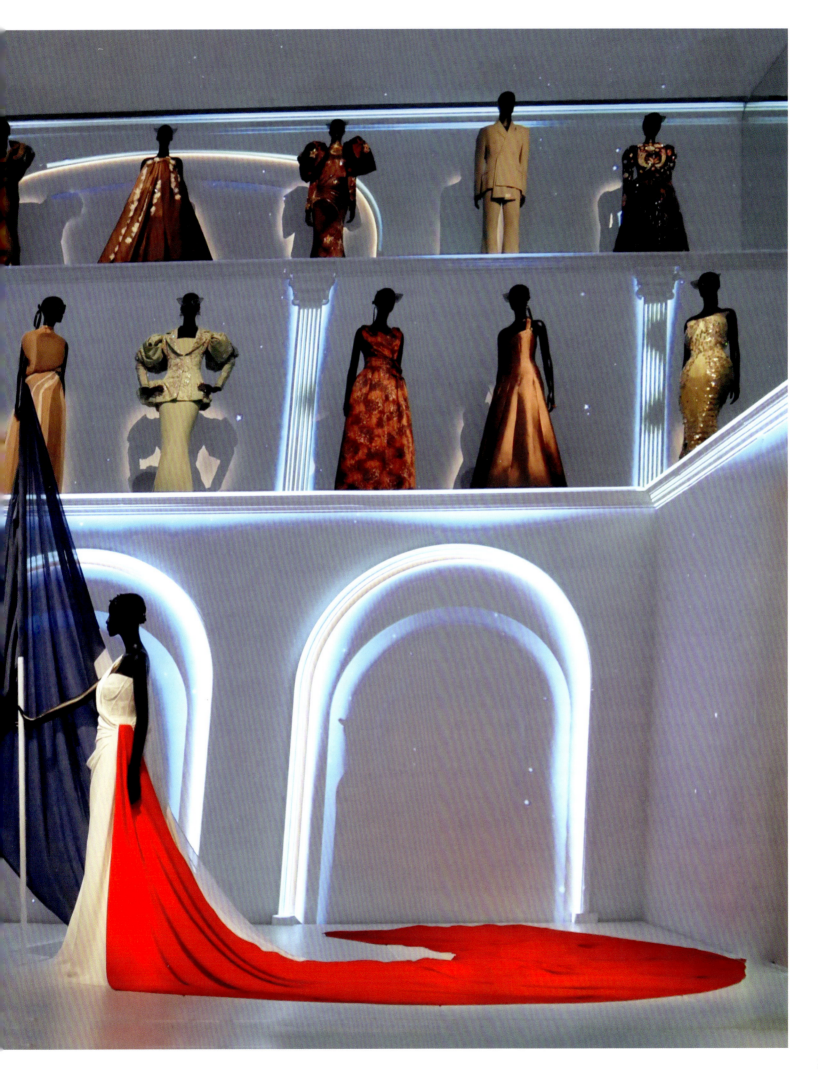

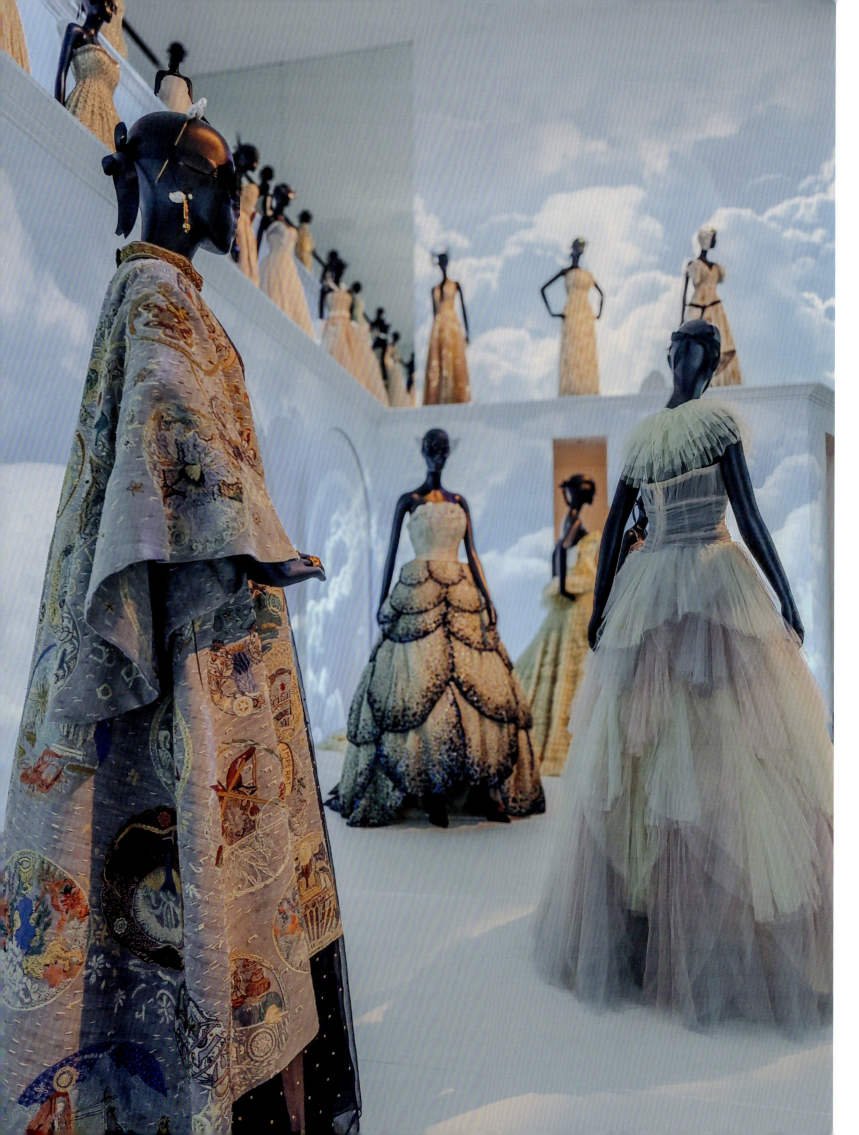

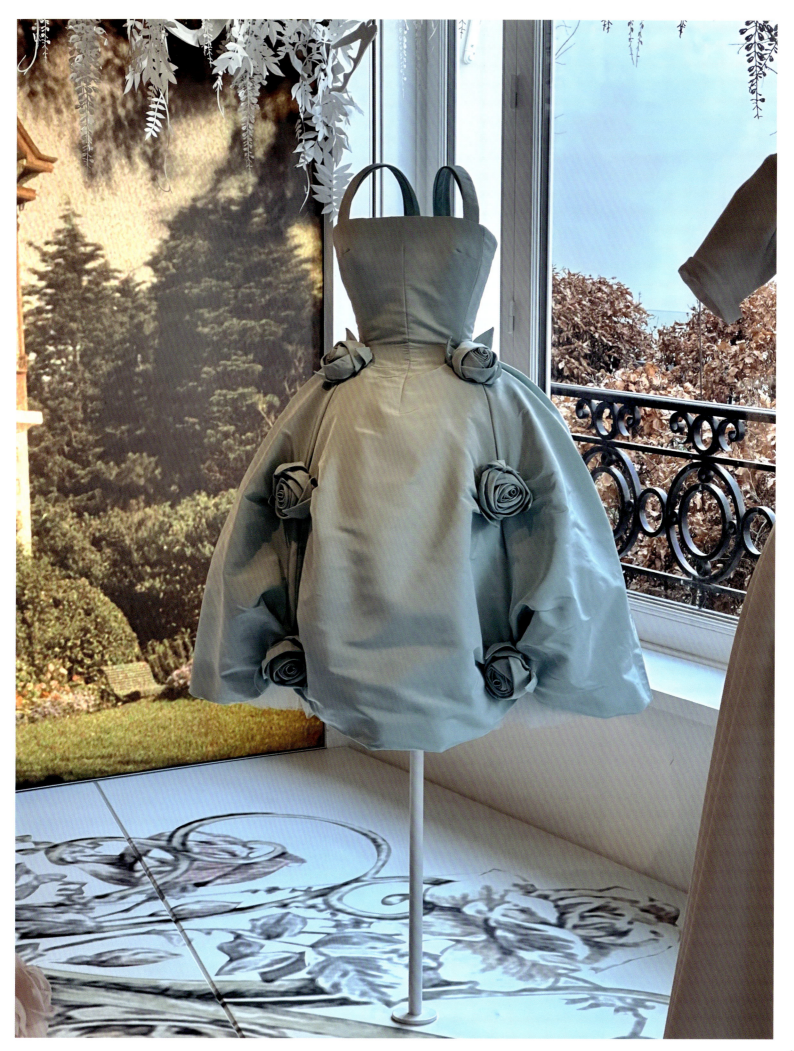

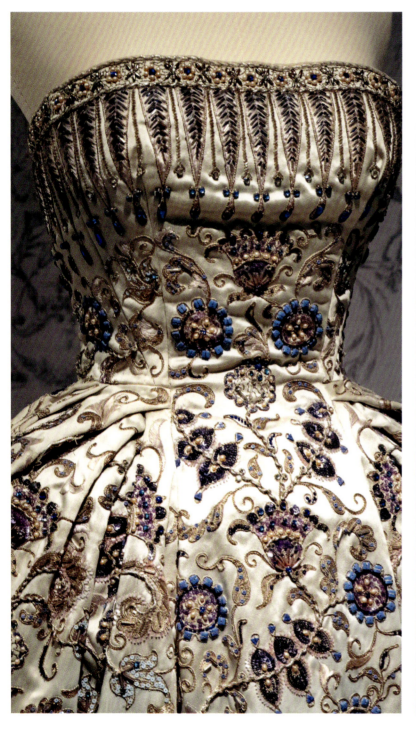
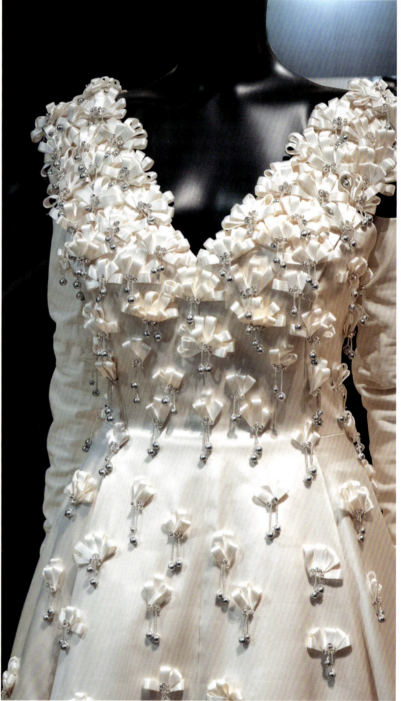

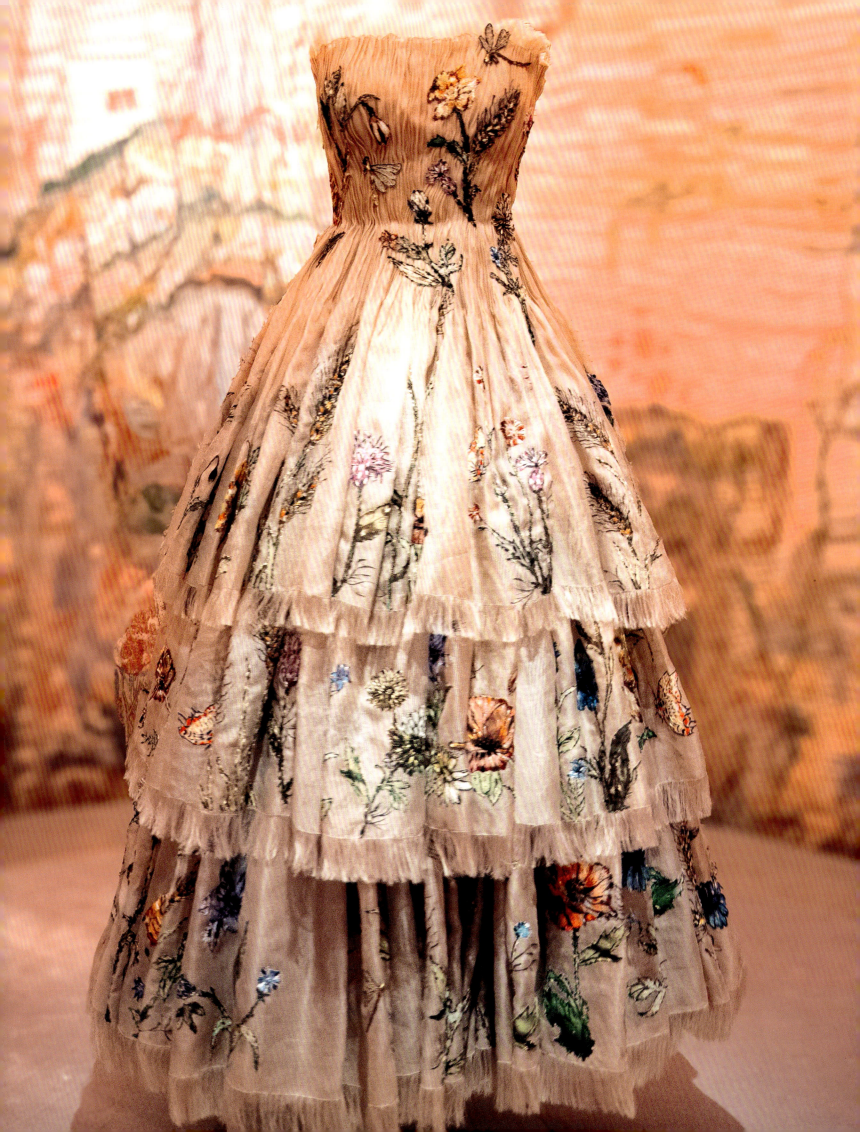

"Fashion is about expressing your individuality, not about fitting into a mould."

INÈS DE LA FRESSANGE

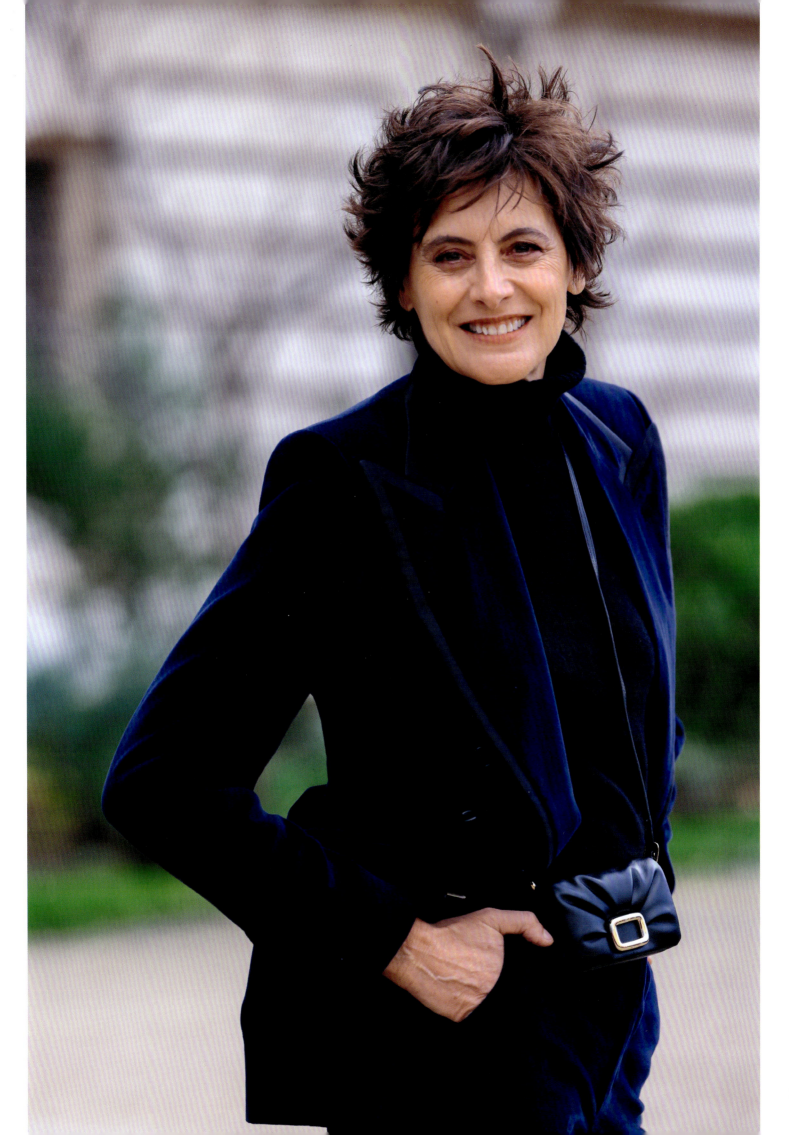

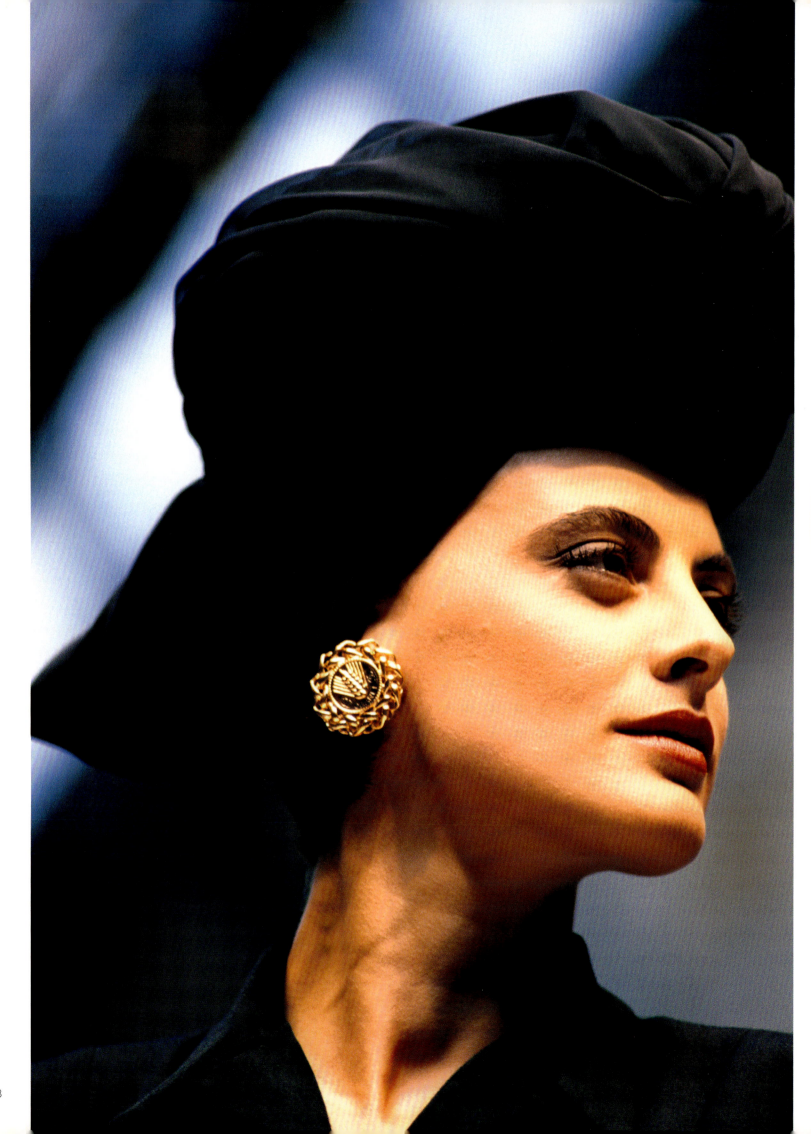

"Confidence is the best
accessory you can wear."

INÈS DE LA FRESSANGE

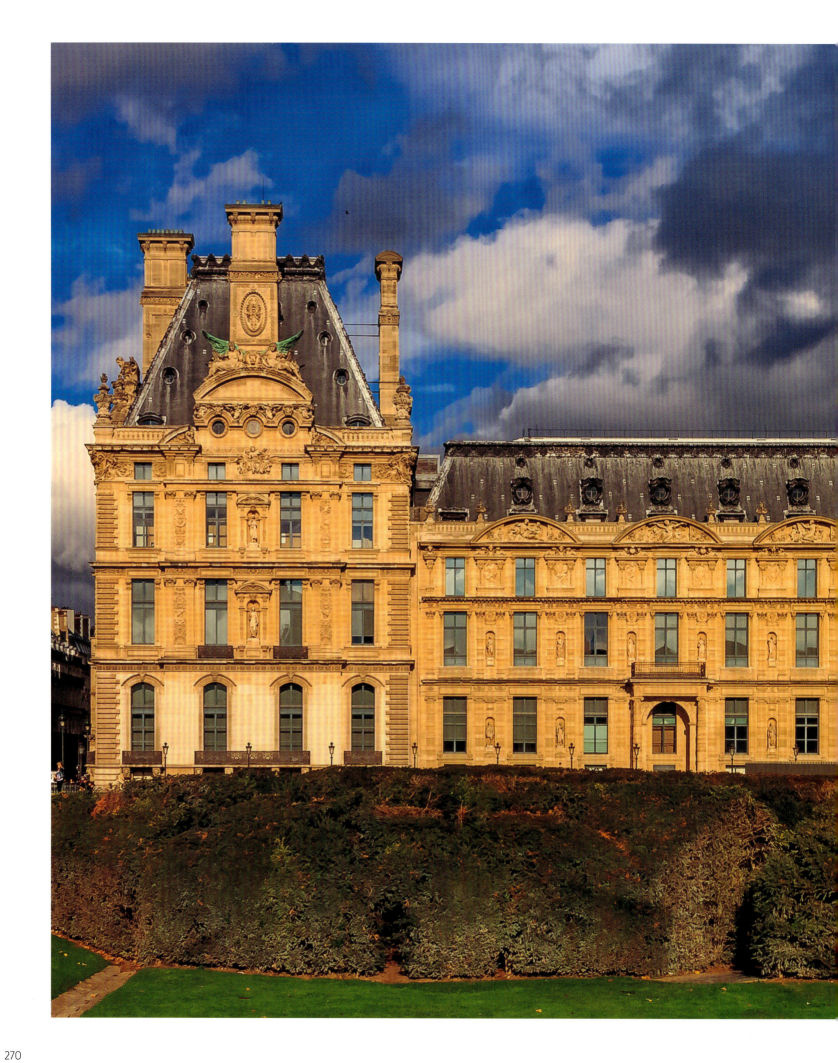

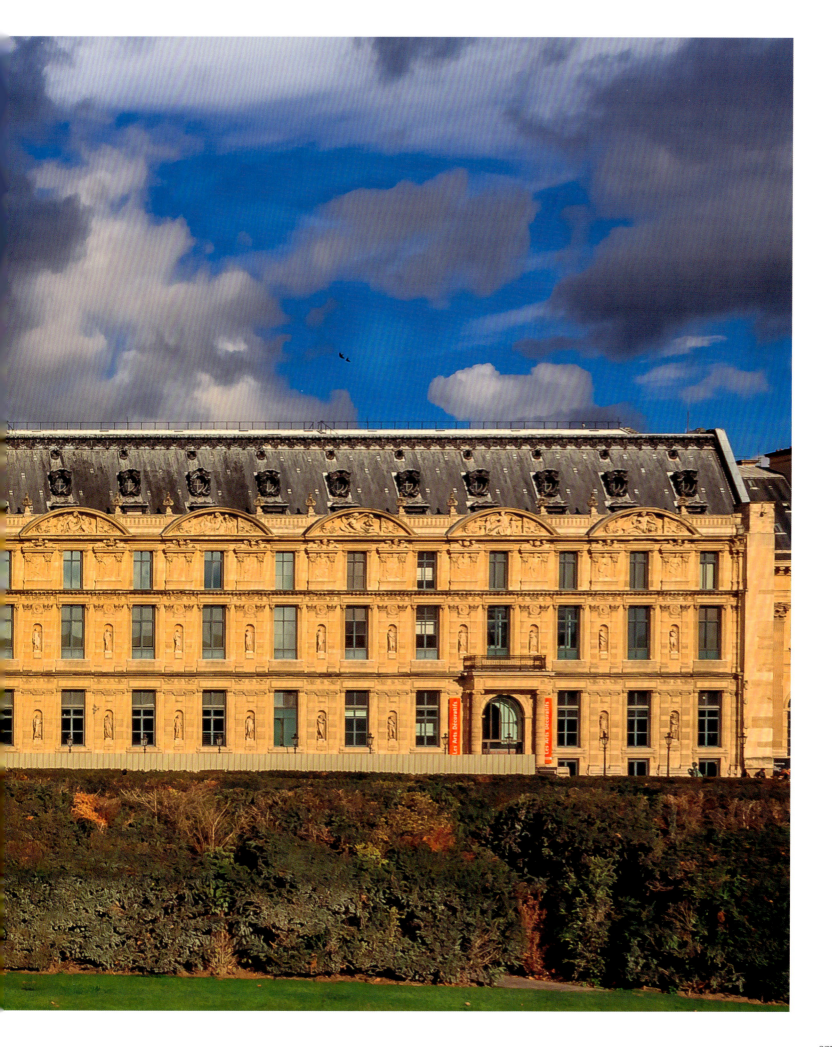

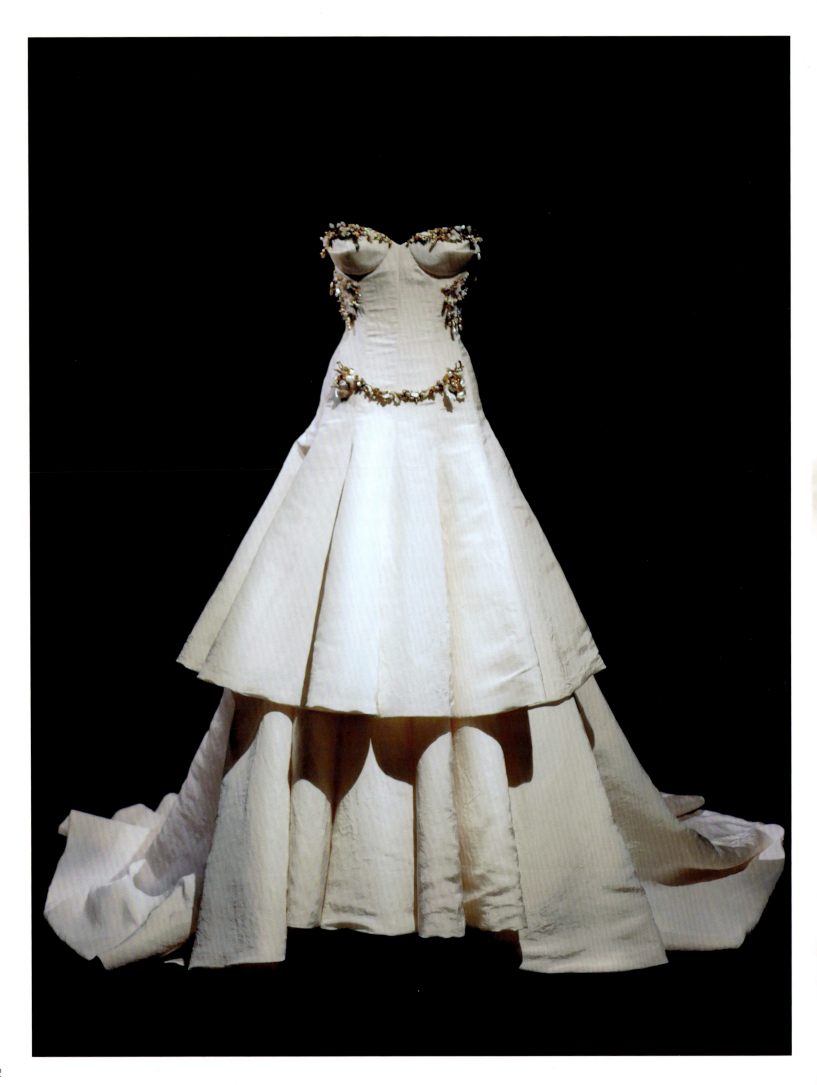

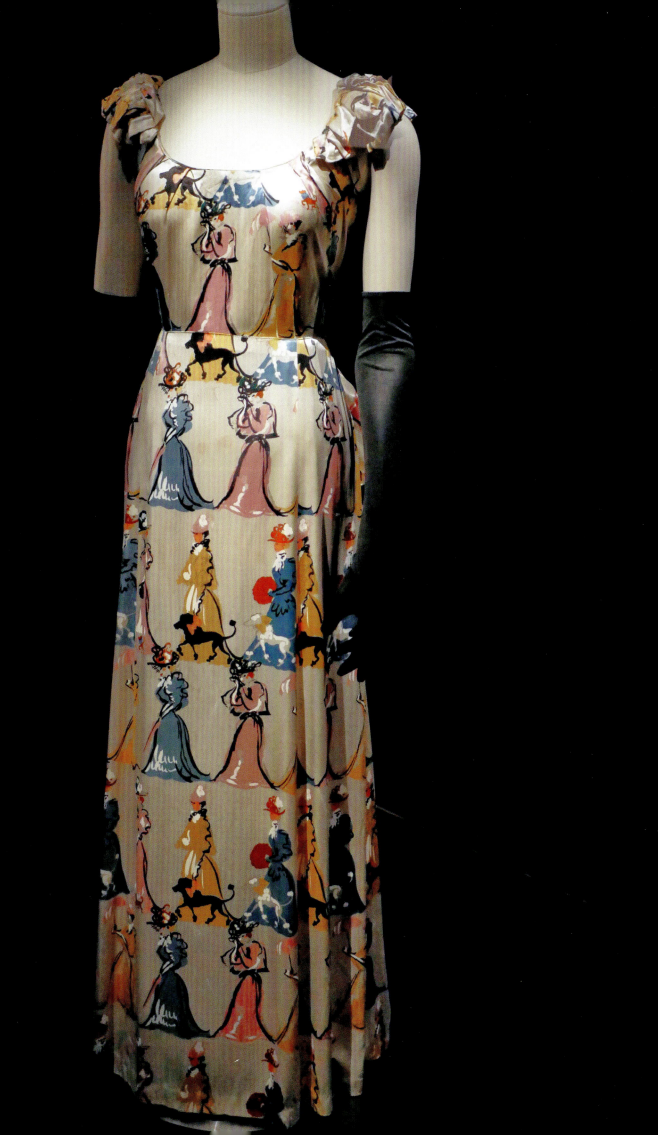

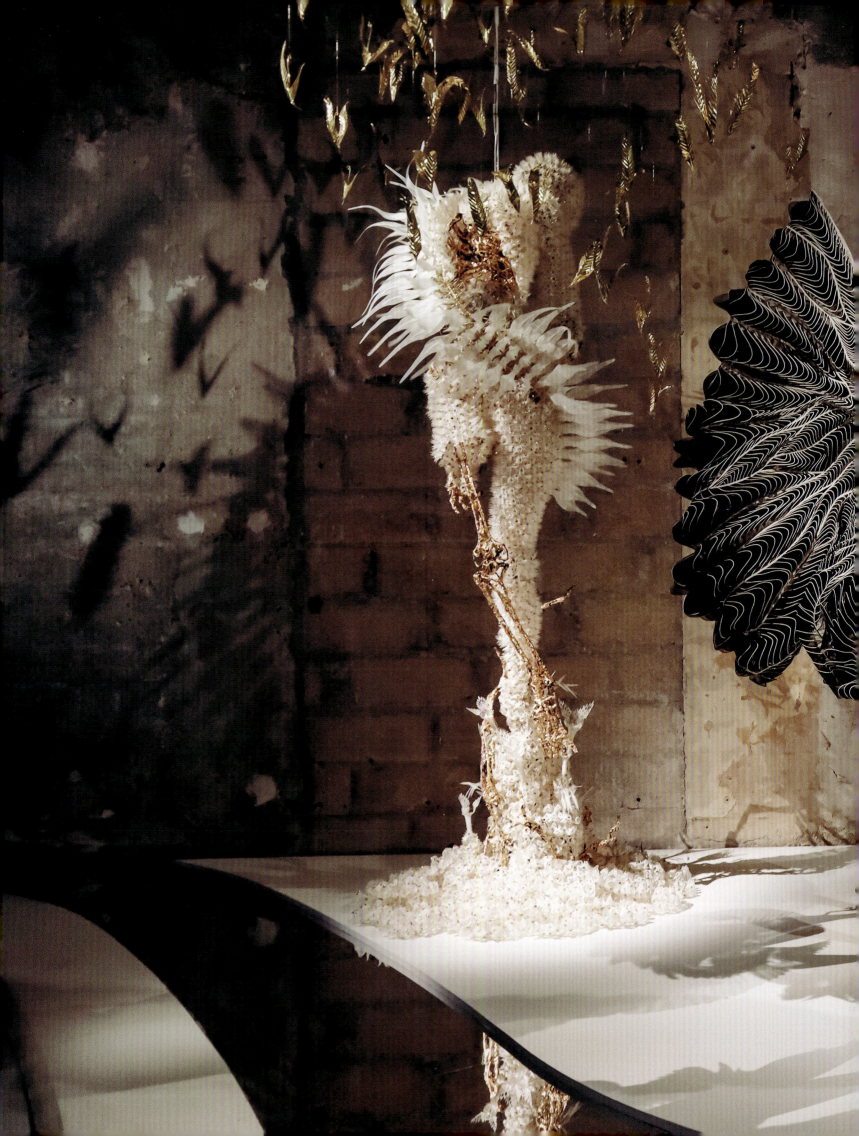

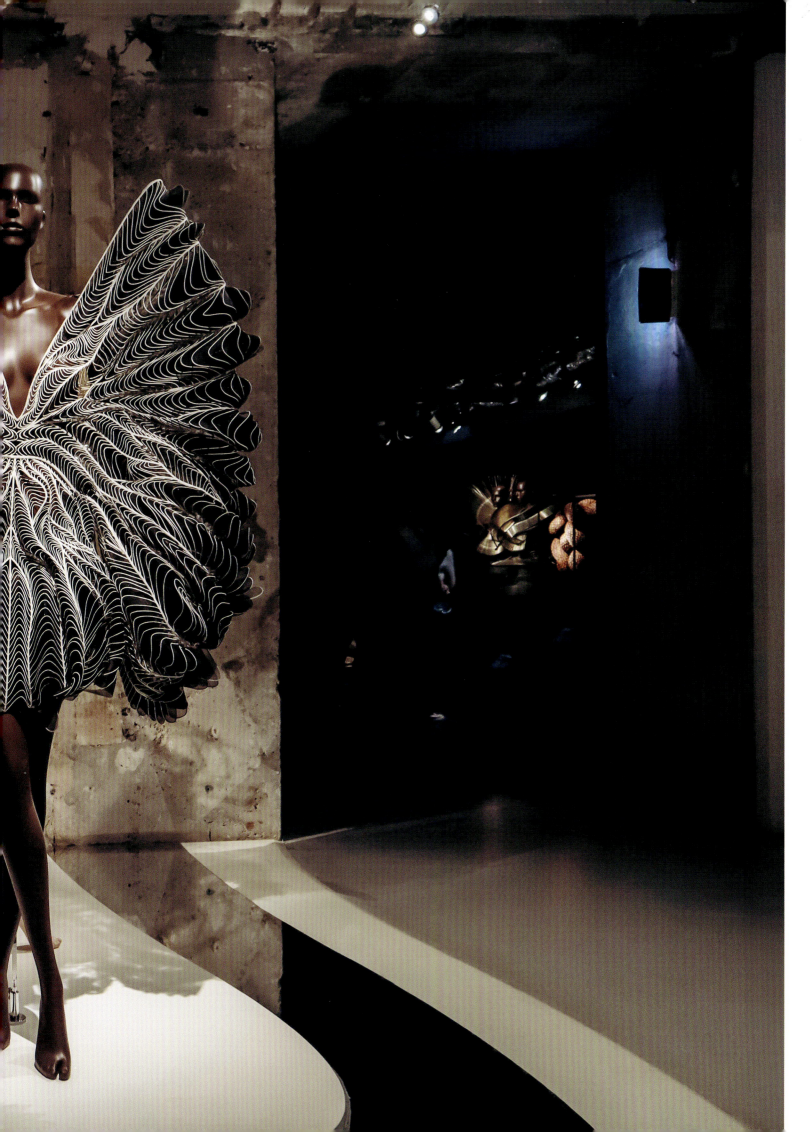

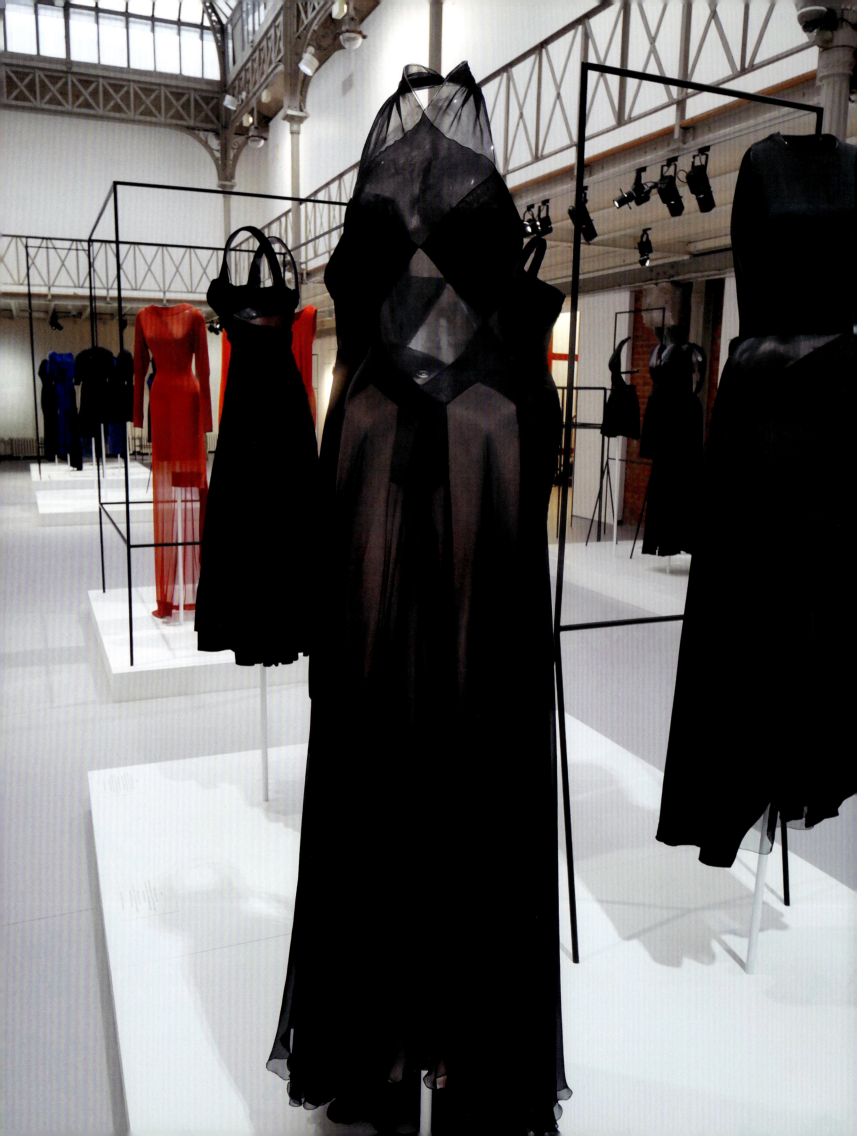

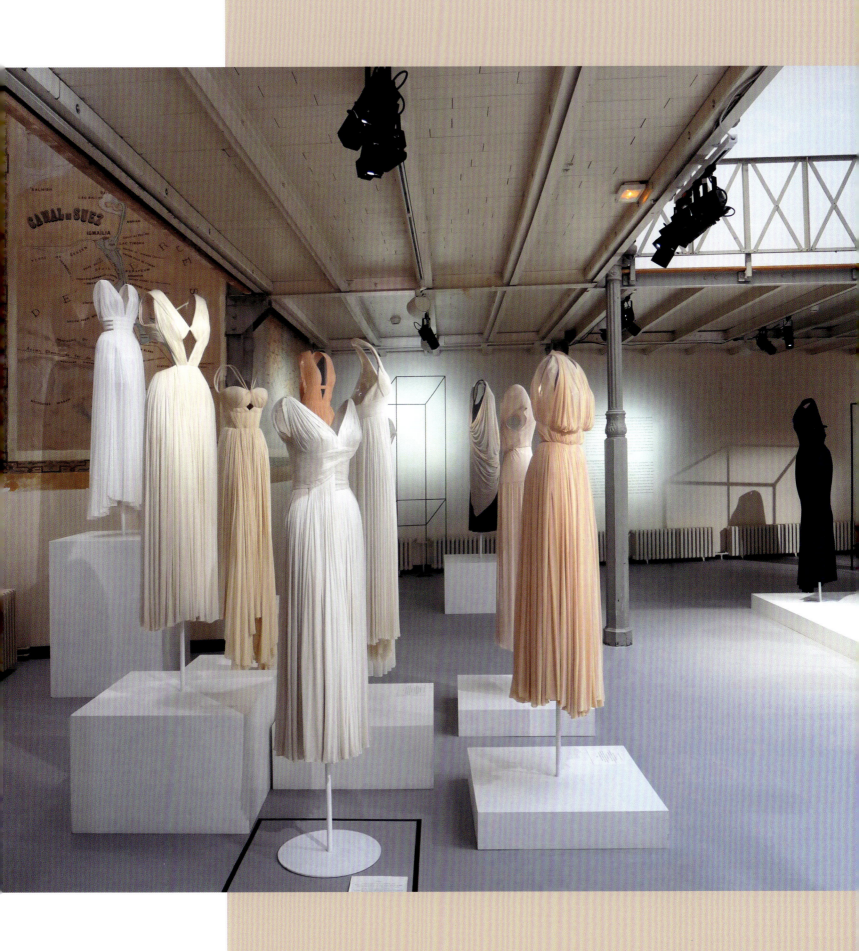

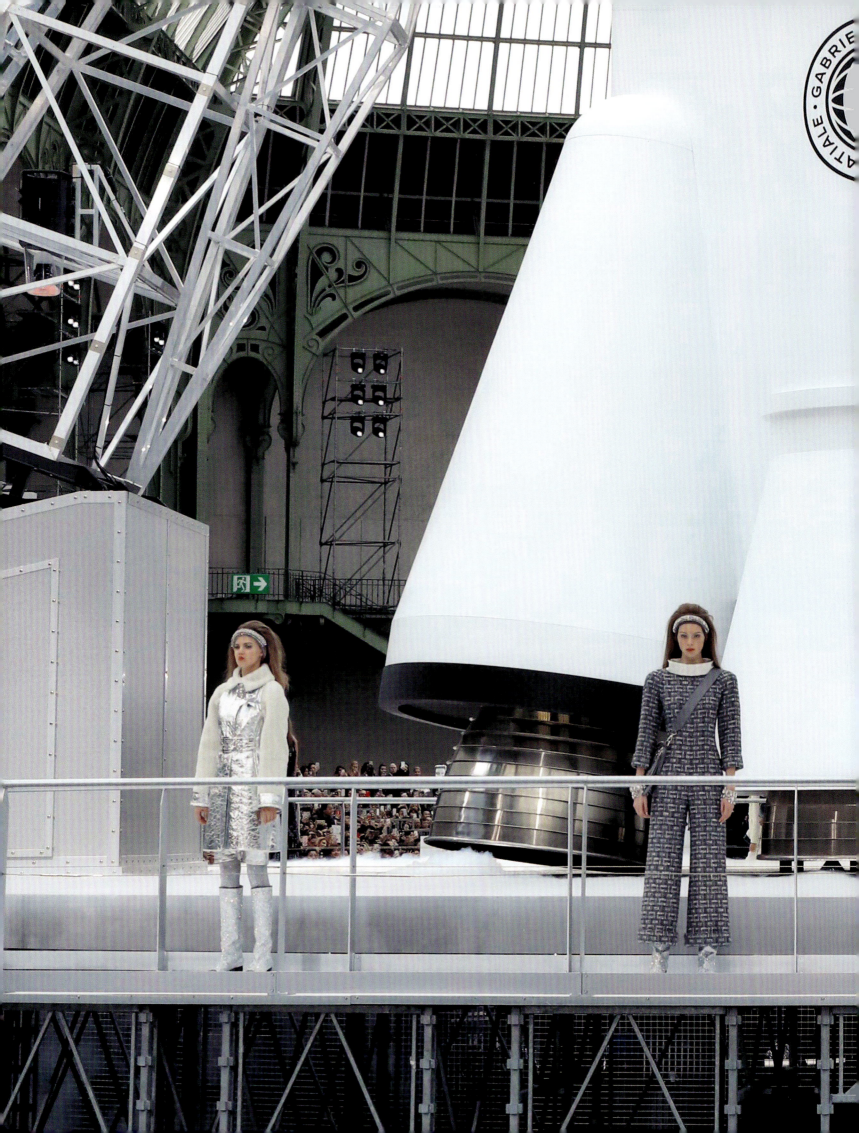

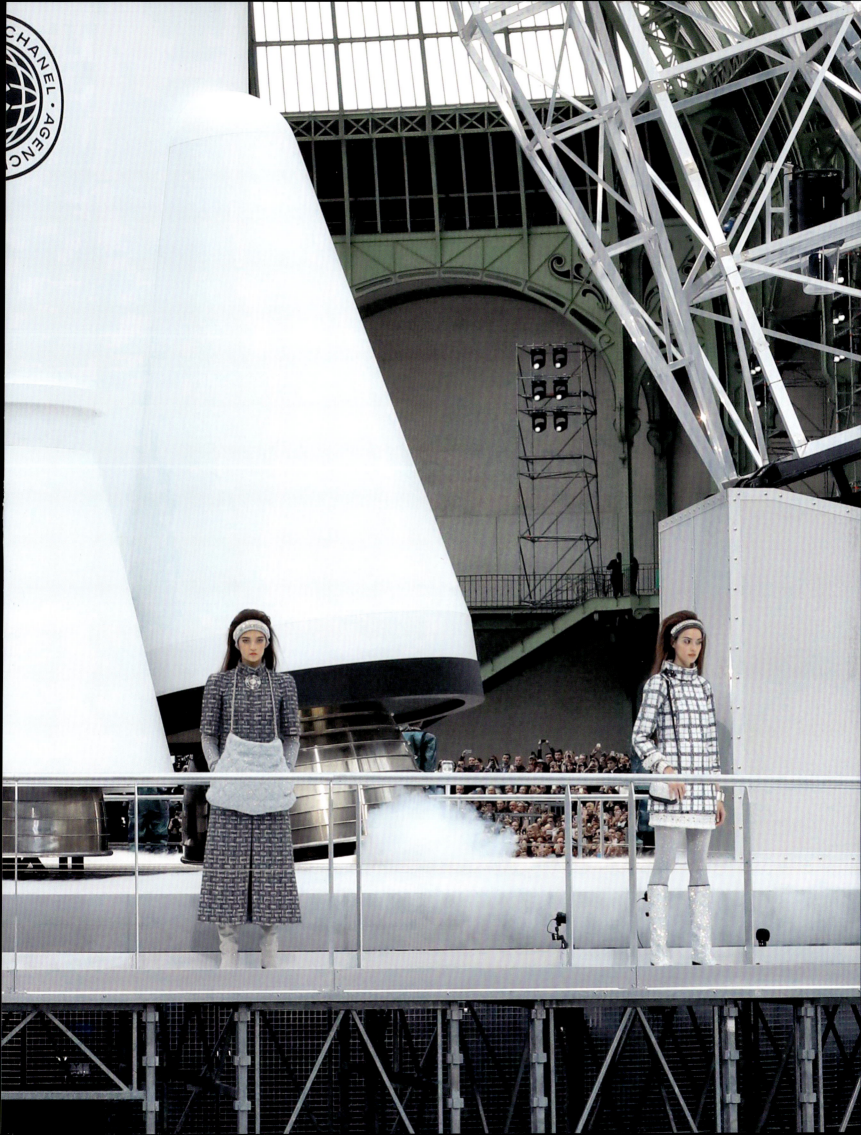

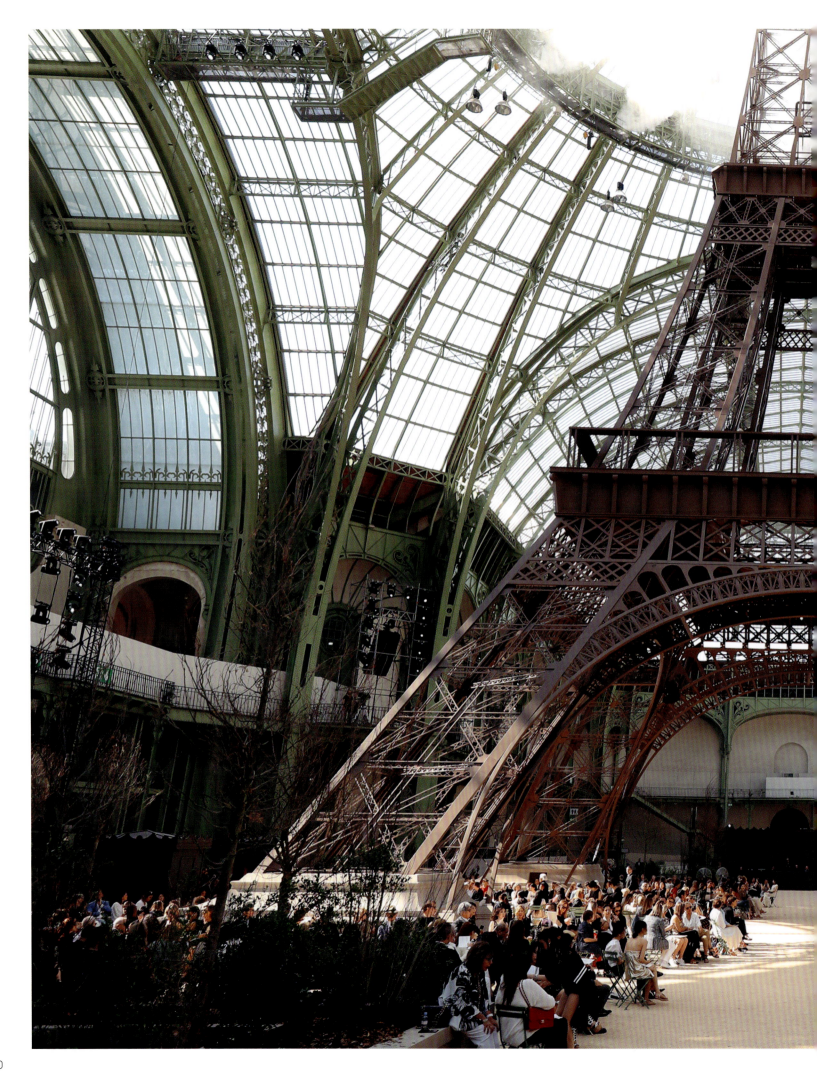

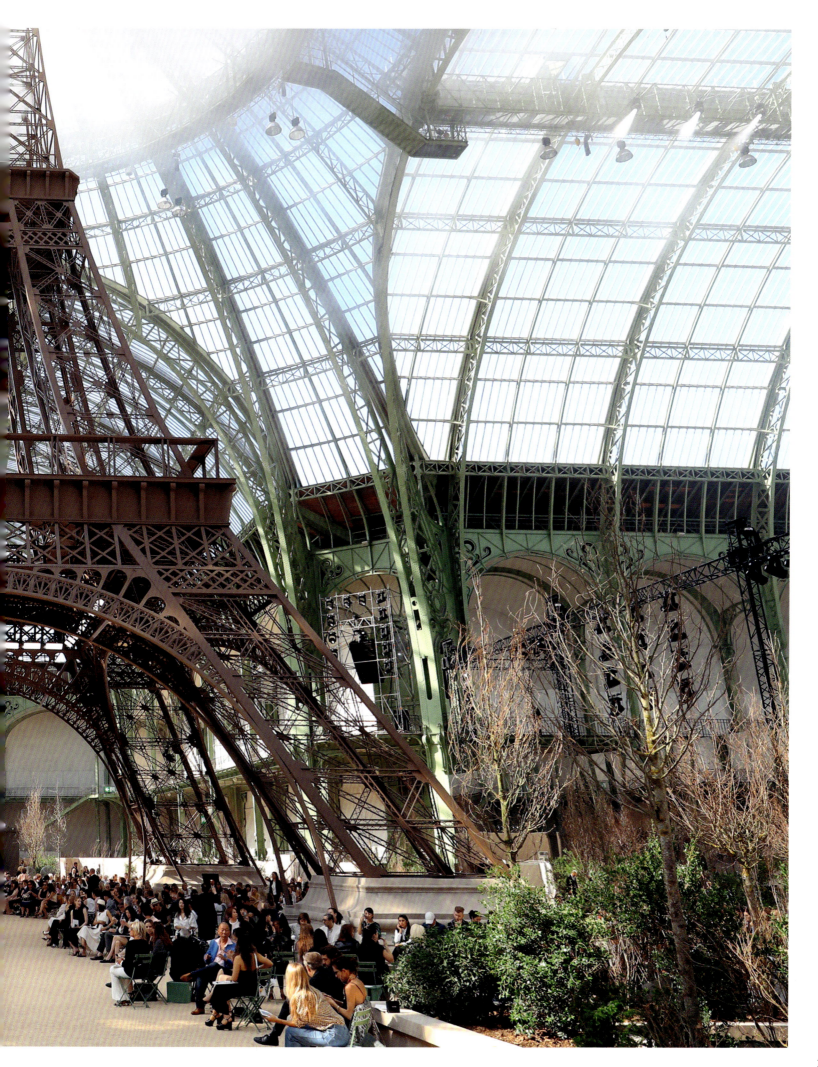

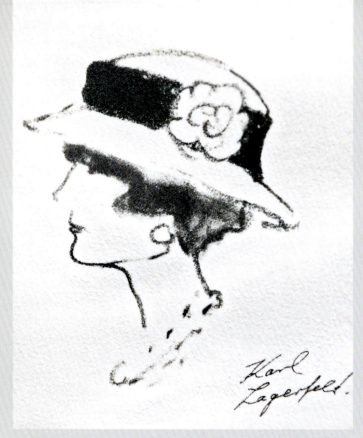

A portrait of Coco Chanel by Karl Lagerfeld.

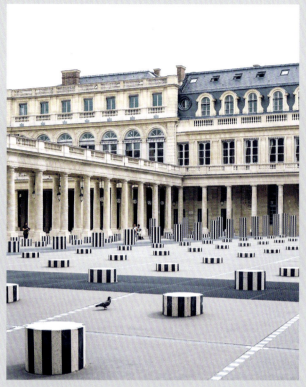

The Colonnes de Buren, an installation by artist Daniel Buren in the inner courtyard of Palais Royal.

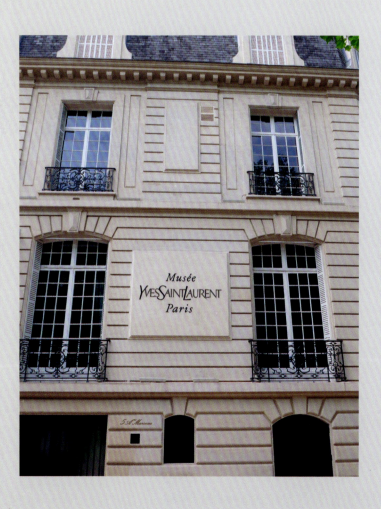

The façade of Musée Yves Saint Laurent, avenue Marceau.

Fashion magazines on display, Galerie Dior, avenue Montaigne.

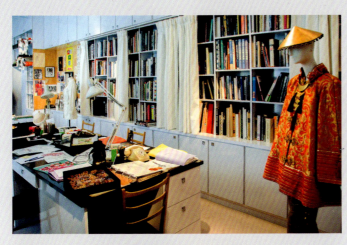

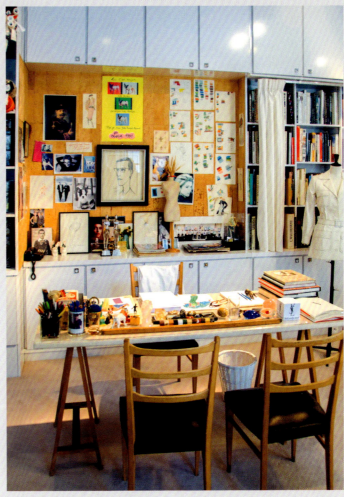

Yves Saint Laurent's couture workshop and desk.

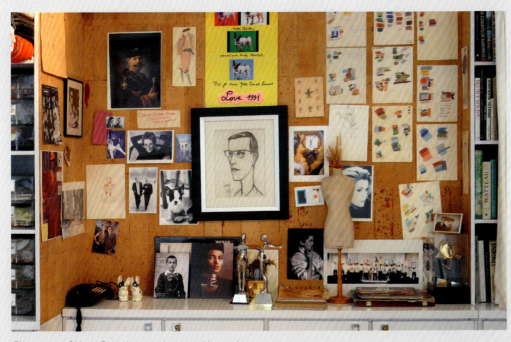

Close-up of Yves Saint Laurent's mood board.

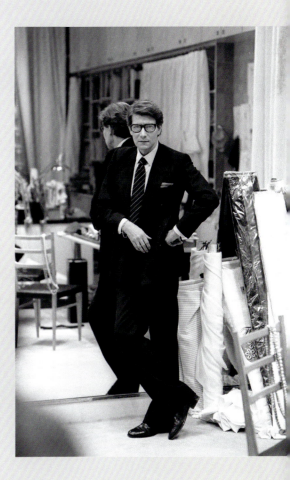

Yves Saint Laurent in his Paris studio, January 1982.

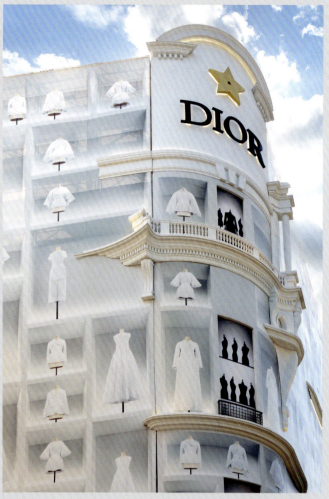

A temporary decoration on the façade of the Dior boutique on Champs-Elysées.

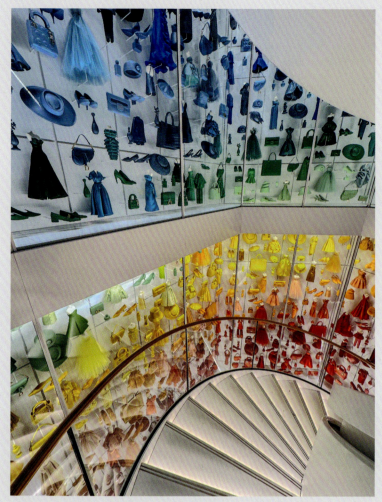

Inside the Galerie Dior, avenue Montaigne.

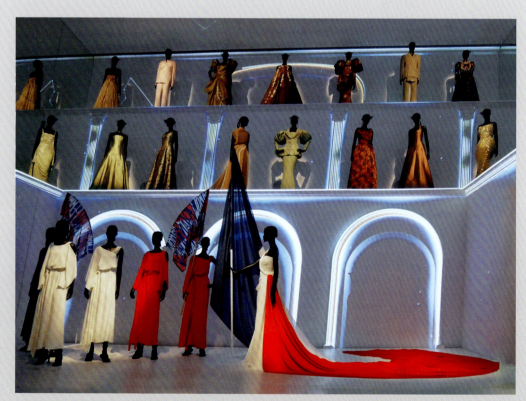

Galerie Dior. The dress worn by opera singer Axelle Saint-Cirel, who performed France's national anthem, *La Marseillaise*, at the opening ceremony of the 2024 Summer Olympic Games.

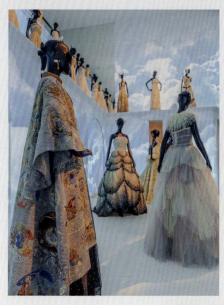
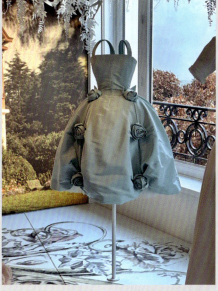

Some of the haute couture designs displayed at Galerie Dior.

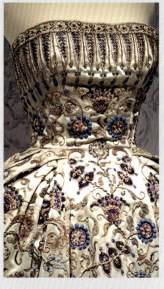
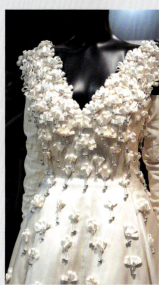
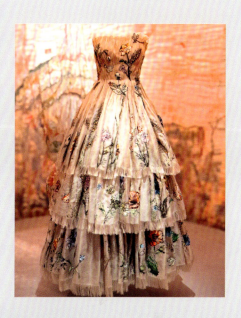

Karl Lagerfeld's former favourite model and muse, Inès de la Fressange is now the author of best-selling books on Parisian style and an authoritative fashion expert.

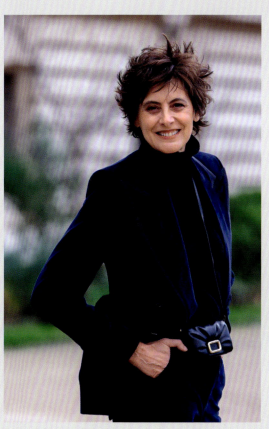

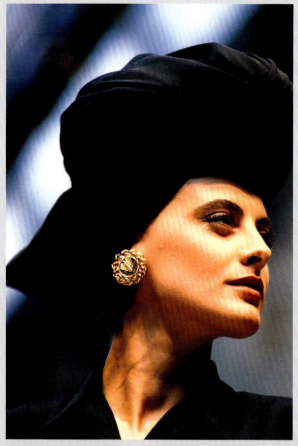

Inès de la Fressange modelling a Chanel turban in 1990.

Musée des Arts Décoratifs, famous for its fashion rooms.

A wedding dress designed by Daniel Roseberry for Schiaparelli, 2022.

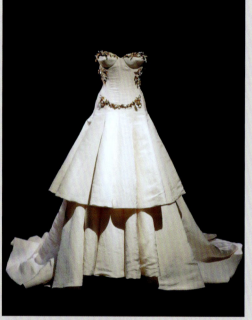

Evening dress by Elsa Schiaparelli.

At the Iris van Herpen exhibition, Musée des Arts Décoratifs, 2024.

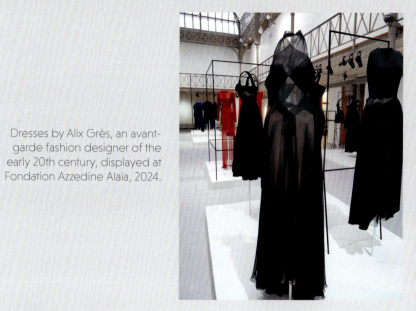
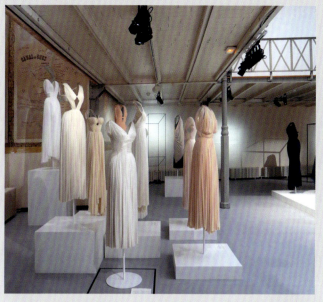

Dresses by Alix Grès, an avant-garde fashion designer of the early 20th century, displayed at Fondation Azzedine Alaïa, 2024.

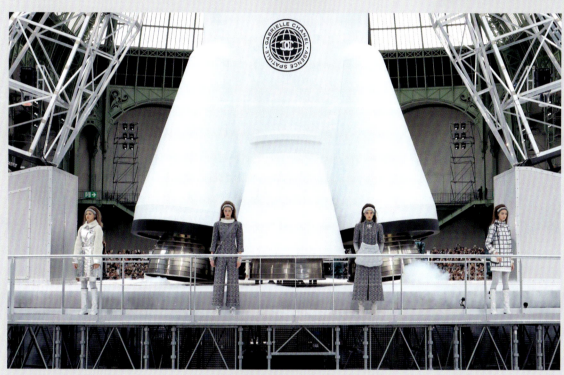

Models stationed around a space shuttle during Chanel's Autumn/Winter show at Paris Fashion Week, March 2017.

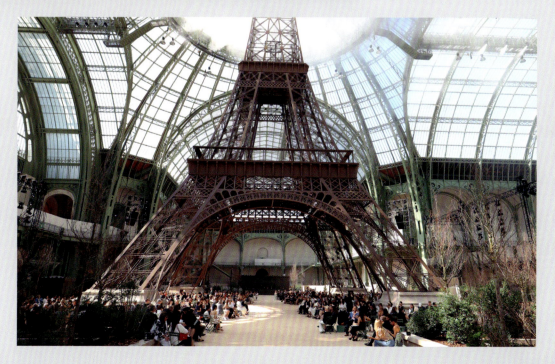

Incredible mock Eiffel Tower over the Chanel runway, July 2017.

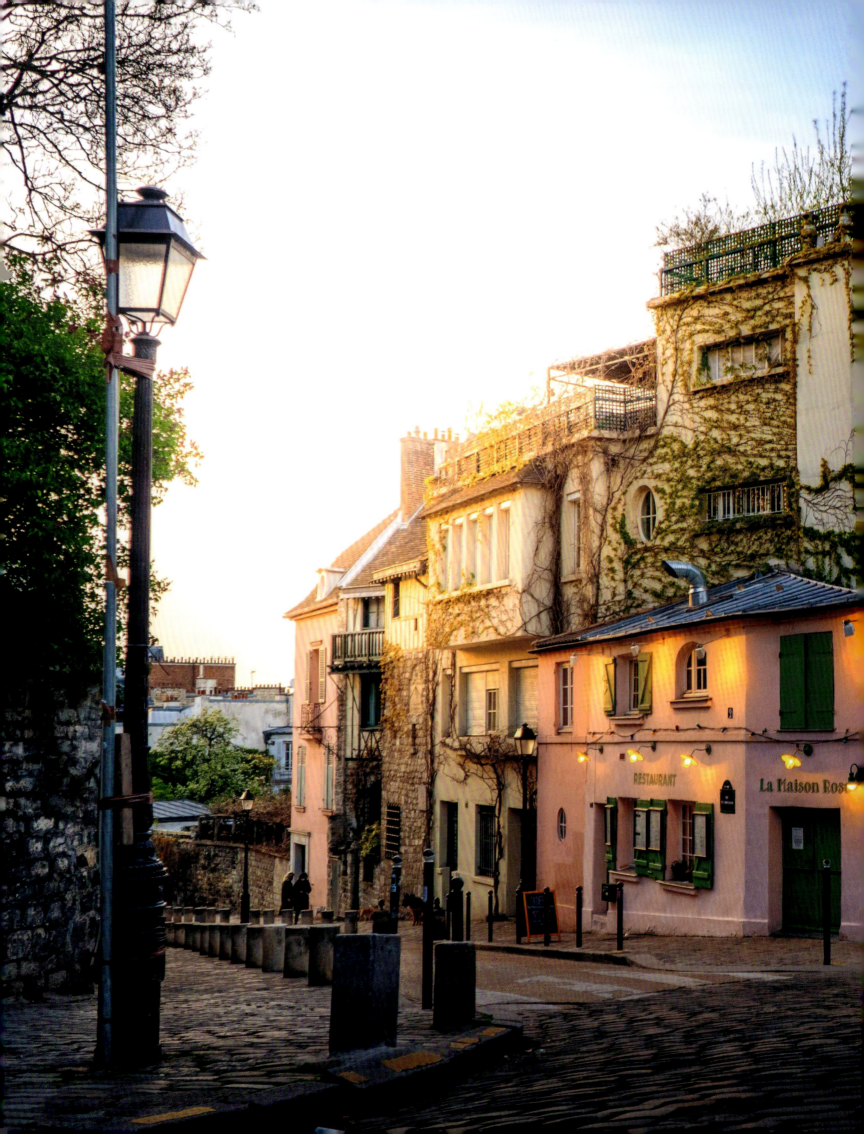

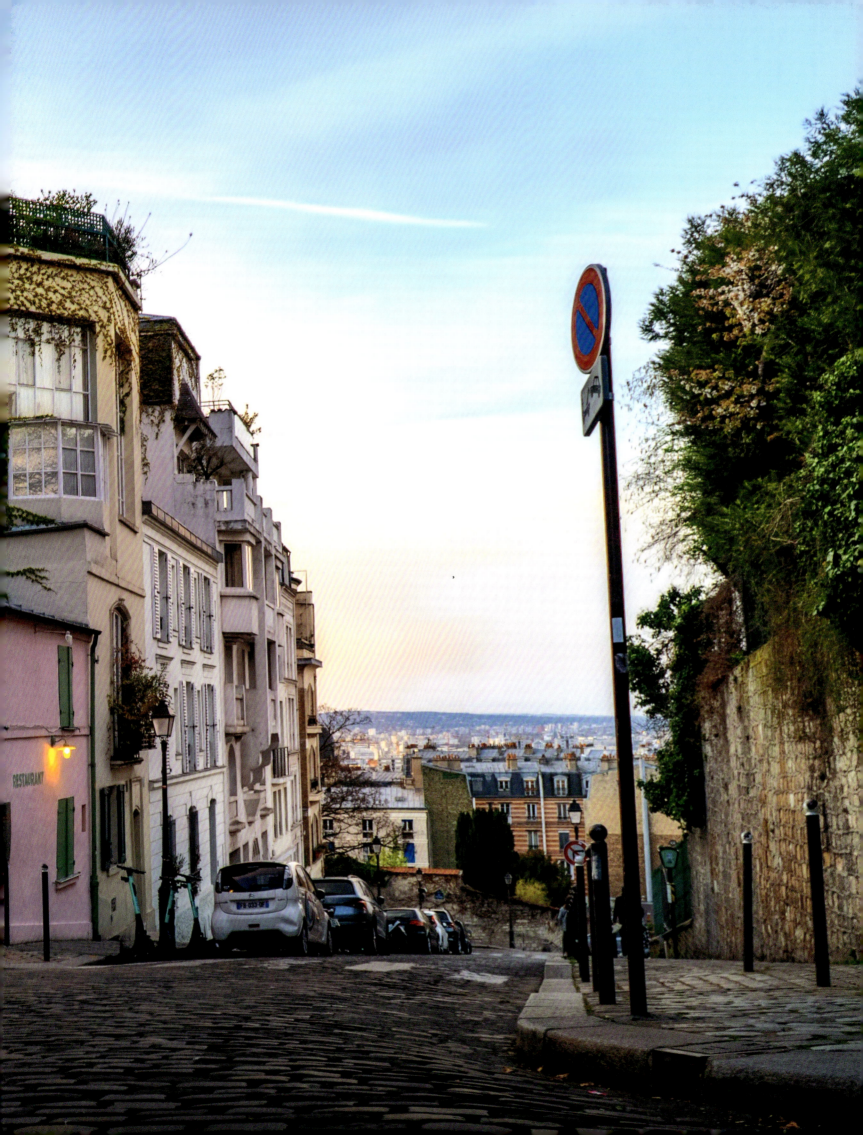

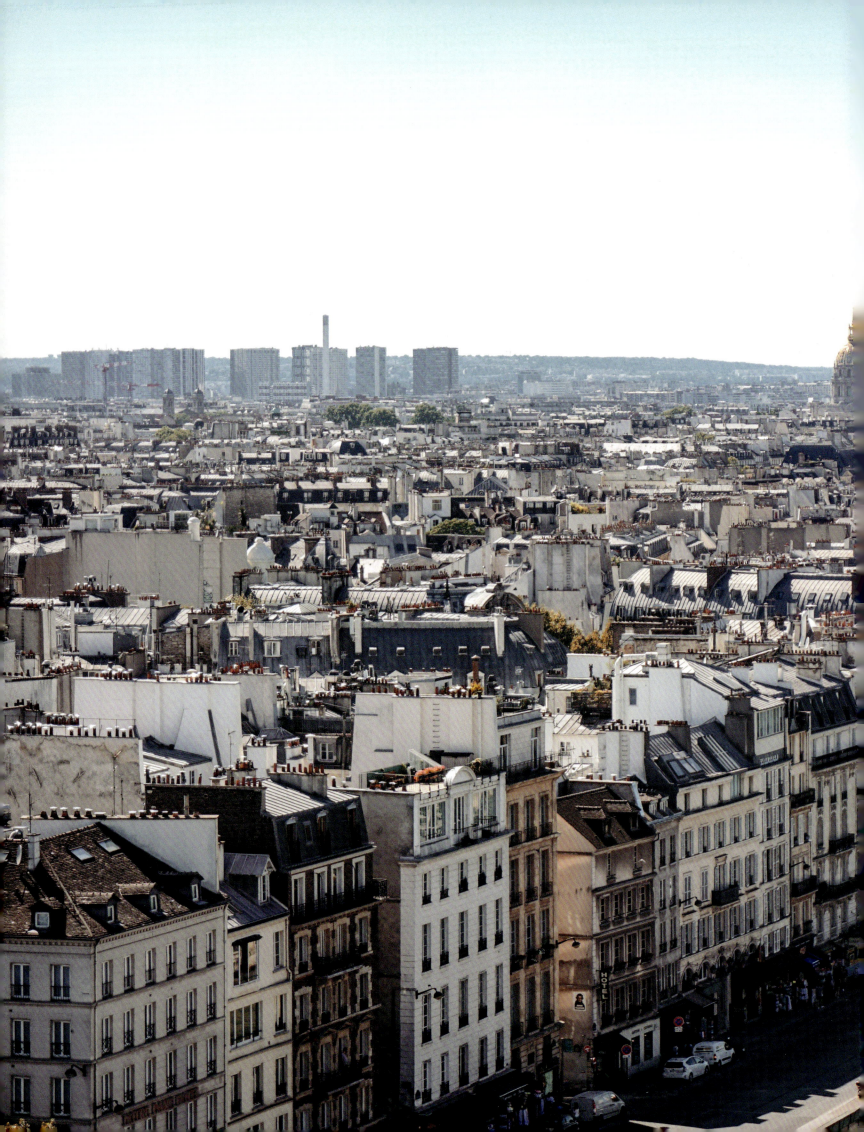

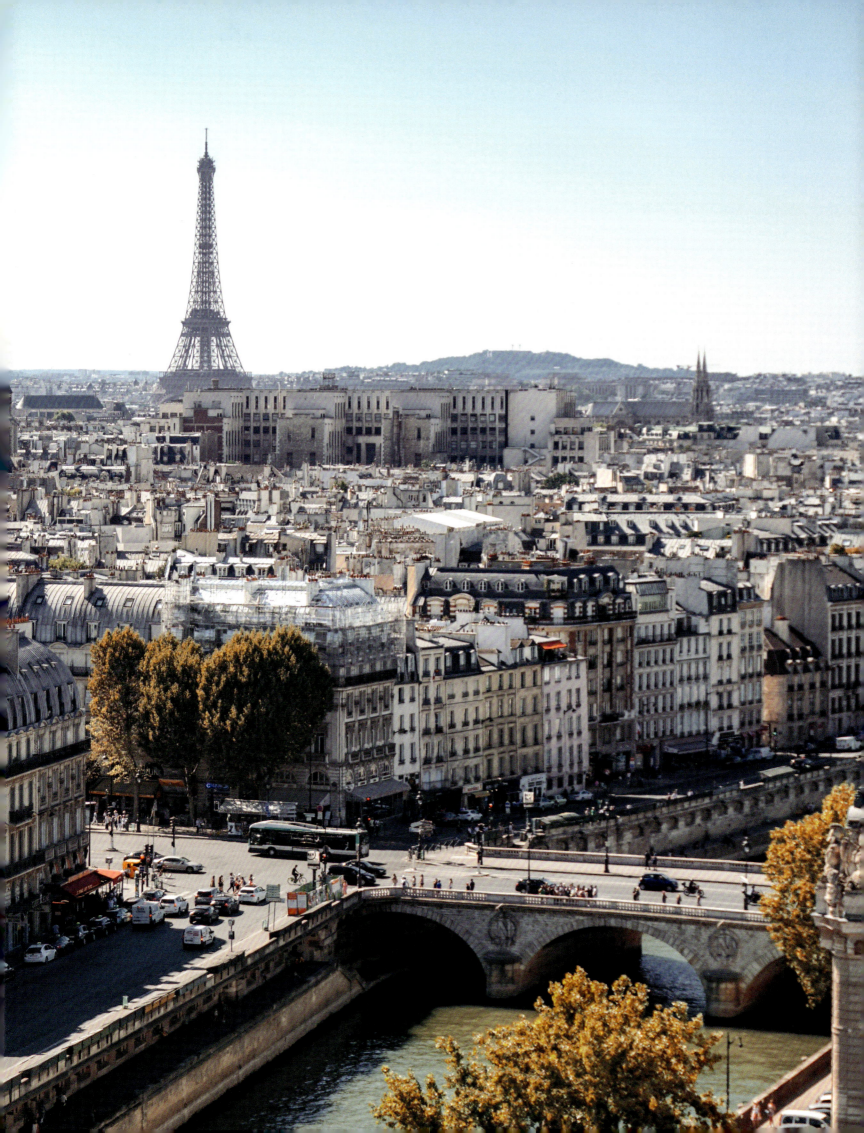

PHOTO CREDITS

Front cover © photo-lime/Shutterstock
pp. 2 © Tommy Milanese/Pexels
pp. 4–5 © PositiveTravelArt/Shutterstock
pp. 6–7 © UlyssePixel/Shutterstock
pp. 8–9 © Petr Kovalenkov/Alamy Stock Photo
pp. 10–11 © Hemis/Alamy Stock Photo
pp. 12–13, 53 © Alberto Grosescu/Alamy Stock Photo
pp. 14, 53 © Creative Lab/Shutterstock
pp. 16–17 © Huang Zheng/Shutterstock
pp. 20, 50 © Musée Carnavalet, Paris
pp. 23, 50 © Palais Galliera, Musée de la Mode de la Ville de Paris
pp. 24, 50 © Musée Carnavalet, Paris
pp. 27, 50 © Kunsthistorisches Museum, Vienna
pp. 28, 51 © Rijksmuseum, Amsterdam
pp. 30, 51 © Rijksmuseum, Amsterdam
pp. 32, 51 © Rijksmuseum, Amsterdam
pp. 33, 51 © Rijksmuseum, Amsterdam
pp. 34–35, 52 © Musée Carnavalet, Paris
pp. 37, 52 © Kurt Hutton/Getty Images
pp. 38, 52 © Serge Balkin/Condé Nast via Getty Images
pp. 41, 52 © Reporters Associati & Archivi/Mondadori Portfolio via Getty images
pp. 42–43, 52 © Alain Nogues/Sygma via Getty Images
pp. 44, 53 © Fairchild Archive/Penske Media via Getty Images
pp. 47, 53 © FashionStock.com/Shutterstock
pp. 49, 53 © Stephane Cardinale/Corbis via Getty Images
pp. 54–55, 106 © FashionStock.com/Shutterstock
pp. 57, 106 © FashionStock.com/Shutterstock
pp. 58–59, 106 © FashionStock.com/Shutterstock
pp. 60–61, 106 © dpa picture alliance/Alamy Stock Photo
pp. 62, 106 © FashionStock.com/Shutterstock
pp. 64 left, 106 © Daniel Simon/Gamma-Rapho via Getty Images
pp. 64 right, 106 © Guy Marineau/Penske Media via Getty Images
pp. 65, 106 © Daniel Simon/Gamma-Rapho via Getty Images
pp. 66, 107 © FashionStock.com/Shutterstock
pp. 67, 107 © FashionStock.com/Shutterstock
pp. 68–69, 107 © FashionStock.com/Shutterstock
pp. 70, 107 © Peter White/Getty Images Entertainment via Getty Images
pp. 71, 107 © Estrop/Getty Images Entertainment via Getty Images
pp. 72, 108 © FashionStock.com/Shutterstock
pp. 73 all images, 108 © FashionStock.com/Shutterstock
pp. 74, 108 © FashionStock.com/Shutterstock
pp. 75, 108 © FashionStock.com/Shutterstock
pp. 76, 109 © FashionStock.com/Shutterstock
pp. 77, 109 © FashionStock.com/Shutterstock
pp. 78, 109 © FashionStock.com/Shutterstock
pp. 79, 109 © FashionStock.com/Shutterstock
pp. 80, 110 © Victor Virgile/Gamma-Rapho via Getty Images
pp. 81, 110 © FashionStock.com/Shutterstock
pp. 82, 110 © FashionStock.com/Shutterstock
pp. 83, 110 © FashionStock.com/Shutterstock
pp. 84, 110 © FashionStock.com/Shutterstock
pp. 85, 110 © Estrop/Getty Images Entertainment via Getty Images
pp. 86–87, 111 © FashionStock.com/Shutterstock
pp. 88–89, 111 © Associated Press/Alamy Stock Photo
pp. 90, 111 © FashionStock.com/Shutterstock
pp. 91, 111 © Fairchild Archive/Penske Media via Getty Images
pp. 92–93, 111 © FashionStock.com/Shutterstock
pp. 94, 112 © FashionStock.com/Shutterstock
pp. 96, 112 © FashionStock.com/Shutterstock
pp. 97, 112 © FashionStock.com/Shutterstock
pp. 98, 112 © FashionStock.com/Shutterstock
pp. 99 all images, 112 © FashionStock.com/Shutterstock
pp. 100, 113 © FashionStock.com/Shutterstock

pp. 101, 113 © FashionStock.com/Shutterstock
pp. 102–103, 113 © FashionStock.com/Shutterstock
pp. 104–105, 113 © Victor Boyko/WireImage via Getty Images
pp. 114–15, 164 © DKSStyle/Shutterstock
pp. 117, 164 © Edward Berthelot/Getty Images Entertainment via Getty Images
pp. 119, 164 © Kirstin Sinclair/Getty Images Entertainment via Getty Images
pp. 120, 164 © photo-lime/Shutterstock
pp. 121, 164 © Creative Lab/Shutterstock
pp. 122, 164 © Edward Berthelot/Getty Images Entertainment via Getty Images
pp. 123, 164 © Edward Berthelot/Getty Images Entertainment via Getty Images
pp. 124, 165 © Creative Lab/Shutterstock
pp. 125, 165 © DKSStyle/Shutterstock
pp. 126, 165 © Hanna Putylina/Alamy Stock Photo
pp. 127, 165 © eversummerphoto/Shutterstock
pp. 128, 165 © Huang Zheng/Shutterstock
pp. 129, 165 © Hanna Putylina/Alamy Stock Photo
pp. 130 top left, 166 © eversummerphoto/Shutterstock
pp. 130 top right, 166 © Alberto Grosescu/Alamy Stock Photo
pp. 130 bottom left, 166 © Christopher Neve/Alamy Stock Photo
pp. 130 bottom right, 166 © eversummerphoto/Shutterstock
pp. 131, 166 © Creative Lab/Shutterstock
pp. 132, 166 © Valentina Ranieri/Alamy Stock Photo
pp. 133, 166 © Mauro del Signore/Shutterstock
pp. 134, 166 © Huang Zheng/Shutterstock
pp. 135, 166 © Huang Zheng/Shutterstock
pp. 136, 167 © Huang Zheng/Shutterstock
pp. 137, 167 © Frédéric VIELCANET/Alamy Stock Photo
pp. 138, 167 © Creative Lab/Shutterstock
pp. 139, 167 © Creative Lab/Shutterstock
pp. 140, 167 © DKSStyle/Shutterstock
pp. 141, 167 © Valentina Ranieri/Alamy Stock Photo
pp. 142, 167 © DKSStyle/Shutterstock
pp. 144, 168 © Valentina Ranieri/Alamy Stock Photo
pp. 145, 168 © Frédéric Vielcanet/Alamy Stock Photo
pp. 146–47, 168 © Creative Lab/Shutterstock
pp. 148, 168 © eversummerphoto/Shutterstock
pp. 149, 168 © Frédéric VIELCANET/Alamy Stock Photo
pp. 150–51, 169 © Vincent Migliore/Alamy Stock Photo
pp. 152, 169 © eversummerphoto/Shutterstock
pp. 153, 169 © valentina ranieri/Alamy Stock Photo
pp. 154, 169 © eversummerphoto/Shutterstock
pp. 155, 169 © Ferruccio Dall'Aglio/Shutterstock
pp. 156, 170 © Mauro del Signore/Shutterstock
pp. 157, 170 © Alya108k/Shutterstock
pp. 158, 170 © andersphoto/Shutterstock
pp. 159, 170 © Alberto Grosescu/Alamy Stock Photo
pp. 160, 171 © sama_ja/Shutterstock
pp. 161, 171 © eversummerphoto/Shutterstock
pp. 162 top left, 171 © Ferruccio Dall'Aglio/Shutterstock
pp. 162 top right, 171 © Creative Lab/Shutterstock
pp. 162 bottom left, 171 © photo-lime/Shutterstock
pp. 162 bottom right, 171 © DKSStyle/Shutterstock
pp. 172–73, 234 © Elena Dijour/Shutterstock
pp. 175, 234 © andersphoto/Shutterstock
pp. 176, 234 © Kiev Victor/Shutterstock
pp. 177, 234 © Kiev Victor/Shutterstock
pp. 178, 234 © P-Kheawtasang/Shutterstock
pp. 180–81, 234 © Creative Lab/Shutterstock
pp. 182–83, 234 © pio3/Shutterstock
pp. 184, 235 © FoxPictures/Shutterstock
pp. 185, 235 © Fox_Dsgin/Adobe Stock
pp. 186, 235 © Petr Kovalenkov/Shutterstock
pp. 187, 235 © Petr Kovalenkov/Shutterstock
pp. 188–89, 235 © Andrei Antipov/Shutterstock
pp. 190 top, 235 © HJBC/Shutterstock
pp. 190 bottom, 235 © HJBC/Shutterstock

pp. 191, 236 © LIT / Shutterstock
pp. 192 top, 236 © EricBery/Shutterstock
pp. 192 bottom, 236 © Andrei Antipov/Shutterstock
pp. 193, 236 © SWAPFrance/Shutterstock
pp. 194–95, 236 © Andrei Antipov/Shutterstock
pp. 196–97, 236 © anna.q/Alamy Stock Photo
pp. 198–99, 237 © Kiev Victor/Shutterstock
pp. 200, 237 © Kiev Victor/Shutterstock
pp. 201, 237 © Creative Lab/Shutterstock
pp. 202–203, 237 © HJBC/Alamy Stock Photo
pp. 204–205, 237 © Franck Legros/Shutterstock
pp. 206–207, 237 © Franck Legros/Shutterstock
pp. 208–209, 238 © Feel good studio/Shutterstock
pp. 210–11, 238 © Franck Legros/Shutterstock
pp. 212–13, 238 © Lila Louisa/Shutterstock
pp. 214, 238 © Jacques Demarthon/AFP via Getty Images
pp. 215, 239 © Dave Z/Shutterstock
pp. 216, 239 © Creative Lab/Shutterstock
pp. 217, 239 © Okcamera/Shutterstock
pp. 218–19, 239 © Huang Zheng/Shutterstock
pp. 220–21, 240 © HJBC/Shutterstock
pp. 222 top, 240 © andersphoto/Shutterstock
pp. 222 bottom, 240 © EricBery/Shutterstock
pp. 223, 240 © 18th Studio/Shutterstock
pp. 224–25, 241 © Directphoto Collection/Alamy Stock Photo
pp. 226, 241 © Brian Jannsen/Alamy Stock Photo
pp. 227 top, 241 © Chris Redan/Shutterstock
pp. 227 bottom, 241 © Report/Shutterstock
pp. 228 top, 242 © Bruno Bleu/Adobe Stock
pp. 228 bottom, 242 © Michael Sheridan/Shutterstock
pp. 229, 242 © eddie linssen/Alamy Stock Photo
pp. 230, 243 © Jérôme Labouyrie/Shutterstock
pp. 231 top, 243 © bepsy/Shutterstock
pp. 231 bottom, 243 © EricBery/Shutterstock
pp. 232–33, 243 © agcreativelab/Adobe Stock
pp. 245, 282 © Helen89/Shutterstock
pp. 247, 282 © Maria Orlowa/Pexels
pp. 248, 282 © Dcps Chloé/Unsplash
pp. 250, 282 © Vernerie Yann/Shutterstock
pp. 252 top, 283 © Alina Sun/Shutterstock
pp. 252 bottom, 283 © Lila Louisa/Shutterstock
pp. 253, 283 © Alina Sun/Shutterstock
pp. 255, 283 © NBCU Photo Bank/Getty Images
pp. 256–57, 283 © Lila Louisa/Shutterstock
pp. 258, 284 © Telly/Shutterstock
pp. 259, 284 © Putri Aurina/Shutterstock
pp. 260–61, 284 © Lila Louisa/Shutterstock
pp. 262, 285 © Putri Aurina/Shutterstock
pp. 263, 285 © Raffaella Galvani/Shutterstock
pp. 264 left & right, 285 © Dcps Chloé/Unsplash
pp. 265, 285 © Dcps Chloé/Unsplash
pp. 266, 285 © EricBery/Shutterstock
pp. 267, 285 © Pierre Suu/Getty Images Entertainment via Getty Images
pp. 268, 286 © Michel Arnaud/Corbis Entertainment via Getty Images
pp. 270–71, 286 © SvetlanaSF/Adobe Stock
pp. 272, 286 © Irisa/Adobe Stock
pp. 273, 286 © Irisa/Adobe Stock
pp. 274–75, 286 © Andrei Antipov/Shutterstock
pp. 276, 287 © Irisa/Adobe Stock
pp. 277, 287 © Irisa/Adobe Stock
pp. 278–79, 287 © Yasushi Kanno/Associated Press/Alamy Stock Photo
pp. 280–81, 287 © Antonio de Moraes Barros Filho/WireImage via Getty Images
pp. 288–89 © Bastien nvs/Unsplash
pp. 290–91 © Stefano Huang/Unsplash
pp. 292–93 © Alexander Kagan/Unsplash
p. 295 © Celine Ylmz/Unsplash
Back cover © PositiveTravelArt/Shutterstock

ACKNOWLEDGEMENTS

I would like to thank the entire team at ACC Art Books for their constant, friendly support and valuable knowledge. I rarely enjoyed working on a new book project as much as I did in this case, so good karma maybe exists, after all…

A big thank you to my wife Agata, both for selecting the best pictures with me and for designing this gorgeous, colourful book, and to our daughters Emilie and Mathilde for their patience and young enthusiasm.

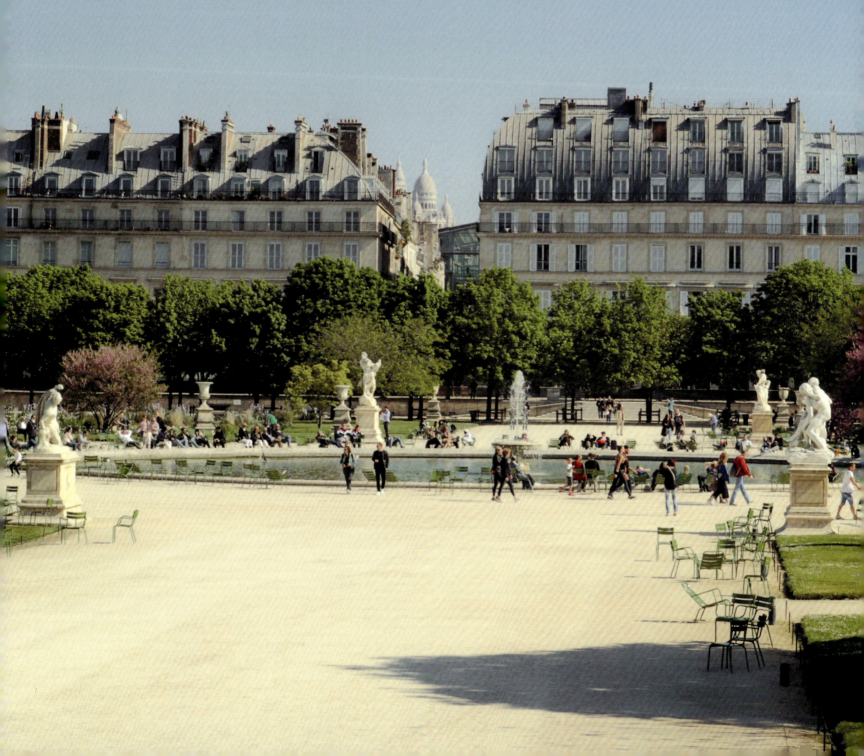

© ACC Art Books, 2025
Texts and layouts © Fancy Books Packaging UG (haftungsbeschrankt).
World copyright reserved

ISBN: 978 1 78884 313 3

The right of Pierre Toromanoff to be identified as author of this work has been asserted by him in accordance with the Copyright, Designs and Patents Act 1988

All rights reserved. No part of this publication may be reproduced, stored in a retrieval system, or transmitted in any form or by any means electronic, mechanical, photocopying, recording or otherwise, without the prior permission of the publisher

A CIP catalogue record for this book is available from the British Library

The author and publisher gratefully acknowledge the permission granted to reproduce the copyright material in this book. Every effort has been made to trace copyright holders and to obtain their permission for the use of copyright material. The publisher apologises for any errors or omissions in the text and would be grateful if notified of any corrections that should be incorporated in future reprints or editions of this book.

Senior Editor: Alice Bowden
Creative Direction: Mariona Vilarós Capella
Design: Steve Farrow
Colour Separation: Corban Wilkin

EU GPSR Authorised Representative:
Easy Access System Europe Oü, 16879218
Address: Mustamäe tee 50, 10621 Tallinn, Estonia
Email: gpsr@easproject.com Tel: +358 40 500 3575

Printed by C&C Offset Printing Co. Ltd in China
for ACC Art Books Ltd, Woodbridge, Suffolk, UK

www.accartbooks.com